HPBooks®

W9-CPE-248

How To Select and Use
PENTAX SLR CAMERAS
by Carl Shipman

CONTENTS

THIS IS AN INDEPENDENT PUBLICATION

Cooperation of Pentax Corporation and Asahi Optical Company, is gratefully acknowledged. However, this publication is not sponsored in any way by the manufacturer or importer of Pentax cameras.

Information, data and procedures in the book are correct to the best of the author's and publisher's knowledge. Because use of this information is beyond the author's and publisher's control, all liability is expressly disclaimed.

Specifications, model numbers and operating procedures for the equipment described herein may be changed by manufacturer at any time and may no longer agree with the content of this book.

Publisher: Rick Bailey; **Editor:** Theodore DiSante; **Art Director:** Don Burton; **Book Assembly:** Kathleen Koopman; **Typography:** Cindy Coatsworth, Michelle Claridge.

ISBN 0-912656-57-3
Library of Congress Catalog Card No.: 76-51908

HPBooks, Inc., P.O. Box 5367, Tucson, AZ 85703 602/888-2150
©1984, 1982, 1981, 1980, 1979, 1977 HPBooks, Inc.
Printed in U.S.A.
10th Printing

1
PREVIEW

The manufacturer of Pentax cameras, Asahi Optical Company, has pioneered many new features in SLR cameras, beginning in 1952 with production of the first 35mm Single-Lens-Reflex (SLR) camera manufactured in Japan.

This was followed by a series of new models with advanced features, such as *through-the-lens metering,* that are used today in nearly every brand of SLR.

The early cameras used screw-mount lenses, called *Takumar,* that screwed onto the front of the camera.

In 1975 a new K-series of cameras was introduced with a bayonet-type lens mount that has several advantages including easier mounting of the lens. This K mount has been standard on lenses for all Pentax 35mm SLR cameras since then.

In the 1970s, a trend in SLR design was to make cameras and lenses smaller. Pentax introduced the M-series of cameras in 1976, which were smaller than any other popular SLR on the market. Along with these cameras was a new M series of lenses that were similarly compact and lightweight.

All Pentax 35mm SLR cameras and lenses manufactured since 1975 use the same lens mount and are compatible. All Pentax SLRs use a variety of interchangeable accessories. The combination of camera and accessories is considered a *system* because the accessories allow you to set up the camera for virtually any kind of photography.

In 1980, Pentax celebrated 60 years of design and manufacture of photographic equipment by naming a new model the LX—Roman numerals for 60. The LX is a top-of-the-line camera system for professionals and advanced amateurs. Among Pentax models, it has the widest array of accessories. In addition to those designed specifically for the LX, the camera can use many accessories common to other current models.

Four types of 35mm SLR cameras are discussed in this book—K-type, M-type, the LX, and a new series of programmed automatic cameras.

In 1983 and 1984, Pentax announced two new cameras: the *Program Plus* and the *Super Program.* As discussed later, programmed automatic cameras are easier to use for general photography because they do more of the "thinking" for you.

Other Pentax SLR Cameras—In addition to SLR models using 35mm film, Pentax manufactures SLR cameras for two other film formats.

The Auto 110 SUPER is a small camera with detachable lenses that uses 110-size film. It provides high-quality 110-size images with the additional flexibility of interchangeable lenses. It's a good choice for travelers and people who prefer the drop-in convenience of 110 film cartridges. The negatives can produce good prints up to about 5" x 7" in size, but cannot be enlarged as much as

35mm negatives and preserve comparable image quality. It is included in this book.

Pentax also manufactures two medium-format cameras. Frame sizes are approximately 6 x 7cm and 4.5 x 6cm. These models are usually considered professional cameras. The larger negatives can produce very large prints without noticeable reduction in image quality.

Medium-format cameras are not discussed in this book. They are included in another HP photography book, *How to Select & Use Medium-Format Cameras,* by Theodore DiSante.

About This Book—Beginning in Chapter 2, there are fundamentals that apply to photography in general and of course to Pentax cameras. I use photos of Pentax 35mm cameras and accessories to illustrate the discussions—which helps you become acquainted with the camera models and their features.

In Chapters 16 and 17, this book becomes specific about individual models. Each of the models listed on the front cover is discussed with complete specifications and information on how to use it.

In case you are not now familiar with Pentax cameras, the rest of this chapter is a brief introduction to current models.

The heart of the Pentax LX Professional 35mm SLR System is the LX camera itself. It sets exposure for you automatically, or you can do it yourself using manual control. This camera combines the advanced features of a thoroughly modern automatic camera with desirable old-fashioned virtues such as a shutter mechanism that works even with dead batteries in the camera. A very wide range of interchangeable lenses and other accessories is available to meet nearly any photographic requirement.

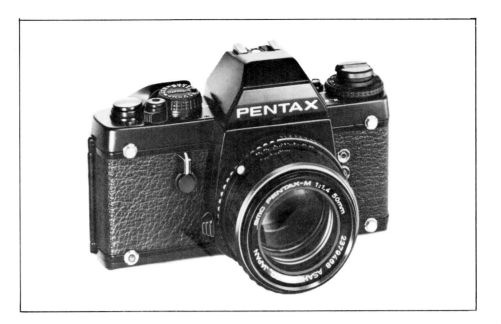

The SUPER PROGRAM camera has six modes of operation. It has five automatic modes in which the camera controls exposure. The programmed automatic modes make photography so simple that all you do is focus and press the shutter button. The programmed modes require use of Pentax-A type lenses. Other automatic modes give you more control for special cases, such as "freezing" a moving subject. For complete control of every creative aspect of photography, it can be operated with manual exposure control.

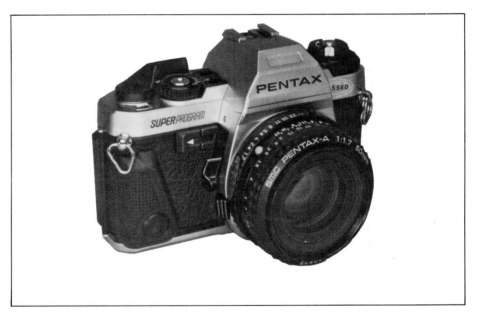

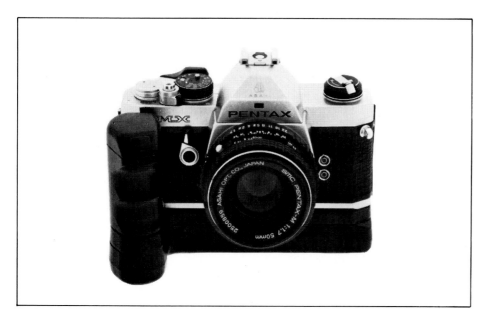

The MX is a non-automatic, manual camera with a full system of accessories.

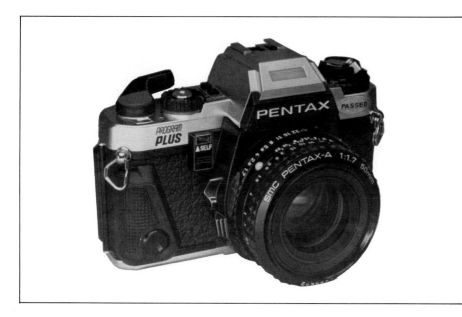

The PROGRAM PLUS camera has four modes of operation. Two are programmed automatic modes that make photography so simple that all you do is focus and press the shutter button. Another automatic mode gives you more control for special situations. The camera can be operated with manual exposure control when desired, so you can control every creative aspect of photography. The programmed modes require use of Pentax-A type lenses.

The ME Super is a compact camera with both automatic and manual exposure control. When the ME Super is used on manual, shutter speeds are selected by two pushbuttons on top of the camera. One increases shutter speed; the other decreases it. The viewfinder display shows you exactly what is happening.

The Auto 110 SUPER is a tiny SLR camera offering take-along convenience and the simplicity of drop-in cartridges of 110-size film. It is part of a complete little SLR system with its own flash, interchangeable lenses, a battery-powered film winder and an assortment of useful accessories. The 110-size negative is smaller than a 35mm negative. Medium-size enlargements show excellent detail and fidelity. For large prints, better quality usually results from a larger negative, such as 35mm or medium-format.

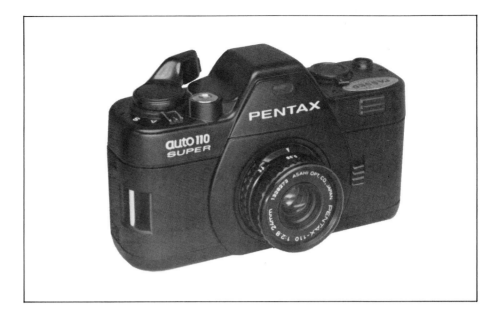

The K1000 is a simple, non-automatic camera for the budget-minded or beginning photographer. It is a basic camera, capable of high-quality photographs, but without as many camera controls and features as more expensive models.

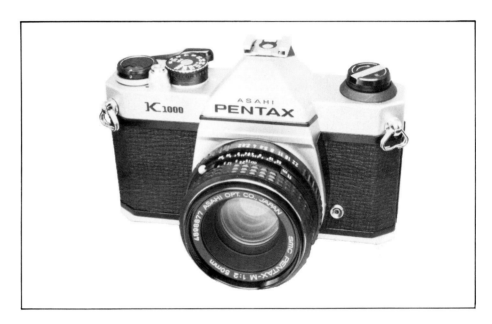

2
EXPOSURE— THE BASIC TECHNICAL PROBLEM

Inside each lens is a *diaphragm* with an *aperture* in the center that can be changed in size. Changing aperture size allows more or less light to reach the film. Aperture size is controlled by a ring on the lens barrel, called the Aperture Ring or the Diaphragm Ring. These photos show aperture changing from maximum, to medium, to minimum.

Everything about a camera serves in one way or another to get proper exposure of light onto the film. The camera body excludes stray light or leaks which can affect the film. The lens admits light from the subject being photographed.

One control setting of lenses, called *f-number* or *f-stop* is an indication of *how much* light the lens collects and relays to the film surface.

Inside each lens is a *diaphragm*, made up of several movable leaves which form the edge of an approximately circular hole or *aperture*. By changing the position of the leaves, the hole in the center of the diaphragm can be made larger or smaller and thus transmit more or less light through the lens into the camera where it exposes the film.

The control for aperture size is a knurled ring on the outside of the lens body or barrel. It is called the *aperture ring* or *diaphragm ring.* Click-stops, or *detents*, on the ring cause it to move in definite steps as you rotate the control. Each major step is numbered, with each number representing a definite aperture size. These numbers are called *f*-numbers.

The aperture ring on each lens is marked in a series of *f*-numbers representing all steps between the largest possible setting and the smallest. Usually there is an intermediate detent between numbered settings which represents a half step.

A peculiarity of *f*-numbers is that large numbers mean smaller aperture and less light on the film. For example, if a lens has settings ranging from *f*-2 to *f*-22, *f*-2 transmits the most light and *f*-22 transmits the least.

The *f*-numbers are an important part of photography with adjustable cameras and you will become very familiar with them. They are written in more than one way: *f*-2, *f*/2 and *f*:2. Pentax literature uses the form *f*/2. This book is part of the H. P. Books series on photography where the form *f*-2 has been standardized. However *f*-2 and *f*/2 mean exactly the same thing.

EFFECT OF LIGHT

The effect of light on negative film is to create a record of the light pattern in the light-sensitive layer, called *emulsion*, coated onto a clear base.

Exposure of film to cause an

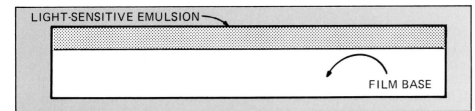

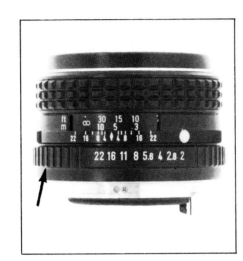

The simplest film structure is a light-sensitive layer of emulsion supported by a film base. Most films are more complex than this. Color film, for instance, has three layers of emulsion—each sensitive to a different color.

The Aperture Ring on SMC Pentax lenses is knurled for sure grip and labeled with a series of *f*-numbers which are read against the diamond shaped index mark on the next scale. The lens is set at *f*-16.

image after development is not just a matter of how bright the light on the film is. Exposure is determined both by *how bright* the light is and *how long* it is allowed to fall on the film.

The length of time light is allowed to fall on the emulsion is measured in seconds or fractions of a second. It is controlled by a *shutter* inside the camera body, just in front of the film.

RECIPROCITY LAW

The amount of exposure can be expressed by a simple formula which is a basic fact of photography:

Exposure = Illumination x Time

Illumination means the brightness of the light which falls on the film. *Time* is the length of time the shutter is open.

This formula is often written in abbreviated form as: E = I x T, where the letters stand for the words given above. This is called the *reciprocity law.*

The important thing about the reciprocity law is this:

To get a certain amount of exposure on the film, no particular amount of light is required and no particular length of time is required. The requirement is, the amount of light multiplied by the length of time must equal the desired exposure.

This means you can use less light and more time, or the reverse. When there is not much light, you expose for a longer time so the product of the two values is the desired exposure.

This leads to the basic rule for controlling exposure. When you

double the intensity of light reaching the film, reduce exposure time to half. When you double the exposure time, cut the amount of light on the film in half. This is the essence of the reciprocity law.

HOW FILM REACTS TO DIFFERENT AMOUNTS OF EXPOSURE

This discussion of how film responds to exposure applies to any kind of film, color or black and white (b&w). It is simpler to describe and understand when related to b&w film, but the same basic ideas apply also to color film.

If negative film is not exposed at all, but put through development anyway, it will be clear. Not perfectly clear, but practically clear.

Increasing exposure causes b&w film to become increasingly dark when it is developed. It will change from light gray to medium gray to black. There is a limit to how black it can get, just as there is a limit to how clear it can be.

It is convenient to think of changing exposure in a series of definite steps and then observe the amount of darkening which results at each step. The technical word for darkening of the film is *density.* More density means it is blacker or more opaque and transmits less light when you look through it.

All human senses, including vision, operate in a way that's surprising when you first learn of it. Suppose you are looking at a source of light such as a light bulb. It is making a certain amount of light and it gives you a certain *sensation* or mental awareness of brightness.

Assume the *amount* of light coming from the source is *doubled.* It will look brighter to you. Not twice as bright, but you will notice a definite change.

To make another increase in brightness which you will interpret as the same amount of change, the amount of light must be *doubled again.* Successive increases in brightness which all appear to be *equal changes* must be obtained by doubling the actual amount of light and continuing to double each value to

get the next higher step. This is a fact about the way we see and therefore tells us what must be done on film to make equal steps of brightness to a viewer of the film.

This is the reason standard step increases in exposure are in multiples of two. When you rotate the diaphragm ring on a lens from one numbered setting to the next numbered setting, you always either double the amount of light or cut it in half, depending on which way you rotate the control.

Shutter speed is controlled by a separate dial on the camera which has a series of standard steps such as 1, 2 and 4 seconds. Notice that the standard steps of shutter speed are also multiples of two. This makes it very handy to make exposure settings following the rule given earlier. If you double the amount of light passing through the lens aperture, or double the length of time the shutter is open, you have made a *step increase* in exposure. Reducing either to one-half its former value is a *step decrease* in exposure.

Figure 2-1 is a test made by exposing each frame on a roll of film at a different exposure, doubling the exposure each time. The subject is a white piece of paper.

The result shows how film behaves over a wide range of different exposures which were made in orderly steps for convenience. You can see that the negative reaches a point where it doesn't get any blacker even with more exposure. It also reaches a point where it doesn't get more clear with less exposure.

These two limits of the film—maximum black and maximum clear—are practical limitations in photography. Normally you try to fit the different brightnesses or *tones* of a real-world scene into the range of densities the film can produce.

This is done by adjusting the camera controls with a rather simple idea in mind. The film can produce a range of different densities between maximum and minimum. One of these densities *on the film* is the middle one. The scene you are photographing also has a range of brightnesses or tones which are going to be transformed into densities on the film. One tone *in the scene* is the middle one.

If you arrange exposure so the middle tone of an average scene is transformed into the middle density on the film, exposure is just right. When the negative is made into a print, lighter tones of the scene use lighter densities on the print—above the middle value. Darker tones of the scene use the darker densities of the print.

The only technical problem which can result from exposing film this way is if the brightness range of the scene exceeds the density range of the film. In that case, the film doesn't have enough different densities to match the different brightnesses of the scene. That can happen when part of a scene is in bright light or sunlight and another part is in shadow.

CONTROL OF EXPOSURE

Getting a desired exposure on the film depends basically on three things:

The amount of exposure the film needs—it varies from one type of film to another.

The amount of light reflected

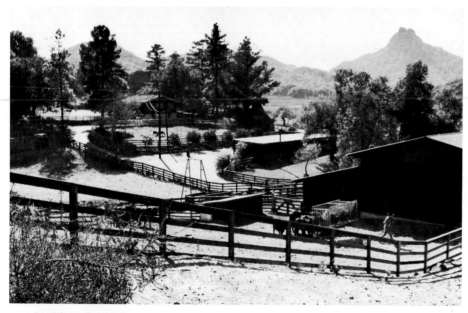

Figure 2-1/Black-and-white photographic materials record shades of gray, ranging from white to black, according to the amount of exposure received. When the amount of exposure is doubled, that is one standard step-increase. Film is often exposed with a series of standard steps for testing. In this series of steps, increasing exposure causes this negative film to become darker until a point is reached where additional exposure has no effect. Similarly, reduced exposure makes the film less dense until it finally becomes as white (clear) as it's going to get. Real-world scenes can give any amount of exposure—standard exposure steps or any value in between.

In this real-world scene, you can see many shades of gray, from white to black.

Overexposure on black-and-white film makes everything too light on a print and loses detail into white. Underexposure loses picture detail into black. With color film, the effects are the same but there may also be visible color changes when exposure is not correct.

ASA																				
		5000 4000		2500 2000	1250 1000		640 500		320 250		160 125		80		50 40		25 20		12 10	
ASA	•	• •	•	•	• •	•	• •	•	•	•	• •	•	•	•	• •	•	• •	•	• •	•
	6400		3200		1600		800		400		200		100	64		32		16		8

There isn't room on the small film-speed dial to show numbers for each possible setting. Pentax film-speed dials show commonly used film speeds with numerals. Dots in between numerals are other film speeds as shown here. Not all cameras have this entire range of film-speed settings.

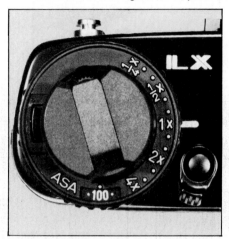

On some camera models, the Film-Speed Control surrounds the Rewind Knob. The film-speed setting appears in a window. This camera is set to use ASA/ISO 100 film. To change the setting, press the lock button at left and turn the outer rim of the control.

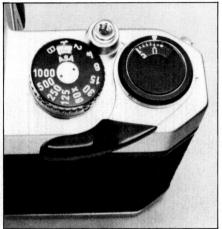

On the K1000 and MX cameras, the Film-Speed Control is part of the Shutter-Speed Dial. To set, lift the outer rim and turn it to place the desired ASA film-speed number in the window. This control is set to ASA 100.

toward the camera by the scene or subject.

The settings of the camera exposure controls.

ASA Film Speed—Film manufacturers publish numbers called *ASA Film Speed*, a way of stating the amount of exposure needed by each film type.

Film speed is a number such as 25 or 400. Higher speed numbers mean the film is more sensitive to light and requires less exposure. Doubling the film-speed number means it requires half as much exposure. Doubling it again requires one-fourth the amount of exposure.

The standard series of ASA Film Speed numbers is 12, 25, 50, 100, 200, 400, and so on. It can be extended in either direction by doubling or halving the numbers.

Pentax cameras have a film-speed dial which you use to set the ASA speed number of the film you are using. This sets the camera to give correct exposure to that film.

Not all films have ASA speed ratings which fall in the series of numbers given above. For example, Kodak Panatomic X has an ASA speed of 32. Kodachrome 64 has a speed of 64. Ektachrome 160 film has a rating of 160.

Film manufacturers and camera makers have agreed to divide the ASA scale in thirds, so there are two additional numbers between each standard pair. That is two possible film speeds between ASA 25 and ASA 50, two between 50 and 100, and so forth. Films which don't have speed numbers on the standard series are assigned one of the intermediate numbers, such as 32.

All Pentax cameras have a mark or dot on the film-speed dial for each standard speed number and each of the intermediate numbers, but there isn't room to engrave all of the numbers. Some are shown and some are represented by a dot. The accompanying table shows you ASA numbers for every setting of a film-speed dial.

Here's a little memory trick that can save you the problem of trying to remember what all the unlabeled dots mean. Just remember, 8, 10 and 12. Start doubling any one of these three numbers and you get one-third of all possible film-speed numbers.

ASA OR DIN?

In the **ASA** system, each step is *double* the next lower value. In the **DIN** system, the steps mean the same thing, but are obtained by *adding* 3 units to get the next higher number.

The two speed numbering systems agree at 12 and then follow their individual patterns for higher and lower speeds:

ASA 6 12 25 50 100 200 400...
DIN 9 12 15 18 21 24 27...

With either system higher speed numbers mean the film is more sensitive and therefore requires less exposure.

ISO?—The International Standards Organization has combined both ratings in the ISO film speed. ISO 100/21° means the film is ASA 100 or DIN 21°.

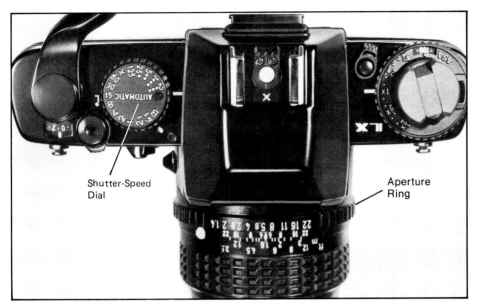

The two basic exposure controls are the Aperture Ring on the lens, which changes aperture size, and the Shutter-Speed Dial on the camera, which controls shutter speed. On this LX camera, you can choose any of the marked shutter speeds to control the camera manually, or you can set it to Automatic as shown here—and let the camera choose the correct shutter speed for the aperture size set on the lens.

Amount of Light from the Scene—After film speed is set into the camera, the next essential is to measure the amount of light reflected by the scene. Pentax 35mm cameras do this automatically, inside the camera. They measure light that has come through the lens, using an *internal* light meter built into the camera.

Exposure Controls—With film speed dialed into the camera, and the amount of light coming through the lens measured inside the camera, the camera itself can now figure the correct settings for the exposure controls. It indicates the correct setting on a display in the viewfinder, as you adjust the camera controls. Or, if you are using an automatic camera, you can allow it to make the exposure setting for you.

The two exposure controls—aperture size and shutter speed—are used together to arrive at a pair of settings which produces the desired exposure indicated by the viewfinder display. Several pairs of settings can produce the same amount of exposure. You can change shutter speed and make a balancing or compensating change in aperture size so you end up with the same amount of exposure but you get it with a different *pair* of exposure control settings —a practical application of the Reciprocity Law.

VIEWFINDER DISPLAYS

SLR cameras show you several things in the viewfinder. You see the scene you are photographing. In the center of the image is a focusing aid to help you find best focus. At the side is an exposure display.

If the camera is on automatic, the display shows the exposure selected automatically by the camera for the next shot. If the camera is on manual, you must make exposure settings yourself, but the viewfinder display will show it if the setting is correct.

Either way, the camera is set to give the amount of exposure requested by the ASA speed number of the film, which you have already dialed into the camera.

A common error is to assume that this will be correct for any-thing you photograph. It will be correct for *average* scenes of the type most people shoot. It will not be correct for non-average or unusual scenes, which often make the best photographs. This is discussed in Chapter 10.

It is possible to choose a setting of one exposure control and then find it impossible to get correct exposure by adjusting the other control.

For example, larger apertures require faster shutter speeds. If you decide to shoot at *f*-2 on a bright day, the camera display may show overexposure even with the fastest available shutter speed. Use a smaller aperture to bring shutter speed within the operating range and to get correct exposure.

APERTURE PRIORITY AND SHUTTER PRIORITY

For reasons covered later, there are times when shutter speed is the most important setting so it is set first and you use whatever aperture setting is necessary to get correct exposure. When you choose shutter speed first, you are operating the camera with *shutter priority* or *shutter-preferred*. If you choose an aperture setting first and accept whatever shutter speed is needed, you are operating with *aperture priority* or *aperture-preferred*.

AUTOMATIC MODES

Depending on the model, Pentax cameras offer one or more of three types of automatic exposure control.

Aperture-Priority Automatic—In this mode, you set the lens aperture. The camera automatically selects the shutter speed that will be used.

Shutter-Priority Automatic—You set the shutter speed. The camera sets lens aperture size.

Programmed Automatic—The camera selects both aperture size and shutter speed for each exposure, using a built-in program stored in the camera electronics.

The MX display shows shutter speed on a rotating scale. This camera is set for 1/125 second. In use, only one LED glows at a time. Correct exposure is indicated by the green LED. Overexposure of 1/2 step is indicated by the yellow/orange indicator above center. Overexposure of 1 step or more is indicated by the red LED at the top. The LEDs below center show 1/2 or 1 step of underexposure.

The PROGRAM PLUS viewfinder displays digital readouts in two windows below the image. Depending on the mode, the display shows shutter speed, aperture, flash-ready and flash-exposure confirmation, an error indication if camera controls are incorrectly set, over- and underexposure in the manual mode, and a low-battery warning.

The LX display shows the lens aperture setting at the top. On automatic, the blue pointer indicates A and one LED glows to show the shutter speed selected by the camera. On manual, the pointer indicates the shutter speed you have selected. The red LED at top indicates overexposure. On manual, the red LED at bottom indicates underexposure. On automatic it means a very long exposure.

The ME Super display gives you a lot of information. The symbol EF means you are overriding the camera on automatic to give more or less exposure than usual. M means manual control. OVER and UNDER mean over- or underexposure. Shutter speeds are shown from 1/2000 to 4 seconds. The colored LED indicators glow as needed to tell you what's going on.

The SUPER PROGRAM viewfinder displays digital readouts in two windows below the image. Depending on the mode, the display shows shutter speed, aperture, flash-ready and flash-exposure confirmation, an error indication if camera controls are incorrectly set, over- and underexposure in the manual mode, an indicator that exposure compensation is being used, and a low-battery warning.

The K1000 uses a *needle-centering* display. If the needle is centered, exposure is correct. If it moves up, overexposure is indicated. If it moves down, underexposure is indicated.

3

HOW A SINGLE-LENS REFLEX CAMERA WORKS

The main feature of a single-lens reflex (SLR) camera which distinguishes it from other types is: You view and focus through the same lens used to cast the image onto the film. This has several important advantages and some relatively minor disadvantages.

The word *reflex* is a form of the word *reflection* and indicates that the image you see in the viewfinder is bounced off a mirror in the optical path between the lens and your eye.

Single-lens reflex cameras are designed as shown in Figure 3-1. The lens captures light from the subject being photographed. A focusing control moves the lens closer to or farther away from the film.

To view, a mirror is moved to the "down" position to intercept light traveling from the lens toward the film. This intercepted light is bounced upward by the mirror to a viewing screen and then through a special prism so it finally emerges at the viewing window where you can see what is coming in through the lens. You get the same view the film will get when you take the picture.

The *pentaprism* not only reflects the light rays internally so they come out the viewing window, it also causes the image you see to be correctly oriented—top to bottom

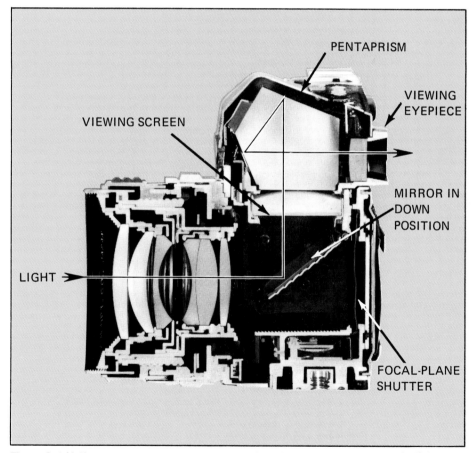

Figure 3-1/A K-type camera was cut in two to make this photo so you can see the light path from the scene to your eye. The mirror is down. When it moves up, your eye loses the view, but the same view falls on the film to make the exposure.

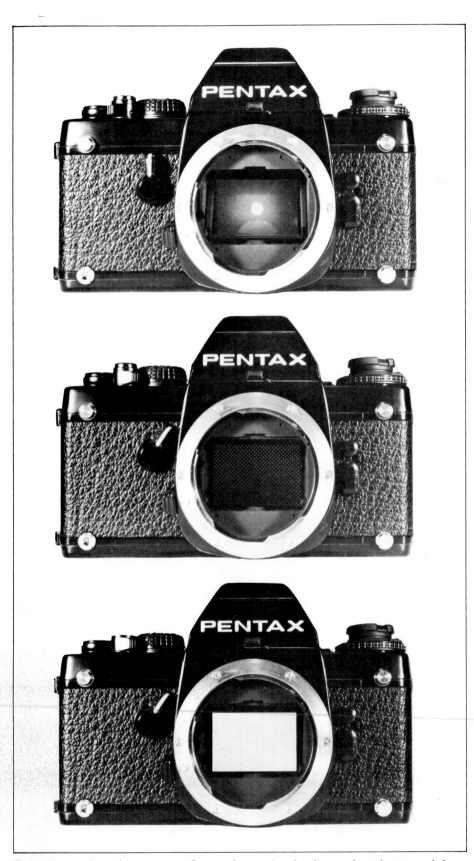

These photos show the sequence of events in opening the shutter. Lens is removed. In top view, mirror is down and shutter is closed. When you depress Shutter-Release Button, mirror moves up as in center photo. Shutter is still closed. The first shutter curtain in the LX has a checkerboard pattern as shown. When fully open, entire film frame is open to receive light as in bottom photo. When exposure is complete, shutter closes and mirror moves down.

and left to right. Like being wealthy, it's easy not to appreciate the benefit of correct viewing until you have to do without it.

The viewing screen is just below the pentaprism. The camera is built so the distance from lens to viewing screen by way of the mirror is the same as the distance from lens to the film in the back of the camera. Therefore, if the image is in focus as you see it on the viewing screen it will later be in focus on the film when the mirror is moved out of the way to take a picture.

A convenient way to think about it is this: You look through the pentaprism to examine the viewing screen which is showing you the image that will fall on the film when you trip the shutter. If you like what you see, squeeze the shutter button and several things happen very quickly.

The mirror moves up out of the way. As it swings up to its parking place you lose your view of the image. When the mirror is out of the way, the focal-plane shutter in front of the film is opened so light from the lens falls on the film.

In addition to mirror movement in synchronism with operation of the focal-plane shutter, the busy camera mechanism also lets you view the scene through the widest possible lens aperture for maximum scene brightness in the viewfinder. When you press the shutter button, the camera automatically closes lens aperture to the f-stop you previously selected when balancing the viewfinder exposure display. For example, if you selected f-11 with the control ring on the lens, the lens will automatically close down to f-11 after you depress the shutter button.

When the desired amount of time for film exposure has passed, the shutter closes.

The mirror automatically swings back down to the viewing position. Even though you lose sight of the scene while the film is being exposed, this time is usually brief and you quickly learn to ignore the

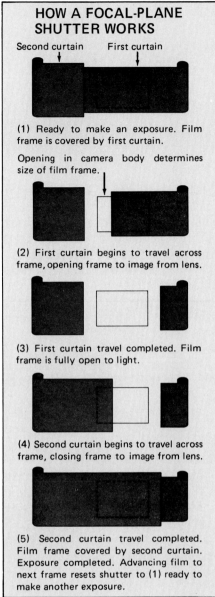

HOW A FOCAL-PLANE SHUTTER WORKS

Second curtain First curtain

(1) Ready to make an exposure. Film frame is covered by first curtain.

Opening in camera body determines size of film frame.

(2) First curtain begins to travel across frame, opening frame to image from lens.

(3) First curtain travel completed. Film frame is fully open to light.

(4) Second curtain begins to travel across frame, closing frame to image from lens.

(5) Second curtain travel completed. Film frame covered by second curtain. Exposure completed. Advancing film to next frame resets shutter to (1) ready to make another exposure.

Figure 3-2/This drawing shows operation of a two-curtain focal-plane shutter which travels horizontally. When exposure time begins, the first curtain is released to start its travel. As it moves, the first curtain passes across the film frame, allowing light to fall on the film. When the first curtain has completed its travel, the frame is fully opened. When exposure time ends, the second curtain is released to begin its travel and close off light to the film.

Exposure time is measured from *release* **of the first curtain to** *release* **of the second curtain. This drawing shows an exposure time long enough that the second curtain does not begin to move until after the first curtain has reached the end of its travel.**

"blackout." It's as if the camera "blinked."

With all that done and the image captured on one frame of the film, use the Rapid-Wind Lever to move the next frame of film into position for the next picture. The lever also winds up the camera mechanism so it can operate mirror, lens aperture and shutter for the next exposure.

Early SLR cameras were built so the mirror moved up at the instant of exposure and then remained up until the camera was wound up again for the next shot.

Second curtain First curtain

If exposure time is short, second curtain "chases" first curtain across frame and exposure is through a narrow traveling slit between the two curtains.

For short exposures such as 1/500 second, the second curtain follows so closely behind the first curtain that the entire frame is never open to light all at the same time. The frame is exposed by a traveling slit of light formed by the narrow gap between the two curtains.

With these cameras following action and making sequence shots was very difficult because the photographer lost sight of the subject for relatively long periods.

Today, all modern SLR cameras return the mirror instantly to the "down" position as soon as the shutter is closed—a feature commonly called *instant-return mirror.* This feature was invented and first used by Asahi Pentax in 1954 with the introduction of the Asahiflex II, predecessor of modern Pentax SLR's.

Focal-plane shutters are mounted in the camera body very close to the surface of the film.

The basic idea is illustrated in Figure 3-2. Two opaque curtains are mounted on rollers. Normally, the *first curtain* is positioned so it covers the surface of the film and does not allow light to reach it.

To make an exposure, the first curtain travels from one roller to the other. As the edge of the first curtain travels across the frame, it gradually opens the entire frame to receive light from the lens.

When the desired time of exposure is ended, the *second curtain* is released. The second curtain moves from roller to roller and covers the film frame so it can no longer receive light. Exposure is completed.

Exposure time is measured from *release* of the first curtain to *release* of the second curtain.

Pentax cameras use focal-plane shutters called *horizontal* or *vertical* according to which way the curtains move.

Horizontal shutters are cloth, wound on rollers as shown in the accompanying illustration. Vertical shutters are metal leaves which move vertically across the film frame—one set of metal leaves to open the frame to light and another set following along behind to close off the light. The general idea is the same no matter which way the curtains travel.

Either way, every point on the surface of the film receives the same total time of exposure by the moving curtains.

Art, like beauty, is in the eye of the beholder. This backlit flower may be artistic. Direct sunlight into a lens sometimes causes geometrical *ghost images* of the lens aperture.

When the film frame is fully opened to light by completed travel of the first curtain, the edge of the frame which first received light will have been exposed for a slightly longer period of time than other parts of the frame.

The small time difference is balanced out by the closing curtain. It follows the first curtain and stops exposure on one side sooner than it does on the other. The total time of exposure is the same at all points in the frame.

For a relatively long exposure such as one second, the exposure time begins with release of the first curtain. It moves quickly across the frame and stops with the entire frame open to light. One second later, the other curtain is released and closes off the film. For most of that one second of exposure, nothing is happening mechanically. The film just sits there looking out the window.

For a short exposure such as 1/1,000 second, the same rule holds—the second curtain is re-leased 1/1,000 second after release of the first. The first curtain will not have traveled very far before the second curtain starts chasing it across the film frame.

The effect of the second curtain following so closely behind the first is, the film is exposed through a narrow traveling slit—about 0.1 or 0.2-inch in width.

A frame of 35mm film is about one inch tall and about 1.5 inch wide. When it is exposed by a traveling slit only about 0.1 inch wide, all of the frame cannot be exposed at the same instant of time. It is exposed by a *moving slit* of light.

With short exposures the strip of film near one edge of the frame will have started and completed its exposure before the strip of film nearest the opposite side even begins to receive exposure.

With the back open, you can see the cloth horizontal-travel focal-plane shutter in this MX camera. It is closed to block light from the film.

GETTING ACQUAINTED WITH LENSES

Pentax lenses for 35mm SLRs are available in five types, all with the same mount. They are identified as SMC Pentax, SMC Pentax-M, SMC Pentax-M* (pronounced M-star), SMC Pentax-A, and Takumar Bayonet. The latter are not the same as the earlier Takumar screw-mount lenses.

SMC stands for *Super Multi-Coating*. This is a multiple-layer lens coating applied to glass surfaces of the lens. Its gives improved image quality as discussed in Chapter 8.

M-type lenses are "miniaturized." When Pentax introduced compact cameras, compact SMC Pentax-M lenses were produced.

The symbol * indicates that special low-dispersion glass is used in the lens to produce superior image quality.

SMC Pentax-A lenses are also compact. They have additional features allowing them to be used with a program camera, such as the Super Program. On cameras without programmed automatic, SMC Pentax-A lenses work the same as any other Pentax lens.

Takumar Bayonet lenses are manufactured in a limited range of focal lengths. Image quality is slightly less than that of SMC Pentax lenses. They are packaged with a camera body, to be sold as a kit, and are normally not sold separately.

The lens tables in Chapter 15 show currently available lenses for Pentax 35mm SLR cameras in all of the previously mentioned types except Takumar Bayonet.

Lenses for the Auto 110 Super are labeled Pentax 110. They are

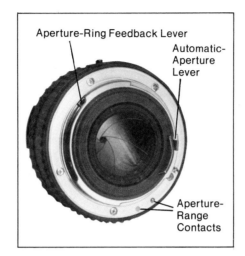

Aperture-Ring Feedback Lever

Automatic-Aperture Lever

Aperture-Range Contacts

The Pentax bayonet lens mount was introduced in 1975 with the K-series cameras and is called the Pentax K mount. It fits all Pentax 35mm SLRs manufactured since that date. The Aperture-Ring Feedback Lever "tells" the camera the setting of the Aperture Ring on the lens. The position of the Automatic-Aperture Lever is controlled by the camera. This allows automatic diaphragm operation by the camera. This is a KA mount used on SMC Pentax-A lenses. It has Aperture-Range Contacts, which allow a program camera to set aperture size automatically.

discussed in Chapter 17, along with the 110 camera.

AUTOMATIC DIAPHRAGM

The aperture inside each lens is formed by a diaphragm with pivoted overlapping metal leaves which move in unison to change the size. When aperture is small,

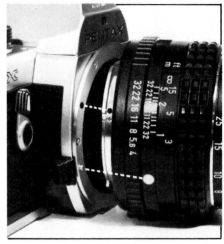

To mount Pentax lenses on Pentax 35mm SLR cameras, align the red dot on the lens with the red dot on the camera. In the dark, align the white button on the lens with the Lens-Release Lever on the camera—which you can do "by feel." Place the lens flat against the camera body and turn the lens clockwise until it clicks into place. To remove, depress the Lens-Release Lever and turn the lens counterclockwise.

Pentax-110 lenses are tiny. They use a two-prong bayonet mount and attach the same way as the larger lenses for 35mm cameras. All of the automatic features are built into the Auto 110 Super camera body, so the lenses are mechanically very simple. Levers on the back of the lens are not necessary.

Photography is more successful and more fun with lenses for different shooting situations. Photo of seagull was made with a 200mm lens, the Pekinese with a 50mm, and the grasshopper with a close-up supplementary lens described in chapter 11.

not much light gets inside the camera and the image you see in the viewfinder may be dim or even too dark to see properly. Therefore it is desirable to view at wide-open aperture and then take the picture at whatever smaller aperture size is needed for correct exposure.

In modern SLR cameras, this is done automatically and the feature is called *automatic diaphragm*, sometimes *automatic aperture*. A mechanism inside the camera body works with a lever on the rear surface of the lens to control aperture size so it remains wide open until the shutter button is depressed to take the picture. The aperture then quickly closes to the size you selected and the exposure is made.

Nearly all current Pentax lenses have the automatic diaphragm feature.

STOP-DOWN METERING

Sometime before the moment of exposure, light coming through the lens must be measured by the camera's built-in exposure meter, so the exposure controls can be set correctly. Even though you are viewing at open aperture with the brightest possible image on the viewfinder screen, the light-measuring system in the camera needs to know the amount of light that will come through the lens later—when the aperture is made smaller to take the picture.

One way is manually closing down the lens to "shooting" or "taking" aperture so you can get a light reading and set the exposure controls.

In the language of photography, reducing the size of a lens aperture is called *stopping down*. When you measure the light through a lens which is stopped down, rather than wide open, it's called *stop-down metering*.

This is an extra step in preparing to take a picture. After viewing and focusing at open or full aperture, you operate camera controls to close the lens aperture, reducing the amount of light. This reduced amount of light is measured inside the camera while you set the

Lenses are usually identified on the front. This is an SMC Pentax-A lens with maximum aperture of *f*-1.7 and a focal length of 50mm.

exposure controls to get correct exposure. Changing aperture size changes the amount of light, and you can see it happen.

After setting exposure controls with the lens stopped down you have two choices. You can open up the lens again and allow the camera's automatic diaphragm mechanism to close it down once again to take the picture. Or, you can just leave the lens stopped down and shoot. Either way you get the same exposure.

OPEN-APERTURE METERING

An improvement over stop-down metering allows measuring light *and* setting the exposure controls without stopping down the lens. It's called *open-aperture metering* or *full-aperture metering*. This requires a second mechanical linkage between lens and camera, which "tells" the camera the aperture size or *f*-number you are selecting at the lens. The lens aperture does not change while you are rotating the aperture control—it remains wide open for maximum brightness of the viewing screen.

Even though the camera light meter is measuring through a wide-open lens, the mechanical linkage tells the camera what the lens aperture *will be later* when it is stopped down automatically at the moment of exposure. The camera exposure meter takes this into account and compensates for the fact that it is not measuring at shooting aperture.

The main advantage of open-aperture metering is convenience—you don't have to bother with stopping down the lens to get a light reading.

All current Pentax cameras have this feature. Because open-aperture metering is a cooperative thing between camera body and lens, both must be equipped with the levers and mechanism to accomplish it. Not all lenses for Pentax 35mm cameras have an automatic aperture mechanism. Therefore, these cameras have open-aperture metering with most, but not all, lenses. The lenses without an automatic aperture mechanism are identified in later chapters.

The Auto 110 Super camera and lenses are a special case. Both shutter and diaphragm are in the camera body so no levers are needed on the lens. The only thing that moves in the lens is the focusing mechanism. Even though these lenses have no aperture mechanism, metering is always open-aperture because the camera body does it all.

There are some lens accessories—a bellows for example—that fit between lens and camera and do not complete the mechanical linkage needed for full-aperture metering. This will be discussed later, along with the accessories and their functions.

With these accessories, you must meter stopped down. You read and use the exposure display in exactly the same way whether measuring at full aperture or stopped down.

LENS IDENTIFICATION

Information engraved on a lens tells you its essential specifications and other data. On the front of most lenses for Pentax cameras, engraved on the metal ring surrounding the glass, is the lens identification.

Following the lens name is a

ESSENTIAL LENS ACCESSORIES

When you are not actually using a lens, you should clip on the front lens cap to protect the front glass surface against dirt and damage. Pentax front lens caps have two "ears" at opposite ends of the word PENTAX. Squeeze on both sides to attach or remove the cap. Front lens caps can be used with the lens mounted on the camera or not mounted.

Rear lens caps protect the mechanical parts on the back surface of the lens and also protect the rear glass surface. Remove the rear cap to mount the lens on a camera. Put the rear cap on the lens *immediately* when you remove lens from camera body. Rear lens caps fit the rear bayonet-mount of the lens. Place the cap on the lens and rotate clockwise until it is securely attached.

set of numbers such as 1:1.2 50mm. This gives you the two essential specs of every lens—maximum aperture and focal length. The first part of the designation—1:1.2—is yet another way of stating maximum aperture. Disregard the first part (1:) and what's left is maximum aperture expressed as an *f*-number. In this case, *f*-1.2.

The remaining part of the designation—50mm—states lens focal length in millimeters. This lens has a focal length of 50 millimeters (mm).

Also there is a lens serial number which you should record for insurance purposes and so you can identify your lens if it is ever lost or stolen. Finally, the lens manufacturer is given—Asahi Optical Company, Japan.

A few lenses with very large front glass elements have this information engraved around the outside of the lens barrel, near the front.

Another way to find maximum aperture of a lens is to look at the diaphragm ring on the lens barrel. All *f*-number settings are engraved on the ring, and the smallest *f*-number you see represents the largest possible aperture setting.

EFFECT OF FOCAL LENGTH

Focal length is expressed in millimeters, abbreviated *mm*. Technically, focal length is the distance between a certain location in the lens and the film in the camera when the lens is focused on a distant subject.

One practical value of focal length is a label or name for different types of lenses. The focal-length number tells you what the lens will do on the camera.

Lenses are grouped by focal length into three classes: Short, medium and long, according to this table:

Short:	35mm and shorter
Medium:	40mm to 85mm
Long:	100mm and longer

The differences are *angle of view* and *magnification*. Short-focal-length lenses such as 20mm and 28mm have wide angles of view and

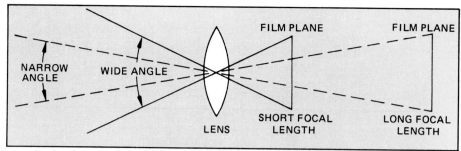

Angle of view is the angle between the outermost light rays which can enter the lens and form an image in the film frame. Short-focal-length lenses have wide angles of view; long lenses have narrow viewing angles.

low magnification.

Angle of view is the angle between the two edges of the field of view. Because a lens "sees" a circular part of the scene and makes a circular image, its true angle of view is the same vertically, horizontally, or at any angle in between.

Because the 35mm film format is a rectangle fitted closely into the image circle made by the lens, everything seen by the lens is not recorded in the film frame. This results in a slightly different definition modified to mean "the angle of view which is recorded on film." In that sense, a lens mounted on a camera using 35mm film has three angles of view: Horizontal, Vertical, and Diagonal. Diagonal is the largest angle because it is corner-to-corner of the film frame. Horizontal is smaller; vertical is smallest because the film frame is not as tall as it is wide. In Pentax literature, when only one angle of view is given for a lens, it is the diagonal angle.

Use wide-angle short-focal-length lenses when you want to show a lot of the scene being photographed. They are handy in taking interiors when you want to get a lot of the room but the walls prevent you from backing up very far.

You can get a feel for angle of view by testing your own vision. With both eyes open, hold your arms straight out to the sides and then move them forward until you can just see your hands while looking straight ahead. The angle will be less than 180 degrees.

Do it again with one eye closed.

The angle will be a lot less. Clear vision for a single eye covers a total angle of around 50 degrees or so, depending on where you decide you can't see clearly.

A 50mm lens has an angle of view of about 46 degrees. This is often called a *normal* lens for 35mm cameras and the reason given is the angle of view is about the same as *one* human eye.

A 40 or 50mm lens is considered *standard* for 35mm cameras because it is a good general-purpose lens and a compromise between wide and narrow angles of view. You can't do everything with a 40 or 50mm lens, but you can make a lot of fine pictures with it.

Long lenses such as 200mm and 300mm have narrow angles of view. A 200mm lens has an angle of about 12 degrees. A common type of lens with long focal length is called *telephoto.* Not all long lenses are of the telephoto design but most are and the word has come to mean the same thing as a long lens in popular terms.

We think of a long lens as one that can "reach" out and fill the frame with a distant subject such as a mountain climber high up on a rock face. It excludes most of the mountain because of its narrow angle of view. What that really means is the lens has high *magnification.*

Magnification is the size of the image on the negative divided by the size of the subject. Pentax literature sometimes shows this as a fraction or ratio such as 1/5 which means the image is *one unit* tall on film and the object is

five units tall in the real world. Some Pentax magnification data is obtained by performing the indicated division (1/5 or 1÷5) to get the equivalent, 0.2, expressed as a decimal. The fraction, 1/5, and the decimal, 0.2, have the same value mathematically and the same meaning when used to compare image and object sizes.

Pentax literature refers to this number, either as a ratio or decimal, by two names—*scale of reproduction* or *magnification.* This book will use *magnification* and you can consider both terms to have the same meaning.

If magnification is less than one, the image on film is smaller than the object being photographed. For example, a magnification of 0.1 means the image is one-tenth as large as the object. A magnification of 1.0 means image and object are the same size. If magnification is larger than one, image is larger than object. For example, a magnification of 2 means the image is twice as large on film as the real-life object.

Special lens attachments discussed in Chapter 11 can greatly increase the magnification of most lenses. When using these, you will often want to calculate or estimate the magnification needed.

Here's a simple way to do it. The picture-taking area or frame on 35mm film is about one-inch tall and 1.5-inch wide. When you hold the camera normally, the one-inch dimension is vertical on the film. Suppose you are photographing a person who is 6 feet tall (72 inches) and you want to fill the frame with the image of this tall stranger. Magnification is *always* image size (1") divided by object size (72"), so in this case it's 1/72. This can be done with a standard lens.

If you intend to shoot a half-inch-tall bug and fill the one-inch dimension of the frame, magnification will be 1/0.5, which is 2. This requires special lens equipment.

In ordinary photography without special equipment, there are two ways to increase magnification and make the image larger on film. With any camera, just move closer. With a camera using interchangeable lenses, switch to a lens with longer focal length and you get the same effect without moving closer.

With an SLR camera, you look through the lens which will take the picture so you can see angle of view and magnification. When you own more than one lens and become familiar with what they do, you will almost automatically select a lens for each different picture-taking situation.

ZOOM LENSES

A special type of lens called *zoom* changes focal length by a control on the lens. One Pentax zoom lens lets you use any focal length from 85mm up to 210mm. If you want the subject to fill the frame, zoom until it does. Then adjust the exposure controls on the camera and shoot the picture.

MACRO LENSES

Special features are included on some Pentax lenses, such as a *macro* setting for use at higher magnifications. These and other special lenses are discussed later.

PERSPECTIVE

The word *perspective* literally means *to see through.* If you are looking at a photo or painting and the perspective is correct, what you see is indistinguishable from the original scene. You can't be too picky when applying this definition because it applies to the big parts of the picture—its geometry. Depending on the skill of the painter or the quality of the film, colors may be different, the range of tone brightnesses may not be identical and small details may be lost, but that doesn't count. If perspective is correct, the geometry you photograph will be indistinguishable from real life. Streets will become narrower as they recede into the distance. The side wall of a building becomes less tall at greater distance from the viewer. Distant people and automobiles are smaller than those nearby. As far as lines, angles and relative sizes of things are concerned, it's as though you are not looking at a picture, you are *seeing through* it to the actual scene.

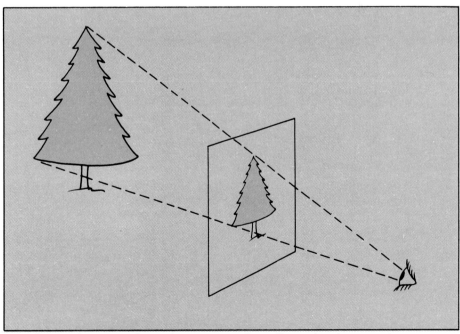

Perspective means that an image captured on a flat surface between viewer and scene is indistinguishable from the real scene. If the image were removed, the viewer wouldn't notice any difference. To see correct perspective in any photo, you must hold it at the correct distance from your eye.

EFFECT OF FOCAL LENGTH FROM THE SAME CAMERA LOCATION

15mm

28mm

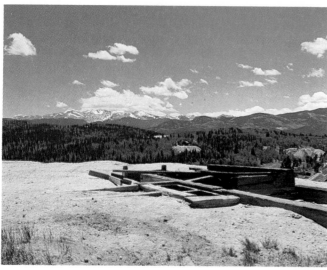

50mm

105mm

210mm

500mm

These photos by David Larsen show the effect of changing lens focal length while keeping the camera in the same location. Each view with a longer lens is an enlargement of the center part of the preceding view. Perspective is the same in all shots, but magnification increases with longer lenses.

35mm

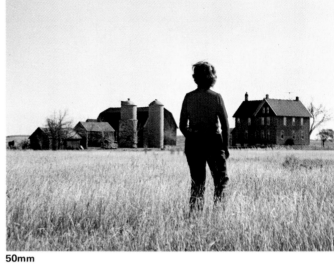
50mm

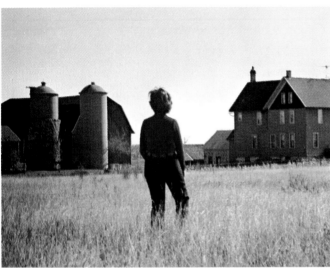
105mm

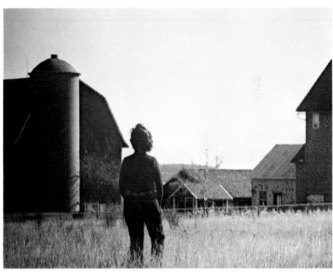
200mm

Perspective changes when you move the camera. In this series, the model was kept the same size in the viewfinder with different lenses. Model didn't move, camera did. Notice apparent change in distance between model and barn.

A strict statement of perspective *must include* the viewing distance at which it is correct. Usually the photographer has no control over the distance from which people look at his pictures.

If you make a slide using your 50mm lens, correct viewing distance of the slide itself is the same as the focal length of the lens—about 2 inches. Don't bother to try it because your eye can't focus that closely. When the image is made larger, correct viewing distance increases the same amount. Let's say you have a print made from your slide, so everything on

the print is ten times as tall. Viewing distance becomes ten times as great—500mm or about 20 inches. This formula—focal length multiplied by enlargement of the image—gives the correct viewing distance for any photo taken with any lens. But most people don't pay any attention to it.

Because all of us have grown up looking at photos from the right distances and the wrong distances, we are very tolerant of incorrect perspective unless the effect is extreme. We often notice incorrect perspective in shots made with long-focal-length lenses and with

short lenses. This is never the fault of camera or lens. It always results from viewing the finished photo at the wrong distance.

As photographers we can *cause* these perspective effects to happen by choosing lenses which make it impossible or unlikely that the viewer will use the correct viewing distance for proper perspective.

Perspective with Long Lenses— When two similar objects are near-by we judge the distance between them by their relative sizes. You may have to look outdoors to confirm this: A car at the end of the block is tiny compared to a car in

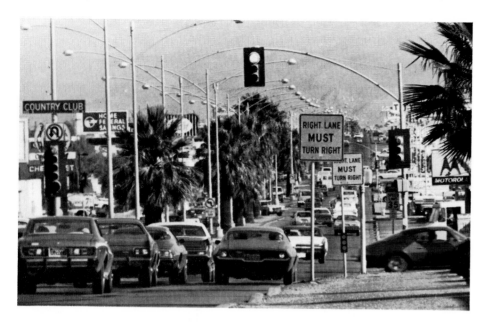

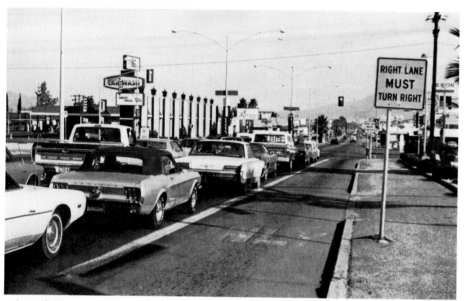

Long lenses are sometimes deliberately used to give a false impression of distance between objects. Top photo was made with a 400mm lens and is typical of shots made to show how crowded the streets are and how everything is jammed together. Notice the visual relationship between the signal light and the first sign.

Bottom photo was made with a 50mm lens. The sign and signal light are the same ones but their visual relationship is a lot different. This photo more nearly represents what you see with your eyes.

from that distance. It will be viewed from a few feet or maybe even held in the viewer's hand. This tricks the viewer's mind into thinking it is seeing two cars that are nearby. Because they are about the same size, the mind says they are very close to each other. Of course they aren't, but the picture sure looks that way.

This technique is often used in photographing race cars to make them look very close together, perhaps coming out of a turn. It is often used as a trick in newspapers and magazines to make houses or traffic signs appear jammed up against each other when in reality they are not. There are a lot of ways you can use this trick and all are OK except one. Don't use it by accident. You should know when you are doing it.

Perspective with Short Lenses—Put your eye about 8 inches from somebody's nose and notice *exactly* what you see. You see a very large nose with smaller facial features and ears receding into the distance. Find somebody with his feet on the desk and put your eye about 12 inches from the sole of his shoe. You see a very large shoe connected to a person with a tiny head.

Put your camera lens at either of these viewpoints and you'll get the same view on film. However, most lenses of 50mm focal length or longer won't focus that close. Lenses of shorter focal length allow close focusing, therefore they allow the short-lens perspective trick.

Assume you used a 20mm lens and enlarged the negative so everything is ten times as tall on the print. Correct viewing distance of the print is 200mm—about 8 inches. Put your eye 8 inches from the print and you get exactly the same view you would in real life. But most people *don't know* that's what they actually see in the real world. At any other viewing distance, the picture doesn't

your driveway. Your mind doesn't say it's tiny, your mind says it's a block away from the nearest car.

Now we play a photographic trick on the viewer. Photograph the two cars from a quarter-mile away, using a long-focal-length lens such as 500mm. They are still a

block apart, but they look about the same size on film. Enlarge the negative so the cars are ten times as tall on the print. The correct viewing distance for proper perspective is then 5,000mm—about 200 inches or nearly 17 feet.

Nobody will view your print

"Is that your new 20mm lens?"

look right. They think your picture has wrong perspective and is very funny.

Perspective in Portraiture—Because we don't often look at other people with our eyes eight inches from the nose, we quickly notice the short-lens perspective effect in a portrait. The long-lens effect can also occur—it tends to reduce the apparent distance between nose and ears, giving a face-flattening effect—but we are a little more tolerant of that because we see it often in real life.

Some combinations of focal length, distance between camera and subject, subsequent enlargement and viewing distance result in portraits with short-lens effect even when taken with the *standard lens* that came with your camera—40mm or 50mm. It's never really obvious, but experienced photographers can see it readily or your subject may see it without being aware of it and reject the portrait as a "bad picture."

That's why most photographers using 35mm film prefer lenses of 85mm up to 135mm for portrait work. If you use a lens much longer than 135mm, you risk the long-lens effect.

Do Lenses Get Different Perspective?—From the same camera loca-

tion, all lenses get the same perspective when perspective is defined as the *see-through* property as discussed earlier. A long lens gets a small section of the overall view; a short lens gets a larger section; but both get the same perspective when viewed from the correct distance. You could cut out a section of the wide-angle view, enlarge it, and the result would be indistinguishable from the view obtained with a long lens as far as perspective is concerned.

Change camera location and you change perspective, no matter what lens you are using. Every different camera location gets a different perspective view of the scene.

Earlier in this chapter, I said you can put on a long lens and get the same view from a distance that you would get when using a short lens up close. Theoretically this is not true because each camera location gets its own perspective. In practice, it is true because we are tolerant of changes in perspective unless the change is extreme. As long as you avoid the short-lens and long-lens effects I just discussed, you can use a long lens instead of getting closer to the scene and everybody will think your picture is just fine.

THANKS

This book was prepared with a lot of assistance from some capable and generous people. Some helped get the project underway; some helped during preparation by providing information and also equipment for me to use and photograph; some helped by reading copy and correcting my errors and oversights. I want to say *thank you!*

Some of those who helped in one way or another are listed below in no particular order. Because job titles and company affiliations change occasionally, I have omitted this information to keep it from being wrong some time in the future.

Phil Kerswill
Corinne DuBois
Roger Barnaby
Yoshio Arakawa
Barry Goldberg
Jan Brown
Dave Plesser
George Ohtani
Sharon Martin
Masa Tanaka
Al Sewald
David Larsen
Dan Werbe
R.L. Pennock
Ernst Wehausen
Gene Wentworth
Kate Botkin

5
FILM HANDLING

Let's look at how film should be handled by you and how the camera mechanism handles it.

The light-sensitive material in a photographic emulsion is a compound of silver of the general name *silver halide.* This is used in both b&w and conventional color films although the structure and processing of color film is different to produce a color image.

The characteristics of photographic emulsion change slowly after manufacture in two principal ways. After development, old film shows an overall density, called *fog*, which cannot be accounted for by exposure to light. It is a deterioration of the silver halide in the emulsion.

The density range which the film can produce is limited by this because areas on the film which should be clear are fogged instead. Also, the difference in tone between two objects in the picture will be less on old film than fresh film. This difference is called *contrast* and lack of it causes prints to look "flat." They have an overall gray appearance instead of strong blacks and vivid whites with definite visible differences between the image tones.

With color film, the image recorded by silver halide in the emulsion is converted during processing to appear in color. Changes in the photographic emulsion due to aging affect the colors in the final transparency or color print in ways that are difficult or impossible to correct.

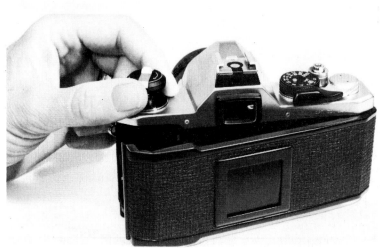

1/To load film, first be sure the camera is empty. Turn the Rewind Knob clockwise. If it turns freely, the camera is empty or the film has been rewound into the cartridge. Either way, it's safe to open the back. Lift up on the Rewind Knob and the back cover pops open.

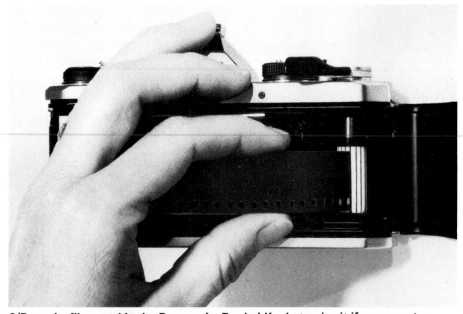

2/Drop the film cartridge in. Depress the Rewind Knob, turning it if necessary to return it to its normal position. Pull the end of the film across and insert it into a slot on the Take-up Spool. M cameras, and the LX, use *Magic Needles,* shown here. Insert the film end between any two needles.

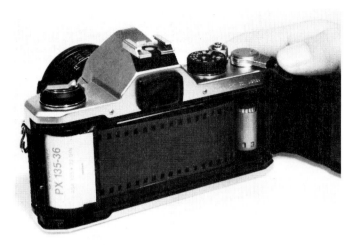

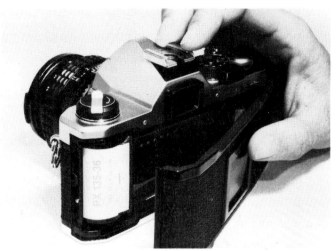

3/Use the Rapid-Wind Lever to advance film while you watch it wind onto the Take-up Spool. When sprocket holes in both sides of the film are engaging teeth on the sprocket in the camera, you've wound far enough. Film should lie flat across the back of the camera.

4/Close the camera back. The spring-loaded pressure plate on the inside of the camera back cover will touch the outer metal rails on each side of the film, creating a channel to guide the film and hold it flat. Check the kind of film you have loaded before you click the back shut.

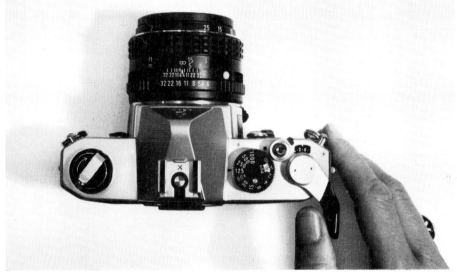

5/With camera back closed, gently rotate the rewind knob clockwise as though you are rewinding, until you feel a slight resistance. Then advance film, using the Rapid-Wind Lever, while watching the Rewind Knob and Exposure-Counter Window. The Rewind Knob should turn during film advance to show that the camera is loaded properly and film is actually advancing. When the exposure counter passes 0, stop at the next dot. The camera is ready to shoot frame 1.

Films carry a date on the carton referred to as the *expiration date* even though nothing drastic actually happens at that instant. Although film should be exposed and processed before that date, the film will probably be about as good during the month after its expiration as during the month before. The date means the film should perform satisfactorily up to that time under normal conditions of storage.

Expiration dating of films intended for amateur use is based on storage at room temperatures comforable for people—around 70 degrees Fahrenheit (20°C.) and around 50% relative humidity.

High temperature and higher humidity accelerate the aging process and humidity is the worst culprit. Most film is sealed in a pouch or can to protect the film from external humidity changes. If the emulsion dries out excessively, that's not good either.

Storing film at reduced temperatures—such as in your refrigerator—slows down the aging process, and is recommended both before and after exposure if you keep the film a long time before shooting or a long time after shooting and before development.

An exception is color films intended for professional use and some special b&w films. These should *always* be stored at reduced temperature—follow the film-manufacturer's instructions.

Film should be sealed before storage and allowed to return to room temperature before breaking open the seal, otherwise moisture may condense in the package and the film may be ruined. If you buy film in quantity, storing it in the refrigerator is a good idea provided you observe this precaution. After development, room-temperature storage of photographic materials is normally OK.

LOADING FILM INTO THE CAMERA

This description and the accompanying photos show how to load film into 35mm cameras. The 110 camera uses different methods, discussed in Chapter 17.

If your camera has a Memo Holder on the back, tear off the end of the film carton and insert it in the holder as a reminder.

Lift the film-rewind knob and the back cover of the camera pops open. A crank in the top of the knob folds over and fits into a groove. If you have difficulty grasping the knob, unfold the crank and use it to pull upward on the knob.

Open the back cover all the way and inspect the interior of the camera. Occasionally it's a good idea to brush out the interior carefully with a *clean* soft brush, a puff of air from a rubber squeeze bulb, or a pressurized can of dust remover.

When cleaning the interior of the camera, remember the focal-plane shutter mechanism is delicate and treat it accordingly. Avoid touching it or blasting it directly with air.

Drop the film cartridge into the chamber on the left and follow the steps shown in the accompanying photographs.

When the film is caught in the take-up spool and you have advanced it far enough so sprocket holes on *both* sides of the film are engaging teeth on the sprocket, close the camera back.

With the back closed, very gently rotate the rewind knob clockwise as though you are rewinding until you feel a slight resistance. That takes up any slack film inside the cartridge.

The frame counter on top of the camera automatically resets each time the camera back is opened.

When buying film, check the carton to be sure you get what you intended to buy. Notice the ASA film-speed number. Check the expiration date on the carton—9/1983 on this one—so you don't buy film that was inadvertently left on the shelf past its expiration date.

It moves to the second dot on the right-hand side of zero. Advancing film with the back open does not advance the frame counter, so when you close the back it still shows the second dot below zero. All of the film between cartridge and take-up spool was exposed to light just before you closed the back, so none of it can be used to make pictures. It is necessary to advance the film three frames to clear the light-struck film and move unexposed film into position behind the lens.

By operating the rapid-wind lever and the shutter-release button,

advance the film past 0 to the first dot on the left of 0, which is frame 1. You can expose this frame to make the first picture on the roll.

While advancing the film to frame 1, watch the rewind knob on top of the camera. It should revolve counterclockwise each time you advance film. This shows that the spool inside the film cartridge is actually turning and you are actually advancing film through the camera—which means you have it loaded properly and nothing is wrong.

If it does not turn, you'd better open the back of the camera to make sure the film leader is firmly engaged in the take-up spool. You may lose a frame or two if the film *is* advancing properly. *But, if it really isn't advancing you'll lose 20 or 36 exposures.*

It is important to understand that the frame counter does not actually count frames of film as they go through the camera. It only counts the number of times you have operated the rapid-wind lever. If the film leader is caught in the take-up mechanism and is advancing through the camera each time you operate the lever, the frame counter will be telling the truth. If the film leader is not grasped by the take-up, it will not move through the camera as you work the advance lever, but the frame counter will keep on indicating higher numbers.

Loading and unloading a camera should always be done in subdued light. If you have to do it outdoors, shade the camera with your body to avoid direct sunlight on the film cartridge. The film slot in the cartridge is lined with a soft black material which contacts the surface of the film on both sides to exclude light and prevent fogging film inside the cartridge. This is a practical but not perfect device and you can help it protect your film by minimizing both the amount of light on the cartridge while loading and unloading and also the length of time the cartridge is in any light.

The cartridge should be left in the package until you are ready to use it and returned to the package or some other light-tight container as soon as you remove it from the camera.

It's a good idea to keep a lens cap over the lens when not shooting and leave it in place while loading film and advancing film.

With some Pentax models, uncovering the lens automatically turns on the camera light meter which then draws current from the battery. The battery will last longer if you keep the lens covered except when actually shooting. Also lenses last longer without getting scratched and dirty if you keep them covered.

There is no harm in firing blank shots with the lens uncovered except it gets confusing later. You can end up with well-exposed negatives or slides which show somebody's feet or a handsome navel.

FILM GUIDING AND FLATNESS

There are four polished metal rails, two above and two below the focal-plane shutter opening in the back of the camera. The film rides on the two inside rails. They are separated enough not to be in the picture area. In fact, they are directly underneath the sprocket holes. The outer two rails are edge guides. They stand slightly higher than the inner rails so the edges of the film are guided in a straight path from cartridge to takeup.

Because film is wound up inside the cartridge, it tends to curl in the long direction as it is pulled out and across the camera. Because the film is layers of different materials—the base and the emulsion—it may tend to curl crossways also, depending on humidity.

A spring-loaded pressure plate is on the inside of the rear cover of the camera. When the cover is closed, this flat smooth plate gently presses against the two outer guide rails and contacts the back of the film. The two outer guide rails hold the pressure plate away from the two inner rails a small amount to allow for the film thickness. This creates a channel closely confining the film to keep it traveling straight across the camera and hold it flat while being exposed.

The film is in contact with camera parts everywhere it can safely be touched without scratching the emulsion. The inner guide rails touch the emulsion side of the film in the sprocket-hole area. The outer rails touch the edges of the film. The pressure plate touches the back side of the film—the base. If the pressure plate scratches the back side of the film, those scratches will show in a slide or print. Dirt on the pressure plate or gouges due to extreme abuse can scratch the film.

REWINDING FILM

When you have exposed the last frame in the cartridge, the rapid-wind lever will become difficult to move. *Don't force it!* If the lever completed a full stroke, the camera is cocked and there is a fresh frame in position. You can shoot that frame. If the lever only moved part of a stroke, rewind the film immediately.

Don't try to force the lever hoping to get one more exposure on the roll. If you do, the film may tear out the sprocket holes or pull off the spool inside the cartridge— it's only held with tape! If it pulls off the spool, you will not be able to rewind the film. If this happens by accident, the film must be removed from the camera in a darkroom or you will have to improvise a dark container for your hands and the camera.

There are light-tight cloth bags for this purpose, called *changing bags.* I have read about clever people using a coat for the purpose, gathering the folds of the coat tightly around the camera and inserting their arms backwards in the sleeves. I have never tried it, because I have never had to. Don't try it outdoors, because you'll surely fog the film.

Film wound on the take-up side of the camera is not protected from light. If you don't rewind immediately and later forget that you didn't, you can ruin the entire roll by opening up the back of the camera.

Much of good camera-handling technique is based on well-formed habits. If you get in the habit of rewinding immediately when you have exposed the last frame, you will never ruin a roll of exposed film by opening the camera.

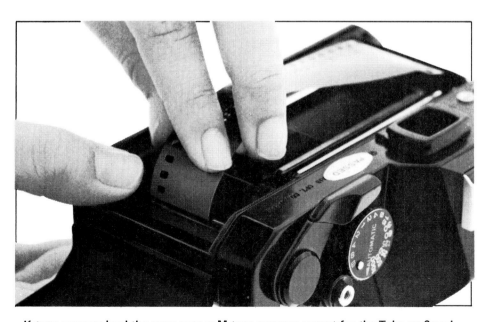

K-type cameras load the same way as M-type cameras except for the Take-up Spool. On K cameras, the spool has slots. Insert the film end into any slot, then advance film using the Rapid-Wind Lever.

On the bottom plate of the camera, directly below the film-advance lever is a small button called the Film Rewind Button, which must be depressed to rewind.

Because both your hands will be busy rewinding rather than supporting the camera, I think it's a good idea to have the neck strap around your neck when rewinding. It helps to support the camera and eliminates any chance of dropping it.

I use my left hand to hold the camera and depress the rewind button. Tilt up the rewind crank on the rewind knob and turn it with your right hand in the direction of the arrow—clockwise.

Rewind slowly, particularly if the humidity is low. Static electricity can build up on the film and discharge during rewinding. This is a flash of light, like a miniature lightning bolt inside the camera. It can cause strange tracks on the film. Slow rewinding reduces the chance of this happening.

By rewinding slowly and paying attention to the feel of the rewind crank, you will be able to tell when the film end pulls clear of the takeup mechanism. When that happens, there will be about as much leader extending from the cartridge as there was when you loaded the camera.

It's a good idea to stop rewinding at that point, leaving some leader sticking out of the cartridge. The light trap where the film comes out of the cartridge works best when the opening is partially filled with film. If you wind it all the way into the cartridge you increase the chance of a light leak into the cartridge which can fog the exposed film. On the other hand, if you wind the film all the way into the cartridge, you will never expose the same roll twice.

One side of the film leader is cut off in a standard pattern, making it narrower for the first couple of inches. The light seal of the cartridge works best when the full width of film is in the trap. If you rewind too far and there's some

To rewind film, depress the Film-Rewind Button on the bottom of the camera and hold it depressed for a few turns of the Film-Rewind Crank (arrow). Then the button will remain depressed without holding it. The Film-Rewind Crank is normally folded over into the Film-Rewind Knob. To use, tilt the crank up and turn it in the clockwise direction.

film sticking out, pull a little bit out of the cartridge so the full width is in the trap.

Rewinding this way makes an exposed cartridge look exactly like an unexposed one. If you think there is any chance of getting confused and putting the same roll back into the camera, you can use a pencil to mark the leader on the emulsion side. Write the letter E for *exposed.* If you've never looked closely at film, the base side is shiny and the emulsion side is a dull gray or brownish color before processing.

You shouldn't ever get confused about whether a roll of film has been exposed or not if you form the habit of never opening the factory package until just before loading the cartridge into the camera.

Another good habit to form is *look at the cartridge* just before

you close the camera back cover. If you carry more than one type of film and you are busy shooting action or something that takes a lot of concentration, it's easy to grab and load the wrong kind of film while your mind is busy with something else.

Sometime during the loading procedure you should have an automatic check point to verify what's in the camera. I formed the habit of doing this just before closing the back. It's not too late to take it back out if you have the wrong film and it is reassuring to *know* you have the right film in the camera.

On closing the camera back, *immediately* check the ASA film speed dial on the camera to be sure it is set at the right number. Do that even before advancing the film to frame 1.

EXPOSURE CONTROLS AND THEIR EFFECTS

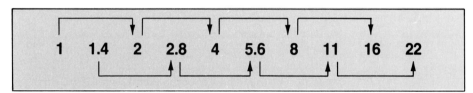

Figure 6-1/It's easy to write or remember the *f*-number series by starting with two numbers, 1 and 1.4. Begin the series with those two numbers and double them alternately as shown.

In Chapter 2 I mentioned that the two exposure controls working together determine exposure but they each have other effects on the picture. Often these other effects have a major influence on the control settings you choose to use.

This chapter discusses the side effects of aperture and shutter speed. A side effect may cause you to change one exposure control and make a compensating change in the other so total exposure remains the same.

THE *f* - NUMBER SERIES

Aperture size is indicated by a standard series of *f*-numbers engraved on the control ring. It is useful and practically necessary to memorize the series, and it is easy to do. See Figure 6-1.

Even though it seems complicated at first, all you have to remember is two numbers: 1 and 1.4. Double them alternately as

shown by arrows in the figure. The *f*-number series continues both above and below the numbers shown, but those are the common *f*-numbers.

Notice there is an approximation between 5.6 and 11. The *f*-number 11 is not exactly double 5.6, but it is close enough and easier to remember.

The series of *f*-numbers is chosen so the *area* of the aperture *is doubled* with each full step in *f*-number. Because the amount of light that gets through a hole is determined by the area of the hole, each *f*-number step allows *twice* as much light, or *half* as much, as its immediate neighbor in the series.

Larger *f*-numbers mean smaller lens openings, something you also have to remember.

If you have a lens set at *f*-8 and change it to *f*-11, the amount of light passing through the aperture will be reduced to half. If you

change a lens aperture setting from *f*-2 to *f*-1.4, the amount of light on the film will be doubled.

In the early days of photography, variable apertures had not been invented. Cameras used removable metal plates in the light path to the film. The metal plates were made with holes of different size and the thinking was that the plate would *stop* all of the light except that which got through the hole. Changing these plates to allow more or less light on the film became known as changing *stops*.

The word remains with us; *f*-numbers are often called *f*-stops and changing the *f*-number setting of a lens to allow more or less light on the film is often called *stopping up* or *stopping down.*

Changing from *f*-22 to *f*-16, the nearest larger opening, is called changing by one stop. Earlier I defined doubling the amount of light as an exposure change of one *step*. You can conclude that the words *step* and *stop* mean the same thing in photography. I prefer to use *step* to mean doubling or halving exposure and international standards for the photographic industry use *step* rather than *stop*. Popular literature and most books cling to *stop* and we will probably never eliminate it from our vocabularies.

THE SHUTTER-SPEED SERIES

Shutter speeds also change in steps so each longer time is double the preceding step. The standard

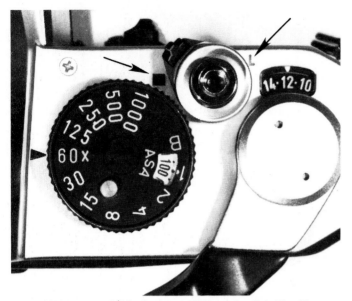

This MX is set at 1/60, shown as 60X on the dial. The Shutter-Button Lock Lever surrounds the shutter button. When set so letter L (arrow) is visible, as shown here, shutter button is locked and cannot be depressed. Rectangular window at left of shutter button (arrow) is Cocked Indicator. If window is red, shutter is cocked and camera can be operated. If window is black, shutter is not cocked. Not all Pentax cameras have a Cocked Indicator window.

Time exposures are made with the Shutter-Speed Dial set to B. If the camera has a Shutter-Button Lock Lever, depress the shutter button and hold it down by operating the lock lever. Another way is using a locking cable release. Hold the operating plunger of the cable release depressed while tightening the set screw. When you want to release the shutter, release the set screw. This works on any camera. On cameras without a shutter-button lock, such as this K1000, it's the only way other than holding the shutter button down with your finger.

series of shutter-open times in seconds is:
1 1/2 1/4 1/8 1/15 1/30 1/60 1/125 1/500 1/1,000

Just below the slowest timed shutter speed on the dial is the symbol B which we say stands for *bulb.*

The B setting is used for exposures longer than the shutter mechanism will perform automatically. When set at B the shutter will remain open as long as you hold the shutter-release button depressed. On all Pentax cameras you can transfer the burden from your finger to a locking cable release for long-time exposures. The cable release screws into the top of the shutter button and allows you to operate the shutter remotely by a plunger at the far end of the cable. Locking cable releases have a set screw or locking arrangement to keep the plunger depressed when you want a long exposure.

Some Pentax models have a

Shutter Button Lock Lever which surrounds the shutter button. It serves two purposes. When the lock lever is rotated so the letter L is visible, the shutter button cannot be depressed. Therefore you can't make an accidental exposure while handling the camera or showing it to a friend. If the shutter is set to B, the shutter button depressed *and then* the lock lever is flipped to L, the button is held in the down position and the shutter stays open until you turn the lock lever back to release the shutter button. This is a handy way to make long-time exposures.

For simplicity and ease of reading, the shutter-speed dial does not show the numerator of the shutter opening-time fraction. Instead, 125 is used to mean 1/125 second, 500 means 1/500 second, and so forth.

The shutter speed series is *intended* to double as it goes from shorter to longer times. There are some approximations such as be-

tween 1/125 and 1/60 but they are not important. You should also learn this series of numbers, and it is easy to do.

EXPOSURE VALUE

Suppose you have just set the exposure controls to satisfy the display in the viewfinder. The aperture is set for f-5.6 and the shutter speed is set for 1/125. Those settings determine some total exposure on the film—some *exposure value* which we abbreviate *EV.*

Because there are usually several f-stop and shutter-speed combinations which give the same exposure on the film, it is convenient to have some way of saying how much exposure it is—rather than reciting all possible pairs of settings which give that same exposure.

Pentax doesn't use EV numbers on the cameras, but they are used in some specs, so you should have some idea of what they are about.

EV NUMBERS & EQUIVALENT EXPOSURE SETTINGS

EV	4 min.	2 min.	1 min.	30 sec.	15	8	4	2	1	1/2	1/4	1/8	1/15	1/30	1/60	1/125	1/250	1/500	1/1000	1/2000
-8	f-1																			
-7	1.4	f-1																		
-6	2	1.4	f-1																	
-5	2.8	2	1.4	f-1																
-4	4	2.8	2	1.4	f-1															
-3	5.6	4	2.8	2	1.4	f-1														
-2	8	5.6	4	2.8	2	1.4	f-1													
-1	11	8	5.6	4	2.8	2	1.4	f-1												
0	16	11	8	5.6	4	2.8	2	1.4	f-1											
1	22	16	11	8	5.6	4	2.8	2	1.4	f-1										
2	32	22	16	11	8	5.6	4	2.8	2	1.4	f-1									
3	45	32	22	16	11	8	5.6	4	2.8	2	1.4	f-1								
4	64	45	32	22	16	11	8	5.6	4	2.8	2	1.4	f-1							
5		64	45	32	22	16	11	8	5.6	4	2.8	2	1.4	f-1						
6			64	45	32	22	16	11	8	5.6	4	2.8	2	1.4	f-1					
7				64	45	32	22	16	11	8	5.6	4	2.8	2	1.4	f-1				
8					64	45	32	22	16	11	8	5.6	4	2.8	2	1.4	f-1			
9						64	45	32	22	16	11	8	5.6	4	2.8	2	1.4	f-1		
10							64	45	32	22	16	11	8	5.6	4	2.8	2	1.4	f-1	
11								64	45	32	22	16	11	8	5.6	4	2.8	2	1.4	f-1
12									64	45	32	22	16	11	8	5.6	4	2.8	2	1.4
13										64	45	32	22	16	11	8	5.6	4	2.8	2
14											64	45	32	22	16	11	8	5.6	4	2.8
15												64	45	32	22	16	11	8	5.6	4
16													64	45	32	22	16	11	8	5.6
17														64	45	32	22	16	11	8
18															64	45	32	22	16	11
19																64	45	32	22	16
20																	64	45	32	22
21																		64	45	32

An EV table shows pairs of f-stops and shutter-speed settings that represent the same amount of exposure and the same EV number. For example, EV 11 can theoretically be obtained with any of 13 shutter speeds ranging from 2 seconds to 1/2000 second. For each shutter speed, the f-number shown in the table should be used, so there are also 13 different f-numbers, to make 13 pairs of settings, all giving the same amount of exposure.

Not all combinations are possible on all cameras because the table uses extreme ranges of aperture and shutter speed.

COUNTING UP AND DOWN THE EXPOSURE SCALE

You don't have to memorize any EV numbers, but please note the plan so you can mentally figure or "count" pairs of camera settings quickly. Example: You have the camera set at 1/500 and f-11. If you change shutter speed to 1/250, what f-stop will give the same exposure? You doubled the time, so you should use the next smaller aperture, f-16.

EFFECT OF APERTURE SIZE

Field of view of a particular lens means the total width and total height of the scene as viewed through that lens. Different lenses have different fields of view.

The camera lens also "sees" near and far objects. Not all objects between zero distance from the camera and infinity will be in sharp focus on the film. The distance between the nearest object in good focus and the farthest object in good focus is called *depth of field.*

With an adjustable camera, depth of field is controlled by aperture size. If you are taking a portrait of a person against a foliage background, the picture will often be improved by "throwing" the foliage out of focus.

When you become used to having control of depth of field in your pictures, it will become as important to you as any other photographic control on your camera.

Smaller lens aperture gives more depth of field. When shooting at f-22 with some lenses virtually everything in view will be in good focus—beyond a certain minimum distance. When shooting at f-1.4, depth of field will be greatly reduced. Objects both front and

These three pictures show depth of field used as a photographic control. In the top photo, focus is pretty good everywhere. A small aperture, f-16, was used to give large depth of field.

In the center shot, a larger aperture was used, f-1.8, to give short depth of field. Subject of interest is the barn, so the lens was focused on the barn. Nearby flowers are out of focus.

In the bottom photo, the same lens aperture was used for reduced depth of field. But this time the lens was focused on the flowers. The barn and some of the flowers are beyond the depth of field and are out of focus.

Good photography nearly always requires *deliberate* control of depth of field.

Some Pentax cameras have a control to stop down the lens so you can see depth of field in the viewfinder, at the aperture you have chosen to make the exposure. On the LX, you can see depth of field by pushing this lever toward the lens.

back of your subject will be out of focus.

Because Pentax cameras allow viewing through wide-open aperture so you get the brightest image on the viewing screen, you are not seeing depth of field that will result when the camera closes aperture to the value you have selected.

After composing, focusing and setting the exposure controls, the last step should be a check of depth of field.

Some models have a control to close lens aperture to the value you have selected so you can see depth of field in the viewfinder before you make the exposure. Among current models, these are the LX and MX.

Pentax lenses have a special depth-of-field guide to show depth of field on a scale marked in feet and meters. The scale shows the distance to the near limit of good focus and the distance to the far limit of good focus.

No matter which camera you are using, you can always consult the depth-of-field guide on the lens.

You should think about depth of field every time you take a picture and consider it just as important as proper composition, lighting or focus. The effect is sometimes subtle, but it is always there. You must decide if you want the foreground in focus—or the background—and set aperture and focus controls to get the desired effect. You must decide if you want shallow depth of field, or everything in sharp focus from here to there. To help you decide, view depth of field at different aperture settings by changing lens aperture and operating the depth-of-field control if the camera has one. Sometimes

Tom Monroe photographed these drag racers near the finish line, traveling faster than 200 MPH. To keep them in the viewfinder, he panned (swung) the camera as the cars came down the strip. A shutter speed of 1/1000 second stopped the motion of the cars and also prevented the camera movement from showing up as blurred spectators in the stands.

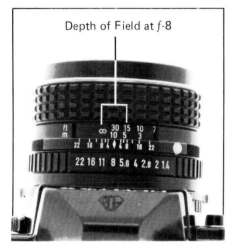

Figure 6-3/Reading from top to bottom in this picture, the scales on the lens are: Focused distance in feet, focused distance in meters, Depth-Of-Field Guide, Diaphragm Ring. The focused distance is about 10 meters and the lens is set at ƒ-8.

To read depth of field, notice that the same numbers are in pairs on each side of the index mark. If you are set at ƒ-4, depth of field is from 4 to 4 on the indicator. If set at ƒ-8, depth of field is from 8 to 8 on the indicator. To find depth of field in feet or meters, read the focused distance scale opposite the two depth of field limits on the Depth-Of-Field Indicator, as shown by the bracket.

This lens is set at ƒ-8, so the limits on the indicator scale are 8 and 8. Reading the focused distance scale opposite 8 and 8, depth of field is from infinity (∞) to about 4 meters, or from ∞ to about 15 feet, depending on which distance scale you read.

the change will make an important difference in the picture.

When you check depth of field by stopping down, the image on the viewing screen gets darker because less light comes in the smaller aperture. With some practice, you learn to ignore the change in brightness of the image and judge depth of field.

In dim light, or if you are using a very small aperture, the viewfinder image may be too dark to judge depth of field. If so, you can rely on the depth-of-field guide engraved on the lens itself.

HOW TO READ THE DEPTH-OF-FIELD GUIDE

You will get more depth of field when the lens is focused at greater distances from the camera, so the depth-of-field guide on the lens is operated by the focusing control of the lens.

The depth-of-field indicator is pairs of lines engraved on the lens, centered on the index mark which you use to read focused distances from the focusing ring. Rather than read that again, look at Figure 6-3.

RULES ABOUT DEPTH OF FIELD

Smaller apertures give more depth of field. Shorter focal lengths

give more depth of field. Longer distances between subject and camera give more depth of field in the vicinity of the subject.

EFFECT OF SHUTTER SPEED

Shutter speed has three effects: It affects how much a moving subject is blurred on the film.

With a hand-held camera, it affects the amount of image blurring of a stationary subject due to your inability to hold the camera absolutely steady.

It affects the aperture size you can use because aperture and shutter speed in combination must give the desired exposure.

Blurring of a moving subject is most noticeable when the subject is moving directly across the field of view of the camera—in other words, at right angles to the direction the camera is pointed. If blurring is a problem and you can't solve it any other way, move your shooting location so the subject is traveling more nearly toward or away from your position.

Both shutter speed and lens focal length determine blurring due to camera shake when you are hand-holding—also how steady you are and the way you support the camera. Some people simply do better than others and some improve by

adopting good camera-handling technique with conscious attention to the problem and some practice.

It's easier to hand-hold with shorter focal lengths because they magnify less. Shake is magnified by longer lenses just as the image itself is. Slight jiggling of the camera produces a visual effect on the print very similar to being out of focus. More pictures are harmed by camera shake than any other cause.

A guide to shutter speeds when hand-holding the camera is to take the reciprocal of the lens focal length. The reciprocal of any number is that number divided into one. The reciprocal of 50 is 1/50 and so forth. Use the reciprocal of focal length as the longest time of exposure that can safely be hand-held unless you have proved to yourself that you can hold the camera steady at slower shutter speeds. With a 200mm lens, use 1/250 because 1/200 isn't an available shutter speed.

With a 50mm lens, you shouldn't have any trouble shooting at 1/60 and most people who are careful

about it can shoot at 1/30. By bracing yourself you can do better and by pressing the camera against the side of a building or a post, you can do still better. Don't pass by a good shot on account of this rule of thumb. Give it your best effort and get the picture. If it blurs you can always say you did it on purpose.

Sometimes there is conflict between the aperture you would like to use for depth-of-field effect and the shutter speed you need to stop motion or to hand-hold the camera. The two adjustments together must satisfy a third requirement—correct exposure. However, exposure is not the same for all film types because films have different speed ratings. It always helps to select a film speed for the kind of shooting you intend to do—it gives you the best chance of being able to use appropriate apertures and shutter speeds.

EFFECT OF FILM SPEED

The film-speed rating is assigned by the manufacturer and is a way of stating how much exposure a

particular type of film requires. When you dial the film-speed number into your camera, you set up the camera light-metering system so it gives the desired exposure for that film type.

Among commonly available film-speed ratings, ASA 25 is considered slow, 125 is intermediate, and 400 is fast. More exposure is required when you have ASA 25 film in your camera than when using ASA 400.

Here's another rule of thumb that's worth remembering:

To photograph a subject illuminated directly by sunshine, use f-16 and a shutter speed which is the reciprocal of the ASA film speed. If you are using ASA 25 film, shoot at 1/25 second—1/30 will be close enough. If you are using ASA 64 film, shoot at 1/60 second, and so forth.

This is not a hard and fast rule, but it beats an outright guess. With through-the-lens metering, you seldom have need for rules about exposure but this one is easy to remember and worth storing in your mental computer.

Naturally you don't have to shoot at f-16 and 1/30 with ASA 25 film, even if you use the rule. You can change f-stop and make compensating changes in shutter speed to end up a long menu of possible settings in sunlight:

f-16	1/30
f-11	1/60
f-8	1/125
f-5.6	1/250
f-4	1/500
f-2.8	1/1,000
f-2	1/2,000

Without putting film in your camera or even going out in the hot sun, you can use the menu just figured to see how it's going to be when you go out there.

Assume you intend to shoot action with a 200mm lens. You decide to shoot at 1/1,000 so you can hand-hold the camera. Depth of field will be poor because you also have to shoot at large aperture —f-2.8. If you close down to f-11

Using a shutter speed of 1/125, Josh Young panned the camera horizontally to follow the subject. Horizontal motion of subject was stopped by panning. Vertical motion—the moving arms and legs—was not stopped by horizontal panning. Terrain is also blurred.

A fast shutter speed "stops motion" and gives a sharp image of a moving subject. Because fast shutter speeds require large aperture, sometimes you may find a depth-of-field problem. Notice the vaulter's foot is out of focus.

or f-16 to get better depth of field, the action will blur at the slow shutter speeds and you will not be able to hand-hold that long lens.

The only way out of this problem is not to use ASA 25 film for this shooting assignment because the film is too slow. With some films, you can deliberately underexpose to operate at faster shutter speeds than normal exposure requires. For these films, most labs can make a compensation in development called *push-processing*.

If you turn up at your friendly local lab and ask the man to push-process your ASA 25 film because you had to underexpose it in sunlight, he will think you didn't ever read this book.

Let's try the whole deal again with ASA 400 film, which is faster by 4 exposure steps. You have to double four times to get from ASA 25 to ASA 400.

The choices in sunlight then become:

f-16 1/400—use 1/500
f-11 1/1,000
f-8 1/2,000
f-5.6 No shutter speed available
f-4 No shutter speed available
f-2.8 No shutter speed available
f-2 No shutter speed available

As you can see, using ASA 400 film in sunlight forces you to small apertures and fast shutter speeds. That very neatly solves the problem I just mentioned.

But if you are photographing people or flowers in the garden, you may not want depth of field from here to the back fence. A much more artistic photo usually results when the competing background is thrown out of focus by using less depth of field. With the settings required for 400 film

Sometimes a little image blur helps the picture. It conveys the feeling of motion and adds realism to a subject which is obviously moving.

speed, you can't reduce depth of field by using large aperture because you don't have fantastic shutter speeds. You can reduce the amount of light entering the camera by using a neutral-density filter on the lens as described in Chapter 12.

These kinds of problems can go on forever and they do go on forever in real life when photographers choose film for a certain purpose.

An oversimplified rule is to buy fast film for shooting in dim light such as indoors and slow film for shooting in bright light. But the amount of light is not the only factor. You also have to worry about depth of field and shutter speeds.

You will end up wishing that films in both b&w and color were available at ratings faster and slower than you can find at your friendly camera store. Film manufacturers supply a wide range of films and some of these are shown with their speed ratings in Chapter 12.

Choosing film speed for the kind of photos you intend to make is helpful. A way to eliminate background is, use large aperture to reduce depth of field. In bright daylight, slow film helps.

RECIPROCITY FAILURE

By now it may seem that you can shoot at virtually any shutter speed you choose, simply by counting up or down the exposure scale, adjusting aperture to compensate for shutter-speed changes.

The reciprocity law indeed says so, but here is the fine print that takes it away:

People once thought the law applied to all values of light and time, but there are exceptions when the shooting light is either unusually bright or unusually dim. These exceptions are called reciprocity-law failure, usually known as *reciprocity failure.*

The problem lies in the nature of film, not in the camera. It is always due to light which is brighter or more dim than the design-range of the film emulsion. Even though reciprocity failure is caused by the amount of light, the best *clue* to the camera operator is shutter speed because unusually short shutter speeds mean there is a lot of light and unusually long exposure times mean the light is dim.

As a general rule for most amateur films, if you are shooting faster than 1/1,000, or slower than 1 second, you should think about the possibility of reciprocity failure. Consult the film data sheet supplied by the film manufacturer. Some films have a more limited "normal" range of exposure times than stated above.

The basic effect of reciprocity failure is always *less* actual exposure on the film than you expect. Therefore, the basic cure is to give more exposure by using larger aperture, more time, or both. For example, if an exposure meter or an exposure calculation suggests using f-4 at 4 seconds, the data sheet packed with the film may say to give one step more exposure than that to compensate for reciprocity failure. Use f-2.8 if it is available on the lens, or shoot at 8 seconds.

With b&w film, the film data sheet may call for more exposure and also a change in the development procedure. With color film, reciprocity failure can cause both underexposure and a color change on the film. The recommended compensations may be more exposure, use of a color filter on the lens, and a change in development.

Pentax cameras will meter in dim light and make exposures that are well into reciprocity failure for most films. Making pictures in dim light is challenging and enjoyable provided you *remember* to compensate for reciprocity failure.

There are four ways: Best is to use the film manufacturer's data. If you don't have data, you can make tests to find the best correction. If you don't have time to make tests, you can shoot several different exposures such as 4, 8 and 16 seconds, hoping one will be right. The poorest way is to guess at it, but even that is better than making no correction at all.

LX

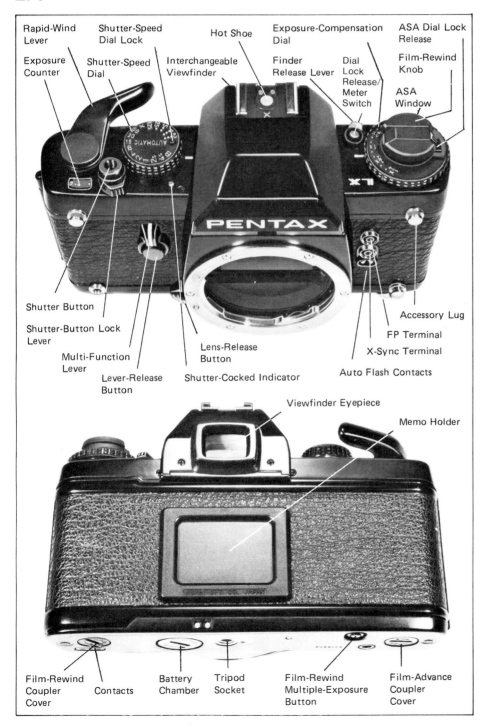

Rapid-Wind Lever
Shutter-Speed Dial Lock
Hot Shoe
Exposure-Compensation Dial
ASA Dial Lock Release
Exposure Counter
Shutter-Speed Dial
Interchangeable Viewfinder
Finder Release Lever
Dial Lock Release/Meter Switch
Film-Rewind Knob
ASA Window
Shutter Button
Shutter-Button Lock Lever
Multi-Function Lever
Lever-Release Button
Lens-Release Button
Shutter-Cocked Indicator
Accessory Lug
FP Terminal
X-Sync Terminal
Auto Flash Contacts

Viewfinder Eyepiece
Memo Holder

Film-Rewind Coupler Cover
Contacts
Battery Chamber
Tripod Socket
Film-Rewind Multiple-Exposure Button
Film-Advance Coupler Cover

This is a good time to list the camera controls discussed so far, along with most of the others. The camera shown is an LX. Most controls on Pentax cameras are similar and have similar locations. Some models have slightly different controls and some don't have as many features as the LX.

Rapid-Wind Lever—Hook this with your thumb and rotate it a full stroke to advance the film one frame. It has a *stand off* position away from the camera body, to make it convenient to operate. To store the camera, or when using a motor drive or winder, push it fully against the camera body. This is often called the *film-advance lever.*

Shutter-Cocked Indicator—A window on top of the camera shows black when the camera is not cocked; red when it is. *Cocked* means that film is advanced and the camera is ready to shoot. The K1000 doesn't have this.

Exposure Counter—Counts frames of film as they are exposed. The number in the window is the *next* frame to be exposed.

Shutter Button—Depress this button *smoothly* to make an exposure. On all current models except the K1000, depressing this button partway turns on the camera electronics and viewfinder display.

Shutter-Button Lock Lever—Locks the shutter button so it can't be depressed accidentally. Not all models have a lock.

Shutter-Speed Dial—Used to select shutter speed or to select automatic operation on automatic cameras. Shutter-speed selection is done with pushbuttons on some models. See the camera descriptions in Chapter 16.

Shutter-Speed Dial Lock—Locks the dial when set to automatic operation to prevent accidentally moving it to another setting.

Viewfinder—You compose and focus the scene being photographed while looking into the eyepiece on the back of the viewfinder. Viewfinders are interchangeable on the LX, but not on other models.

Hot Shoe—This mounts flash units and makes the electrical contacts to the flash.

Exposure-Compensation Dial—When using a camera on automatic to photograph a non-average scene, such as a portrait against a bright background, you will usually want to give more or less exposure than the camera would normally use. This dial lets you change exposure up to two steps plus or minus without taking the camera off automatic.

ASA Window—Shows the ASA film-speed setting.

Film-Rewind Knob—Lift this knob to open the camera back. Turn it clockwise to rewind film. When rewinding, it's easier to use the flip-up crank built into the knob.

Flash Terminals—If you don't mount a flash in the hot shoe, connect it to the camera with a sync cord plugged into the flash terminal. The LX has three terminals: X-Sync for use with electronic flash and some flashbulbs; FP for use with special FP flashbulbs; and Auto Flash contacts for use with special Pentax TTL Auto flash units.

All models have a hot shoe, but some don't have a flash terminal on the body.

Lens-Release Button—Press this in to remove the lens.

Multi-Function Lever—On the LX, this lever sets the self-timer, which delays the exposure so you can dash around in front to take your own picture. Another use of a self-timer is to make an exposure without touching the shutter button. This prevents jiggling the camera just before the shutter opens.

On the LX, this control may be used to lock up the mirror or to stop down the lens so you can see depth of field at shooting aperture, called *depth-of-field preview.*

On other models, this is called the Self-Timer Lever and has only that function. The K1000 does not have this control.

Memo Holder—This holds the end of a film carton so you won't forget what kind of film is loaded. Not all models have a Memo Holder.

Film-Advance Coupler—Provides a mechanical connection for a motor drive or winder to advance film.

Film-Rewind/Multiple-Exposure Button—Depress this button to prepare the camera so you can rewind film. Also used in the multiple-exposure procedure.

Tripod Socket—Used to mount the camera on tripods that have U.S. standard mounting screws (1/4", 20 threads per inch).

CAUTION: K, M and LX cameras may be damaged if a tripod screw longer than 5.5mm (0.21 inch) is screwed in forcefully.

Battery Chamber—Where the batteries live.

Film-Rewind Coupler Cover—Provides a mechanical connection for a motor drive or winder to rewind film. Only the LX has this feature.

Contacts—Electrical contacts on the bottom are used with motor drive or winder. The two unlabeled contacts just below the memo holder are used with special data backs that replace the standard camera back and record data on the film.

HOW LENSES WORK

So far, the discussions of lenses have been either descriptive or practical information on how to attach and remove them. Focal length has been treated as the label which indicates angle of view and magnification. That's all you really need to know to use lenses in normal photography.

Pretty soon, I'm going to discuss some things about close-up and macro photography and for that you need more basic information about how a lens makes an image, types of lenses, and what focal length means in the technical sense. This requires some formulas and simple math but it has a practical payoff in several ways. The most important is in photography with attachments to the camera.

If you are interested in more information on most of the technical matters discussed in this book, I recommend another book entitled *Understanding Photography* which has impressed me favorably. It is from the same publisher as this book, and by the same author.

LIGHT RAYS

We assume that light travels in straight lines, called *rays* and light rays do not deviate from straight-line paths unless they are acted on by something with optical properties such as a lens.

Light rays which originate from a source such as the sun, or which reflect from an object such as a mountain, appear to be parallel rays after they have traveled a considerable distance. In explaining how lenses work, the simplest case is when the light rays reaching a lens

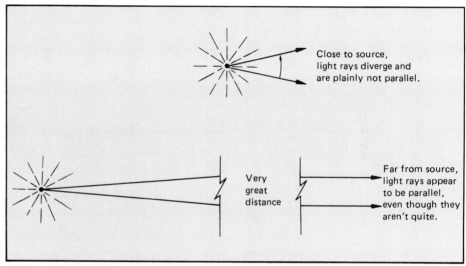

Figure 8-1/Light rays from a point source obviously diverge when you are close to the source. At a great distance, they still diverge but *appear to be* parallel.

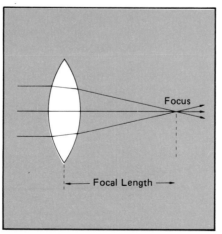

Figure 8-2/Lenses treat rays which appear parallel as though they actually are parallel and bring them to focus at a distance equal to the focal length of the lens.

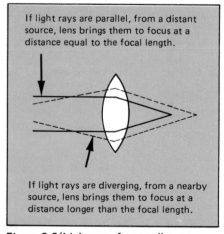

Figure 8-3/Light rays from a distant source are brought to focus closer to the lens than rays from a nearby source. Because the film plane is in a fixed location in the camera, focusing is done by *moving the lens* farther from the film to focus on nearer subjects.

have traveled far enough to appear parallel as in Figure 8-1.

CONVERGING LENSES

If you photograph a distant mountain, each point on the surface of the mountain reflects light rays as though it is a tiny source of light. The rays which enter the lens of your camera are effectively parallel. Rays from each point of the scene are scattered all over the surface of your lens but all those which came from one point of the scene should be focused at one point on the film. Here's how a lens does that.

Figure 8-2 shows a simple single-element lens which is convex on both sides. This is called a *converging* lens because when light rays pass through, they converge and meet at a point behind the lens.

Focal length is defined as the distance behind the lens at which *parallel* light rays will be brought to focus by the lens. That implies a subject which is far enough away from the lens so the light rays appear to be parallel. We label that distance *infinity* on the distance scale of a lens, but it actually doesn't have to be very far away.

For example, the last marked distance on a Pentax 50mm lens is 30 feet and the next symbol is ∞, which indicates infinity. Any subject beyond 100 feet or so from this lens appears to be so far away that the light rays from it are effectively parallel.

Because the focal length of a 50mm lens is 50mm, that's how far the lens must be positioned from the film to form a focused image of a distant subject—which we *say* is at infinity even though it may be close enough that we could hit it with a rock.

Figure 8-2 shows what happens to *parallel* rays when they are brought to focus by a converging lens.

This lens will also image subjects closer than infinity, but it takes a greater distance between lens and film to bring nearby subjects into focus.

Figure 8-4/A diverging lens causes rays to diverge as they pass through the lens.

Most lenses focus by an internal screw thread called a *helicoid*. When changing focus from a distant subject to a nearby subject, most lenses become physically longer to position the glass lens elements farther from the film.

Figure 8-3 shows why. Light rays from a nearby subject appear to diverge as they enter the lens. The lens will still change their paths so they come to focus, but because they were diverging rather than parallel it takes a greater distance behind the lens to bring them all together at a point.

Focusing a camera moves the lens toward or away from the film so there is the needed amount of distance between lens and film. This will bring light rays from the subject into focus at the film, whether the subject is near or far.

Please notice that the *shortest* distance ever required between lens and film occurs when the subject is at infinity and this distance is equal to the focal length of the lens. All subjects nearer than infinity require a longer distance between lens and film. To change focus from a distant subject to something nearby, you move the lens away from the film.

DIVERGING LENSES

Diverging lenses are shaped the opposite way and do the opposite thing. Parallel rays entering a diverging lens emerge on the other side as divergent rays—angled away from each other, Figure 8-4.

FOCUSING A LENS

The focusing ring on the lens operates on an internal screw thread called a *helicoid*. To focus closer to the camera than infinity, the lens travels outward on the screw thread. When the end of the thread is reached, that's as close as you can focus with that lens. With different lenses, the shortest focused distance varies, ranging from inches with short-focal-length lenses to feet with long lenses.

THE IMAGE CIRCLE

A circular lens makes a circular image of a circular portion of the scene. In the camera, a rectangular mask or opening in front of the film allows only part of the circular image to fall on the film.

Dimensions of the image frame

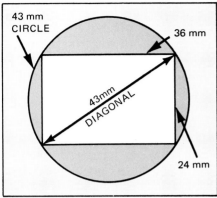

The image made by a lens for a 35mm camera is a circle closely containing the film frame as shown. The part of the circular image cast by the lens which actually falls on the film is determined by a rectangular window in the camera body—opened and closed by the focal-plane shutter.

An exception is the shift lens, discussed in Chapter 15.

on 35mm film are 24mm by 36mm. The circular image cast by the lens has a diameter slightly larger than the diagonal of the film frame, about 43mm.

Even though the camera viewing system shows you an image with correct orientation, the image on the film is upside down and reversed left-to-right.

MAGNIFICATION

Magnification is illustrated with the outside rays of the lens, Figure 8-5, where the subject is an arrow and the image is an upside-down arrow. In each case, the arrow extends all the way across the field of view.

Magnification is a ratio or fraction: *The size of the image divided by the size of the subject.*

Because lenses are symmetrical, the angle of view is the same on both sides of the lens. The sizes of image and subject are therefore proportional to their distances from the lens. If image and subject are the same distance from the lens, they will be the same size.

This leads to two ways to think about magnification. You can compare sizes and you can compare distances. Either way, you get the same answer. A simple formula to figure magnification, M, is:

$$M = I/S$$

where I is either image size or image distance from the lens, and S is either subject size or subject distance.

FLATNESS OF FIELD

The film in a camera is flat and held so deliberately. In fact, Pentax cameras are very carefully designed to hold the film as flat as possible while it is being exposed. Lenses would work better and require less correction if the film were curved in both directions as though it was a section of a sphere. Nobody has figured out how to make and handle roll film that way, so lenses are corrected for flatness of field. This means that if you photograph a flat surface such as a newspaper, all parts of the image should be in good focus on the flat film in the camera. If not, the lens correction for flatness of field is poor.

This is not of concern in most photography of nature, people and other non-flat objects. In close-up photography, many people copy things like postage stamps so special lenses for high magnification are designed with particular attention to flatness of field.

FLARE AND GHOST IMAGES

Light arriving at the air-glass surface of a lens is partly reflected at the surface and partly transmitted in the direction we want it to travel. This happens at both surfaces of a piece of glass, so there are internal reflections within a single glass lens element and multiple reflections in a compound lens with several pieces of glass.

In general, any light which is deflected or scattered from its intended path of travel will land somewhere it doesn't belong. This tends to put light on the film where there would otherwise be less light. The stray light has been "robbed" from areas where it should have been. Therefore light areas on the film are not as light as they should be and dark areas are not as dark. The result is a general reduction in contrast between light and dark areas.

If the light which is scattered around by lens reflections forms no definite image on the film but is an overall fog or even a fog over a relatively large area of the picture, we call it *flare*.

Sometimes the reflections from lens surfaces happen in a way that causes a definite shape on the film. Images of this sort are called *ghosts*.

The cure is to reduce light reflection at each glass-air surface which is done by lens coating.

LENS COATING

The first lens-coating method was a single very-thin layer of a

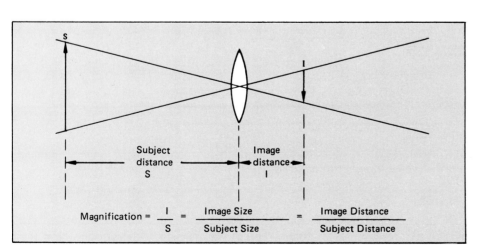

Figure 8-5/Because a lens angle of view is the same in both directions, the ratio of image size to subject size is the same as the ratio of their distances from the lens.

transparent material such as magnesium fluoride, applied in a vacuum chamber. This made a great improvement in picture quality by reducing reflections from coated lens surfaces, however a single coating is not effective at all visible colors of light. Super Takumar lenses, no longer in production, were manufactured with a single-layer lens coating.

An improvement was obtained by using multiple coating layers of different thicknesses, so reflections are reduced throughout the visible spectrum. Pentax calls this Super-Multi-Coating, abbreviated SMC.

Multi-coating was first applied to screw-mount Takumar lenses, identified as SMC Takumar.

With the development of the bayonet-mount SMC Pentax lenses, the multi-layer coating was used on additional glass surfaces, giving greater reduction of flare and ghost images in SMC Pentax lenses compared to SMC Takumar lenses.

LENS ABERRATIONS

To photographers, lens aberrations are like the boogie-man—mysterious, threatening and always lurking around trying to do something bad. Aberrations of a lens cause defects in the image.

There is a long shopping list including spherical aberration, chromatic aberration, coma and astigmatism. All lenses have all of these defects to some degree. Total elimination is probably impossible but partial elimination of these defects, called *correction,* is part of the design of each lens and, for more money you get more correction.

Part of the problem is the fact that the surface of conventional lenses is spherical, mainly for ease of manufacture. Another part of the problem rests in the nature of light and lens glass which does not behave the same with different colors of light—called *chromatic aberration.*

Correction of lens aberrations is done three ways. Basic is the design of the lens itself, using multiple pieces of carefully shaped glass, called *elements,* to make a complete compound lens assembly in a mechanical housing. This has always involved laborious mathematics. The process has been both speeded and improved by use of modern electronic computers to do the arithmetic.

To correct some of the lens aberrations, glass of differing chemical composition is used for the various elements in the lens. A limitation in the past has been the range of different types of glass.

The chemical fluorite is a transparent crystal found in nature which can be man-made in sizes large enough to manufacture lens elements. The mineral quartz can also be fabricated into lens elements and used to extend the range of available types of lens material and therefore extend the designer's ability to correct aberrations.

Because of the long list of aberrations and the fact that correcting them is a series of compromises, the best guide to the user is simply the reputation of the lens maker. Pentax lenses and cameras are made by Asahi Optical Company—the second-oldest Japanese lens maker. They have established a world-wide reputation for quality.

Most lens aberrations have less effect on the image if the lens is used at small aperture. Using ordinary films, it's hard or impossible to see any difference, but theoretically it is better to shoot at an aperture smaller than wide-open.

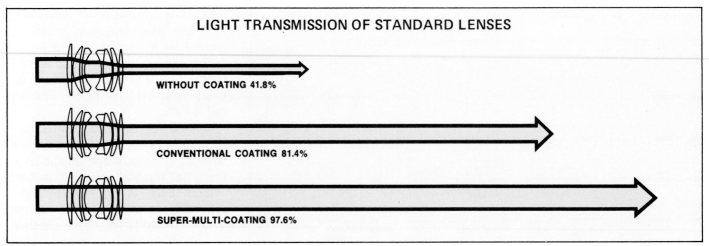

LIGHT TRANSMISSION OF STANDARD LENSES

WITHOUT COATING 41.8%

CONVENTIONAL COATING 81.4%

SUPER-MULTI-COATING 97.6%

Because a coated lens reflects less light at each air-glass surface, more of it continues through the lens. This Pentax drawing shows the increase in light transmitted through a lens due to conventional coating, and the further increase due to Super-Multi-Coating. A more important benefit of reduced reflections in the lens is reduced flare and improved contrast in your pictures.

Ghost images are unpredictable. Shooting into the morning sun caused one near the bottom of this picture.

Josh Young positioned his camera so the flames from a waste-gas jet in an oilfield seem to emanate from the setting sun.

DIFFRACTION

Diffraction happens when a light ray makes grazing contact with an opaque edge such as the lens barrel and the edges of the aperture. Rays which contact the metal edge of the aperture on their way into the camera are changed in direction slightly, bending toward the metal edge. Also, a pattern of alternating light and dark bands of light is formed.

Light rays from any point of a scene should converge to a point-image on the film. Because of diffraction, some of the rays will be diverted and the image will be spread out. Only those rays which pass very close to the edge of the aperture are affected—those which go through the center of the lens are not diffracted.

Therefore the amount of image degradation due to diffraction depends on what proportion of the rays graze by the edge of the aperture and what proportion pass through the center part of the hole.

As an aperture is made smaller, there is more edge and less center area, so the total percentage of rays which are diffracted by the edge is higher.

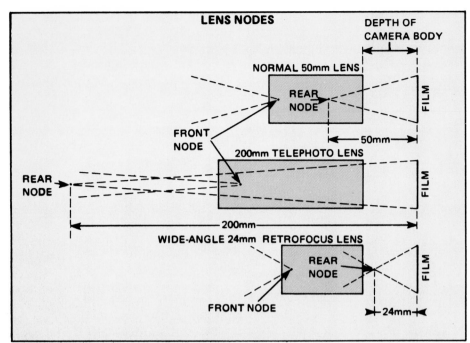

Lenses all mount the same place on the camera, but longer lenses require more optical distance to make the image. This is done by optical trickery which moves the *lens node* forward or backward. Lens-to-film distance is measured from the rear lens node and is always equal to the lens focal length, when focused at infinity. Sometimes the rear lens node is moved so far forward, it's in the air in front of the lens. The standard design for telephoto lenses moves the rear lens node forward. The standard design for wide-angle retrofocus lenses moves the lens node toward the film.

OPTIMAL SHOOTING APERTURE

If a lens is scientifically tested for image quality, starting at maximum aperture, the image will improve at successive *f*-stops as the lens aperture is closed because the effect of aberrations is reduced. It varies among lenses, but typically at around *f*-5.6 or *f*-8 the image is as sharp as it's going to get. Further reductions in aperture size cause diffraction effects to degrade the image. This degradation is gradual and even at *f*-22 it is unusual to identify diffraction effects with the unaided eye.

Usually there are other compelling reasons that determine aperture size, but if you have none and you want the best image, set the lens at an *f*-stop near the center of its range.

LENS NODES

As you remember, the technical definition of focal length is the distance from lens to film when the lens is focused at infinity.

All lenses mount on the camera the same way and at the same place, so you may wonder how a long-focal-length lens finds additional room behind the lens to make the image.

Image distances are not tiny. As a rule of thumb, 25mm equals one inch. A 50mm lens needs about 2 inches between lens and film. A 200mm lens needs about 8 inches behind the lens to make a focused image.

Each lens of different focal length does have the correct distance between lens and film when mounted on the camera, but it's done optically rather than mechanically. There is a point in the optical path from which the distance to the film is figured. This point is called a *node*, and its location is controlled by the optical design of the lens rather than its mechanical construction. To get a longer *optical* distance between lens and film, the node is moved forward by scientific trickery. You can't see a node and you can't find

it to measure from, but it's there. You can always assume that the *optical* distance between lens and film is equal to the focal length of the lens—when the lens is focused at infinity.

TELEPHOTO LENSES

The basic requirement to make a long-focal-length lens is to have a relatively long optical distance between lens and film. This can be done in a clever way by using a diverging lens element in the lens as shown in Figure 8-6.

The first lens converges the rays so they would come in focus as shown by the dotted lines. Before reaching the film, the converging rays are intercepted by the diverging lens element which causes them to come together at a greater distance as shown by the solid lines.

Lenses built this way are called *telephoto* although the word has come to mean any long lens in popular language. The telephoto principle has two advantages. A lens can be physically shorter than it would be without the diverging element. The node can be located where it needs to be so the focused image lands on the film plane in the camera body.

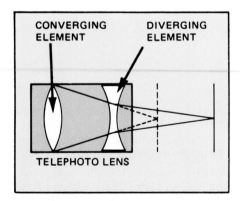

Figure 8-6/Telephoto lenses use a diverging lens element which increases the lens-to-film distance and gives a longer focal length.

SMC Pentax 200mm f-4 lens is a telephoto design. Looking in the front of a telephoto lens, you see a large pupil. Looking in the rear you see a smaller pupil. With wide-angle lenses, it's the other way—rear pupil is larger than the front.

Telephoto lenses can be identified by looking into the front and back of the lens while holding it away from your eye and pointing it toward a window. At each end of the lens you will see a spot of light, called the *pupil,* which is actually the lens aperture seen through that end of the lens.

With a conventional lens, the two pupils will be the same size or nearly so. With a telephoto lens, the pupil seen looking in the front will be plainly larger than the pupil seen looking in the back.

RETROFOCUS LENSES

The telephoto design is used to move the lens node forward so there is enough distance between node and film plane to accommodate a long focal length.

The problem is reversed with very short focal-length lenses. For example, a 24mm lens has a rear focal length of about one inch. The distance between the lens mounting surface and the film plane on Pentax camera bodies is about 1.75 inch. Therefore a conventionally designed 24mm lens would make a focused image about three-quarter inch in front of the film plane in the camera—with the lens set at infinity.

The design principle of the telephoto lens can be reversed to move the lens node *toward* the film plane rather than away from it. A *reversed telephoto* lens design is often called a *retrofocus* lens. The design is used primarily to fit a short focal-length lens onto a camera body whose dimension between lens mount and film exceeds the focal length of the lens. It moves the node closer to the film.

With a retrofocus lens, the pupils are not the same size either—the rear pupil is bigger than the front.

REAR CONVERTERS

A Rear Converter is an optical accessory that is inserted between lens and camera. It is also called a *tele-extender* and a *tele-converter.* The effect is similar to the diverging element in a telephoto lens. A lens plus rear converter has a longer focal length than the lens used alone. A disadvantage is that less light reaches the film.

A-type rear converters, such as this Rear Converter-A 2X-S, have electrical contacts to couple A-type lenses to a program camera, allowing programmed automatic exposure.

The increase in focal length is indicated by a factor such as 1.4X or 2X. Focal length is multiplied by the factor. For example, a 200mm lens used with a 2X rear converter has an *effective* focal length of 400mm.

The decrease in light reaching the film is stated by multiplying the f-number of the lens by the same factor. For example, an f-2 lens used with a 1.4X rear converter has an *effective* aperture of f-2.8. The light loss is one step. With a 2X rear converter, the light loss is two steps.

Depth of field is *reduced* by the same factor, if subject distance is unchanged. To read depth of field from the scale on the lens, use the *effective* aperture value.

Four A-type rear converters are available. They are Rear Converters 1.4X-S, 2X-S, 1.4X-L and 2X-L. They have electrical contacts to couple A-type lenses to the KA mount on program cameras, allowing programmed automatic exposure. They also mechanically couple the levers on the lens mount to the camera body, to preserve full-aperture metering and automatic aperture operation with all Pentax lenses and SLR cameras.

The S-types are for use with most Pentax lenses up to 300mm focal length. L-types can be used with specified longer lenses. Attempting to mount the wrong converter may damage a lens. Because lens design and availability may change, lists of usable lenses for each converter are not included here. They are in the instruction booklet packaged with Rear Converters—which your dealer will be glad to show you.

Image quality is reduced, but usually imperceptibly. For best quality, close the lens at least two steps from maximum aperture. Don't use apertures larger than f-2.8.

A non-automatic rear converter, K T6-2X, is for use with lenses from 135mm to 300mm.

The SMC Pentax Zoom *f*-4, 45 to 125mm lens has all focal lengths between 45mm and 125mm. The lens focuses by rotating the large knurled ring and zooms to different focal lengths by sliding the knurled ring along the lens barrel. As the ring moves forward, focal length is read on the scale along the lens barrel. This lens is zoomed all the way to 45mm.

ZOOM LENSES

All I will attempt to do here is give you the general idea of what happens inside a zoom lens. As you probably know, these lenses can be focused on a subject and then by a separate control the lens focal length can be changed to alter the magnification and the size of the image on film.

If you will please refer back to Figure 8-6, which shows how a diverging lens alters the focal length of a converging lens, it will be apparent that the distance between the converging and diverging lens controls the focal length of the combination.

Zoom lenses are complex, using many glass elements in a mechanical assembly which requires high precision and extremely close manufacturing tolerances. They work by moving lens elements inside the lens tube to alter focal length. It would be ideal if nothing changed

except focal length when zooming the lens. Focus on the film should remain sharp while image size changes; the *f*-number of the lens should remain constant; and aberrations should not increase.

In practice this is difficult to accomplish. A lens design can preserve good focus at one or more points along the zoom range, but it is difficult to keep sharpest focus at all focal lengths.

When using a zoom lens, focus at its longest focal length where depth of field will be smallest and, therefore, the focus adjustment will be more accurate. Then zoom to shorter focal lengths.

If you do it the other way, you can miss exact focus slightly when starting at a short focal length, because of the greater depth of field available. Then when you zoom to a longer focal length and get less depth of field, your subject may be outside the zone of critical focus.

MACRO LENSES

Macro means photography at magnifications of 1.0 or greater. Close-up photography includes magnifications from 0.1 up to 1.0. The dividing point—a magnification equal to 1.0—is called *life-size.*

Conventional lenses are corrected

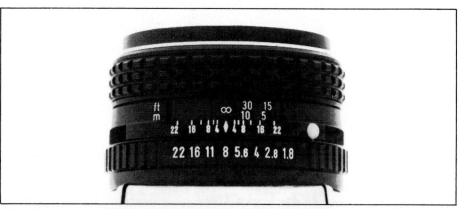

1/How to set a lens at its hyperfocal distance so you get maximum depth of field: First, focus the lens at infinity. Notice the near limit of depth of field, at the aperture you are using. This lens is set at *f*-8. The near limit of depth of field is 10 meters. In fact, *f*-8 on the Depth-Of-Field Indicator Scale lines up with the first numeral of 10 on the distance scale.

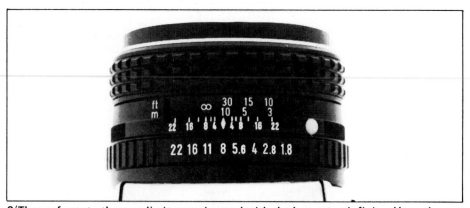

2/Then refocus to the near limit you observed with the lens set at infinity. Here, the first numeral of 10 on the distance scale is carefully located opposite the diamond-shaped index mark. The lens is set at its hyperfocal distance (about 12 meters). Depth of field extends from infinity to half the hyperfocal distance.

Now that you've done it the hard way, here's a shortcut. Just position the infinity symbol on the distance scale opposite the *f*-number on the Depth-Of-Field Indicator that indicates the far limit. That's the way this lens is set.

Result of hyperfocal-distance setting shows maximum depth-of-field.

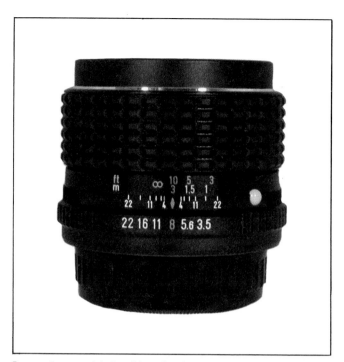

Pentax lenses with focal lengths shorter than 50mm are color-coded to help you quickly find the hyperfocal-distance setting for ƒ-8. Notice that ƒ-8, the diamond-shaped index mark, and a focused-distance of 10 feet (3 meters) are all the same orange color. When set for hyperfocal distance at ƒ-8, this 28mm SMC Pentax lens has good focus from 5 feet to infinity.

Orange mark to left of diamond-shaped index mark is focused-distance index when using b & w IR film. On some lenses, the IR index coincides with an ƒ-number on the Depth-of-Field Guide scale, so the mark serves two purposes.

for aberrations on the assumption that the subject distance will be considerably longer than the image distance. At magnifications greater than 1.0, image distance is longer than subject distance. Conventional lenses work better if physically reversed on the camera to keep the long dimension on the same side of the lens even though that long dimension becomes image distance.

Pentax supplies reverse-mounting rings to attach lenses backwards. The loss of camera automation when this is done is usually not a major problem.

Because of increasing interest in close-up and macro photography, Pentax has developed special Macro lenses and the other equipment lenses and other equipment for this purpose—see Chapter 11.

HYPERFOCAL DISTANCE

If you focus a lens at infinity it has some depth of field in both directions from the focused distance. However, that part which extends *beyond* infinity is wasted because nobody lives there.

A way to use all of the depth of field without wasting any on the far side of infinity makes use of the lens designer's term *hyperfocal distance.*

When focused at the hyperfocal distance, the lens has more *total* depth of field than at any other setting of the focus control. Therefore it is a very good way to set the camera when you are carrying it around. Then, if something happens suddenly and you want to shoot as fast as possible, you have a very good chance of getting the picture

without fooling around with focus.

Finding the hyperfocal distance is easy because it is just the near limit of depth of field when the lens is set for infinity. You read it off the lens. It will vary with ƒ-stop, but the depth of field indicator on the lens takes care of that problem.

Set the lens to infinity and notice the near limit of. depth of field, at the aperture you intend to use. Then refocus to that distance.

Do that a few times for practice and you will soon start using the hyperfocal distance as an automatic stand-by setting of the focus control.

9

VIEWING AND FOCUSING

How to hold the camera for good support and fast shooting. Operate camera-body controls with your right hand; lens with your left. Support the lens with your left hand and press the camera firmly against your face. While shooting, don't breathe. Squeeze the shutter—don't jab or jerk.

For a vertical frame, some people are comfortable holding the camera this way. Notice the lens is cradled in left hand.

Others rotate the camera so shutter-button is down and operate the shutter with their thumb. Learning to shoot with one eye open is handy. It allows you to track objects not in the field of view; it helps keep you oriented in the real world so you don't walk over cliffs or out into the traffic.

In an SLR camera, one purpose of viewing the image from the lens is to determine if it is in good focus. The way to do this is to put a ground-glass screen above the mirror with the mirror angled so it intercepts light rays from the lens.

The irregular surface of the ground-glass screen is called a *matte* surface. Each small point on the screen receives light from the lens and becomes luminous. Each small point retransmits light rays toward the eye of the camera operator. What you see is the image on the screen whether it is in focus or not.

This is commonly called a *focusing screen* because you use it to judge focus. It is also called a *viewing screen* because you use it to view the image. Sometimes we just call it a screen. Some Pentax models have interchangeable screens with different features, described later.

The camera is designed so the distance from the lens mounting surface to the film plane is the same as the distance to the focusing screen by way of the mirror. Therefore, if the image is in focus on the screen, it will also be in focus on the film when the mirror is moved out of the way.

FOCUSING SCREEN BRIGHTNESS

A matte screen works fine as a surface on which to judge image focus. It tends to be brighter in the center than the edges unless the brightness is corrected by another lens.

When you can, take advantage of steady-rests for you or the camera. The world is full of them; walls, posts, railings, fences, furniture, trees and other things.

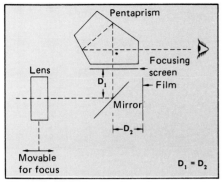

Distance from lens to focusing screen by way of mirror must be identical to distance from lens to film when mirror is raised. Judging focus by looking at the screen is equivalent to examining the image on film.

Figure 9-1/Most focusing screens use an irregular *matte* surface such as ground glass. Without correction for the edges, much of the light goes out of the observer's line of vision. An uncorrected ground-glass screen appears dark around the edges even when the image itself is uniformly bright.

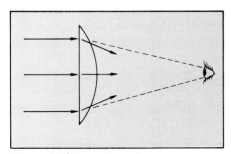

Figure 9-2/Correction of uneven illumination of a focusing screen is made by a *field lens* that bends the outside light rays toward the viewer's eye.

As shown in Figure 9-1, each point of the matte screen, when acting as a light source, sends light rays forward in all possible directions. Away from the center of the screen, the brightest rays are not directed toward the observer's eye, so the screen appears dark around the edges.

More uniform viewing-screen brightness is obtained by use of a converging *field lens* which bends the rays from the edges of the screen toward center, as shown in Figure 9-2.

A field lens to correct screen brightness tends to be thick and heavy. The part of a lens which refracts light rays is the front and back surface—the glass inside does nothing. Therefore it is possible, for special applications, to remove glass from the inside of the lens without changing the contour or shape of the surface. Visualize the result, a *Fresnel lens,* by looking at Figure 9-3. The lens is divided into a series of concentric rings by slices through the lens.

Pentax focusing screens are precision molded of clear plastic. A matte surface, where used, is on the top. As you will see on following pages, some have engraved reference lines. Where provided, these are also on top.

A Fresnel field lens is molded onto the bottom surface except for a circular area in the center that appears brighter. Focusing aids, when used, are placed in the center circle. Interchangeable screens must be handled very carefully, to avoid scratching.

FOCUSING AIDS

Judging focus by looking at the image on a matte screen depends a lot on how good your eyesight is. Even with good vision it is inferior to other methods of indicating good focus. Two other methods, called *focusing aids* are used.

Split Image—A split-image focusing aid is two small prisms with their faces angled in opposite directions to form a *biprism* as shown in Figure 9-4.

Figure 9-3/To save weight and space, a converging lens can be "flattened." Viewed from the front, this lens shows concentric circles at the steps in the less contour. This is a Fresnel lens.

Figure 9-4/A biprism is two wedges of glass, tapering in opposite directions. Normally made to fit a circular area in the center of the focusing screen.

Each of the two prisms refracts or bends light rays that pass through it. If the image from the lens is brought to focus *in front of the focusing screen,* rather than *at* the screen, the two halves of the image appear misaligned as shown in Figure 9-5.

If the image comes to focus *on the viewer's side of the screen,* the effect is reversed and the image is misaligned in the opposite direction. At the point of best focus, the two halves of the image are not displaced in respect to each other.

The human eye is better at judging alignment of lines or edges in an image than judging focus by general appearance so a split-image focusing aid is a good way to find focus.

For most effectiveness with vertical lines in the scene, the display should move the top half of a vertical line to the right or left and the bottom half in the opposite direction.

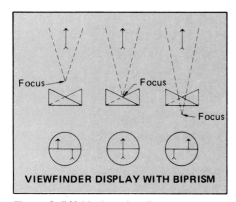

Figure 9-5/A biprism visually separates lines into two displaced segments when the image is not in focus.

If the prisms are positioned in the camera to split vertical lines and the image consists mainly of horizontal lines, it will be difficult to see any indication of focus.

Some split-image viewfinders are angled at 45 degrees to give some focus indication on both vertical and horizontal lines. If the split-image focusing aid is not oriented correctly to split the lines of whatever you are shooting, rotate the camera until it does. Focus, return the camera to the best orientation for the scene, and make the picture.

Focusing and Blackout—Imagine that your eye is looking out at the scene through the biprism and the lens. Your line of sight will be displaced in one direction by one prism and in the other direction by the other prism.

Even though the prism angles are small enough to allow you to look through the lens at full aperture, a smaller aperture may block your line of sight so you end up looking at the back side of the aperture diaphragm rather than out to the world beyond. This is common for focusing aids of this type and the biprism will black out on one side or the other.

The side that goes black depends on where your eye is. Move your head one way or the other and the opposite side of the biprism will go black. By changing the position of your eye, you alter your line of vision to favor one prism or the other.

This problem puts the camera designer into a technical conflict. Large prism angles cause large image displacements when the image is not in focus and therefore give a very good indication of focus. However, the larger the angle the sooner the focusing aid blacks out when stopping down the lens.

Standard Pentax lenses start to black out the prism-type focusing aid about midway between maximum and minimum aperture, and work satisfactorily for a stop or two beyond.

This is not a handicap when focusing at full aperture, but you may notice the effect when you stop down to judge depth of field or if you attempt to use the focusing aid when stopped down and using a long-focal-length lens.

A biprism which splits lines doesn't work well when there aren't any lines in the picture. The worst case is either a plain surface or a mottled surface such as a mass of foliage.

Microprism—Another type of focusing aid which is more useful on scenes without strong geometric lines is a *microprism*, shown in Figure 9-6.

It is an array of many small pyramids whose intersections work in a way similar to the biprism. Visually, the microprism displaces small segments of the image causing it to "break up" and have an overall fuzzy appearance. When focus is reached, the image seems to "snap" into focus.

A microprism is even more helpful when hand-holding the camera. If you jiggle the camera—on purpose or because you can't help it—the image will seem to scintillate when it is out of focus.

Because operation of the microprism is similar to the biprism, it has the same problem with blackout at reduced apertures.

Combination Screen—A combination screen has two focusing

Figure 9-6/A microprism is an array of small pyramids whose intersections work like little biprisms. Microprisms work well on any subject with surface details.

aids, a circular biprism surrounded by a microprism ring.

The MEF and MG cameras have permanently installed combination screens. Screens for the ME Super can be changed at Pentax service centers. You can select from: biprism only, microprism only, or all matte.

The LX, MX and K1000 have interchangeable screens with a choice of focusing aids and other features.

Choosing a Focusing Aid—Some people develop a strong preference, favoring the biprism over the microprism, or the reverse. It depends on individual reactions to these focusing aids and also on the types of scenes photographers shoot. In general, a biprism works better when there are definite visible lines in the scene that can be split by the biprism. If the scene doesn't have strong lines, then a microprism works best.

For people used to one type of focusing aid, the combination screen takes some getting-used-to, but it does combine the best of both methods.

INTERCHANGEABLE SCREENS

The LX, MX, ME Super and K-series cameras offer a choice of interchangeable screens, shown on the following two pages.

Matte screen with no focusing aid. Can be used with any lens but intended for lenses with maximum aperture of about ƒ-5.6 and smaller because microprism and biprism focusing aids don't work with such small apertures anyway.

Standard biprism focusing aid, factory installed. Sometimes called *split-image,* sometimes called *rangefinder* type. This also blacks out one side at about ƒ-4.5 to ƒ-5.6 but surrounding area can be used for focusing at any aperture.

Photomicrographic screen has X-shaped microprism, surrounded by a clear area, surrounded by a ground glass matte surface. For ordinary situations, use the microprism area. When set up for high magnification or with small apertures, use the area around the X-shaped microprism.

Cross-microprism, alternate screen for standard microprism, has steeper microprism face angles and gives better indication of focus when using lenses with large maximum aperture such as ƒ-1.2 to ƒ-2.8. Not suitable for lenses with maximum aperture smaller than ƒ-2.8 because of blackout.

Standard microprism focusing aid, factory installed. Suitable for lenses with maximum aperture of about ƒ-4.5. At smaller apertures, microprism loses effectiveness because of blackout, but surrounding screen can be used for focusing.

Any of these screens can be installed in any K-series camera by a Pentax service center. Screens can not be changed by the camera user.

Screens for the LX and MX are user-interchangeable after removing the lens. They are held in a hinged frame in the top of the camera body.

A special tool is provided with replacement screens. Use the handle of the tool to release the catch at the front of the frame, which allows the frame to swing down. Then use the pincers end to grasp the tab on the front of the screen and lift it out. Use the tool to install the new screen and push the frame up until it latches.

Screens for K-series and ME Super cameras must be changed at Pentax service centers.

Camera models that do not use interchangeable screens have a combination screen—a biprism surrounded by a microprism.

A rubber eyecup makes viewing more comfortable, excludes stray light and prevents eyeglasses from bumping against the camera.

INTERCHANGEABLE VIEWFINDERS

In addition to interchangeable focusing screens in the camera body, LX cameras use interchangeable viewfinders. You can choose from an assortment of viewfinders of various types to set up the camera for the kind of photography you are doing. Available viewfinders and their applications are described in Chapter 16.

VIEWING AIDS

Accessories are available to make viewing more comfortable or more convenient, and to make focusing more precise. These fit onto the eyepiece of all camera models with fixed viewfinders by sliding into the grooves on the sides of the eyepiece frame. They also fit the eyepiece of LX interchangeable eye-level pentaprism finders.

Correction Lenses—Correction lenses allow you to put your eyeglass prescription into the viewing system so you can shoot without wearing glasses.

Rubber Eye Cup—This is a very convenient accessory with or without eyeglasses. It excludes stray light coming from the gap between your face and the finder. This helps reduce reflections from the

INTERCHANGEABLE SCREENS FOR LX AND MX

For LX, SC-21
For MX, SC-1
This is the standard screen for these cameras. It has a biprism, surrounded by a microprism ring, all in a matte field. Both focusing aids are suitable for lenses with maximum aperture up to ƒ-4 or ƒ-5.6, depending on lens in use. They black out at smaller apertures.

For LX, SA-21
For MX, SA-1
This screen has a circular microprism in a matte field. Prism face angles are suitable for lenses with maximum aperture up to ƒ-4 or ƒ-5.6, depending on lens in use.

For LX, SA-23
For MX, SA-3
Uses a microprism focusing aid with prism face angles that give more definite focusing indication with lenses having larger maximum apertures. Suitable for use with lenses having maximum apertures in the range of ƒ-1.2 to ƒ-2.8. Blacks out at smaller apertures.

For LX, SB-21
For MX, SB-1
A biprism focusing aid in a matte field. Some Pentax literature refers to a biprism as a split-image focusing aid. Prism angles are suitable for lenses with maximum aperture up to ƒ-4 or ƒ-5.6, depending on the lens in use.

For LX, SD-21
For MX, SD-1
A matte focusing screen with central cross hairs in a clear spot. Does not have a prism-type focusing aid. Recommended for photographing through microscopes and telescopes and for any high-magnification setup such as with extension tubes or bellows.

For LX, SE-20
For MX, SE
All matte with no focusing aid. Central spot has no Fresnel lines. This results in a brighter image and slightly improved focusing accuracy. Useful with very-long-focal-length lenses and macro applications where focusing aid would black out, blocking part of image from view.

For LX, SG-20
For MX, SG
All matte with no focusing aid and no Fresnel lines in center spot. Has engraved grid lines at 6mm intervals to aid in photographing architecture, for positioning subjects for multiple exposures and similar uses.

For LX, SI-20
For MX, SI
All matte screen with no focusing aid and no Fresnel lines in center circle. Engraved with vertical and horizontal ruled scales that are useful to measure, compare or repeat image size on screen. Used in high-magnification photography.

For LX, SD-11
For MX, SD-11
All clear screen with no focusing aid and no Fresnel lines in center circle. Has central cross hairs to aid focusing. Gives brighter image with microscopes and telescopes. With a clear screen, you cannot see depth of field.

Focusing screens for LX and MX have the same dimensions but are not interchangeable, except for the SD-11. Matte surface LX screens are specially coated for increased light transmission and a brighter image. If these screens are installed in an MX, the exposure meter will not read correctly.

glass surface of the viewfinder window which can be distracting and prevent a good view of the screen. It also helps prevent stray light from entering the viewfinder window and finding its way to the camera light-measuring system which could affect exposure settings.

Right-Angle Finders—The normal viewing arrangement through the window on the back of the camera is called eye-level viewing and is convenient for most shooting. If you use the camera on a tripod or stand with the lens pointed downward to photograph something directly below the camera or if you have the camera at ground level, it is inconvenient to get your eye where it needs to be to look through the finder window.

Clip-On Magnifier—For critical focusing, a magnifier can be attached to the viewfinder with a hinged adapter to allow it to be moved out of the way when not needed. Magnifying the image on the focusing screen helps focus accurately but you can't see the entire screen. For composing, move the magnifier up out of the way.

Viewfinder Cap—With most 35mm SLR cameras on automatic, except the LX, it is necessary to prevent light from entering the viewfinder eyepiece while the camera is setting

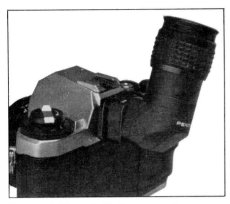

Pentax right-angle finders are called *refconverters.* Attached to the viewfinder eyepiece, a refconverter can be rotated to allow viewing from any angle—top, side or bottom. Refconverter-A, shown here, also shows the LCD readouts in the viewfinder of program cameras. Refconverter-M is used with M and LX cameras. Refconverter fits the K-1000.

SMC Correction Lens Adapter-M fits eyepiece to add your eyeglass correction to the viewing optics. Adapter range is −5 to +3 diopters, but excludes zero. To choose, add 1 to your medium- or distant-vision prescription. Test before buying. For K cameras, omit -M in nomenclature.

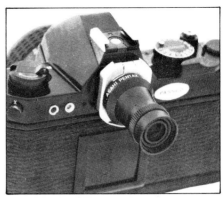

A magnifier gives enlarged view of center part of screen to aid precise focusing. It can be tipped up out of the way to view entire screen. Magnifier-M fits all cameras in this book except K-1000. For K cameras, omit -M in nomenclature.

exposure—otherwise exposure will not be correct. If your eye is at the eyepiece, this normally blocks the light satisfactorily unless strong sunlight is entering from the side, between your eye and the eyepiece.

The LX camera uses a different light-measuring system and sets exposure as described in the next chapter. When using the LX, light entering the viewfinder window cannot affect the exposure reading. Therefore, it is not necessary to close off the eyepiece of the LX even if your eye is not there.

All other 35mm Pentax SLR models determine exposure by measuring the brightness of the focusing screen before you press the shutter button. When you are using the camera on a tripod or copy stand, your eye may not be against the viewfinder eyepiece just before you trip the shutter. For example, if you are using the self-timer, or a shutter-release cable, you are likely to remove your eye from the viewfinder when you are all set to shoot so you can find and operate the self-timer or cable release.

If your eye is away from the finder window, light can come into the camera and affect the

When using cameras on automatic, except the LX, stray light entering the viewfinder eyepiece may give incorrect exposure. Some models are packaged with a Viewfinder Cap for use when your eye is not at the eyepiece when you make the shot. If you don't have a finder cap, cover the eyepiece some other way.

exposure reading when the camera is setting exposure automatically. If you are using a non-automatic camera or an automatic set for manual control, this is not a problem because you would already have set the exposure controls before moving your eye from the finder window and, of course, the controls stay where you set them.

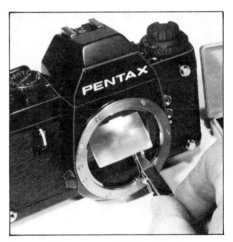

Use special tool supplied to interchange focusing screens of MX and LX. One end releases catch and lowers frame. Other end grasps tab to lift out screen or insert replacement.

All M-series cameras come with a Viewfinder Cap that slides into the accessory grooves on each side of the eyepiece. When shooting on automatic, with your eye away from the finder, use the cover to exclude light.

If you don't have a finder cap, you can cover the eyepiece with your finger or a piece of opaque tape.

10 EXPOSURE METERING

Full-frame averaging metering responds uniformly to light anywhere in the frame. A bright spot in one corner has as much effect on the meter reading as a bright spot in the center. Circle in center is focusing aid. Ring around focusing aid is fine-ground screen for focusing. Neither affects metering pattern.

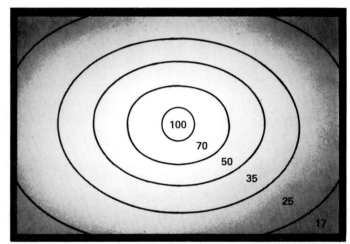

Center-weighted metering responds more to light in the center and lower-center of the frame. A bright spot in the center has full effect on the meter. A bright spot in the edge of the frame has very little effect. 100% sensitivity is in center circle. Sensitivity is reduced in each zone toward edges of frame. Numbers are percentages.

The purpose of exposure metering is to get correct exposure onto the film. Measuring the light after it has gone through the lens and any accessories such as filters is an advantage because what the internal light meter ''sees'' is the light that will expose the film.

LIGHT SENSORS

Pentax uses three types of light sensors:

Cadmium Sulfide (CdS) was standard for many years. It is used in the K1000 camera. CdS responds more slowly than the other two sensor types discussed here, particularly in very dim light. If the reading changes slowly, wait for it to stabilize. In very dim light

this can take 30 seconds or more. CdS sensors also require a short time to adjust to large changes in light intensity. If you measure a very bright scene and then immediately measure a very dark scene, the meter reading will not be accurate. If a minute or so elapses between such major changes in light intensity, the CdS cell works OK. Both of these disadvantages are minor and do not affect normal use of the camera.

The *Silicon Photo Diode* (SPD) requires more electronics in the camera but responds virtually instantaneously and is not affected by sudden large changes in illumination. This type of light sensor is used in the LX.

M-series and program cameras

use a *Gallium Photo Diode* (GPD) made of gallium, arsenic and phosphorus. The operational characteristics of GPD sensors are similar to silicon cells.

METERING METHODS

Two metering methods are used in Pentax 35mm SLRs: For one method, the light sensor is in the viewfinder housing at the top of the camera body. For the other method, the light sensor is at the bottom of the camera, in the chamber between the back of the lens and the film plane—usually called the *mirror box.*

M- and K-Series—The light sensor is located in the viewfinder housing, looking at the focusing screen from above, just as you do

when your eye is at the viewfinder eyepiece.

With M or K cameras set for *manual* exposure control, the light-measuring system is used to operate the viewfinder exposure display. You set both shutter speed and aperture manually until the display indicates correct exposure.

With M cameras set for *automatic* exposure, you set only lens aperture manually. The light-measuring system chooses a shutter speed to give correct exposure and *remembers* that setting for use later during the actual exposure.

Note that light measurement and exposure calculations must be completed *before* the mirror moves up to make the exposure.

LX—The SPD light sensor in the bottom of the camera body looks backward, toward the film. This sensor serves three purposes.

When the LX mirror is down, 15% of the light striking a semi-transparent area in the center of the mirror passes through and is used for exposure measurement.

A small rectangular *secondary mirror* is located behind the semi-transparent area of the main mirror. The secondary mirror is angled so it reflects the light downward and into the SPD sensor at the bottom of the camera body. When the main mirror moves up, the secondary mirror folds up flat against the back of the main mirror.

The first purpose of the system is to provide exposure measurement for manual control. This is done with the main mirror down.

The second purpose is to provide an indication of shutter speed in advance, before you make an exposure on automatic. This is done with the main mirror down, in a way similar to that just described.

When you press the shutter button with the camera set for automatic exposure control, the third function of the sensor begins. The mirrors move up out of the way. Light from the lens

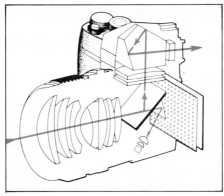

When the LX main mirror is down so you can view the scene in the viewfinder, a portion of the light passes through the central area of the mirror. This light is reflected downward into the SPD light sensor. This method is used to set exposures when the camera is operated on manual and to give an advance indication of the camera-selected shutter speed when the camera is on automatic.

travels toward the film, making a focused image at the film plane.

As you remember from Chapter 3, exposure time begins at the instant the first shutter curtain is released to travel across the frame. It ends at the instant the second shutter curtain is released. With an LX set to automatic, exposure measurement also begins at the instant the first shutter curtain is released.

The light sensor looks toward the film plane, but what it sees at the first instant is the first shutter curtain just starting to move. This curtain has a checkerboard pattern, shown in the accompanying photo, which causes it to reflect approximately the same amount of light as the emulsion surface of all films normally used for pictorial photography.

As the first curtain moves across the frame, the sensor sees less curtain and more film surface, but the two are indistinguishable to the sensor. It continues to measure light at the film plane until enough light has been measured for correct exposure. Then the camera's electronic system signals the second curtain to start closing. It closes and the exposure interval is ended. Pentax

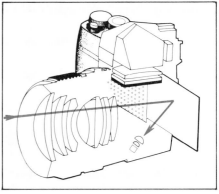

When the LX is on automatic, metering begins when the main mirror is up, at the instant the first shutter curtain is released. Metering is done by the SPD light sensor "looking" at the film plane during the actual exposure. When the film has received sufficient light for correct exposure of an average scene, the light-measuring system releases the second shutter curtain to end the exposure.

Looking in the back of an LX body, with the shutter open, you can see the SPD light sensor at the bottom of the mirror box, looking backward toward the film.

Looking in the front of an LX body, with lens removed, the first shutter curtain closed, and the mirror up, you can see the checkerboard light-reflecting pattern on the first curtain. At the top of the mirror box is the small secondary mirror folded against the back of the main mirror.

calls this system *Integrated Direct Measurement* (IDM). When the LX is set for automatic exposure, the IDM system works *after* the mirror moves up and during the actual exposure.

IDM has several advantages. If the light changes during the exposure interval, it compensates automatically and assures correct exposure. The IDM system can control exposure when using special Pentax *dedicated* flash units as described in Chapter 13. This method is normally more accurate because it measures light directly at the film plane rather than relying on a light sensor mounted in the flash, looking at the scene. This has particular advantage when using flash for close-up and high-magnification photography.

IDM metering is independent of the viewfinder. For cameras with interchangeable viewfinders, this is an important advantage. With IDM, metering is available with all viewfinders and no adjustment or calibration is required when interchanging viewfinders or focusing screens.

When the LX mirror is up, it prevents light from the viewfinder eyepiece from reaching the sensor in the bottom of the camera. Therefore, a viewfinder cap is not needed on automatic, when your eye is not at the eyepiece.

Super Program Camera—This model has two light-sensing systems. A GPD sensor in the viewfinder housing measures focusing-screen brightness to set exposure, except when using flash. When a Pentax dedicated flash is used, exposure is controlled by an SPD sensor in the side of the mirror box, looking backward toward the film surface. When sufficient exposure has been measured—from both flash and ambient light—the SPD sensor system turns off the flash.

METER SENSITIVITY PATTERNS

Two light-measuring sensitivity patterns are used, depending on the camera model. It's important to know which pattern the meter in your camera uses.

Full-Frame Averaging—The light-measuring sensor examines the entire frame and averages all of the light. The sensor considers light anywhere in the picture area to be just as important as light anywhere else. A street light in the upper left corner affects the meter just as much as it would in the center of the frame.

Center-Weighted—In a lot of shooting situations, the subject of interest is near the center of the frame and more importance can be given to light from that part of the scene. The light sensor is designed with a *sensitivity pattern* such that it responds more to light near the center of the image and less to light nearer the edges. This type of metering is called *center-weighted* because more "weight" or significance is attached to light at the center.

Using the same example as before, a street light in the upper left corner would have *less effect* than in the center of the frame—if the metering pattern is center-weighted.

The sensor still averages all the light in its view but assigns less value to light at the edges so it has

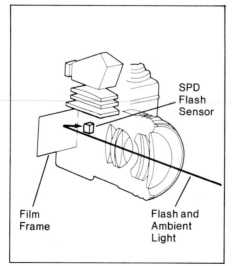

The **Super Program** camera uses a light sensor in the side of the mirror box to control exposure when Pentax dedicated flash is used. It measures both flash and ambient light from the scene.

less effect on the overall average.

PENTAX METERING PATTERNS

Among the Pentax 35mm SLRs discussed in this book, only the K1000 has full-frame averaging.

All cameras except the LX use a light sensor mounted in the viewfinder housing to measure the brightness of the focusing screen image. For these cameras, the metering pattern is determined by the optics used with the light sensor.

The LX camera metering pattern is center-weighted. When the light sensor is viewing the film plane directly, to provide automatic exposure control, center-weighting is provided by the metering optics.

When the LX light sensor receives light from the secondary mirror, measurement is slightly more complicated. Only light rays that strike the rectangular secondary mirror can be reflected into the light sensor and measured. If this mirror were at the focusing screen or film plane where the image is in focus, it would reflect a precisely defined rectangular area of the image and all parts of the image outside that area would be measured.

The secondary mirror is in the light path between lens and film at a point where the image is not yet in focus. Because the image is not in focus, some rays that will form the edges of the focused image pass through the central area and are intercepted by the secondary mirror. Those rays are measured by the light sensor along with a greater proportion of rays that will produce the central part of the focused image. This gives some sensitivity to light at the edges of the image and greater sensitivity at the center.

The Super Program camera has a flash sensor in the side of the mirror box, measuring light at the film surface. This is also center-weighted, due to the optics of the flash sensor.

Metering on an 18% gray card in the same light as your scene or subject automatically sets correct exposure. Naturally you can remove the card after setting exposure and before shooting the picture. With a full-frame averaging meter, be sure the gray card fills most of the frame and no unusually bright spots or reflections peek around the card. With center-weighted metering, be sure the card fills the center area of the viewfinder—where the brightness has most effect on exposure.

Average outdoor scenes include some sky, foliage, dirt and people, but not portraits. All average scenes reflect 18% of the light averaged over the entire frame whether photographed in color or b&w.

AN AVERAGE SCENE

In the discussion of over- and underexposure, I pointed out that film has a limited range of density between fully clear and fully black. An important idea of exposure is to cause the various light values from a scene to produce densities within the range of the film. The safest thing to do is put the middle light value of the scene right on the middle density of the film density scale. The higher and lower light values from the scene "have a place to go" on the film.

By measurement of many typical scenes, it has been found that most outdoor scenes and many shots in a man-made environment have the same average amount of light coming from the entire scene. Some parts are brighter and some are darker but they average out, or *integrate*, to the amount of light that would come from a certain shade of gray. This gray shade is called 18% gray because it reflects 18% of the light that falls on it.

I think we are indebted to Eastman Kodak for this discovery. Anyway, Kodak publishes cards which are 18% gray on one side and 90% white on the other. These cards are bound into some Kodak reference books, and sold separately at camera shops.

The idea is that you can meter on the average scene, or meter on an 18% gray card in the same light, and the exposure meter in your camera will give the same settings.

HOW TO INTERPRET EXPOSURE READINGS

If you decide to go around photographing 18% gray cards, I guarantee every exposure will be a whopping success. It's built into the system. The exposure called for by ASA film-speed ratings will put an 18% gray card right in the middle of the density scale of the film.

It takes good photographic judgment to look at a real-world scene and decide if it will average out to 18% gray. If so, you can shoot it just as you would a gray card—follow the advice of the camera exposure meter. Most outdoor scenes have sky, people, dirt, rocks, foliage and maybe a distant building. This is average. If your scene is mainly sky, that is not an average scene *but the exposure meter in your camera doesn't know the difference.*

The exposure meter, unless you override it with your own good judgement, will place the *average* brightness or tone of every scene at the middle density of the film. If the scene is mainly sky, sky will be rendered middle gray on the print and faces of people against the sky will be too dark.

You can only believe your exposure meter when it is looking at an average scene. If you shoot a bird on a snow bank, the camera will think the snow bank is a gray card in very bright light. It will stop

down so the white snow appears gray on the negative. If faithfully printed, it will also appear gray on the print.

If you shoot a coin on black velvet, the camera will think the gray card is in very poor light and open up the lens until the black velvet registers middle gray on the film.

The clue is the amount and brightness of the background. If the subject is small and the background large, worry. If the background is significantly brighter than middle gray, you know the camera exposure meter will want to stop down on account of the bright background and underexpose your subject. You have to give more exposure than the exposure meter will suggest.

If the background is significantly darker than average and your main interest is the subject against that background, you have to give less exposure than the meter suggests to avoid overexposing the subject.

Another situation where an exposure meter may give an unsatisfactory reading is when everything in the scene is unusually light or dark. If you photograph a marshmallow on a white table cloth, the exposure meter will suggest camera settings which make everything

middle gray on the negative. If printed that way, the result is a gray marshmallow on a gray table cloth—probably not your intention.

To make marshmallow and cloth both appear white on the negative, you need about two more steps of exposure than the meter will suggest.

Similarly a dark subject against a dark background will both be changed to a medium gray by the unthinking exposure meter if you allow it to happen. For realism, you probably want both subject and background to appear dark on the print. You probably need one or two steps less than the meter will suggest.

With an automatic camera, the exposure-measuring system does more than suggest exposures. It adjusts the camera and takes the picture the way it thinks is right. I'll tell you in a minute how Pentax automatic cameras allow you to take charge of the exposure setting when photographing non-average scenes, so you can prevent the camera from making a mistake.

SUBSTITUTE METERING

This is a way to solve some difficult exposure problems. Suppose you are shooting a scene with no

A handy substitute metering surface you are not likely to leave behind is your handsome palm. Most reflect about 36% of the light, so are one step brighter than a gray card. Meter on your palm in the same light as the scene, open up one step and shoot.

middle tone. Everything is very bright or very dark. If areas of bright and dark are about equal and the exposure meter includes an equal amount of each, the meter itself will average light and dark and give an exposure as though it was examining the middle tone of the scene. For example, a checkerboard with black and white squares will affect a meter as though it was a uniform gray color.

This requires some judgment on your part as to how bright and how dark the two extremes are and whether they appear in equal amounts to the meter.

You can sidestep the problem by placing an 18% gray card in the scene, so it receives the same amount of light as the rest of the scene. Meter on the card and shoot at the exposure setting which results. If you shoot that picture, it will show the 18% gray card as a middle tone with the bright and dark areas appropriately lighter and darker than middle gray.

A more artistic effect results from removing the 18% gray card after taking the reading but before exposing the film. The picture will be the same as before except the card won't be there. Bright and dark areas will reproduce properly.

If it is not convenient to place the 18% gray card at the scene—

This is a non-average scene—bright sky background and a person's face in shadow. If you let the bright background influence the meter reading, face will be underexposed.

One way to defeat unusually light or dark backgrounds is to move up close for metering, so the camera doesn't see much background. When metering on light skin, give about 1 step more exposure than meter indicates because light skin reflects about 1 step more light than 18% gray.

perhaps because the scene is on the other side of a chasm or river— you can meter on the card anywhere as long as it is in the same light as the scene. If you are shooting in sunlight for example, you can assume it has the same brightness everywhere as long as it falls on the scene or subject at the same angle. Hold the gray card near the camera in the same light as the scene and meter on the gray card.

Angle the card so it faces a point between camera and main light source *and* so the camera does not see glare reflected from the surface of the card.

Metering on a substitute surface instead of the scene itself is called *substitute metering.* Many photographers carry an 18% gray card for this purpose.

In dim light, a gray card may not reflect enough light to allow metering. Some gray cards are 90% white on the reverse side and white paper is about the same. If you meter on 90% white instead of 18% gray, the white card will reflect *five times* as much light into the exposure meter as the gray card would, because 90% ÷ 18% = 5.

Because the exposure meter assumes everything out there is 18% gray, it attributes the high value of light to brigher illumination rather than more reflectance of the sur-

face. Therefore it will recommend an exposure only 1/5 as much as it would if you were actually metering on 18% gray. Because you know that, you compensate by *increasing* exposure by 5 times over the exposure metering reading.

To make the correction, multiply the indicated shutter-opening time by 5 and select the nearest standard number. If the exposure meter says shoot at 1/60 second, you will want to shoot at 5/60 second which reduces to 1/12 second. The nearest standard speed is 1/15 second.

You can also correct by changing aperture. Opening up by 2 stops is an increase of 4 times, which is often close enough. Opening up aperture by 2-1/2 stops increases exposure 5.6 times, which is closer. The click stops or detents between the numbered settings of the diaphragm ring are half-stops. There is no exact setting of the diaphragm ring which gives a 5-times exposure increase. You can guess at it by setting between 2 steps and 2-1/2 steps increase but you normally don't need such precision.

A very handy substitute metering surface is the palm of your hand. You should check your own palm but light skin typically reflects about one stop more light than an 18% gray card. If so, you can hold your palm in front of the camera—

in the same light as the subject or scene—meter on your palm and then open up one stop. If your palm reflects only a half stop more, obviously that's how much to open before shooting.

You will find that dirt, grass, weeds, foliage and other common things have a surprisingly uniform reflectance and often it is the same as an 18% gray card. Spend some time measuring common surfaces around you and you can learn to use them in a hurry as substitute metering surfaces to set your camera for a quick shot of some unusual scene such as a flying saucer passing by. Another advantage of using your exposure meter to measure the reflectance of common objects is that it helps you learn to distinguish non-average scenes from average scenes.

You can use substitute metering with any camera with manual control of exposure settings. To use substitute metering with an automatic camera requires a memory-hold control to hold the reading from the substitute metering surface or a special technique explained later. Among the Pentax automatics, only the K2DMD has a memory-hold control.

WHEN TO WORRY ABOUT BACKGROUND

The only time you need to worry about background is when there is a lot of it *in the metering area* and the background is brighter or darker than middle gray.

Center-Weighted System — The metering area is not the same in a center-weighted system as in a full-frame-averaging system as already discussed. The center-weighted system is helpful because it disregards the edges of your picture—therefore it doesn't matter much how bright that part of the background is. A common background which can upset full-frame meter readings is sky. But with center-weighting, the meter automatically disregards sky unless a lot of it gets into the center metering area.

LX center-weighted metering pattern on IDM automatic as measured by *Modern Photography* **magazine. Numbers indicate relative sensitivity. Drawing courtesy of** *Modern Photography.*

When metering, it's important to consider both the metering pattern of your camera and the distribution of light and dark areas in the scene. Center-weighted metering recorded this scene satisfactorily. Full-frame averaging would probably have required some exposure compensation to allow for the reflectivity of the white structure.

100 70 50 35 25 17

M-series metering pattern is center-weighted with added sensitivity toward the bottom. Numbers are percentages.

As a rule of thumb for center-weighted metering, if your subject fills the center areas of the viewing screen, you can disregard background. Typical center-metering areas of Pentax cameras with 50mm lenses are shown in the accompanying illustrations. You don't need to know the metering area exactly, but it helps to know the general shape and location.

Even when the subject of interest fills the metering area, you are not relieved of your photographic responsibility to consider the reflectance of the subject.

If the subject of interest is small *compared to the metering area*, we are back where this discussion started. Increase exposure over the meter recommendation if the background is bright, decrease if the background is dark—because the meter reading is being affected by background. The amount to increase is basically an estimate and you'll get better at estimating if you practice. The usual limits are:

2 steps more exposure if the background is white as paper.

2 steps less exposure if the background is very black.

Full-Frame-Averaging System— When the meter is responding equally to everything in the frame, you have to consider everything you see. This really isn't any more difficult than doing it with center weighting and has one advantage: The metering area is clear-cut and definite with full-frame averaging; it is indefinite with center-weighting.

Otherwise, the rules are exactly the same. If the subject of interest fills the frame, or nearly so, don't worry about the background. If background is large compared to subject and the background is not medium in tone, make an exposure adjustment.

Because sky background is more likely to be a problem with

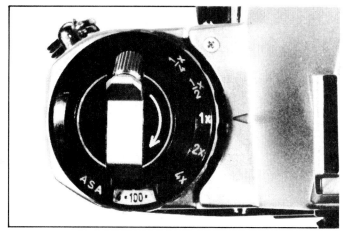

The exposure-compensation dial is associated with the film-speed dial because they have the same effect. To set film speed on this ME Super, lift the outer rim and turn. To use exposure compensation, turn the rim without lifting it. This control is set for ASA 100 and 1X exposure compensation.

full-frame averaging, here's an old trick that simplifies outdoor portraits. Point the camera down so the viewfinder includes the person and the ground at his feet, while metering and setting exposure controls. Then change the camera angle to include as much sky as you wish and shoot without changing the controls.

This doesn't work at the beach where the sand is about as bright as the sky. A trick to use at the beach and many other circumstances is to move close enough so the subject fills the frame. Meter and set exposure controls. Then back up and shoot the picture you want, without changing the controls.

An alternate to marching forward with your camera is to substitute a long-focal-length lens and get a bigger image of the subject for metering. Then put another lens on and shoot using the same settings you found with the long lens.

AVERAGING f-NUMBERS

Here's another way of solving some difficult exposure problems that is highly regarded by some photographers. Suppose the scene has bright areas and dark areas, both of interest. Move your camera close enough to get an exposure reading on the bright area and notice the recommended settings. Say it's f-8 at 1/125. Then meter on the dark area and again note the recommended setting. Say it's f-2 at 1/125.

You average these two exposure recommendations and shoot at that average setting. It doesn't matter if the scene has any middle tones or not.

How do you average f-numbers? Do it by counting exposure steps. I promised you it would be a useful skill. The average of f-2 and f-8 is f-4, two steps from each end. If you want to do it by mathematics, you can't take a common arithmetic average because it gives the wrong answer. For example, the *wrong* answer is $(2+8)/2 = 5$. The correct middle step if f-4, not f-5.

To average f-numbers, you have to find the geometric average of two numbers. Multiply them together and then take the square root of the result—easy to do if you carry a scientific pocket calculator with you on photo trips. The square root of 2x8, or 16, is 4.

Another benefit of measuring the brightest and darkest areas of the scene is that it tells you the overall brightness range of the scene. If this exceeds the capability of the film, you can't get all of the scene on the film. This is discussed later in this chapter.

HOW TO TAKE CHARGE OF AN AUTOMATIC CAMERA

When a Pentax 35mm SLR operates automatically, it chooses shutter speed all by itself to get what it thinks is correct exposure based on the light-meter reading. It can be fooled by non-average scenes just like any other meter and camera can be fooled.

Take It Off Automatic—You can observe the exposure settings in the viewfinder display and on the lens—shutter speed and f-stop—before releasing the shutter. If you don't want to use those settings, and your camera can be controlled manually, take the camera off automatic. Change f-stop and shutter speed as needed to increase or decrease exposure compared to the amount that the camera would have used automatically.

Exposure Compensation—Some automatic cameras have a special control that allows you to take the camera off automatic operation so you can give more or less exposure. It is the Exposure Compensation Dial. On the LX camera, for example, this control has 5 positions, labeled 1/4 1/2 1X 2 4. These change the normal exposure the LX would give according to which exposure factor you

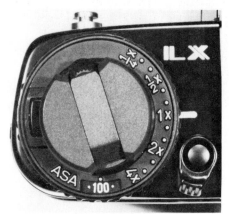

In the LX, both the Exposure Compensation Dial and the Film-Speed Control surround the rewind knob. This camera is set to ASA 100 and an exposure compensation of 1X—which means the exposure as set by the camera will be used.

The program cameras—Program Plus and Super Program—are similar. The Exposure Compensation Dial and the Film-Speed Control surround the rewind knob. To set exposure compensation, just turn the outer rim of the control to place the desired amount of compensation opposite the triangular index mark at the right. To change film speed, depress the black rectangular release button just to the left of the rewind knob. While holding the button down, turn the outer rim of the control. The film-speed value appears in the window near the back of the camera. This camera is set for ASA/ISO 100 film and 1X, indicating no exposure compensation.

select on the dial. The word *factor* implies multiplication and the exposure on film is equal to the normal exposure that would automatically be set, *multiplied* by the selected factor.

Remembering that one exposure step is obtained by doubling or halving, you can translate the labels on the dial as follows:

1/4	minus 2 exposure steps
1/2	minus 1 exposure step
1X	no change
2	plus 1 exposure step
4	plus 2 exposure steps

The exposure compensation dial is *always* working according to where you have it set. If you forget and leave it set for 2, it will add one exposure step to every shot you make. When you don't want the exposure changed, set the dial to 1X, which is the equivalent to turning it off because it doesn't do anything to exposure.

The LX reminds you that you are using compensation. When the dial is set to any value other than 1X, a red warning flag appears at the top of the shutter-speed scale on the right side of the viewfinder.

FILM SPEED AS AN EXPOSURE CONTROL

ASA film speed is a message from the film manufacturer to the exposure system in your camera, requesting a certain amount of exposure. With a non-automatic camera, the film will receive that amount of exposure if you set the controls the way the exposure display recommends. With an automatic camera, the film gets that amount of exposure if you stand back and let the camera do it.

As you remember, *doubling* ASA film speed means the film needs *half* as much exposure, and the reverse.

You don't have to use the ASA speed number as an input to the camera—you can use whatever you choose. If you dial in a higher or lower speed number, then you are not using the ASA number but you are using your own *exposure index* to guide the camera.

If you have selected 32 at the camera when the film is ASA 64, the camera is set to give one step more exposure than it would if you dialed in 64.

This is not necessarily a wrong exposure. Suppose you have performed substitute metering using your precision palm, which reflects 36% of the light. To use your palm instead of a gray card, you meter on it and open up one step.

On manual, there are three ways to give one step more exposure—change shutter speed, change aperture, or change the film speed setting. If you change shutter speed or aperture to give one more step, the viewfinder display will show overexposure. Shoot anyway, that's what you *intend* to do.

On automatic, shutter speed is controlled by the camera. If you change aperture to the next larger size, the camera will select the next faster shutter speed and exposure will not change. That is not what you intend to do.

On automatic, use the Exposure Compensation Dial if the camera has one. For one step more exposure, set it to 1/2X. The camera will automatically select

the next slower shutter speed, and the display will continue to indicate correct exposure.

The MG camera is automatic only and doesn't have an Exposure Compensation Dial. You must change the film-speed setting. For one step more exposure, divide the existing setting by two. if the dial is set to **64**, change it to **32**. The camera will then select the next slower shutter speed. The display will indicate correct exposure. The film will receive one step more exposure that it would with film speed set at **64**.

The MG has an Exposure-Compensation Guide under the Rewind Knob. To use it, lift up the knob to the first detent. Don't lift it any farther or you'll open the camera back and the film will become light struck. It's use is shown in the accompanying photo.

Film speed is changed directly by the film-speed control, indirectly by the Exposure Compensation Dial. Either way, be sure to reset the control so the film will receive correct exposure when you no longer need compensation.

Another use of film speed is to deliberately underexpose or over-expose an entire roll. It is common to shoot with a film speed set into the camera which is higher than the manufacturer recommends. This amounts to deliberate underexposure but many photographers don't think of it that way. They say, "I am rating this film at a higher speed, so I can use it in dim light." Even so, it's still underexposed and requires special development in the film lab, called *push processing*.

When you shoot any part of a roll with a higher speed number so it requires special processing, you must expose the entire roll that way. It is convenient to change the film-speed setting and leave it for the entire roll. That way you use the camera normally and you don't have to remember not to. You also need to remember to mark that cartridge so it won't get mixed. up with the rest of your film and get normal development.

SUBSTITUTE METERING METHODS

There are several ways to meter on a substitute surface, such as a gray card, and then photograph a different scene without losing the exposure settings you made on the substitute surface. With a manual camera, set the exposure controls by metering the substitute surface, then point the camera wherever you choose and shoot. Exposure controls won't change.

On automatic, meter the substitute surface and notice the shutter-speed indication. Then aim at the scene you intend to shoot and adjust the Exposure Compensation Dial until the shutter-speed is the same as for the substitute surface. Make the exposure. With the MG, use the same procedure, except change film speed directly.

HOW MANY EXPOSURE STEPS CAN A CAMERA MAKE?

That's an interesting question. The ME Super has shutter speeds from 1/2000 to 4 seconds. If you use the 50mm *f*-1.4 lens, it can close aperture down to *f*-22.

Suppose we set the lens to its smallest aperture and the shutter to its fastest speed. Then move the shutter to slower speeds until we use them all up. Then, at the slowest shutter speed, continue to increase exposure a step at a time by opening the lens until it is fully open. Count the steps. Each *space* between lines in the accompanying table is an exposure step.

I make it 21 steps, total. Most cameras don't have that many control settings.

The number of exposure steps has practical significance. You should recognize that each of the exposure settings in the preceding list is a definite amount of exposure—different by a factor of two from the one above or below.

EXPOSURE STEPS		
f-Number	Shutter Speed	EV Number
22	2000	20
22	1000	19
22	500	18
22	250	17
22	125	16
22	60	15
22	30	14
22	15	13
22	8	12
22	4	11
22	2	10
22	1 second	9
22	2 seconds	8
22	4 seconds	7
16	4 seconds	6
11	4 seconds	5
8	4 seconds	4
5.6	4 seconds	3
4	4 seconds	2
2.8	4 seconds	1
2	4 seconds	0
1.4	4 seconds	−1

With this range of shutter speeds and aperture settings, exposure can be varied over a range of 21 steps.

To simplify identification of these exposure settings, let's assign a number to each one as shown in the right-hand column. Those identification numbers are exposure-value (EV) numbers as discussed earlier. For some purposes they are more convenient to use because each exposure is represented only by a single EV number rather than the whole assortment of combinations of *f*-stop and shutter speed that will yield the same amount of exposure.

Pentax specifies the working range of the exposure-measuring system in EV numbers.

We encounter a minor complication here. As originally used in some camera lenses, the operator was expected to measure the light and compute an EV suitable for the film speed used. Therefore film speed is implied in the EV system.

Another complication when using EV numbers to specify the operating range of an exposure-measuring system is that the camera meter cannot measure light which can't get through the lens. If you have an *f*-4 lens installed on the camera, the most light the meter can see is what comes through at *f*-4. If you then change to an *f*-1.4 lens, the light meter can work at a lower EV number simply because the lens opens up more.

Therefore the EV range of Pentax exposure meters is specified for a certain film speed *and* a certain lens aperture. EV meter ranges are based on ASA 100 and *f*-1.4.

Let's keep separate the exposure steps you can make by different camera control settings and the EV range of the exposure-metering system because they are not necessarily the same. If the exposure meter can see 15 steps, but the camera can make 18, the exposure meter cannot work at all camera settings.

It is unusual but not impossible for film to *need* an exposure which the camera cannot provide. This will never happen due to decreased light because you can always set the camera on B and expose for two or three weeks if necessary.

It may happen when using fast film in bright light. The film may need *f*-64 at 1/4,000 but the camera can't do that. You will look for a way to reduce the amount of light coming in the lens. When you find the way, it will be in the form of a *neutral-density filter*—see Chapter 12.

MEASURING RANGE OF THE EXPOSURE METER

This gets complicated, but all you really need to grab is the general idea.

The basic limits in an exposure-measuring system are: When setting exposure or telling you how to do it, the system cannot use any settings that aren't possible. For example, *f*-64 and 1/4,000. Also,

CAMERA EV RANGE AND LIGHT SENSOR			
EV -6 to EV 20	**EV 3 to EV 18**	**EV 1 to EV 18**	**EV 1 to EV 19**
LX on auto (SPD)	K 1000 (CdS)	Program Plus	LX on manual (SPD) ME Super MX Super Program

THE SHORTEST SHUTTER-OPEN TIMES YOU CAN USE WITH ASSURED CAMERA EXPOSURE-METER ACCURACY

ASA FILM SPEED	UPPER METERING LIMIT OF CAMERA		
	EV 18	**EV 19**	**EV 20**
25	1/250 second	1/500 second	1/1000 second
50	1/500 second	1/1000 second	1/2000 second
100	1/1000 second	1/2000 second	1/2000 second
200	1/2000 second	1/2000 second	1/2000 second
400	1/2000 second	1/2000 second	1/2000 second

This table assumes use of a lens with minimum aperture of *f*-16 and stop-down metering. For lenses that can be set smaller, each step toward a smaller aperture allows use of one step longer shutter-open time. This table also assumes the fastest available shutter speed is 1/2000.

THE LONGEST SHUTTER OPEN TIMES YOU CAN USE WITH ASSURED CAMERA EXPOSURE-METER ACCURACY

ASA FILM SPEED	LOWER METERING LIMIT OF CAMERA			
	EV -6	**EV 1**	**EV 2**	**EV 3**
25	500 seconds	4 seconds	2 seconds	1 second
50	250 seconds	2 seconds	1 second	1/2 second
100	125 seconds	1 second	1/2 second	1/4 second
200	64 seconds	1/2 second	1/4 second	1/8 second
400	32 seconds	1/4 second	1/8 second	1/15 second

This table assumes use of a lens with maximum aperture of *f*-1.4. For lenses with smaller maximum aperture, each step toward a smaller aperture allows use of one step longer shutter-open time.

the light-measuring sensor cannot be expected to read light levels beyond its range. There is a limit in both directions. The light can be too dim for an accurate reading, or it can too bright.

The limits are easy to express in EV numbers as shown in the accompanying table.

A camera that measures accurately down to EV 1 can work two exposure steps further into darkness than one that measures accurately to EV3.

Because few people go around with an EV table in their heads or pockets, camera makers publish tables of possible *f*-number and shutter-speed combinations for different film speeds. Pentax calls these "Meter Coupling Range".

These tables are published in most camera instruction booklets. They appear in more than one form, but in every case they are based on a film speed of ASA 100. The table for the LX camera shows other film speeds also.

Double exposures are fun. This shot brought back the essence of our family vacation on a Colorado ranch.

Double exposure of sun, one with red filter, one without.

Tables in this book give the measuring range of various Pentax SLRs in EV numbers, and then translate the EV numbers into maximum and minimum permissible shutter speeds for a range of film speeds. There are some assumptions about lens settings, explained with each table.

These limits on camera-exposure settings only identify the range of settings in which exposure measuring is accurate. It is common to use cameras outside their metering-accuracy limits with manual exposure control. When you do, the camera gives whatever exposure you have the controls set for. However, you can't depend on the built-in meter for an accurate reading. Sometimes you can change shutter speed and get a valid reading. Or you can use a separate meter.

MULTIPLE EXPOSURES

If you make a double exposure and use normal exposure settings both times, the film will usually be overexposed—if the two subjects overlap. If they do not overlap, then each will receive normal exposure but the background may be overexposed. A dark background is best, because it won't "burn out."

In general, the rule for double exposures is to divide the normal exposure by two when exposing the same frame twice. Divide by three when making a triple exposure, and so forth.

It is convenient to do this with film speed. Simply multiply the ASA rating of the film by the number of exposures you plan to make. If you are using Kodachrome 25 and plan a double exposure, set the film speed dial to **50** and fire twice.

With an automatic camera, that's a handy way to make multiple exposures. With a manual camera, it's the best way to avoid becoming confused halfway through the operation.

THE THREE-FINGER METHOD

For cameras with a multiple-exposure control, the procedure is included in the camera description of Chapter 16.

For cameras without a control, this "three-finger" method will usually be satisfactory.
1. Before the first exposure, take any slack out of the film by turning the rewind knob until *slight* resistance is felt. Hold it that way for the rest of this procedure.
2. Depress the film-rewind button on the bottom of the camera and hold it down.
3. While holding everything that way, move the film-advance lever one full stroke.

This procedure allows you to wind up the camera without actually advancing the film. The film may move slightly between exposures but in many cases a small amount of film movement doesn't matter. If the film moves slightly, it may not harm the multiple exposure you intend to make, but it may spoil the following shot by overlapping it. Therefore, it's a good idea to shoot one blank frame after each multiple exposure, just for insurance.

This multiple-exposure technique "fools" the frame counter because it really counts strokes of the rapid-wind lever rather than actual film movement. If you make a triple exposure on frame 12, the counter will advance to **14** without the film advancing at all. Each following frame will be indicated by a frame-counter number that is too high. Frame 13 will show as **15** and so forth. When the counter indicates frame 36, you are actually on frame 34 and have two more exposures left on the roll.

WHEN TO WORRY ABOUT SCENE BRIGHTNESS RANGE

First, let me tell you when *not* to worry. All film manufactured for general use will record any scene under uniform illumination—unless the scene itself includes bright light sources. If the light everywhere in the scene is the same or nearly so—such as on an overcast day or in the shade—any film will get details in the brightest part of the scene and in the darkest part.

When the scene is uniformly illuminated, light reflected toward the camera is governed only by the reflectance of different surfaces in the scene. A very light object may reflect about 90% of the light; a very dark object may reflect 3% or 4% of the light; but this is a brightness range of only about 5 exposure steps. All films can handle that. Just put the middle tone of the scene on the middle density of the film and you will get a satisfactory picture.

The brightness-range problem occurs when part of the scene is in light and part in shade. If you go exploring outdoors with the light meter in your camera, you'll find lots of shaded areas where the amount of light is 3 or 4 steps less than direct sunlight.

If the light across a scene changes by 4 steps because part of it is in shadow, you can normally figure that the scene-brightness range is increased by that same number of exposure steps.

This will happen when the lowest-reflectance part of the scene is in shadow, because then it will reflect 4 steps less light than it would if the scene were uniformly illuminated by sunlight.

A scene with a reflectance range that uses 5 exposure steps, illuminated by light and shadow with a 4-step difference needs 9 exposure steps on film.

Normally, film can't do that. You may decide either to sacrifice picture detail in highlights or shadows because you can't get both.

If you want to preserve detail in the highlights, meter on a medium tone in the brightly lit part of the scene. If necessary, put a substitute-metering surface in that light. This gives a full range of tones in the brightly lit part of the scene and the lighter tones in shadow.

If you want to preserve detail in the shadows, meter on a medium tone in the shade. If necessary, put a substitute-metering surface in shadow. This gives a full range of tones in shadow and the darker tones that are in full light.

If you want to make a compromise between losing detail in highlight and shadows, average the highlight and shadow readings as described earlier.

With experience, you learn to judge scenes for brightness range, according to the film you are using. Sometimes you can get fooled. If you use your camera meter to measure the brightest part and the darkest part where you want to record surface texture or details, you won't be fooled. Count the number of step difference between these two exposure readings and that's the brightness range you must cope with.

 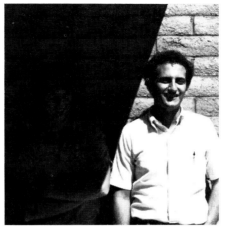

It's 2-1/2 steps darker in the shade at this location. In the left photo, I exposed for the shade using f-8. Ted looks OK, Tony is overexposed out there in the bright sunlight. In the center photo, I took exposure from the wall in sunlight and used f-19 which is halfway between f-16 and f-22. We get a dim view of Ted and a bad portrait of Tony because of shadows due to direct sunlight. Notice that details are preserved on white shirt in sunlight. At right, I averaged the two exposure settings, approximately. White shirt in sunlight is overexposed and lost detail. Facial shadows in sunlight are less and it's probably a better portrait. Shadow side doesn't have enough exposure.

The best solution is to move Tony into the shade with Ted. If I ever shoot this photo again, I will do exactly that.

Here's a rule of thumb about what films can do:

B&W film can record 7 exposure steps.

Color-slide film can record 6 steps.

Color-negative film can record 5 steps.

When using this rule, it's important to remember to measure only surfaces where detail is important to the picture. If a white shirt or a white painted wall is in the picture, surface details may not be necessary in these.

SUMMARY OF METERING TECHNIQUES

With full-frame metering, you have to decide if the scene is *average* or not. The usual problem is background, and you have to think your way to the needed correction.

Center-weighted metering is less sensitive around the edges where the background usually lives. It helps you compensate for unusually bright or dark backgrounds. You learn to use it by using it.

The camera metering system tends to make the average tone it sees into middle gray on the print. With color film, it will make the average *brightness* it sees into the middle *brightness* of print or slide, no matter what color it is.

If you meter on Caucasian skin, you should probably use one step more exposure—or maybe half a step.

When using substitute metering, the tone you show to the meter will record as a middle tone on the film. An 18% gray card is just right—or anything else with 18% reflectance. There are many common things you can use. If you meter on a surface with reflectance different than 18%, you should correct the reading.

You can always meter at a different aperture, film speed, or shutter speed, and then count steps to find your way back.

Film speed is an exposure control only if the camera ends up set for the exposure requested by that speed.

A good exposure usually results if you meter the brightest and darkest areas of interest in the frame and then set to the average of the two exposures that result. Average by counting steps.

With b&w or color-negative film, the exposure range the film can accept is often wider than the brightness range of the scene. If so, you can miss exposure a step or two without losing picture detail into white or black. Overall scene brightness will be wrong on the negative but can be corrected on the print, and usually is. When the exposure range of the film is greater than the brightness range of the scene, we say there is some *latitude*. Latitude is not a property of film. It results from a combination of film and scene.

Everybody says color-slide film must be properly exposed within a half step. The main reason for this is to get correct scene brightness when you project the slide. A moderately underexposed slide will appear too dark when projected. If you could increase the brightness of the projector lamp, the slide would look just fine. But you can't do that, so you must control exposure closely with color slides. Metering on a gray card in the same light does the job, as does any other thoughtful metering technique.

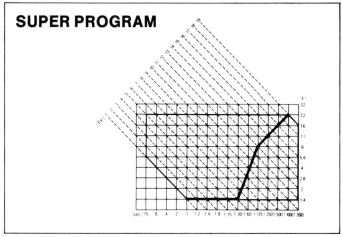

SUPER PROGRAM

As the scene becomes darker, the programmed automatic exposure system in the Super Program camera opens aperture and reduces shutter speed in equal steps until a shutter speed of 1/125 is reached. Then, the program favors high shutter speed by "yielding" aperture steps faster than shutter-speed steps. This graph is for ASA/ISO 100 and a lens with maximum aperture of f-1.4.

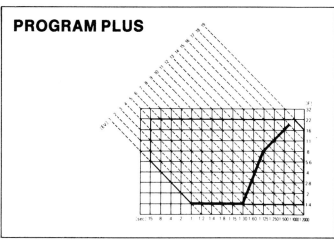

PROGRAM PLUS

The programmed automatic exposure graph for the Program Plus camera is similar to that of the Super Program, except at top right. The upper limit of metering accuracy for the Program Plus is one EV lower, therefore the graph does not reach f-22 or 1/1000 second.

PROGRAMMED AUTOMATIC EXPOSURE

With the program cameras, Program Plus and Super Program, Pentax introduced *programmed* automatic exposure control. The camera sets *both* shutter speed and aperture. This is called *programmed automatic* because the camera uses a built-in program to calculate shutter speed and aperture settings for the measured scene brightness and the film speed being used.

Use of programmed exposure is optional because the cameras offer other modes, such as aperture-priority and manual exposure control.

An advantage of programmed exposure is that camera operation is simplified—all you do is point, focus and shoot. This makes the camera easier to use for people who are intimidated by camera controls. It also makes it easier for anybody to grab a shot quickly, when there is no time to set camera controls.

The disadvantage is loss of "creative" control. You can't choose shutter speed to freeze motion or to deliberately blur the image. You can't select aperture to control depth of field. You must use whatever settings the camera program chooses.

Because the main advantage is to shoot quickly, Pentax assumes that the camera will be hand held and that the user doesn't want blurred photos. Therefore, the exposure programs use the fastest practical shutter speed for each scene brightness.

The accompanying drawing of the automatic exposure program for the Super Program camera assumes that the 50mm f-1.4 lens is used and the film speed is ASA/ISO 100. The top-right corner of the graph represents maximum scene brightness.

The graph begins at f-22 and a shutter speed of 1/1000 second. If the light becomes less bright, the graph shows a gradual change in aperture from f-22 to f-16 accompanied by a simultaneous gradual change in shutter speed from 1/1000 to 1/500.

In this region of the graph, a change of one step in aperture is accompanied by a change of one step in shutter speed. The program assigns equal importance to maintaining depth of field by using small aperture and minimizing blur by using fast shutter speed.

The angle of the graph changes when aperture has closed down to f-8, and shutter speed is 1/125. At shutter speeds slower than 1/125, image blur is likely when you are handholding the camera. Therefore, the program favors higher shutter speeds by "giving up" aperture more rapidly. As shutter speed changes two steps, from 1/125 to 1/30, aperture changes from f-8 to f-1.4, which is five steps.

At the bottom of the graph, with the aperture fully open, slower shutter speeds are used when there is less light on the scene—until the slowest shutter speed is reached. If the lens in use has an aperture range that is not f-1.4 to f-22, the program will use the actual maximum and minimum aperture values, whatever they are.

The programmed exposure settings are based on the assumption that the scene is average. If the subject is against an unusually light or dark background, exposure compensation may be necessary for correct exposure of the subject.

Even though the fastest shutter speed of the Super Program

camera is 1/2000 second, the graph stops at 1/1000 second. That's because the upper limit of metering accuracy—the meter-coupling limit—is reached at that point with ASA/ISO 100 film. With faster film, the higher shutter speed would be used. With slower film, the fastest shutter speed used by the program would be slower than 1/1000.

The accompanying graph for the Program Plus camera is similar. The only difference is the upper limit of the graph, which is determined by the metering range of the camera. The Super Program has a metering range of EV 1 to EV 19. The range of the Program Plus is EV 1 to EV 18.

A good standby setting for a camera is the programmed automatic mode, if available. Focus the lens at its hyperfocal distance and you have the best possible chance of getting a quick shot when there is a sudden and brief photographic opportunity. Just point and shoot.

HOW APERTURE SIZE IS CONTROLLED

Only the program cameras can set aperture, and only with an SMC Pentax-A lens. These cameras have six electrical contacts on the lens mount that mate with contacts on the back of the lens.

Setting the aperture ring to A causes a contact on the lens to move outward so it touches one of the six contacts on the camera. This "tells" the camera to control aperture size. On the camera, the contact used for this purpose has a flat tip. The other five have rounded tips. Two are above the flat contact and three are below.

The group of three contacts receives the maximum-aperture f-number of the lens. Each contact will touch either the metal ring on the back of the lens or an insulated round spot that is set into the metal ring. Thus, each contact is either "shorted" by touching metal or "open" because it touches an insulated spot.

Pentax program cameras use the KA lens mount, which is a standard K mount with six electrical contacts added. The electrical contacts on the camera receive the following information from an SMC Pentax-A lens: the lens maximum and minimum aperture sizes and whether or not the lens is set for program control of aperture.

With three contacts, each of which can be shorted or open, there are eight possible combinations ranging from all three shorted to all open. Each combination is a code for an aperture size, such as f-1.2, f-1.4, and so forth.

The remaining two contacts are used in a similar way to receive the minimum aperture value for the lens in use. Two contacts have four possible combinations of short and open.

Through the electrical contacts, the program camera "knows" the maximum and minimum aperture and that the lens is set to A. The camera measures light from the scene and calculates the aperture to be used.

To understand how the camera controls aperture, you should first review ordinary operation of the lens, such as in the aperture-priority automatic or the manual mode. When the lens is used in those shooting modes, the Aperture Ring is set manually to an f-number—not to A.

A lever in the camera body rests on top of the Automatic-Aperture Lever on the lens. While metering, the camera lever is locked so it holds down the Automatic-Aperture Lever. That keeps aperture wide open for full-aperture metering.

When the shutter button is pressed, the camera lever is released. That allows the Automatic-Aperture Lever on the lens to move upward, driven by a spring in the lens, to close the aperture gradually. The f-number setting of the Aperture Ring on the lens is a mechanical limit. The aperture closes to the set value and can close no farther. The exposure is made.

In the program mode, the lens is set at A. To do that, the Aperture Ring is turned beyond the smallest aperture. There is no mechanical limit and all apertures are available.

When the shutter button is pressed, exposure begins the same way. The lever in the camera is released and travels upward, riding on top of the Automatic-Aperture Lever in the lens. Aperture starts closing. A mechanism in the camera body monitors the position of the levers as they move upward and thereby monitors aperture size.

When the lever position corresponds with the desired aperture value, the lever in the camera is clamped so that the Aperture Lever on the lens can't move upward any farther. The aperture is set to the size selected by the camera. The exposure is made at that aperture.

This method of aperture control is used in the program mode and also in the shutter-priority automatic mode of cameras equipped with that mode.

11
CLOSE-UP AND MACRO PHOTOGRAPHY

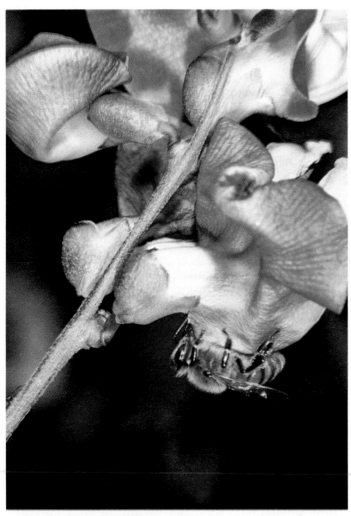

Photographed with 200mm camera lens and a 3 diopter accessory close-up lens, using flash. This is a good combination for stalking insects because you can take the picture with the front of the lens about 8 to 12 inches away. Flash stops motion. Magnification on the slide is about 0.7.

Two different types of accessory items are used in close-up and macro photography. They will be discussed separately with the simple theory of how each of these devices work. After that, application is easy.

MAGNIFICATION OF A STANDARD LENS

A 50mm lens used by itself on the camera has greatest magnification when focused on the closest possible subject. Closest focus with the standard lens is a little less than 0.45 meters—the closest marked distance on the focusing ring. This distance is measured from the film-plane inside the camera body.

To focus at the closest distance, rotating the focus control moves the 50mm lens away from the film by about 7.5mm, so the distance from lens node to film becomes about 57.5mm.

Under these conditions, magnification is approximately 0.15—the image on the negative is about 15% as tall as the subject.

CLOSE-UP PHOTOGRAPHY

Close-up photography begins at about the same place standard lenses leave off. Close-up photography starts at a magnification of about 0.1 and extends up to a magnification of 1.0 or life-size. Macro takes over from there and gives larger-than-life images on the negative. **Close-Up Lenses**—Clear-glass accessory lenses used to increase magnification look like filters and attach the same way. They are called *supplementary* lenses, *close-up* lenses

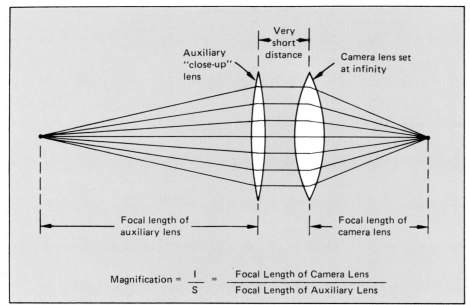

Figure 11-1/With a close-up lens attached to a camera lens set at infinity, magnification is easy to calculate.

Magnification $= \dfrac{I}{S} = \dfrac{\text{Focal Length of Camera Lens}}{\text{Focal Length of Auxiliary Lens}}$

Pentax close-up lenses screw into the camera lens the same way filters do. Close-up lenses are clear and normally do not affect the exposure setting of the camera.

and sometimes *portrait attachments.* Pentax refers to them as close-up lenses.

They work by playing a little optical trick on the camera lens, Figure 11-1. You remember that a converging lens which receives parallel rays of light will bring them to focus at a point behind the lens equal to its focal length.

A lens will also work backwards. A source of light *at the focal point* of the lens will send out diverging rays. Those intercepted by the lens pass through and emerge as parallel rays—just the reverse of the case described above.

To use a close-up lens, it is screwed into the filter-mounting threads on the front of the camera lens—sometimes called the *prime lens.* This results in a very short distance between close-up and prime lens as indicated in Figure 11-1.

The subject is placed at the focal point of the close-up lens. If the close-up lens has a focal length of 500mm, the subject is placed 500mm in front of the lens. Light rays from every point of the subject enter the close-up lens and emerge on the back side as parallel rays. The parallel rays immediately enter the front of the prime camera lens.

The simplest example is when the camera lens is focused at infinity. It is "expecting" parallel rays from a distant subject but it actually receives parallel rays from a nearby subject due to the action of the close-up lens. The prime lens doesn't care—when it receives parallel rays, it brings them to focus behind the lens at a distance equal to its focal length. If the camera

lens has a focal length of 50mm, it will bring parallel rays to focus at a distance of 50mm behind the lens—actually behind the optical point called the lens *node.*

In this situation, when the camera lens is focused at infinity, magnification is very easy to figure.

$$M = \frac{\text{Image distance}}{\text{Subject distance}}$$

Image distance is the focal length of the camera lens; subject distance is the focal length of the close-up lens. I'll show an example of this calculation in a minute.

You need to know both focal lengths. It's engraved on the camera lens but typically concealed in the nomenclature of close-up lenses.

Because close-up lenses attach by screwing into the filter threads, they are virtually universal in application. All you have to do is buy close-up lenses with the correct thread diameter to fit your lens. If your lens uses filters with a 52mm thread diameter, get close-up lenses with the same diameter. Several accessory manufacturers offer sets of close-up lenses in various thread diameters. These are available at most camera shops, in commonly used sizes.

Accessory close-up lenses often come in sets of three, identified as 1, 2 and 3. Some makers offer a 10 lens also. The focal length of the lens is disguised in its identification number.

These numbers are properly called *diopters,* a measure of lens *power.* Eyeglass prescriptions are written in diopters. The diopter rating of a lens is the reciprocal of its focal length—1 divided by focal length—when focal length is *expressed in meters* rather than millimeters or any other unit. To find the diopter rating of a 500mm lens, notice that 500mm is 0.5 meter.

$$\frac{1}{0.5 \text{ meters}} = 2 \text{ diopters}$$

That's a 2 close-up lens.

An easier way to do it is divide

Figure 11-2
MAGNIFICATION WITH ACCESSORY CLOSE-UP LENSES

Camera Lens	Close-Up Lens	Maximum Subject Distance		Minimum Subject Distance		Magnification	
		MM	IN	MM	IN	MIN	MAX
50mm	1	1000	40	333	13	0.05	0.17
	2	500	20	250	10	0.10	0.22
	3	333	13	200	7.9	0.15	0.28
	3+1	250	10	167	6.2	0.20	0.33
	3+2	200	7.9	143	5.6	0.25	0.39
	3+2+1	167	6.2	125	4.9	0.30	0.45
	10	100	3.9	83	3.3	0.5	0.67

Figure 11-2/Approximate range of magnifications with commonly available accessory close-up lenses used with a 50mm camera lens. For each case, maximum magnification occurs at minimum subject distance.

table shows a magnification range of 0.20 to 0.33 if you stack a 3 with a 1 lens—a total of 4 diopters. With this combination, you will get the desired magnification with the camera lens focused near its closest distance. If you have the camera on a copy stand or tripod, you can set it so the front of the lens is about 6 inches from the subject and then find best focus by looking.

This table is for a 50mm lens. If you use a 100mm lens, all magnifications in the minimum magnification column will double. Maximum values will not double, for a complicated reason.

1,000 by the lens focal length *in millimeters:*

$$\frac{1,000}{500mm} = 2 \text{ diopters}$$

To figure magnification with an accessory close-up lens rated in diopters, you need to work that problem backwards. You know the diopter rating, it's engraved on the close-up lens—you need to know focal length.

$$\frac{1,000}{2 \text{ diopters}} = 500mm$$

If you are using a 2 close-up lens with a 50mm camera lens set at infinity, now you can figure magnification.

$$M = \frac{\text{Image distance}}{\text{Subject distance}}$$
$$= \frac{\text{Focal length of close-up lens}}{\text{Focal length of camera lens}}$$
$$= \frac{50mm}{500mm}$$
$$= 0.1$$

In this example, the image in the camera will be 0.1 (one-tenth) as tall as the subject. That is true *only* when the camera lens is focused at infinity. Focus closer and two things happen.

Image distance gets longer because the focusing mount moves the lens farther from the film. Subject distance gets shorter.

Therefore when you focus the camera lens closer than infinity with a close-up lens attached, mag-

nification increases. Greatest magnification occurs with the camera lens focused at its shortest distance, but it isn't simple to calculate because both image distance and subject distance have changed and you don't know what they are.

Figure 11-2 does the arithmetic for you if you are using accessory close-up lenses rated in diopters. Based on a camera lens with focal length of 50mm, it gives minimum and maximum distances at which the subject can be focused, and it gives the range of magnifications obtainable over the focusing range of the lens. The numbers are approximate but close enough to get you set up. Then look through the viewfinder to make final adjustments. This table covers all possible combinations of the standard set of three accessory lenses, and also a 10 lens.

Here's how to use the table. First, figure the amount of magnification you need. You can compare the height of a 35mm frame with the height of your subject, or compare widths. The height is 24mm, a little less than one inch. For most purposes assume it is an inch.

If the subject is 3 inches tall and you want it to fill the frame vertically, you want a magnification of approximately 1/3, or 0.33. The

PENTAX CLOSE-UP LENSES

With the introduction of the K-series cameras, Pentax introduced companion accessories also identified with the letter "K." There are K-series close-up lenses but this can mislead you if you think they are only for the K-type cameras. They attach by screwing into the filter threads and will fit any lens with the matching thread diameter.

As you can see in the accompanying table, close-up lenses are available with thread diameters of 49mm, 52mm and 58mm. The lens table in Chapter 15 shows the thread diameter for each lens in the column headed "Filter Size." You can intermix close-up lenses and camera lenses by using a simple adapter.

There are adapters to go either way. These are simple metal rings with internal threads of one size and external threads of another diameter. They fit between a close-up lens or filter of one diameter and a lens of a different diameter, providing the correct thread size for each.

Identification of these adapters is by two numbers, written in several different ways such as: 49mm→52mm, 49mm–52mm, and 49/52. However written, the first number is always the thread diameter of the camera lens; the second

number is the diameter of the accessory to be mounted. With a 49mm–52mm adapter you can attach a 52mm thread-diameter close-up lens to a camera lens which accepts 49mm threaded accessories.

Pentax calls these *adapters* but the more common name is *step-up ring* or *step-down ring.* This is determined from the point-of-view of the lens. A 49–52 is a step-up because if fits between the smaller 49mm lens and a larger 52mm accessory. Pentax also offers a 52mm/49mm step-down ring or *adapter* which mounts 49mm thread-diameter accessories on K-type lenses. With wide-angle lenses, a smaller-than-normal lens accessory may vignette the image.

Please notice the designation SMC in the accompanying list of available Pentax close-up lenses. Super-Multi-Coating reduces reflections and flare; improves image quality in the same way as SMC lenses do.

Focal Lengths—Pentax spares you the arithmetic of converting diopters into focal lengths by labeling close-up lenses with letter-number combinations such as S40 and T95. I'll tell you what the letters mean in a little bit. The numbers are focal length, but they are in *centimeters. You need the information in millimeters,* but conversion is easy. Just multiply centimeters by 10. The S25 lens has a focal length of 250mm; T95 has a focal length of 950mm.

Magnification with Pentax Close-Up Lenses—Camera manufacturers are perfectionists about image quality. It is common for the camera maker to advise users that a certain lens combination or accessory is unsuitable or not recommended when the only penalty for its use is some reduction of

Close-up Lenses and filters with 52mm thread diameter can be used on lenses with 49mm thread diameter by using a 49→52 adapter.

		MAGNIFICATION OF PENTAX SMC CLOSE-UP LENSES		
Close-Up Lens	Available Thread Diameters (mm)	Recommended Camera Lenses	Minimum Magnification (Approx.)	Maximum Magnification (Approx.)
S25	49, 52	40mm f-2.8	0.16	0.24
		50mm f-1.4	0.20	0.36
		50mm f-1.7	0.20	0.36
		50mm f-2	0.20	0.36
		55mm f-1.8	0.22	0.42
S40	49, 52	40mm f-2.8	0.10	0.18
		50mm f-1.4	0.13	0.27
		50mm f-1.7	0.13	0.27
		50mm f-2	0.13	0.27
		55mm f-1.8	0.14	0.32
T80	49, 52	85mm f-1.8	0.11	0.24
		100mm f-2.8	0.13	0.25
		120mm f-2.8	0.15	0.29
		135mm f-3.5	0.17	0.30
		150mm f-3.5	0.19	0.32
		150mm f-4	0.19	0.32
T95	52, 58	135mm f-2.5	0.14	0.27
		150mm f-4	0.16	0.26
		200mm f-4	0.21	0.38
T160	49, 52	100mm f-2.8	0.06	0.18
		120mm f-2.8	0.08	0.21
		135mm f-3.5	0.08	0.20
		150mm f-3.5	0.09	0.21
		150mm f-4	0.09	0.21
T183	52, 58	135mm f-2.5	0.07	0.20
		150mm f-4	0.08	0.18
		200mm f-4	0.11	0.26

image quality. Because most close-up lenses are single pieces of glass, they cannot be corrected for imperfections such as chromatic or spherical aberration. When used with a camera lens, they introduce aberrations into the picture and the defects get worse as magnification is increased.

Therefore a magnification of around 0.5 is often suggested as the upper limit for good image quality with close-up lenses. In fact, the upper limit is an individual decision of the user. You can get higher magnifications using close-up lenses if you are willing to sacrifice image quality. Nobody says the picture will be sharp and clear, but it may be good enough for a particular purpose.

To protect the unwary user against noticeable image degradation, Pentax labels close-up lenses with the letters S or T, which mean *standard* or *telephoto*. The S lenses have relatively short focal lengths—250mm or 400mm—and are intended primarily for use with standard camera lenses with 40 or 50mm focal length. When used this way, resulting image magnification is held below 0.5 as you can see in the accompanying table. Similarly, the T close-up lenses are primarily intended for use with long focal lengths and when used as recommended they also hold magnification to less than 0.5.

In summary, if you use Pentax close-up lenses according to Pentax recommendations, you will get moderate increases in magnification —in the range of 0.1 to 0.5—with good quality images. If you buy accessory diopter-rated close-up lenses in the correct thread diameters, you can get higher magnification if desired but with reduced picture quality.

Incidentally, some books about photography say close-up lenses don't change exposure, which is not always true. When you use them with the camera lens set at infinity, it's true. When you use them with the camera set closer than infinity, the amount of light reaching the film is reduced. It is seldom reduced enough to do anything about, and if you are using through-the-lens metering you will compensate for it anyway.

If you're curious about it, stack as many diopters as you own on your lens, change focus from infinity to the near limit, and watch the exposure reading change.

Stacking Close-up Lenses—These lenses, and filters, normally repeat the thread pattern on the front of the lens so one can be screwed into another. For optical reasons, when close-up lenses are screwed together or stacked, the highest diopter rating should be nearest the camera lens. If you are using focal lengths instead of diopters, put the shortest focal length close-up lens nearest the camera lens.

The main advantage of describing these lenses by using diopters is ease of calculating the result of stacking two or more. The diopter numbers simply add together. If you use a 3 in combination with a 2, the combination has a diopter rating of 5.

To figure magnification, convert 5 diopters to focal length:

$$\frac{1,000}{5 \text{ diopters}} = 200\text{mm}$$

To find the focal length of two Pentax close-up lenses stacked, convert each focal length into a diopter rating, add the diopters, convert back to focal length.

Here's an example. Suppose you stack the S25 and S40. Convert each to diopters:

$$\frac{1,000}{250\text{mm}} = 4 \text{ diopters}$$

$$\frac{1,000}{400\text{mm}} = 2.5 \text{ diopters}$$

Add the diopter ratings:

4 diopters + 2.5 diopters = 6.5 diopters

Convert the result back to focal length:

$$\frac{1,000}{6.5 \text{ diopters}} = 154\text{mm}$$

That combination on a 150mm camera lens will give a magnification of approximately 1.0 or life-size if you can tolerate the image quality.

To stack close-up lenses for higher magnification, place the close-up lens with the highest diopter rating nearest the camera lens. When using Pentax SMC Close-up Lenses labeled with their focal lengths, place the shortest focal length nearest the camera lens. In this example, the S40 is nearer the camera lens than the T80.

INTERCHANGEABILITY

There are several types of interchangeable accessories—those that fit lenses or the lens mount, those that mount on the viewfinder eyepiece, interchangeable viewfinders and focusing screens, and accessories that attach to the bottom of the camera body.

All Pentax bayonet-mount lenses and lens accessories can be used with all Pentax bayonet-mount 35mm SLR cameras.

The viewfinder eyepiece is the same on LX, M-type and program cameras. K-series cameras have a slightly larger eyepiece. For eyepiece accessories, use K-type for K cameras, M-type for other models.

Motor drives and film winders fit on the bottom of the camera body. Interchangeability is discussed in Chapter 16.

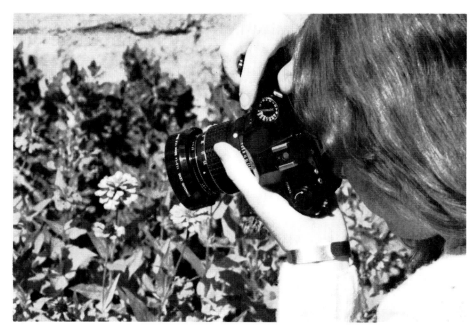

Close-up lenses are handy for nature photography without extreme magnification—such as flowers, insects, rock specimens and similar natural objects. When used this way, they don't reduce light entering the camera enough to matter and you can see well through the viewfinder. Close-up lenses don't take much room in your gadget bag and they go on and off quickly. Find focus by moving the entire camera because changing the focus control on the lens has a large effect on magnification. Use a hood to keep stray light off the surface of the lens.

CHOOSING THE CLOSE-UP LENS

With any close-up lens, magnification changes when you rotate the focus control of the camera lens. When camera lens is set at infinity, magnification is easy to figure because it's simply the ratio of the two focal lengths—camera lens focal length divided by close-up lens focal length. Magnification with the camera lens set at infinity is the *smallest* you can get with that combination because as you change focus to shorter distances magnification increases.

To choose a lens combination, first estimate the amount of magnification you need. Compare the height of your subject—in inches—to the height of the film frame—one inch, approximately. Suppose your subject is 2 inches tall and you decide it should fill 3/4 of the narrow dimension of the frame—3/4". Magnification is 3/4 or 0.75 divided by 2, which is 0.375.

Then find some combination of available camera lens and close-up lens which gives that magnification or a little less, assuming camera lens is set at infinity. You may find it in the table in this chapter or figure it by making trial choices among lenses you own.

A quick way to get an estimate is to divide camera lens focal length by the desired magnification. That will tell you the focal length needed for the close-up lens. Suppose you have a 150mm lens.

$$\frac{150mm}{.375} = 400mm$$

Of course this is the S40 close-up lens. Magnification will start at about 0.375 and increase as you focus the lens closer. It isn't always that easy, but by trying several combinations you can usually figure what you need.

The other way is simple trial and error but it may be easier for

people who aren't math fans. Remember for the close-up lens, higher diopter ratings or shorter focal lengths give more magnification. For the camera lens, longer focal lengths give more magnification. Assemble some combination of camera lens and close-up lens on your camera. Look through it and judge the result. If you need more or less magnification, make appropriate changes according to the rules above. Don't forget to try all positions of the focus control with each combination.

USING CLOSE-UP LENSES

As with any other high-magnification photography, the camera should be on a tripod or solid mount. If you are a solid mount, you can try hand-holding. Use a lens hood to exclude stray light from the surface of the lens.

Close-up lenses are normally screw-in type with the thread pattern repeated on the other side of each lens to allow stacking. *Put the highest diopter lens nearest the camera* or the shortest focal length, whichever way you prefer to identify the lenses.

If the camera permits, lock the mirror up to reduce vibration. These lenses do not interfere with camera automation, so you can meter and set exposure as you normally do.

Depth of field is usually a major problem in close-up and macro photography because it is seldom enough. About the only thing you can do is close down the lens. In the high-magnification domain, closing aperture is not as effective as in normal photography, but it will help some.

You may end up looking for more light and shooting at long exposure times so you can use a small aperture.

Don't use two or three close-up lenses stacked if you can avoid it because every surface reflects light. I think it's better to use only one close-up lens with longer camera lenses to get more magnification.

Changing focus with any lens

changes magnification, but when subject distance and image distance are about the same, focusing the lens causes large magnification changes. When you are trying to control image size in the frame and also find focus, it can be frustrating. A technique you will quickly discover is to set the focus control for magnification, then move the entire camera back and forth to find focus.

A good way to get acquainted with a new set of close-up lenses is to try different combinations while focusing on a yardstick.

MACRO PHOTOGRAPHY

The word *macro* is often used rather loosely in photographic literature and products. The most strict definition is magnifications greater than 1.0. Because the same hardware can be used for magnifications greater and less than 1.0, a more practical definition is: Macro begins where close-up leaves off. If you stop using close-up lenses at a magnification of 0.5 and switch to a different method of getting magnification, you may

There are several ways to get nature photos with medium magnification similar to this: Close-up lenses, a macro lens, or an extension tube between camera lens and camera body.

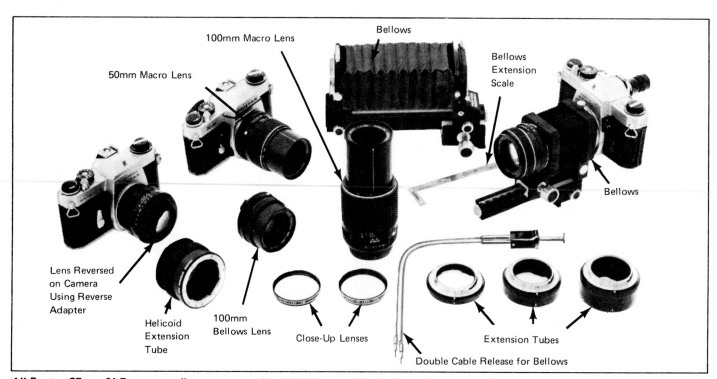

All Pentax 35mm SLR cameras allow you to work with high magnification in various ways. All bayonet-mount accessories are interchangeable, whether labeled K, B (for bayonet), or M. These fit all bayonet-mount cameras. A separate series of accessories is available for the earlier screw-mount cameras.

as well think of it as switching to macro because you will be using hardware capable of magnifications greater than 1.0. This section is about methods recommended for magnifications greater than 0.5—even though they work OK at lower values also.

As you know, rotating the focusing ring on a lens moves the glass elements of the lens farther from the film, to focus on closer subjects. The lens elements travel along an internal thread in the lens barrel, called a *helicoid*. As the lens is extended along the helicoid, magnification increases. The limit is the end of the helicoid because you can't move the lens any farther by twisting the focus control. This is the *near* limit of focus and the *maximum* magnification of any lens without using additional devices to increase magnification still more.

Pentax offers several ways to move the lens still farther from the film to get more magnification. They are all attachments which fit between lens and camera body to increase lens-to-film distance or *extension*. When using these, you face exactly the same proposition as when using close-up lenses. You can have more magnification than the standard lens and camera combinations will give, but the price is reduced image quality.

Because there are two lens-mounting methods among Pentax models, there are two sets of extenders and related items: S for screw-mount cameras and K for bayonet-mount cameras. In function, they are identical. Therefore this discussion will treat lens-extension devices without regard to the end fittings.

Magnification by Lens Extension— When you increase image distance by moving the lens farther from the film, two things happen. Magnification increases and subject distance automatically decreases. This means the point of focus is moved closer to the lens by increasing extension and there's nothing you can do about it.

Extension tubes come in sets, numbered 1, 2 and 3. One end of each tube can mount on the camera, and the other end accepts a lens. You can use a single tube between lens and camera, or the tubes can be stacked. In this photo, tubes 1 and 2 are stacked, at right. The pushbuttons (arrows) act the same as the Lens-Release Lever on a camera body. This is Extension Tube Set K which does not preserve any automatic features of the lens.

One handy way to increase lens extension is the use of spacers called *extension rings* or *extension tubes*. It can also be done by a bellows between lens and body, which has the advantage of continuous lens positioning at any distance between the maximum and minimum extension or *draw* of the bellows.

Magnification obtained by increasing the distance between lens and camera is calculated approximately by the formula:

$$M = X/F$$

where M is magnification, X is the *added* distance or extension of the lens, and F is the focal length of the lens being used. When X and F are equal, magnification is 1.0, as would be the case with a 50mm lens and 50mm of added extension *with the lens set at infinity.*

From the amount of magnification calculated as above, magnification can be increased by focusing the lens to shorter distances because that decreases subject distance and simultaneously adds image distance.

You can rearrange the same formula to figure the amount of lens extension needed for a desired amount of magnification:

$$X = F \times M$$

where the symbols mean the same as before. Suppose you are using a 50mm lens and need a magnification of 0.8:

$$50mm \times 0.8 = 40mm$$

Using bellows or extension tubes, move the lens that far from its normal position and the magnification will be approximately 0.8 with the lens set at infinity.

How Far is the Lens Actually Extended?—Magnification of any lens is determined simply by the ratio of image distance and subject distance. The lens doesn't care how it is positioned in front of the film to get a certain image distance, but the ways can be confusing to a photographer. So, let's spend a minute on the topic.

All lenses that focus by an internal helicoid or similar mechanical arrangement are moved in relation to the film by the focusing action. Typically the amount of movement possible is small—7.5mm for a 50mm lens is an example. Over this range of movement—actually lens extension—focus changes from infinity to the closest possible distance and magnification

increases as the lens is "racked out" to focus on closer subjects.

If an extension device is placed between lens and camera to get still higher magnification, it's plain that the lens is extended by the thickness of the extender. If you insert a 19mm spacer between lens and camera, the lens obviously is 19mm farther away from the film.

Image distance is the total distance between film and lens, no matter how accomplished. It has three parts:

If the lens is focused at infinity and mounted on the camera, it is effectively spaced away from the film plane by the lens focal length. In other words, a 50mm lens is mounted 50mm from the film.

The focusing helicoid in the lens can move the glass lens elements farther from the film by an amount equal to the length of the helicoid. This varies among lenses, but let's assume it's 7.5mm.

With this lens on a camera, the total distance from lens to film can range from 50mm to 57.5mm, depending on where you set the focus control. When focused on the closest subject possible, the image distance is 57.5mm.

If a separate lens extender is inserted between lens and film, its thickness adds to the distance already there. Using 19mm for the extension device, image distance now ranges from:

$$50mm + 19mm = 69mm$$

up to

$$50mm + 19mm + 7.5mm = 76.5mm$$

At an image distance of 69mm, the lens is focused at infinity and is not moved outward at all by its internal helicoid.

At an image distance of 76.5mm, all of the helicoid is used to focus the lens as closely as possible. Magnification will be larger with the larger image distance.

When figuring magnification using the formulas given earlier, the extension (X) is the amount the lens is moved forward by the extension tube plus the amount it is moved forward by focusing closer

than infinity.

Effect of Lens Nodes—In discussing close-up lenses and extension, I've been saying that the simple formulas used here will give *approximate* magnification. The reason is those locations in the optical system that lens designers call *nodes.* As mentioned earlier the lens-to-film distance is really the distance from the *rear* lens node to the film. Because it's an optical location, rather than a physical point on the lens, we can't find it to measure from. Nevertheless, with the lens focused at infinity, you can be sure the image distance is equal to its focal length.

Subject distance and magnification is less certain because lenses have two optical nodes—one front and one rear. Subject distance is from the *front* node to the subject. In the more complicated lens designs, such as telephoto and reversed telephoto, some wide-angles and zooms, the lens designer puts the nodes where he needs them. The rear node may be in the air in front of the lens, and also in front of the front node. Lens designers take this calmly, but ordinary people prefer not to think about it even. Which is exactly what I recommend you do.

Because node location varies among lens types and nodes typically are separated from each other by an amount that you and I can't discover, calculation of magnification is inexact. The formulas given here will usually be close enough but if you find a case where they aren't, just blame it on the nodes and find the magnification you need by experiment.

PENTAX EXTENSION TUBES

Extension tubes are the simplest, handiest and least expensive way to put distance between lens and camera. They also weigh the least and take up the smallest amount of space.

Extension tubes labeled K are bayonet mount and fit bayonet-mount cameras. In some literature you may see them identified with

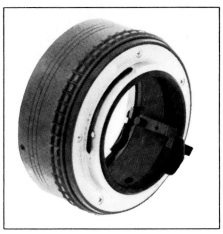

Tubes from Auto Extension Tube Set K have built-in levers so a lens works the same on the extension tube as it would if mounted directly on the camera.

the symbol B, meaning *bayonet,* to make it clear that this equipment fits any 35mm Pentax camera with a bayonet mount. This book uses the symbol K, to agree with the instruction booklets and labels on the boxes.

Auto Extension Tube Set K fits bayonet-mount cameras and preserves all automatic features. You meter with the lens wide open and the diaphragm is automatically closed by the camera—just as though the extension tube was not between lens and camera. These extension tubes come in sets of three, identified by numbers, with lengths as follows:

AUTO EXTENSION
TUBE K

1	12mm
2	19mm
3	26mm

These can be used singly or stacked in any combination as needed for longer extensions.

Notice that the extensions add up to 57mm which is enough to get a magnification of 1.0 or a little more with either of the standard-focal-length lenses, 50mm or 55mm.

Extension Tube Set K fits bayonet-mount cameras but doesn't preserve any automatic features at all. They are just plain tubes so you meter stopped down and control lens aperture manually.

They have the same lengths as the screw-mount set.

EXTENSION TUBE K (NON-AUTOMATIC)

1	9.5mm
2	19mm
3	28.5mm

Notice that the two sets of extension tubes which fit K-series cameras are slightly different in dimensions of tubes 1 and 3 although the total is the same when all three tubes are stacked.

Insertion of a non-automatic extension tube automatically sets up lens and camera for manual aperture control and stop-down metering. Lens aperture closes immediately as you adjust the diaphragm ring because you are manually controlling aperture. This is not a major inconvenience, but should be considered if you plan to do a lot of photography with extension tubes.

There are some applications for which you may want a lot of extension without the bother of stacking extension tubes. Auto Extension Tube K 50mm and Auto Extension Tube K 100mm solve this problem. As the nomenclature suggests, one is 50mm long and the other is 100mm long. Both are automatic and preserve all au-

tomatic features of lens and camera. For mechanical reasons, Pentax does not recommend stacking them to get 150mm unless the lens is reversed.

These tubes have special application with the 50mm and 100mm macro lenses, discussed later in this chapter. They can also be used to get higher magnifications with long-focal-length lenses which require lots of extension. For example, the 100mm extension tube used with the 200mm telephoto lens gives a minimum magnification of 0.5 and goes up to 0.63 with the lens focused as close as possible.

Gaps in the System—Any of the extension tube sets described so far will give magnifications over a wide range. With a 50mm lens, you get 0.19 with non-auto extension tube 1 with the lens focused on infinity. If you stack all three extension tubes to get a total extension of 57mm and also focus the lens to 0.45 meter, which is nearly as close as it will focus, the magnification becomes 1.28.

However you can't get every possible magnification between 0.19 and 1.28 because the tubes are fixed lengths and the lens helicoid has a limited range of travel. In fact, there is even a gap in mag-

Helicoid Extension Tube K installs the same as other extension tubes but provides variable extension so you can get exactly the amount of magnification you need.

nification between the most you can get with the standard lens and the least you can get with extension tubes.

Adjustable Extension Tube—An extension tube with an internal helicoid which allows changing length of the tube helps solve the gap problem.

Helicoid Extension Tube K has bayonet fittings at each end so it can fit between lens and camera body. The length of this tube can be changed by rotating a ring on the body of the tube. Minimum fits on the bottom of the rail and

NOTE: In the table on the following pages, maximum magnification is with the lens set approximately to its closest focusing distance. Total distance is between the film plane in the camera and the point of best focus on the object. Exposure Factor is for use *only* when you determine exposure by a separate meter. If so, multiply separately metered exposure by the indicated factor. If you use the camera's built-in meter, do not use the Exposure Factor.

All combinations shown on this table give magnification less than 1.0 and good image quality. If you use more extension, image quality will be reduced. If you work at magnification greater than 1.0, reverse the lens.

Stacking three Auto Extension Tubes is not recommended for mechanical reasons. Hence no magnification figures are shown for that combination. You can stack three non-auto extension tubes.

Exposure factor shown with no extension tubes is due to extension by lens focusing mechanism.

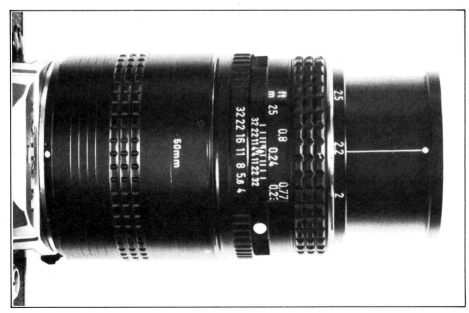

Extension tubes are used with macro lenses to get still higher magnifications. This is the 50mm Extension Tube K used with a 50mm Macro lens.

MAGNIFICATION WITH K-SERIES EXTENSION TUBES*
(LENS NOT REVERSED)
*See note on preceding page

Lens	Extension Tube	MAXIMUM MAGNIFICATION WITH:		TOTAL DISTANCE FROM FILM TO SUBJECT (mm) WITH:		EXPOSURE FACTOR WITH:	
		Auto Extension Tube K	Non-Auto Extension Tube K	Auto Extension Tube K	Non-Auto Extension Tube K	Auto Extension Tube K	Non-Auto Extension Tube K
28mm f-2, f-2.8, f-3.5	None	0.13	0.13	302	302	1.2	1.2
	1	0.56	0.47	152	160	1.8	1.7
	2	0.80	0.80	144	144	2.3	2.3
	3	1.05	1.05	142	142	2.7	2.7
35mm f-2.8	None	0.17	0.17	300	300	1.2	1.2
	1	0.51	0.44	173	182	1.8	1.7
	2	0.71	0.71	161	161	2.2	2.2
	3	0.91	0.98	157	157	2.6	2.8
35mm f-2, f-3.5	None	0.13	0.13	350	350	1.2	1.2
	1	0.47	0.40	169	180	1.8	1.7
	2	0.68	0.68	154	154	2.3	2.3
	3	0.88	0.95	150	149	2.8	2.9
40mm f-2.8	None	0.08	0.08	600	600	1.1	1.1
	1	0.37	0.31	213	232	1.7	1.6
	2	0.54	0.54	185	185	2.1	2.1
	3	0.71	0.77	173	171	2.5	2.6
	1+2	0.83	0.77	170	171	2.8	2.6
	1+3	1.00	1.00	168	168	3.3	3.3
	2+3	1.17	1.23	169	170	3.8	4.0
50mm f-1.2, f-1.4, f-1.7	None	0.15	0.15	450	450	1.3	1.3
	1	0.38	0.34	256	273	1.9	1.7
	2	0.52	0.52	228	228	2.2	2.2
	3	0.65	0.75	214	211	2.6	2.8
	1+2	0.75	0.70	209	211	2.9	2.8
	1+3	0.88	0.88	205	205	3.4	3.4
	2+3	1.02	1.07	204	204	3.8	4.0
	1+2+3		1.25		207		4.7
50mm f-4 Macro	None	0.50	0.50	234	234	2.3	2.3
	1	0.73	0.68	213	215	3.2	3.0
	2	0.86	0.86	209	209	3.7	3.7
	3	1.00	1.05	208	208	4.3	4.5
55mm f-1.8	None	0.17	0.17	449	449	1.4	1.4
	1	0.38	0.34	279	302	1.9	1.8
	2	0.51	0.51	251	251	2.2	2.2
	3	0.63	0.68	236	240	2.6	2.7
	1+2	0.72	0.72	230	230	2.9	2.9
	1+3	0.84	0.84	225	225	3.3	3.3
	2+3	0.97	1.01	223	231	3.8	3.9
	1+2+3		1.18		225		4.6
85mm f-1.8	None	0.13	0.13	839	839	1.3	1.3
	1	0.27	0.24	492	542	1.7	1.7
	2	0.35	0.35	424	424	2.0	2.0
	3	0.43	0.46	384	388	2.3	2.6
	1+2	0.49	0.49	365	365	2.5	2.5
	1+3	0.57	0.57	347	347	2.8	2.8
	2+3	0.65	0.69	335	333	3.2	3.6
	50mm	0.71		330		3.4	
	1+2+3		0.79		324		3.8

MAGNIFICATION WITH K-SERIES EXTENSION TUBES
(LENS NOT REVERSED)
(Continued from previous page)

Lens	Extension Tube	MAXIMUM MAGNIFICATION WITH:		TOTAL DISTANCE FROM FILM TO SUBJECT (mm) WITH:		EXPOSURE FACTOR WITH:	
		Auto Extension Tube K	Non-Auto Extension Tube K	Auto Extension Tube K	Non-Auto Extension Tube K	Auto Extension Tube K	Non-Auto Extension Tube K
100mm f-4 Macro	None	0.50	0.50	450	450	2.5	2.5
	1	0.62	0.60	424	428	2.9	2.5
	2	0.69	0.69	415	415	3.2	3.2
	3	0.76	0.79	408	407	3.5	3.9
	1+2	0.81	0.81	405	405	3.7	3.7
	1+3	0.88	0.88	402	402	4.0	4.0
	2+3	0.95	0.98	401	401	4.3	4.9
	50mm	1.00		401		4.5	
	1+2+3		1.07		401		4.9
100mm f-2.8	None	0.13	0.13	1000	1000	1.4	1.4
	1	0.25	0.22	628	671	1.8	1.7
	2	0.32	0.32	545	545	2.1	2.1
	3	0.39	0.41	495	482	2.4	2.5
	1+2	0.44	0.41	470	482	2.7	2.5
	1+3	0.51	0.51	446	446	3.0	3.0
	2+3	0.58	0.60	429	424	3.4	3.5
	50mm	0.63		420		3.6	
	1+2+3		0.70		411		4.0
	100mm	1.13		399		6.9	
120mm f-2.8	None	0.13	0.13	1202	1202	1.5	1.5
	1	0.23	0.21	805	853	1.9	1.8
	2	0.29	0.29	705	705	2.2	2.2
	3	0.35	0.37	641	623	2.5	2.6
	1+2	0.39	0.39	609	609	2.7	2.7
	1+3	0.45	0.45	575	575	3.0	3.0
	2+3	0.50	0.53	551	544	3.3	3.5
	50mm	0.55		538		3.6	
	1+2+3		0.60		523		4.0
	100mm	0.96		492		6.7	
135mm f-2.5, f-3.5	None	0.11	0.11	1499	1499	1.4	1.4
	1	0.20	0.18	977	1045	1.7	1.7
	2	0.25	0.25	846	846	2.0	2.0
	3	0.30	0.32	762	740	2.2	2.3
	1+2	0.34	0.34	719	719	2.4	2.4
	1+3	0.39	0.39	673	673	2.7	2.7
	2+3	0.45	0.46	640	631	2.9	3.0
	50mm	0.48		622		3.2	
	1+2+3		0.53		602		3.5
	100mm	0.85		551		5.6	
SMC Pentax-M 135mm f-3.5	None	0.12	0.12	1500	1500	1.5	1.5
	1	0.21	0.19	1012	1074	2.0	1.9
	2	0.26	0.26	886	886	2.3	2.3
	3	0.31	0.33	805	783	2.6	2.7
	1+2	0.35	0.35	764	764	2.8	2.8
	1+3	0.40	0.40	720	720	3.2	3.2
	2+3	0.45	0.47	688	678	3.6	3.7
	50mm	0.49		670		3.9	
	1+2+3		0.54		650		4.3
	100mm	0.86		600		7.3	

extension length is 26.5mm; maximum length is 46.5mm. It can be stacked with other extension tubes of fixed length, as needed.

For casual nature photography, such as small wildflowers or insects, a 50mm or 55mm lens with the Helicoid Extension Tube between lens and camera body gives good results. Depending on how you adjust the extension tube, magnification ranges from about 0.5 up to approximately 1.

For best image quality over this range of magnifications, use the special 50mm macro lens or 100mm macro lens as described on pages 96 to 98.

REVERSING THE LENS

Lenses for general use are designed with the expectation that subject distance will be considerably longer than image distance—the subject a few feet from the camera and the lens only a few inches from the film, for example. If the lens is not used as the designer expected, lens corrections don't work as well and image quality is degraded.

If magnification is increased by lens extension until the image on film is larger than the subject in real life, then the image distance must be longer than subject distance. For magnifications larger than 1.0, lenses make a better image if they are reversed so the longer optical path is still on the side of the lens that the designer intended—even though it becomes image distance rather than subject distance.

Mounting a lens reversed is done by a gadget commonly called a *reversing ring;* called a Reverse Adapter in Pentax literature. The adapter screws into the filter-mounting threads on the front of the lens. The other end of the adapter fits the camera mount—screw thread or bayonet. The reverse adapter can mount directly on a camera body or, of course, on the forward end of any combination of extension tubes because extension tubes repeat the camera mount on their forward ends.

Reverse Adapter K has a bayonet mount on one side and threads on the other. It is available in two sizes.: With 52mm threads to fit many SMC Pentax lenses and with 49mm threads to fit most SMC Pentax-M and -A lenses. The Reverse Adapter screws into the front of the lens. Then the lens can be turned around and mounted backwards onto a camera, extension tube or bellows.

When mounted in reverse, the back of the lens becomes the front. All automatic features are lost. Lens aperture is adjusted manually, using the aperture ring on the lens. The focus control on the lens has no effect. Keep stray light off the lens surface even if you have to improvise a hood or shade. Advantages are: Better image quality at magnifications greater than 1.0 and high magnifications with less extension—see the magnification data table.

When a lens is mounted by its filter threads, operating the focus control doesn't do anything to the position of the glass lens elements. You may have to look at a lens and work the focus control to visualize why. The lens barrel telescopes as usual, but the optics don't move.

Reversing a lens changes the amount of extension. Some is due to the reverse adapter itself—see the accompanying data table. Some extension is due to the recess at the front of a lens, between the filter threads and the first glass surface. When a lens is turned around, this recess becomes extension. The amount of extension due solely to reversing the lens isn't a lot on most lenses, but there are a few deeply recessed lenses where it becomes a major factor. The two important examples are the special 50mm and 100mm macro lenses, also listed in the data table, discussed later.

If you are estimating magnification by the formula $M = X/F$, be sure to gather up all of the "X" distances and add them together. These include:

Extension due to the extension tube or tubes.

Extension due to the lens helicoid if the lens is mounted normally and not set at infinity.

Extension due to a reverse adapter if used.

Extension due to reversing the lens itself, if known.

Naturally, with a lens reversed, nothing is automatic. Use manual aperture control and stop-down metering.

BELLOWS

If you do a lot of high magnification photography, you'll find a bellows more convenient than extension tubes because it requires less fiddling and changing. Also, the amount of extension available with a bellows is considerably more than with a set of extension tubes, so maximum magnification is greater.

It is possible to stack extension tubes, theoretically without limit, gaining magnification as you go.

MAGNIFICATION WITH K-SERIES EXTENSION TUBES USING REVERSE ADAPTER K TO REVERSE THE LENS

Lens	Extension Tube	MAGNIFICATION WITH:		TOTAL DISTANCE FROM FILM TO SUBJECT (mm) WITH:		EXPOSURE FACTOR WITH:	
		Auto Extension Tube K	Non-Auto Extension Tube K	Auto Extension Tube K	Non-Auto Extension Tube K	Auto Extension Tube K	Non-Auto Extension Tube K
28mm f-2.8	None	1.78	1.78	139	139	5.6	5.6
	1	2.20	2.11	148	146	7.7	7.3
	2	2.45	2.45	154	154	9.2	9.2
	3	2.78	2.70	162	160	11.3	10.7
	1+2	2.87	2.87	164	164	11.9	11.9
	1+3	3.12	3.12	170	170	13.7	13.7
	2+3	3.45	3.36	179	177	16.2	15.5
	1+2+3	3.79	3.79	188	188	19.1	19.1
28mm f-3.5	None	1.90	1.90	154	154	6.4	6.4
	1	2.32	2.23	164	162	8.7	8.2
	2	2.56	2.56	169	169	10.2	10.2
	3	2.81	2.90	175	178	11.8	12.4
	1+2	2.99	2.99	180	180	13.1	13.1
	1+3	3.23	3.23	186	186	14.9	14.9
	2+3	3.48	3.57	193	195	16.9	17.6
	1+2+3	3.90	3.90	204	204	20.5	20.5
35mm f-2.8	None	1.18	1.18	158	158	3.5	3.5
	1	1.52	1.45	163	162	4.9	4.5
	2	1.72	1.72	167	167	5.8	5.8
	3	1.99	1.92	174	172	7.2	6.8
	1+2	2.06	2.06	176	176	7.5	7.5
	1+3	2.26	2.26	181	181	8.7	8.7
	2+3	2.54	2.46	189	187	10.4	9.9
	1+2+3	2.81	2.81	197	197	12.2	12.2
35mm f-3.5	None	1.40	1.40	153	153	4.7	4.7
	1	1.74	1.67	160	158	6.3	5.9
	2	1.94	1.94	165	165	7.3	7.3
	3	2.14	2.22	170	172	8.4	8.8
	1+2	2.29	2.29	174	174	9.3	9.3
	1+3	2.49	2.49	180	180	10.5	10.5
	2+3	2.69	2.76	186	188	11.9	12.4
	1+2+3	3.03	3.03	196	196	14.4	14.4
40mm f-2.8	2	1.06	1.06	169	169	3.5	3.5
	3	1.29	1.23	171	170	4.4	4.1
	1+2	1.35	1.35	172	172	4.7	4.7
	1+3	1.52	1.52	176	176	5.4	5.4
	2+3	1.75	1.69	182	180	6.5	6.2
	1+2+3	1.98	1.98	188	188	7.7	7.7
50mm f-1.4	1	1.00	0.95	197	197	3.0	2.8
	2	1.14	1.14	198	198	3.5	3.5
	3	1.28	1.33	200	201	4.0	4.2
	1+2	1.38	1.38	202	202	4.4	4.4
	1+3	1.51	1.51	206	206	5.0	5.0
	2+3	1.65	1.70	210	211	5.7	5.9
	1+2+3	1.89	1.89	218	218	6.8	6.8
50mm f-1.7	3	1.00	0.95	204	204	3.7	3.6
	1+2	1.04	1.04	204	204	3.9	3.9
	1+3	1.18	1.18	206	206	4.5	4.5
	2+3	1.31	1.31	209	208	5.3	5.1
	1+2+3	1.54	1.54	214	214	6.2	6.2

MAGNIFICATION WITH K-SERIES EXTENSION TUBES
USING REVERSE ADAPTER K TO REVERSE THE LENS
(CONTINUED FROM PREVIOUS PAGE)

Lens	Extension Tube	MAGNIFICATION WITH:		TOTAL DISTANCE FROM FILM TO SUBJECT (mm) WITH:		EXPOSURE FACTOR WITH:	
		Auto Extension Tube K	Non-Auto Extension Tube K	Auto Extension Tube K	Non-Auto Extension Tube K	Auto Extension Tube K	Non-Auto Extension Tube K
50mm ƒ-4 Macro	1	1.05	1.00	208	208	4.5	4.3
	2	1.18	1.18	209	209	5.1	5.1
	3	1.32	1.37	212	213	5.7	6.0
	1+2	1.42	1.42	214	214	6.2	6.2
	1+3	1.55	1.55	218	218	6.9	6.9
	2+3	1.69	1.74	222	224	7.6	7.9
	1+2+3	1.92	1.92	230	230	9.0	9.0
55mm ƒ-1.8	1+3	1.05	1.05	223	223	4.1	4.1
	2+3	1.17	1.22	225	226	4.6	4.8
	1+2+3	1.39	1.39	229	229	5.5	5.5
100mm ƒ-4 Macro	1+2	0.04	0.04	2941	2941	1.4	1.4
	1+3	0.11	0.11	1149	1149	1.5	1.5
	2+3	0.18	0.20	784	881	1.7	1.9
	1+2+3	0.30	0.30	567	567	2.1	2.1

Notice the high magnification obtained with the 28mm lens using only Reverse Adaptor K between lens and camera. This is due to the location of optical nodes in the lens. For some lenses, this table does not show single extension tubes, or no extension tube because more extension is needed to get a focused image on the film. Notice also the futility of reversing the 100mm macro lens—it's a telephoto design.

EXTENSION LENGTH OF ACCESSORIES

Accessory	Extension (mm)
Auto Extension Tube K	
#1	12
#2	19
#3	26
50mm	50mm
100mm	100mm
Extension Tube K (Non-Automatic)	
#1	9.5
#2	19
#3	28.5
Reverse Adapter K	2
Helicoid Extension Tube K	26.5 to 46.5
Auto-Bellows K	38 to 170
with lens board reversed	62 to 175
Bellows K	32 to 137
Extension Due to Reversing	
50mm Macro Lens	38.5
Extension Due to Reversing	
100mm Macro Lens	−26

Notice that the extension due to reversing the 100mm Macro lens is a negative number (−26). Because this is a telephoto lens design, the lens nodes are moved forward. When reversed, this places the node closer to the camera and effectively reduces the amount of lens extension.

But you have to buy or borrow more extension tubes to make an assembly longer than you can get with the standard set of three.

It is also possible to use extension tubes between bellows and lens to get more magnification than with bellows alone.

A bellows supports and mounts the camera at one end and the lens at the other. The accordion-pleated bellows material allows the distance between camera and lens to be changed.

Non-Automatic Bellows—This bellows type does not preserve automatic diaphragm operation in the lens. Although no longer offered by Pentax, if you have a bellows of this type, you can use it with current camera models.

The mechanical arrangement is simple. The camera-attachment end is clamped to the bellows rail and can be moved only by loosening the clamp. The lens-mounting end is geared to the rail so its position can be conveniently and smoothly changed just by rotating a control knob. A tripod mount

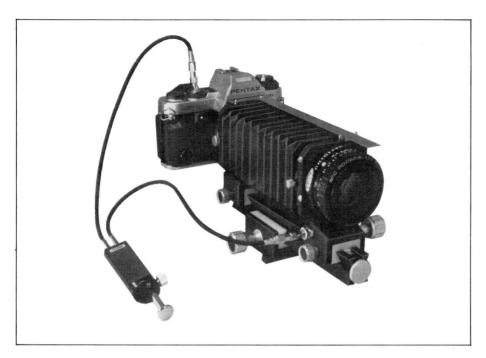

Auto Bellows A has a camera-mounting ring held in the rear standard by a set screw. Remove ring and attach to camera. Place ring in rear standard and tighten set screw. To rotate camera, loosen set screw. Lens mounts in front standard. A metal scale to measure extension rests on tops of the standards. Both standards, and the tripod mount, move along the gear rail by turning an adjuster knob. Each has a clamp knob on the opposite side to hold the setting. The double cable release closes aperture to the set value before operating the shutter.

1/How to reverse the lens with Auto-Bellows. Remove the stop screw on the front end of the gear rail.

2/Loosen set screw and remove bellows from front standard.

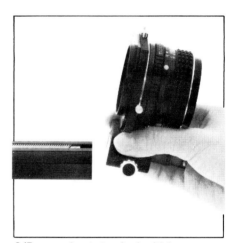

3/Remove front standard, with lens attached.

4/Reverse standard and reinstall. If lens has 52mm filter thread, clamp bellows onto front of lens. An adapter for 49mm filter thread is in the standard on the opposite side from lens. Unscrew adapter, screw it into front of lens, then attach bellows.

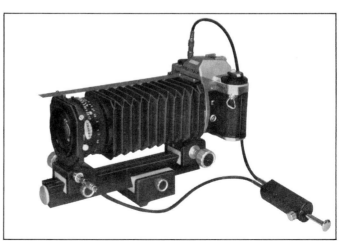

5/Attach double cable release as shown. Notice maximum extension of bellows is reduced when lens is reversed. See data table for magnifications using reversed lenses.

can be moved along the rail by loosening a clamp screw. The tripod mount should be used, rather than the tripod socket on the camera, for better balance and stability.

A scale along the bellows rail shows magnification with standard lenses according to the amount of bellows extension. You can also find magnification by use of the accompanying tables, estimate it by calculation as described for extension tubes, or just fool around with the bellows until you get the magnification you want.

The non-automatic bellows requires manual control of lens aperture and stop-down metering. If magnification is greater than one, you should reverse the lens, using a reverse adapter between lens and bellows.

Automatic Bellows—The current version is Auto Bellows A. Both ends of the bellows are geared to the mounting rail so either end can conveniently be moved. The tripod mount is also geared to the rail.

As with all methods for high-magnification photography, changing the lens focus also changes magnification. It is usually more convenient to set the amount of magnification needed and then move the entire camera back and forth to find precise focus. With bellows and camera mounted on a tripod or similar support, a geared tripod mount on the bellows is very handy. It serves to move the entire bellows back and forth while the tripod remains stationary.

The automatic bellows preserves automatic aperture control by using a special double cable release—essentially two cable releases operated by a single plunger. One cable-release end, marked with red, goes to the front of the bellows and connects to a socket in the lens-mounting board. A mechanism in the lens board closes the lens to shooting aperture whenever the cable release is operated.

MAGNIFICATION WITH AUTO BELLOWS LENS NOT REVERSED				
Lens	Magnification	Bellows Extension (mm)	Film-Plane-to-Subject Distance (mm)	Exposure Factor
50mm -M or -A *f*-1.7	0.8	42	207	3.0
	0.9	47	205	3.3
	1.0	52	204	3.7
50mm -M type *f*-2	0.9	47	205	3.6
	0.8	42	207	3.2
	1.0	52	204	3.9
50mm Macro -A type *f*-2.8	0.8	42	210	2.9
	0.9	47	208	3.2
	1.0	52	208	3.5
50mm Macro -M type *f*-4	0.8	41	210	3.5
	0.9	46	208	3.9
	1.0	52	208	4.3
100mm Macro -M type *f*-4	0.4	40	491	2.1
	0.5	50	451	2.5
	0.6	60	428	2.8
	0.7	70	414	3.2
	0.8	80	406	3.6
	0.9	90	402	4.1
	1.0	100	401	4.6
100mm Bellows lens *f*-4	0.1	48	1210	1.2
	0.2	58	720	1.5
	0.3	68	564	1.8
	0.4	78	491	2.1
	0.5	88	451	2.5
	0.6	98	428	2.8
	0.7	108	414	3.2
	0.8	118	406	3.6
	0.9	128	402	4.1
	1.0	138	401	4.6

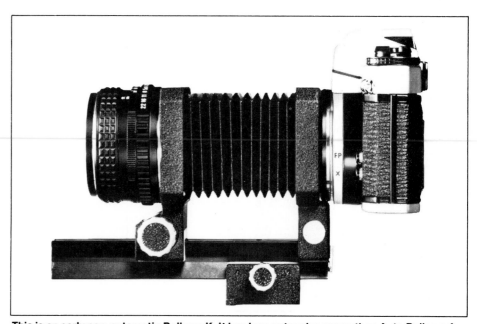

This is an early non-automatic Bellows K. It has less extension range than Auto Bellows A and does not accept a double cable release. Lens aperture is controlled manually and metering is stopped-down. The front standard does not reverse. The lens can be reversed on the front of the bellows by using Reverse Adapter K.

		Bellows Extension (mm)	Film-Plane-to-Subject Distance (mm)	Expo-sure Factor
Lens	**Magnification**			
28mm -A type f-2.8	2.6	63	165	9.6
	3.0	74	175	12.2
	3.3	83	183	14.4
	3.6	92	191	16.8
	4.0	103	201	20.2
	4.3	112	210	23.0
	4.6	121	218	26.0
	5.0	132	229	30.2
	5.3	141	237	33.6
	5.6	149	245	37.2
	6.0	161	257	42.2
	6.3	169	265	46.2
	6.6	178	273	50.4
28mm -M type f-2.8	2.6	56	158	10.1
	3.0	67	167	12.8
	3.3	75	175	15.1
	3.6	84	183	17.5
	4.0	95	193	21.0
	4.3	104	202	23.8
	4.6	112	210	26.9
	5.0	124	220	31.2
	5.3	132	229	34.6
	5.6	141	237	38.2
	6.0	152	248	43.3
	6.3	161	256	47.4
	6.6	169	265	51.6
30mm -M type f-2.8	2.6	64	166	10.0
	3.0	76	177	12.7
	3.3	85	185	14.9
	3.6	94	193	17.4
	4.0	106	205	20.9
	4.3	115	213	23.7
	4.6	124	222	26.7
	5.0	136	233	31.0
	5.3	145	242	34.4
	5.6	155	251	38.0
	6.0	167	263	43.1
35mm -A or -M f-2.8	1.8	59	170	6.2
	2.0	66	175	7.2
	2.3	77	183	8.9
	2.6	87	192	10.8
	3.0	101	204	13.6
	3.3	112	213	15.9
	3.6	122	223	18.4
	4.0	136	236	21.9
	4.3	147	246	24.8
	4.6	157	256	27.9
	5.0	172	270	32.3
40mm -M type f-2.8	1.3	48	171	4.5
	1.6	61	178	5.8
	2.0	77	189	7.9
	2.3	90	199	9.7
	2.6	102	209	11.7
	3.0	11	224	14.6
	3.3	131	235	16.9
	3.6	144	246	19.5
	4.0	160	262	23.2
	4.3	173	274	26.2

MAGNIFICATION WITH AUTO BELLOWS LENS REVERSED

The other branch of the cable release connects to the shutter button on the camera, in the normal way. In operation, the double cable release should close lens aperture before it operates the camera shutter.

The double cable release for Auto Bellows A is adjustable at each end. Loosen a lock ring and screw the tip of the end into or out of the body.

By observing the lens diaphragm, looking into the front of the lens, while listening to the camera shutter, you can make this adjustment. The double cable release also has a lock-screw to hold the plunger depressed for time exposures with the camera set on **B**.

For magnifications greater than 1.0, you should reverse the lens.

To reverse the lens when using an automatic bellows, remove the front lens board and reverse it on the rail. The lens then extends backwards from the lens board, with the normal front end of the lens pointed toward the camera. The bellows clamps around the front of the lens, just as it originally clamped to the lens board, excluding light. The double cable release continues to function as described previously.

Even though the automatic bellows with double cable release preserves the automatic diaphragm feature of the lens, it does not preserve open-aperture metering. Meter stopped-down at shooting aperture.

If you use aperture-priority automatic, the camera will set exposure automatically at shooting aperture. However, you may want to check the reading in advance.

Auto Bellows A, with its double cable release, will work with any current camera. Earlier bellows models may not allow use of the scale with program cameras. Earlier double cable releases should not be used with program cameras.

Depth of Field Limitation— When first you look through a lens set up for high magnification, you'll think there isn't any depth of field. In normal photography, depth of field is greatly improved by stopping down with small aperture. At high magnifications, no matter how achieved, stopping down helps some but not nearly as much.

In general, depth of field is determined mainly by the amount of magnification—the more magnification, the less depth of field. And there isn't anything you can do about it except shoot at small aperture when possible.

In normal photography, the point of best focus is about 1/3 of the way into the depth of field. For example, if good focus extends from 30 feet to 45 feet away from the camera—a zone of 15 feet—sharpest focus will be about 5 feet into the zone or 35 feet away.

In macro photography, the point of best focus is about halfway into the depth of field. Because depth is so limited, most photographers put good focus near the front of the subject and let it get blurred at increasing distance from the lens.

When a lens has poor correction for flatness of field, the edges of a flat subject may go out of focus on film. This effect is masked by depth of field in normal photography. All points on a flat subject should be in focus if any of them are; however because of poor flatness of field there are points around the edges which are not in best focus. Even so, they are still in *acceptable* focus because they are still inside the depth of field—which is defined as the zone of acceptable focus. Therefore insufficient lens correction for flatness of field may not be noticed when there is plenty of depth of field.

In macro, depth of field is so small it can't cover up lens faults. If the lens isn't well corrected for flatness of field, you'll see it go

MAGNIFICATION WITH AUTO BELLOWS LENS REVERSED

Lens	Magnification	Bellows Extension (mm)	Film-Plane-to-Subject Distance (mm)	Exposure Factor
50mm -A type f-1.4	1.0	57	200	3.2
	1.2	68	202	3.9
	1.4	78	206	4.7
	1.6	88	212	5.6
	1.8	99	219	6.6
	2.0	109	226	7.7
	2.2	120	234	8.9
	2.4	130	243	10.1
	2.6	141	252	11.4
	2.8	151	261	12.8
	3.0	161	270	14.3
50mm -M type f-1.4	1.0	55	197	3.0
	1.2	65	198	3.7
	1.4	75	202	4.6
	1.6	85	208	5.4
	1.8	95	215	6.4
	2.0	106	222	7.5
	2.2	116	230	8.6
	2.4	126	238	9.8
	2.6	136	247	11.1
	2.8	146	256	12.5
	3.0	157	265	13.9
50mm -M or -A f-1.7	1.0	61	204	3.7
	1.2	72	206	4.5
	1.4	82	210	5.4
	1.6	92	216	6.3
	1.8	103	223	7.4
	2.0	113	230	8.5
	2.2	124	238	9.7
	2.4	134	247	11.0
	2.6	144	255	12.4
	2.8	155	264	13.8
	3.0	165	274	15.4
50mm -M type f-2	1.0	61	204	3.9
	1.2	72	206	4.8
	1.4	82	210	5.7
	1.6	93	216	6.7
	1.8	103	223	7.8
	2.0	113	230	8.9
	2.2	124	238	10.2
	2.4	134	247	11.5
	2.6	145	256	12.9
	2.8	155	265	14.3
	3.0	165	274	15.9
50mm Macro -A type f-2.8	1.2	75	209	4.3
	1.4	86	214	5.2
	1.6	96	219	6.2
	1.8	106	226	7.2
	2.0	117	234	8.3
	2.2	127	242	9.5
	2.4	138	250	10.8
	2.6	148	259	12.1
	2.8	158	268	13.6
	3.0	169	277	15.1
50mm Macro -M type f-4	1.2	75	209	5.2
	1.4	86	213	6.1
	1.6	96	219	7.1
	1.8	106	226	8.3
	2.0	117	233	9.4
	2.2	127	241	10.7
	2.4	137	250	12.1
	2.6	148	258	13.5
	2.8	158	267	15.0
	3.0	168	276	16.6

MAGNIFICATION WITH BELLOWS K (Lens not Reversed)				
Lens	Magnification	Bellows Extension (mm)	Film-Plane-to-Subject Distance (mm)	Exposure Factor
35mm f-3.5	0.92	32	149	2.9
	1.14	40	150	3.5
55mm f-1.8	0.56	32	242	2.4
	0.70	40	230	2.9
	0.88	50	224	3.4
	1.06	60	223	4.1
85mm f-1.8	0.38	32	408	2.1
	0.47	40	371	2.4
	0.59	50	345	2.9
	0.70	60	330	3.4
	0.82	70	323	3.9
	0.94	80	320	4.5
	1.06	90	320	5.1
100mm f-4 Macro	0.82	32	405	3.8
	0.90	40	402	4.1
	1.00	50	401	4.6
	1.10	60	402	5.1
105mm f-2.8	0.31	32	597	2.1
	0.38	40	536	2.5
	0.48	50	491	2.9
	0.57	60	464	3.4
	0.67	70	448	4.0
	0.76	80	438	4.6
	0.86	90	433	5.2
	0.95	100	431	5.9
	1.05	110	431	6.6
120mm f-2.8	0.27	32	734	2.1
	0.33	40	652	2.4
	0.42	50	590	2.8
	0.50	60	552	3.3
	0.58	70	528	3.8
	0.67	80	512	4.4
	0.75	90	502	5.0
	0.83	100	496	5.6
	0.92	110	493	6.3
	1.08	130	493	7.7
135mm f-2.5	0.24	32	880	2.0
	0.30	40	774	2.3
	0.37	50	693	2.7
	0.44	60	642	3.1
	0.52	70	610	3.6
	0.59	80	586	4.1
	0.67	90	571	4.6
	0.74	100	560	5.2
	0.89	120	551	6.4
	1.02	137	548	7.6
135mm f-3.5	0.24	32	880	1.9
	0.30	40	774	2.2
	0.37	50	693	2.5
	0.44	60	642	2.9
	0.52	70	610	3.4
	0.59	80	586	3.8
	0.67	90	571	4.3
	0.74	100	560	4.8
	0.89	120	551	5.9
	1.02	137	548	6.9

out of focus around the edges. For this reason, Pentax offers special lenses designed with more than usual correction for flatness of field. These are intended for macro use but can be used for other purposes including general photography. They are discussed later in this chapter.

If your subject is perfectly flat, such as a postage stamp, you have some flexibility in choice of aperture but you should try to use small aperture. If your subject is contoured so it needs some depth of field, it will usually pay off in image quality if you shoot at the smallest aperture of the lens—f-16 or smaller.

LIGHT PROBLEMS WITH LENS EXTENSION

From the film's point of view, light comes from the back end of the lens as an expanding cone making a circle at the film plane.

Light sources which produce diverging rays are subject to the *inverse-square law.* The law says the amount of light changes inversely with the distance from the light source. *Inversely,* as used here, means in the reverse or opposite way. If the distance between light source and subject *increases,* illumination of the subject *decreases.* We have all observed that as an everyday occurrence.

When the inverse-square law applies, light decreases according to distance squared. If distance is doubled, light does not decrease to 1/2 its former value, it decreases to 1/4. Making the distance 3 times as large decreases the amount of light by 3^2 which is 9, and so forth.

The inverse-square law is always applicable inside the camera, between lens and film. With an ordinary lens, both magnification and the amount of light on the film change due to focusing. You can see the magnification change by looking through the viewfinder.

The amount of movement in

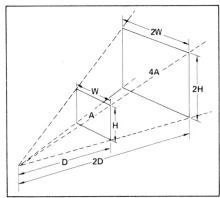

If the distance from light source to the illuminated surface becomes twice as long, the area of the illuminated surface becomes four times as large. Brightness of the surface becomes only one-fourth as much. This illustrates the inverse-square law which applies to any light source that makes an expanding beam.

EXPOSURE FACTORS		
Magnification	Multiply Exposure Time By:	Or Increase Aperture Size By:
0.1	1.2	1/4 step
0.2	1.4	1/2
0.3	1.7	3/4
0.4	2	1
0.6	2.5	1-1/4
0.7	2.9	1-1/2
0.8	3.2	1-3/4
0.9	3.61	1-3/4
1.0	4	4
1.2	4.8	2-1/4
1.4	5.8	2-1/2
1.6	6.8	2-3/4
1.8	7.8	3
2	9	3-1/4
2.2	10	3-1/4
2.4	11.6	3-1/2
2.6	13	3-3/4
2.8	14.5	3-3/4
3	16	4

the normal focusing range of the lens is so small that the amount of light on the film doesn't change very much. If you set exposure controls *after* focusing, it doesn't matter because you set exposure for whatever light there is.

When you use extension tubes or a bellows to put extra distance between lens and film the distance may change enough to have a major effect on the amount of light at the film plane. An easy example is: To get a magnification of 1.0, use added extension equal to the lens focal length. A 50mm lens with 50mm of added extension makes a life-size image of film.

However, inserting 50mm of extension *doubles* the image of distance—from 50mm without the extension to 100mm with extension. By the inverse-square law, doubling distance reduces illumination to 1/4, which is two exposure steps. The image is less bright on film and also in the viewfinder. As magnification is increased above 1.0 the light falls off very rapidly and the viewing screen becomes very dark.

As long as you are using the built-in camera meter and it is reading within its range of accuracy, the camera measures the actual amount of light that will expose film, so the camera-recommended exposure settings should be satisfactory. The possibility of reciprocity failure should be considered for longer-than-normal exposure times.

It's easy to get into situations where a direct through-the-lens light measurement with the camera's built-in meter is not possible because the light is so dim. There are ways around the problem, some based on a simple calculation of the amount of light lost due to lens extension.

Exposure Factor—If you know the amount of magnification you are getting from lens extension, you can calculate an Exposure Factor (EF) which tells you the light loss and also tells you how to correct for it.

$EF = (M + 1)^2$ where the symbol, M, stands for magnification.

Here's an example: How much light do you lose if magnification is 2? Add 2 + 1 and multiply the result by itself.

$$EF = (2 + 1)^2$$
$$= (3)^2$$
$$= 3 \times 3$$
$$= 9$$

This says, because of lens extension the film is receiving only 1/9 as much light as it would without added extension. If you can find proper exposure for the subject when shooting at normal magnifications—without added extension—then you must multiply that by the exposure factor of 9 to correct for the added extension.

Pupilary Magnification—The Exposure Factor formula given above applies only to lenses of conventional design, not telephoto or wide angle (reversed telephoto design).

If you hold a lens at arms length with the aperture set at a medium value, you see a disc of light at each end—the entrance pupil and the exit pupil. If the exit pupil is smaller than the entrance pupil, you know it's a telephoto lens and there's some optical trickery going on there. The formula does not apply.

If entrance and exit pupils are about the same size, the lens design is conventional or nearly so and you can use the formula.

If exit pupil is larger than entrance pupil, it's a wide-angle reversed-telephoto lens with optical trickery. Formula does not apply.

What to do? If you can measure the light with the meter in the camera—operating within its

Lens	Magnification	Bellows Extension (mm)	Film-Plane-to-Subject Distance (mm)	Exposure Factor
28mm f-3.5	3.02	32	180.7	13.3
	3.30	40	188	15.5
	3.66	50	197	18.3
	4.01	60	206	21.5
	4.36	70	216	24.9
	4.71	80	225	28.5
	5.41	100	244	36.5
	6.12	120	264	45.5
	6.72	137	280.5	53.9
35mm f-3.5	2.32	32	175	9.4
	2.55	40	182	10.9
	2.83	50	190	12.9
	3.12	60	199	15.0
	3.40	70	208	17.3
	3.69	80	217	19.8
	4.26	100	236	25.2
	4.83	120	255	31.2
	5.31	137	271.5	36.5
50mm f-1.4	1.40	32	202	4.5
	1.55	40	207	5.2
	1.75	50	213	6.1
	1.95	60	220	7.1
	2.14	70	227.6	8.2
	2.34	80	235.6	9.4
	2.73	100	252.5	12.0
	3.12	120	270	14.8
	3.46	137	285.6	17.5
50mm f-4 Macro	1.44	32	214	6.3
	1.59	40	219	7.1
	1.78	50	225	8.2
	1.98	60	232.5	9.2
	2.17	70	240	10.5
	2.37	80	248	11.8
	2.75	100	265	14.6
	3.14	120	283	17.8
	3.47	137	298.3	20.6
55mm f-1.8	0.95	32	223	3.7
	1.09	40	224	4.2
	1.26	50	226	5.0
	1.44	60	231	5.8
	1.61	70	236.5	6.7
	1.79	80	243	7.6
	2.14	100	258	9.7
	2.49	120	274	12.0
	2.79	137	288.6	14.2

MAGNIFICATION WITH BELLOWS K AND REVERSED LENS

limits of accuracy—you don't have to worry about exposure correction of any kind so you don't need any formulas.

If you can't measure the light because it's too dim *and* the lens is not a standard lens, you can use the $(M + 1)^2$ formula to correct the first exposure and then make additional exposures bracketed above and below the first one.

Or else you can find formulas for lenses with pupilary magnification, meaning they have unequal pupils, in my book *SLR Photographers Handbook*.

For Pentax lenses recommended for use with extension, reversed or not reversed, the accompanying data tables give exposure factors for various magnifications. These exposure factors include the effect of unequal pupil sizes so they reduce the need for bracketing.

SELECTING LENSES FOR USE WITH EXTENSION

In general, large maximum aperture and correction for flatness of field are incompatible in lens design. Among the Pentax 50mm lenses, the f-1.2 and f-1.4 will not give image quality as good as the f-1.7 or f-2 lenses when photographing *flat subjects* with lens extension. With more extension, the difference is more noticeable.

To photograph natural subjects such as bugs or flowers, reduced flatness of field is usually not noticeable and therefore the large aperture lenses are not at a disadvantage. If you plan to do much photography of flat subjects with magnification, you will be better off with one of the smaller maximum aperture lenses. You should consider using one of the special macro lenses, described in a following section, which have even more correction for flatness of field.

Effective Aperture—As you know, aperture size as stated by an f-number is used as an indication of the light-gathering ability of a lens.

Because added extension reduces light on the film, it has an effect similar to using smaller aperture. The lens may be set at f-4 with extension but the amount of light on the film corresponds to f-8 if the lens were being used with no extension. We can say the *effective aperture* is f-8 because that's how much light there is.

The idea is to convert the effect of added extension into a fictitious but practical f-number for the lens, rather than use the exposure factor discussed above. This will be useful when using flash. In some applications of flash, a calculation is made to determine the f-number setting of the lens. This assumes no lens extension. If you are doing macro work with flash and lens extension, you need a way to convert the recommended aperture setting into the effective aperture for the lens with extension.

EA = (f-stop on lens) x (M + 1)

where EA is effective aperture and M is magnification due to added extension.

These are small "red-hot" candies shot at a magnification of about 1. This photo made with lens aperture wide open. Depth of field is pretty bad.

Same subject, lens aperture at f-8. Depth of field better.

Same subject, lens aperture at f-16. Depth of field still better.

Suppose you are set up with extension to give a magnification of 1.75. The f-number setting on the lens is f-8 and the meter in the camera is satisfied that exposure is OK. The effective aperture of the lens:

$$EA = (f\text{-}8) \times (1.75 + 1)$$
$$= f\text{-}8 \times 2.75$$
$$= f\text{-}22$$

This says the amount of light on the film is the same with f-8 and extension tubes as it would be at f-22 without extension tubes.

Usually you have to work this problem the other way. The dials on your electronic flash say to set the lens at f-22. You have some extension behind the lens, so you know the flash unit really wants an *effective aperture* of f-22. What you need to know is where to set the lens diaphragm ring so it will have that effective aperture. To do that, change the formula around like this:

$$f\text{-stop on lens} = \frac{EA}{M+1}$$
$$= \frac{f\text{-}22}{1.75+1}$$
$$= \frac{f\text{-}22}{2.75}$$
$$= f\text{-}8$$

As you can see, this is the same problem turned around. If you have enough extension for a magnification of 1.75 and you need exposure equivalent to a lens setting of f-22, set the lens at f-8.

I confess, I chose numbers for this example so it came out neatly at f-22 and f-8 when worked backwards. Real-world photography often is not that neat and you may get something like f-18.9 or f-8.7. If so, use the nearest f-stop or else set to the odd number by guessing the locations between marked f-numbers on the dial.

When there is any technical or artistic doubt about proper exposure, bracket!

Flash with High Magnification— Because of the extreme light loss at higher magnifications, flash is often an ideal light source. However, setting exposure is very difficult because of exposure factor corrections and flash placement. The LX camera has a major advantage in this application. The camera measures exposure while the flash is happening and turns it off when enough light has been measured.

SPECIAL LENSES
FOR MACRO PHOTOGRAPHY

Already mentioned is the necessity for great attention to flatness of field in lenses used at high magnification. In both screw-mount and bayonet, Pentax offers two special Macro lenses, the 50mm f-4 and the 100mm f-4, highly corrected for flatness of field.

Each of these Macro lenses has extra-long helicoid travel allowing magnification of 0.5 without accessories when the helicoid is fully extended. Each of these lenses can be used with extension tubes in combination with the built-in helicoid to get any magnification between 0.5 and 1.0. Each can be used with additional extension to get magnification greater than 1.0 but the lens should be reversed.

The Macro 50mm f-4 Lens—Helicoid travel in this lens is 25mm, which gives magnifications up to 0.5 when the helicoid is fully extended.

To get higher magnifications, rotate the focus control to the infinity setting so the helicoid is not extended at all and insert a 3 extension tube between lens and camera. The lens is again positioned outward by 25mm, approximately, by the extension tube. Magnification is again 0.5 but the helicoid travel has not been used yet. Then rotation of the focus control adds extension due to the helicoid until the total extension becomes 50mm, approximately, and magnification is 1.0. Magnification and extension will vary slightly depending on which extension tube is used.

Notice that this lens and one extension tube gives *continuously varying* magnifications up to 1.0.

For magnifications greater than 1.0, the lens should be reversed.

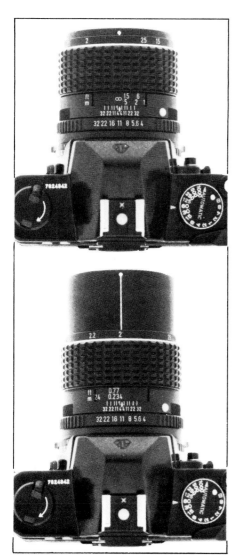

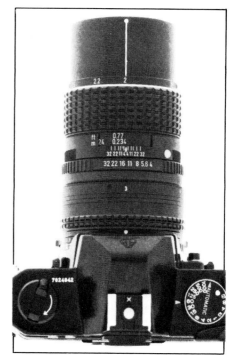

The adapter screws into the threaded filter ring on the front of the lens and mounts the lens backwards on the end of an extension tube.

The lens barrel front overhang—about 40mm—becomes back overhang and adds to lens extension just as if it were an extension tube. Therefore, with the lens reversed a magnification of 1.0 is obtained with the shortest extension tube.

When the lens is reversed, the focusing control doesn't affect the position of the glass lens elements or the added extension due to reversing the lens. It moves the rear mount of the lens in and out in front of the reversed lens with no effect on the picture.

Notice that this lens and one set of extension tubes with a reverse adapter can give continuously varying magnification up to 1.0 and then magnification in steps on up to 1.92. This is a very handy combination, easy to carry and easy to use, with great flexibility. The special correction of this lens for flatness of field improves close-up and macro images, and the lens can be used for ordinary photography just as any other 50mm but with a maximum aperture of

The 50mm Macro lens with tube 3 from the Auto Extension Tube Set K gives magnification of 1.0. With tube 3 from the non-auto Extension Tube Set K, which is a little longer, magnification is 1.05. In both cases, it is assumed the lens is fully extended on its internal helicoid.

Buy a set of extension tubes and you get one that gives a magnification of 1.0 or a little more, plus the other two tubes for more versatility and more magnification when you need it.

Macro lenses are specially corrected to give good flatness of field. This correction does not allow large aperture, so Pentax 50mm and 100mm Macro lenses are *f*-4. Focusing movement of the lens helicoid is one-half of the lens focal length. In top photo, lens is focused at infinity. In bottom photo, lens is fully extended by its built-in helicoid to give magnification of 0.5.

Stamp photographed at approximately life-size to fill the film frame. Shot with SMC Pentax 50mm Macro lens and extension tube 3. Because Macro lenses are specially corrected for flatness of field, photos are sharp all the way to the edges.

SMC Pentax 100mm Bellows Lens has no focusing adjustment because the bellows does it. This is a macro lens also, fully corrected for flatness of field. Even though front lens element is recessed, use of lens hood is recommended. Pentax lens hoods are marked to show which lenses they fit.

f-4 which may sometimes limit its general usefulness.

Auto Extension Tube K 50mm, used with the 50mm macro lens gives a magnification of 1 when the lens focus control is set at infinity. Extending the lens still farther using the focus adjustment in the lens body gives magnifications up to 1.5—with some reduction in image quality if the lens is not reversed.

The Macro 100mm f-4 Lens—This is the "big brother" of the 50mm macro and works the same way. The built-in helicoid extends the 100mm lens about 50mm to give a magnification of 0.5. Adding the entire set of three extension tubes makes possible continuously varying magnification up to about 1.0 and a total extension of about 100mm.

Auto Extension Tube K 50mm, used with the 100mm macro lens gives magnifications from 0.5 up to 1, depending on the setting of the focus control. Auto Extension Tube K 100mm gives a magnification of 1 with the lens focus control set at infinity. Extending the lens still farther using the focusing adjustment in the lens body gives magnifications up to 1.5 with some reduction in image quality.

Reversing the 100mm macro is similar to reversing the 50mm macro, giving additional fixed values of magnification according to the combination of extension tubes you use.

For people who already have one or more lenses but want to add macro, the 100mm lens has the additional advantage of possibly not duplicating a focal length already owned. It can serve as the macro lens in your collection and also as a portrait lens.

Bellows Lenses—For bellows use, there are 100mm f-4 lenses with no focusing helicoid built into the lens. This is sometimes called a *short-mount* type. Because a bellows provides variable extension, a lens intended for bellows use doesn't need a built-in helicoid.

Effect of Focal Length—In choosing equipment and setting it up, focal length of the lens has some effects which may not be obvious. Also, there are some important differences between use of close-up lenses and use of extension, as affected by lens focal length.

The distance between the front of the lens and the subject is called *working distance*, or *free working distance*. Sometimes it is so small that getting light on the subject is difficult.

When using a close-up lens, the working distance is equal to the focal length of the close-up lens,

Sometimes a different set-up solves a light problem or an accessibility problem. These two set-ups have approximately the same magnification. Close subject distance results from using 50mm lens with S40 Close-up lens. Longer subject distance is with 105mm lens and T80 Close-up lens.

With a 50mm macro lens, you use less extension but have less working distance between lens and subject. With a 100mm lens you get more working distance but you use more extension for the same magnification. Maximum magnification is less because the bellows runs out of extension. A copy stand like this is very handy for high magnification and copying. Subject is a stamp.

when camera lens is focused at infinity. Magnification is camera-lens focal length divided by close-up lens focal length, which allows you to have some control over working distance and still get the magnification you need.

When using close-up lenses, magnification is proportional to the focal length of the camera lens. Using the same close-up lens, if you double focal length of the camera lens, magnification will double. But working distance changes only when you change to a different close-up lens.

When increasing magnification by lens extension, the rules are different. Magnification is the amount of added extension divided by lens focal length, $M = X/F$. Suppose you are using 50mm of extension with a 100mm lens. Magnification is 50mm/100mm = 0.5. With the same extension, try a 50mm lens. Magnification becomes 50mm/50mm = 1.0. When using lens extension, shorter focal lengths give more magnification for the same amount of extension.

With any lens extended to pro-

duce a life-size image, image distance and subject distance are equal, and each is twice the lens focal length. If you double focal length, you double working distance but you also have to double the amount of extension to keep the same image size on film.

This idea can help you choose between the 50mm Macro and the 100mm Macro. Both are f-4, so there isn't any difference in light-gathering ability. To make it easy, let's assume each lens is to be used at life-size extension. For the 50mm Macro, working distance will be 100mm, which is about 100mm, which is about 4 inches. For the 100mm, working distance will be 200mm, about 8 inches. At higher magnifications, the working distances get a lot shorter, but the 100mm lens will always give longer distance. There are a lot of advantages to the longer working distance you get with the longer lens. The disadvantage is, you have to use twice as much extension.

SLIDE DUPLICATING

There are some photo accesso-

ries that are hard to resist because they seem like such a great idea. Before I tell you why you should resist buying a slide duplicator, let's discuss the available hardware.

Slide Copier K—For current cameras, there are two types. One, called Slide Copier K, fits on the end of the auto bellows. It holds a slide in front of the bellows-mounted lens and has its own light-tight bellows between the slide and the front of the lens to allow changing the distance between slide and lens.

The slide-copier unit accepts mounted slides or unmounted 35mm film and has a piece of frosted glass between the slide and an external light source to get even illumination across the picture. By adjusting lens-to-film distance and lens-to-slide distance so they are approximately equal and also double the focal length of the lens being used, you get a magnification of about 1.0. From there you can change extension and subject distance to get the amount of magnification you want.

Because you are exposing 35mm film with a 35mm slide as the subject, magnification of less than 1.0 should be avoided because the image will not completely fill the frame in the camera. Your duplicate slide will have a dark border inside the picture area and the image itself will be smaller.

Theoretically a magnification of exactly 1.0 will give an exact duplicate in size, but there are some variables. It's difficult to tell when you have magnification of exactly 1.0 because you don't see the entire frame in the camera viewfinder. You see 93% or 95%, depending on the camera model. Also, the cardboard or plastic frame used to hold finished slides masks part of the picture area on all four sides of the frame. The part of the frame you don't see in the camera viewfinder is approximately the same as the part which is masked by the slide holder.

Therefore if you fill the viewfin-

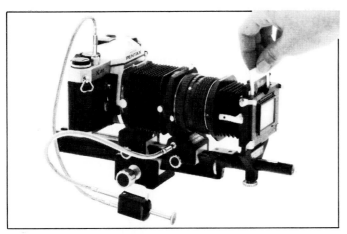

Slide Copier K attaches to the front of Auto-Bellows K. With the lens not reversed, you can make one-to-one copies. With the lens reversed, you can get magnification up to about 1.5, which crops the edges of the original slide. You can move the slide in the holder to change image composition. A macro lens is the best choice because you are photographing a nearly flat subject.

With extension tubes and a reversed 50mm lens, Slide Holder 1x, K makes copies at a magnification of approximately 1.0, depending on which lens and which extension tubes are used.

der with the image from the slide you are copying, the duplicate will be very close to filling the cut-out area of its slide mount.

It's usually better to set up for magnification slightly more than 1.0 to avoid the possibility of underfilling the picture are of the duplicate slide. Many slides benefit artistically from a little cropping at the edges anyway.

When you are magnifying more than 1.0 and therefore cropping edges, you can move the slide in the slide-copier unit so you crop more on one side than the other. The amount you can move it depends on magnification, the direction of movement, and the slide-duplicator model you are using.

Slide Holder 1x, K—Another way of duplicating slides uses extension tubes with a reversed 50mm lens and a slide holder which positions the slide in front of the reversed lens. Order of assembly, starting at the camera is: Extension tube or tubes, reverse adapter K, reversed lens, slide holder attached to rear mount of lens.

Magnification with typical lenses and extension tubes is shown in the accompanying table.

Lens Selection for Slide Duplicating—With ordinary 50mm camera lenses, better image quality will be obtained using lenses with smaller maximum aperture such as f-1.4 or f-1.7. Even so, the aperture should be closed down to f-8 or f-11 to reduce aberrations. Pentax recommends against using smaller aperture because of the increase in diffraction.

This may result in exposure times longer than 1/10 second with color-slide film and the possibility of color changes due to reciprocity failure—depending on the amount of light and film type. If so, Pentax suggests opening up the lens so exposure time is shorter than 1/10 second with color slide films. This assigns more importance to color fidelity than to image sharpness. An alternate approach is to shoot at f-8 or f-11 and use color filters to correct for reciprocity failure as indicated in the tables at the end of Chapter 12.

This problem may be avoided by using the 50mm macro lens. Although slides appear flat, they are actually curved enough to exceed the depth of field of the 50mm macro lens at f-4, so some image fuzziness can arise from limited depth of field. Using the macro lens at f-5.6 gives enough depth of field to cope with slide curvature.

MACROPHOTO STAND

For magnifications from about 0.5 up to about 3 with the 50mm macro lens, you can use a handy

LENS AND EXTENSION TUBE COMBINATIONS FOR USE WITH SLIDE HOLDER 1X, K			
Lens	Auto Extension Tube K	Extension Tube K (non-auto)	Magnification
50mm f-1.4	1		1.00
		1	0.95
50mm f-4 Macro	1		1.05
		1	1.00

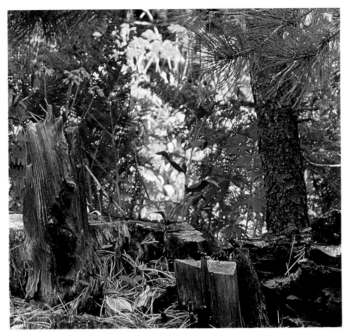 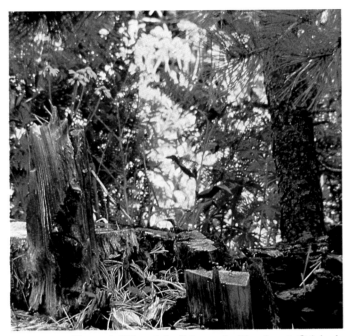

To show what to expect from simple slide copying, I used ordinary daylight slide film and diffused daylight as the illuminant. Original on left, copy on right. Notice slight enlargement, increased contrast and color change. Color change can be reduced by use of filters.

camera support called Macrophoto Stand. It is useful for slide copying and virtually any other kind of high-magnification photography. It's a sturdy base with a rigid vertical column. You can mount a bellows such as Auto Bellows K on the vertical column and attach camera body and lens to the bellows for a very convenient high-magnification setup.

You can also use extension tubes to get the needed magnification. If so, you must use the accessory Fine Focus Adjuster which fits between camera body and the column of the Macrophoto Stand. As you can see in the accompanying photos, the Fine Focus Adjuster allows you to move the camera vertically to change lens-to-subject distance so you can find focus.

A removable metal *stage plate* fits into a recessed opening in the base of the stand. One side of this plate is 18% gray, which is handy for setting exposure. The other side is black. If the stage plate is removed, there is a rectangular opening in the base which can be used to illuminate the subject from below.

Also on the base are two specimen clips used to hold specimen slides

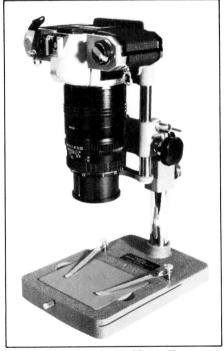

Macrophoto Stand with Macro Focus Rail III (Fine Focus Adjuster) is used to support camera, extension tube and lens. The metal stage plate is installed gray-side-up in the base of the stand.

or other small objects in place. If you use a colored paper background instead of the gray or black side of the metal stage plate, use the clips to hold the background in position. **Lighting Table for Macrophoto Stand**—An important accessory for the Macrophoto Stand is the Lighting Table which fits underneath the base of the stand. An opening in the top of the Lighting Table matches the rectangular opening in the base of the Macrophoto Stand so light can travel upward from the Lighting Table to *transilluminate* an object being photographed, or for copying slides.

The lighting table has a built-in light source at the back: a 25-Watt lamp mounted in a circular holder complete with AC power cord. The lamp holder screws into the back of the lighting table. Light from the lamp is reflected upward by an angled mirror below the opening in the top of the table.

A metal frame, called a Filter Holder, slides in grooves in the top of the lighting table. Two glass stage plates are supplied with the lighting table and fit into the filter holder frame. One is clear glass and the other frosted white which is

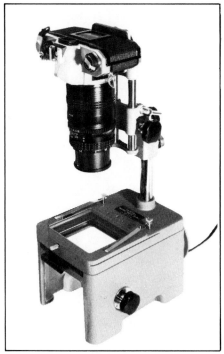

When using the Macrophoto Stand on the Lighting Table, remove the metal stage plate and use one of the glass plates. Stage plates can be installed in the rectangular opening in the base of the Macrophoto Stand or in a metal tray that fits in the top of the Lighting Table. You can see the black handle of the tray extending from the front of the Lighting Table. The internal light source is being used, bounced off the mirror in the table. Mirror position is controlled by the knob on the side of the Lighting Table.

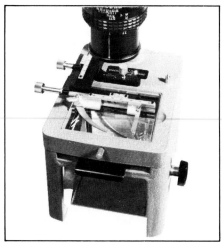

For precise positioning of the specimen, particularly under very high magnification, use the Mechanical Stage. An external light source can be used by angling the mirror to intercept a beam entering the light table from the opening in front.

used to produce a more diffused and even illumination. Because the opening in the base of the macrophoto stand is the same size as the filter holder frame, these glass stage plates can be used in either location.

The 25-Watt lamp supplied with the lighting table produces enough illumination to copy slides conveniently but it may not be enough for other applications with higher magnification. The front of the lighting table has an opening so brighter, external source of light can be used. You can use the beam from a slide projector with no slide being projected, or reflected sunlight, or a studio spot lamp, or electronic flash. When the light comes into the front of the lighting table instead of from the built-in lamp at the back, rotate the mirror so it reflects the outside light source upward through the opening in the table. Mirror position is set by a knob on the side of the table.

Slide Holders—Two metal slide holders, also called slide carriers, are available as accessories for the macrophoto stand. One is for 35mm slides, the other for 6x7 slides to be copied onto 35mm film. Both have an opening of the appropriate size

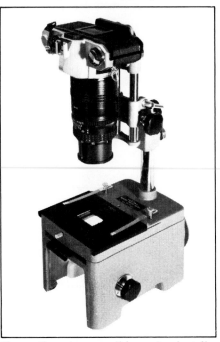

To use the setup as a slide copier, install the 35mm Slide Carrier shown here, or a 6 x 7 Slide Carrier. You can use a bellows instead of extension tubes.

so the slide can be illuminated from below using the lighting table with built-in or external light source.

The slide holders have edge guides to position mounted slides precisely over the opening in the holder, and spring clips to hold the slides in place. To use, install the slide holder from the front, so it fits into the two slots on each side of the base.

If you need to move the slide from side to side for cropping, the slide holders are not suitable. Lay the slide directly on a glass stage plate and position it with your fingers.

Other Macrophoto Stand Accessories—When working at high magnification, it is difficult to move the subject a small amount to improve the composition. Usually you will move it too much or in the wrong direction if you try to do it with your fingers. An accessory called the Mechanical Stage solves this problem. It fits on the base of the Macrophoto Stand and has two arms that extend out over the stage plate. One arm is curved and spring-loaded so it exerts force toward the other arm. Thus the two arms can hold a specimen mounted in a glass slide or other small objects.

Two micrometer screws on the Mechanical Stage control placement of the object being photographed. Turn one screw to move it in one direction; the other to move it at ninety degrees.

Another accessory is the two-piece Extension Column used to make the column taller on the mcrophoto stand so you can photograph a larger area at reduced magnification. To install, remove the Accessory Mount fixture at the top of the standard column; screw in one or both parts of the extension; reinstall the Accessory Mount. Each of the two extensions is 58mm long.

Figuring Magnification—Use the formulas already given or refer to the tables for extension tubes and bellows.

Color-Correcting the Light—Depending on the light source and the type of film you are using, it may be necessary to use color filters to get

realistic colors in the photos. Or you may want to use color filters for a special effect. The Filter Holder in the Lighting Table can be usd with suitably-mounted gelatin filters, or gel filters can be installed on the front of the camera lens using a Pentax Gelatin Filter Holder, or glass filters can be screwed onto the front of the lens.

QUALITY OF DUPLICATE SLIDES

Most use of slide-duplicating equipment is to copy a color transparency. Sometimes the goal is to obtain an exact duplicate, which is virtually impossible, however the results are often quite satisfactory and accepted as duplicates even though close comparison will show them not to be.

Color films are manufactured for a certain type of lighting, such as daylight. If you are copying *any* slide onto daylight film in your camera, the slide holder should be illuminated by daylight or equivalent. If you use light of a different color, the copy will show the effect in the same way that any film shows the effect of not using the correct color of light for exposure.

Photographic daylight is a combination of direct sunlight and light from the sky. The handiest source for daylight is daylight if you are using one of these duplicating sets that requires external illumination. The reflection from a white piece of paper illuminated by both sunlight and skylight is a good daylight source.

If you are using indoor film designed for indoor tungsten or incandescent lighting, you must illuminate the slide being copied with light from an incandescent lamp or equivalent. There may be a problem with color of the light— called *color temperature.*

The color of the illuminating light, and its effect on the film can be adjusted by use of color filters screwed into the camera lens. This will not interfere with attachment or use of slide-duplicating equipment. Chapter 12 has more information on light and filters.

You should be able to get enough light into the camera so you can use the built-in meter and use exposure times short enough to avoid reciprocity failure of the film.

With careful attention to the color of light used to illuminate the slide being copied, use of color filters over the camera lens as needed, and possibly some testing, you can get a pretty good color match between the original and the copy. If you don't compare them side by side, the copy will normally be considered a satisfactory duplicate as far as the main colors are concerned. Exact duplicate colors may not really be important anyway, because the original slide normally does not match the actual colors of the scene it represents.

A problem that cannot be solved with this type of duplicating equipment is increased contrast in the copy. The dark areas appear darker, compared to the light areas. Sometimes this improves the slide artistically, but sometimes it doesn't. The reason is mildly complicated, but is based on the fact that slide duplicating in the camera is a positive-to-positive process. You start with a positive image on the slide to be copied and end up with another positive image—without an intervening negative. This results in increased contrast. Commercial photo labs also do positive-to-positive work, such as making a print from your slide, but when best quality is required commercial labs recommend and use a positive-negative-positive process where the intervening negative (internegative) prevents contrast build-up in the copy. Consult any price list and you will see that printing or duplicating with an internegative costs more because there are more steps involved.

Kodak Ektachrome slide-duplicating film is designed to reduce contrast build-up when making positive-to-positive copies of slides. Until recently it was available only in 100-foot rolls. Now it is available in 35mm cartridges.

Should You Buy Slide-Copying Equipment?—If you want *duplicate* slides—meaning good copies of the original—and need only a few on rare occasions such as once a year, you are probably better off having your work done by a commercial lab. If you need them in large volume and often, you can save money by getting equipment and making them yourself—although you will certainly not save time.

If you know you will need a few copies of a certain slide, the simplest way to get them is shoot the needed number of frames while you are photographing the subject.

Slide-copying equipment is a good purchase if you have interest in altering the image while making the copy. This includes changing magnification, cropping, changing color by filters or controlling color of the illuminating light, and other artistic or corrective variations. Many photographers combine images by sandwiching two or more slides and copying the combination. You can add backgrounds, clouds and moons in the sky, get overlapping images similar to double exposures and produce many other unusual or interesting effects.

Results can be believable images or unbelievable and surprising combinations, depending on what you like to do.

USING CLOSE-UP AND MACRO EQUIPMENT

Except when using flash, camera support is recommended. High magnification and long exposure times both make it likely that hand-holding your camera will result in a blurry picture.

When you have taken time to put the camera on a support, it makes sense to follow some other simple precautions to reduce the possibility of camera motion during exposure. A good rule is: Whenever you have the camera on a support, use a cable release to trip the shutter, or the camera self-timer.

Some mechanical camera supports, such as tripods, are stable unless they receive a bump or jolt. Then they will vibrate for a while and mess up your photo. Just touching the camera to release the shutter can cause vibrations which persist during the exposure period.

Mirror motion inside the camera happens just before exposure, but it also can set up vibrations which last into the exposure interval. If your camera has a mirror lock-up control, use it whenever the camera is on a tripod or other firm support. Set all camera controls and get ready to shoot. Last thing is to lock up the mirror so that mechanical motion is all done and the vibrations over with. Then trip the shutter with a cable release or timer. If you use the timer, set it for a long run to allow the vibrations to settle down—which you caused by touching the camera.

When you are using a lot of extension, focusing the lens causes a large change in magnification in addition to a change in focused distance. Earlier I recommended setting the focus control for magnification and then moving the entire camera toward or away from the subject to find best focus. If you have the camera mounted on a tripod and are using extension tubes, this is not convenient be-cause it means moving the entire tripod. Often the camera movement must be done very gradually and in very small increments so you can find focus.

A clever little gadget, called a Fine Focus Adjuster fits between camera and tripod and allows finely controlled fore-and-aft movement of the camera. The unit is similar to the geared tripod mount on the auto bellows except it does the job when you are using extension tubes.

Finding best focus is aided by a Clip-on Magnifier which fits into the grooves at the sides of the view-finder frame. This magnifies the finder image by 2.0 and helps in critical focusing. You can't see the entire frame with the magnifier in place, however it is hinged so it flips out of the way quickly.

For copying documents and high-magnification photography of small objects such as stamps, coins or jewelry, a copy stand is convenient. Pentax offers two models, one portable. The base of the port-able unit is a box which holds the disassembled upright metal column and other hardware along with a camera and some accessories.

The most portable copying aid is the Copipod, a 4-legged "tripod" in a carrying pouch. It is small enough to fit in luggage or a brief case.

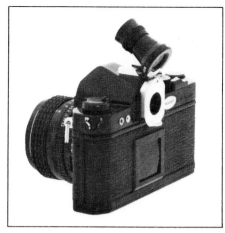

A magnifier helps find best focus, flips up out of the way when you want to examine the entire frame.

It is available with adapter rings which screw into the filter-mounting threads on the camera lens to mount your camera on top of the Copipod. Be sure you get the right size attachment ring.

Depth of field is often a major problem except for flat subjects. To get reasonable depth of field requires shooting at small aperture, which in turn may complicate lighting for exposure. When the camera lens is close to the subject, it is sometimes difficult to get enough light. This is largely a matter of technique and the lighting equipment you have available.

A mirror lock is useful at high magnification or with very long lenses to reduce vibration during exposure. On the LX, use the Multi-Function Lever (arrow) to lock the mirror up.

With higher-than-normal magnification, depth of field is shallow. The best way to find focus is move the entire camera. With extension tubes or close-up lenses, the Fine Focus Adjuster makes small adjustments easy.

A Fine Focus Adjuster is part of Pentax copy stands. This is Copy Stand III Copy Stand IIIP uses a wooden box for its base and all the parts fit into the box for portability.

For magnifications higher than 8 or 10, use a Microscope Adapter to photograph through a microscope. Photo by Gene Wentworth.

The Copipod folds up and fits in a small pouch so you can carry it in a briefcase or camera gadget bag. It is useful for table-top copying and similar applications. An adapter threads into the filter ring on the lens. The adapter is held into the top of the Copipod by a set screw. For lenses with 52mm filter threads, buy Copipod 52mm. For lenses with 49mm filter threads, buy Copipod 49mm. Step-up or step-down rings can be used to convert thread diameters as necessary. To change magnification, use extension tubes between lenses and camera. Filters fit between lens and adapter.

PHOTOMICROGRAPHY

This is photographing through a microscope to get magnifications larger than the 8 or 10 normally practical with extension tubes and bellows.

Because the microscope replaces the camera lens, there is no camera f-stop to be concerned with. Exposure is arrived at using whatever light comes into the camera and an appropriately long exposure time. This makes lighting of the subject critical and sometimes difficult. The technique of using microscopes and illuminating the subject is beyond the scope of this book, but can be found in books on microscopes.

12
LIGHT, FILTERS AND FILMS

Several characteristics of light affect equipment and technique when taking pictures.

COLOR OF LIGHT

We call direct light from the sun *white*. It is composed of all the colors in the visible spectrum. Light appears to travel in waves, similar to waves in water, which have different wavelengths. Different wavelengths appear as different colors in human vision.

The accompanying drawing of the visible spectrum shows colors of visible lights and their approximate wavelengths—Figure 12-1.

Human vision does not actually repond to all colors of light. We see only three colors: Red at the long-wavelength end of the spectrum, green in the middle, and blue at the short-wavelength end. The sensation of other colors is produced in the mind by noting the relative proportion or the mix of these three *primary colors.*

Beyond the visible blues in the spectrum are shorter wavelengths called *ultraviolet*, abbreviated UV. We can't see them, *but film can* and most types of film will be

When sunlight is separated into its components by a prism or rainbow, we see the colors of the visible spectrum.

WAVELENGTH (nanometers) 300 400 500 600 700 800

Ultraviolet | Violet | Blue | Green | Yellow | Orange | Red | Infrared

Figure 12-1/The difference between one color and another is wavelength. Long waves cause the sensation of red; short waves cause blue; green is in the middle. Wavelength is expressed in *nanometers*, one-billionth of a meter.

exposed by UV. When you expose ordinary film, color or b&w, in your camera, some exposure results from light you can see and some from UV wavelengths you can't see. At times this is a technical problem and there are technical solutions.

Most films do not respond to wavelengths longer than visible red, called *infrared* or IR, but some special films do. You have probably seen photos taken with IR-sensitive film and noticed that natural objects such as water and foliage do not photograph the same in IR as in visible light.

Photos taken with b&w infrared usually have unnatural-looking contrast and tones because film exposure is determined by the temperature of objects. Sky doesn't radiate much heat, so it is dark. Nearby bushes, warmed in sunlight, are light-colored. Unusual rock formation is called Cochise Head.

Even though our eyes cannot see IR, we have a sensor for it—our skin. IR waves are "heat waves" and cause the sensation of warmth. When you take a picture using IR film you are photographing reflected or radiated *heat* from the scene rather than visible light. People use IR films both for fun and science, but I don't consider it a major part of ordinary picture taking.

LIGHT SOURCES

Not all light sources produce the entire spectrum. There are two main categories: Those which produce light due to being heated are called *incandescent.* Incandescent sources include the sun, a candle or campfire, and the common household lamp which is sometimes called an incandescent lamp but in photography is called a *tungsten* lamp. The glowing-hot filament inside an incandescent lamp is made of tungsten.

The other category of light sources does not depend on temperature to make light. These are sources such as fluorescent lamps and the yellowish sodium-vapor lamps used to illuminate highways and streets. The quality of light from non-incandescent sources is often a problem in color photography.

COLOR TEMPERATURE

The light produced by an *incandescent* source—including the sun—depends on its temperature. By stating the temperature of the source, the color balance of the

light is implied. When so used, the temperature of the source is called *color temperature.*

Figure 12-2 is the spectrum of several color temperatures. The main thing to observe is that low temperatures produce mainly long wavelengths of light which we see as red, orange and yellow. Candles and matches operate at low color temperatures and you don't see any blue or green in candlelight.

As color temperature increases, the amount of short-wavelength light increases. At a high color temperature, the light appears to be more blue than red. Light from the sky is a very high color temperature and it is blue.

So far this is all technical and not very practical. However, in practical photography you worry about color temperature in one of two ways. For ordinary photography, you think of it in general terms: Is the light warm-looking and made up of red and yellow colors or is it cold-looking and bluish? Are you shooting outdoors under the blue sky, or indoors with warm tungsten illumination?

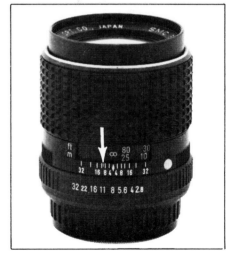

Lenses usually have a special focusing mark (arrow) for use with b&w infrared film. With visible light, focus the normal way while viewing the scene. Then put on an IR filter which excludes visible light. Refocus by moving subject distance from normal index mark over to special IR focusing mark. Color IR films allow visual focusing and use the normal focusing index mark on the lens.

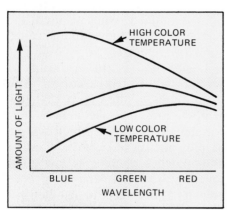

Figure 12-2/Incandescent objects radiate light because they are hot. Low color temperatures mean long wavelengths and reddish light. High color temperatures result in bluish light.

In everyday photography you respond to these questions by selecting film and choosing filters to control the color of the final image.

If you do technical photography where exact color rendition is important, you worry in more detail and use color temperatures to make equipment choices. Color temperatures are disguised in the technical term *mired*. A discussion of these matters is in my book *Understanding Photography*.

Color temperatures are just labels to indicate the color quality of light, expressed in absolute temperature—degrees Kelvin (K).

You can talk about the warm color of candlelight or a color temperature of 1,800 degrees Kelvin. If you say 3,200 or 3,400 degrees, some people will know you are talking about the light produced by the two types of photoflood lamps used in photography. They have a higher color temperature than ordinary room lamps.

Sunlight alone is about 5,000 degrees but the cold-looking blue light from the sky may be around 12,000 degrees. Therefore *combinations* of sunlight, light from the blue sky and a few puffy white clouds—which we call average daylight—is between those two color temperatures. It is about 5,500 to 6,000 degrees. Light from an electronic flash simulates daylight.

A subject in the shade of a tree is illuminated only by the blue light from the sky without the "warming" benefit of direct sunlight. We think the light is cold-looking and too blue.

Much of color photography is concerned with these color effects and sometimes changing them.

THE COLORS OF THINGS

A white piece of paper reflects whatever color of light falls on it. If illuminated by white light, it looks white. If illuminated by red light, it looks red.

Things which don't look white may owe their color to the light which is illuminating them, or to a property known as *selective reflection*. That means they do not reflect all wavelengths of light uniformly. A blue cloth in white light looks blue because it reflects mainly blue wavelengths. The other wavelengths of white light are absorbed by the cloth.

The color of transparent things such as glass is determined by *selective transmission*. Blue glass looks blue because it transmits mainly blue wavelengths. If illuminated by white light, blue wavelengths pass through the glass to your eye.

The other wavelengths are either absorbed by the glass or reflected from its surface—back toward the source. As far as the viewer is concerned, the glass looks blue because only blue wavelengths come through. To the viewer it doesn't matter what happens to the other wavelengths as long as they don't come through.

In general, the color of an object is determined *both* by the color of the light which illuminates it and the selective transmission or reflection of the object.

THE VISUAL COLOR OF FILTERS

If you hold a color filter between your eye and white light, you see the colors which are *transmitted* or passed by the filter. The effect of a filter on film is often more easily predicted by thinking about the colors the filter *stops* rather than those which get through.

Because human vision responds only to red, green and blue, it is only these three colors and their combinations that you have to worry about.

If a filter blocks all three primary colors completely, it looks black. If it reduces light transmission but some light at each color still comes through, the filter appears gray.

APPROXIMATE COLOR TEMPERATURES OF COMMON LIGHT SOURCES (degrees Kelvin)	
Setting sun	1,000K approx.
Burning candle	1,800K
Household incandescent lamps	2,500 to 3,000K
Professional photo lamps	3,200 and 3,400K
Clear flash bulbs	4,000K
Direct sunlight	4,000K to 5,000K
Commercial theater motion picture projector lamps	5,000K
Average daylight (sun, sky, and random clouds)	5,500 to 6,000K
Electronic flash	6,000K
Sun and blue sky	6,500 to 7,000K
Blue sky only (no direct sunlight)	8,000 to 20,000K or more

All successful photos solve technical and artistic problems. The technical problem here was getting fairly good exposure both outdoors and indoors. Solved very simply by waiting for twilight.

Other than that, color filters usually operate by reducing the amount of light transmitted at one *or two* of the three primary colors.

If a filter blocks red, then it transmits both blue and green. To the eye, light coming through the filter appears bluish-green—a color photographers call *cyan*. We say cyan is the *complementary* color to red because you get cyan if you block red but transmit blue and green. Each of the three primary colors has a complement, according to this table.

Primary Color	Complementary Color
Red	Cyan (Blue-Green)
Green	Magenta (Red-Blue)
Blue	Yellow (Red-Green)

In printing color films, laboratories use complementary-colored filters, so the words *cyan, magenta* and *yellow* are part of the language of photography and you should know what they mean.

ADAPTATIONS OF THE EYE

There are three kinds of human visual adaptation which are important in photography. One relates to the brightness of light. We can be visually comfortable in outdoor sunlight. On entering a building, we have the sensation that it is darker only for a few seconds and then we adapt to the lower level of illumination and don't notice it any more. On returning outdoors, we again adapt to the higher brightness in a short time.

The result is, people are very

Scattering of light is caused by the air itself plus dust and smog. If the air is clean, haze looks blue. It gives a perspective effect in photographs, calling attention to the fact that distant objects are distant. Water, dust, and smoke in the air scatter all colors of light. The resulting haze looks white and you can't see through it for any long distance.

Color filters change the color of light by transmitting some wavelengths and blocking others.

Atmospheric scattering extracts blue light waves from sunlight and scatters them all over the sky which makes the sky look blue. Without the blue component, sunlight looks more red-colored. At sunrise and sunset, sunlight travels through more atmosphere, more blue light is scattered, so morning and evening sunlight is more red-colored.

VISUAL APPEARANCE OF FILTERS	
Red	
Green	
Blue	
Cyan	
Yellow	
Magenta	

Some color filters are designed to affect only one or only two of the three color-sensitive emulsion layers of color film. Such filters have the primary and complementary colors when held against white light. These colors are approximately as shown here.

poor judges of the amount of light and should rely on exposure meters which don't have this problem.

We also adapt to color of light in the same way. If you are reading at night, using a tungsten reading lamp, you adapt to the yellowish color and don't even notice it. The paper in this book looks white to your mind. Go outside and look at your window. It will be obvious that you are reading in light which has a definite yellow cast.

Another adaptation results from your feeling of *participation* in a real-life situation. This turns up in several ways which often make a photo look ridiculous.

You can pose somebody in front of a tree and think it's a fine shot. When you look at the print, a tree limb seems to be growing out of your model's ear which seems absurd in the picture, even though it didn't bother you at all when it was real life.

When you look at a person in side-lighting, half of the face is in deep shadow but you think nothing of it. You know the person has a complete face with the two sides similar to each other. Take the picture and it will look different. Without being there, you are not nearly so charitable and when looking at the picture you ask, "Where is the other side of that guy's face?"

THE EFFECTS OF ATMOSPHERE

The sun flings energy toward the earth over an extremely wide spectrum, part of which is visible. The atmosphere acts as a *filter* to block transmission of some wavelengths and allow transmission of others, including all visible wavelengths.

The atmosphere also has an effect on light rays which is called *scattering.* Instead of coming straight-arrow through the air, some light rays are diverted from the straight path and bounce around in the atmosphere. This is light from the sky as opposed to light directly from the sun.

It happens that the atmosphere scatters short wavelengths much more than long wavelengths. Therefore blue light is extracted from the direct rays of the sun and scattered all over the sky. That's why the sky is blue.

More blue light is removed from sunlight by scattering when there is more air between an observer and the sun. At noon, sunlight comes directly to the earth where you are and makes the shortest path through the air. Therefore there is a minimum scattering of blue light and more of it is in the direct rays of the sun.

At morning or evening, the sun's rays come to you at an angle and therefore travel through more air. More blue light is extracted from the sun's rays, so sunlight appears to be more red-colored.

On a nice clear day, the sky is blue except near the horizon where it often looks white. This is another form of scattering caused by dust and smoke particles which are large enough to reflect most wavelengths of the visible spectrum. They scatter all of the light from the sun and the lower atmosphere appears to be white.

If you look from here over to that distant mountain, you are looking through a lot of lower atmosphere with both white-light scattering and blue-light scattering. The light rays coming to your eye from trees and rocks on the mountain are diverted from straight paths, details are obscured and the image looks hazy. We call that *atmospheric haze.* Fog is water droplets in the air and is worse than dust and smoke as a light scatterer and image obscurer.

The air itself scatters blue light and other particles in the air tend to scatter all colors of light. Therefore even from point to point in the lower atmosphere, blue light is scattered more than any other wavelength.

If you take a picture without using the blue light rays to expose the film, there will be less atmospheric haze in your picture. Details of a distant scene will be more distinct. You can do that by putting a color filter over the lens which excludes blue light. It must therefore pass both green and red light. If you hold such a filter against white light it will look yellow, because the combination of red and green makes the sensation of yellow light.

It is common to use a yellow-colored filter over the lens to cut atmospheric haze. This works fine on b&w film, but on color film it will make a yellow-colored picture.

If your picture on b&w film is still too hazy with a yellow filter, remember that short wavelengths of light are scattered more than long wavelengths. If excluding short wavelength blue won't do the job, try also leaving out medium-wavelength greens. The filter now transmits red only, but image detail is greatly improved.

What if you exclude blue, green and also red? That will use still less scattered light to make the picture. A filter that excludes all three primary colors will look black because no visible wavelengths get through. Invisible IR wavelengths can come through a very dark-looking red or IR filter and expose IR film. That's the best haze cutter of them all.

Another effect of light scattering between your camera and the scene is reduced contrast of the image on the film. Light rays coming from bright parts of the scene are diverted by scattering so they land on the film at the wrong places. Some will land where it should be dark and that will make the dark places lighter.

You can see this when outdoors on a sunny day. Notice the contrast in brightness between sunlight and shadow near where you are. Then look as far away as you can and compare the brightness of sunlight and shadowed areas over there. The shadows will appear much lighter than those nearby—due to atmospheric scattering.

Any filter which blocks scattered rays will improve contrast and sharpness of the image on the film.

Top photo at right made with panchromatic b&w film and no filter. Distant valley is obscured by haze. You can see successive improvements in haze-cutting with a yellow filter and, at bottom, a red filter. As filter color becomes more red, it excludes more of the scattered blue light.

Photo at left made with blue filter which transmits haze and blocks longer wavelengths which carry picture detail.

COLOR-SENSITIVITY OF B&W FILM

Even black-and-white film is color sensitive. The early b&w emulsions were sensitive mainly to blue and UV light. Photos of women with red lipstick caused the lipstick to appear black because the film did not respond to red.

An improved film, called *orthochromatic* was still deficient in red-response.

Current b&w films, called *panchromatic* are said to be responsive to all visible wavelengths and as a practical matter, they are. There is still a slight deficiency in red response and too much sensitivity to blue, but it is usually not noticeable.

COLOR FILTERS WITH B&W FILM

Because the result of exposing b&w film to light of various colors is always shades of gray between black and white, we tend to think b&w film is colorblind.

It is difficult to relate the color response of b&w film to human

Photos made with clouds in the sky usually show less contrast between clouds and sky than you saw when you took the picture.

You can get nearly as much sky darkening as you want by using yellow or red filters. Red filters give the darkest sky and influence the tones of colored objecteds in the scene when you are using b&w film. With color film, red filters make a red picture.

With color film objects are visually separated by different colors even though they may be the same brightness.

With black-and-white film, there are only shades of gray to distinguish one object from another. Without a filter, there's not much visual difference between a red tomato and a green pepper.

Used with b&w film, a color filter lightens its own color. Here a yellow filter was used. It lightened the lemon. Tomato and pepper are still distinguishable from one another mainly by shape.

Green filter blocks red light from tomato to make it appear darker. Slight lightening of pepper, not much effect on lemon.

Red filter lightens its own color and also lightens lemon because yellow wavelengths are close to red. Darkens pepper slightly. Use of color filters to improve contrast in b&w is generally predictable but sometimes there are surprises.

The overall orange color of this color negative is caused by masking, which is removed by filtering when the print is made. Notice the reversed densities of colors between negative and positive.

vision which notices *both* color and brightness. Technically, they are tied together by saying that the brightness of an object in b&w, even though it is gray, should correspond to the brightness of that object in the original scene as viewed by people, never mind what color it is.

I think it is more important to recognize the fact that the major problem of b&w film is just that— it records in shades of gray. The print does not show colors which help to distinguish a red apple from green leaves or a yellow skirt from a blue sweater. If the skirt and

sweater happen to cause the same shade of gray on the film they will look the same in b&w.

Usually a b&w picture is improved if objects of different color record as different tones or shades of gray because the viewer of the print *expects* to see some difference between a necktie and jacket, or a rose and foliage.

You can use color filters on your camera so there is a visual difference between adjacent objects of different colors, as you can see in the accompanying photos.

The rule when using color filters with b&w film is: *A filter lightens*

its own color. This applies to the final print, not the negative, but it is the print you are concerned about. A corollary to the rule is: *A color filter used with b&w film darkens every color except its own.*

I often use color filters with b&w film to get strong visual differences in tone between colors of the scene.

It is common with b&w film to use filters to make clouds stand out against a blue sky. With no filter, clouds in the sky are sometimes nearly invisible and the entire sky is light-colored in the print. It is much more dramatic to have a dark sky with white clouds.

White clouds reflect all colors of light, but the sky is blue. Suppress blue with a filter and the sky darkens. The clouds darken too, but not as much. Because you are using b&w film, you can go as wild as you want with filter colors and only different shades of gray will result. The heirachy of sky-darkening filters for b&w film runs from yellow to light red to dark red with more effect as you use darker reds.

Naturally the effect of a red filter appears on everything in the scene. If you include a model with red lipstick, the filter is an open door for red color and your model's lips will be lighter in tone.

A compromise filter often used for outdoor b&w portraits is a shade of green. This suppresses blue to darken the sky some but also holds back red so makeup and skin tones are not affected so much as with a red filter.

HOW COLOR FILMS WORK

Color film and the color-printing process used in books and magazines is possible only because human color vision is based on the three primary colors. A color picture needs to have only these three colors mixed in proper proportions to do a very good job of presenting all colors we can see.

Color film does this with three different layers of emulsion coated on a base. The main difference

between a color slide and a color print is, the base of the print is opaque white paper.

The trick of color film is to use one layer to record the amount of each primary color—at every point in the scene. When viewing a color slide by transmitted light, or a print by reflected light, each layer controls the amount of light at its own primary color. The light we see from the combination of all three layers causes our vision to see the colors of the original scene.

Naturally the colors we see when viewing a slide or print are affected by the color of the light or room illumination where we are viewing the picture.

NEGATIVE-POSITIVE COLOR

Color prints are obtained from color negatives in a two-step procedure. A comparison to b&w will be useful. In b&w negatives, the shades of gray are reversed from the original scene. A white shirt appears black in the negative.

In color-negative film, after development, each layer transmits a reversed density of that particular color. If the subject is strongly red, the color-negative layer will be strongly not-red, meaning cyan-colored. A color print made from the negative reverses the color densities again with the result that a strong red in the scene becomes a strong red on the print.

You have probably noticed an overall orange color of color negatives. Even the clear parts have an orange cast. The dyes used in color films are as good as each film manufacturer can make them, but not as good as the manufacturer would like them to be. These slight deficiencies in the color dyes are corrected by a complicated procedure called *color masking*. Evidence of masking is the orange color. It is removed when the print is made.

Because of color masking, the colors in a negative-positive process can be more true-to-life.

If a color print is made and the colors don't look quite right, it can be fixed by making another print.

Color filters are used to change the color of the *printing* light and thereby make small corrections in the color balance of the final print.

If you miss exposure a step or two when using color-negative film, it is often possible to make a correction during printing, so the print is properly exposed and not too dark or too light.

Color-negative film allows the camera operator to make small mistakes, or be less precise about his work, and still end up with an acceptable print.

COLOR-SLIDE FILM

A color slide or transparency is the same piece of film you originally exposed in the camera. It is developed and chemically processed to make a positive image directly. This procedure is called *reversal* processing because it makes a positive out of a negative. There is no color masking because there is no opportunity to remove the orange color when making a print. The color balance of slide film is *theoretically* inferior to that of a good color negative-positive procedure but in practice, it's hard to see any problem with slide-film colors.

Because there is no separate printing step to make a color slide, there is no opportunity to correct a bad exposure and no way to change the color balance of the positive. This makes exposure more critical, both in the amount of light on the film and its color.

Color-slide film will often make a perfectly good image when under- or overexposed a small amount, but it won't *look right* when projected on a screen. It will be too light or too dark overall, particularly when viewed in succession with other sides which were properly exposed. For this reason, we say that color slides should be correctly exposed—within half a step either way.

When any color film—negative or reversal—is seriously over- or underexposed, two effects may result. One is comparable to over- or

underexposing b&w film. Light areas become too light, or dark areas become too dark, and contrast is lost between portions of the scene in the too-light or too-dark area.

The second effect is peculiar to color film and is caused by reciprocity failure of the three layers, acting individually. Because the three layers are *different emulsions,* they usually don't go into reciprocity failure simultaneously and when they do, they don't react in exactly the same way.

A typical result of serious exposure error with color film is that one layer goes into reciprocity failure and needs more exposure but doesn't get it. Therefore that layer is effectively underexposed and does not properly control its color when developed. The end result is an overall color cast, such as pink or blue, which affects the entire picture.

This can be corrected in a negative-positive process if the color change is not too severe. But with color-slide film, you get what you shoot. Manufacturer's instructions for correcting reciprocity failure with color film usually call for *both* additional exposure *and* a color filter over the camera lens.

Making Tests—Whenever you are making tests of equipment or your skill, it's important to see what you actually put on the film. Most film laboratories will automatically make corrections when printing b&w or color negatives to compensate for apparent errors in exposure or color balance. If you are testing exposures and deliberately shoot some frames over- or underexposed, you don't want the lab to correct your shots.

Color-slide film is the best way to make tests. What you get is what you shot, without any corrections by the film lab.

FILTERS FOR COLOR FILM

First, you should know there are three types of color film. Two are made so they make a good color image with tungsten illumination.

STANDARD PENTAX FILTERS

Film	Filter Type	Filter Appearance	Purpose
B&W	UV	Clear	Block UV
	Ghostless UV	Clear	Block UV, minimize reflections from surfaces of filter
	Y1	Light Yellow	Darken sky and water, cut haze
	Y2	Medium Yellow	More darkening of sky and water; more haze cutting
	O2	Medium Orange	Still more darkening of sky and water; more haze cutting
	R2	Medium Red	Maximum sky darkening and haze cutting
	YG	Yellow-Green	Outdoor portraits; natural reproduction of foliage
Daylight Color	Skylight	Light Pink	Warming effect on color pictures shot in the shade
	Ghostless Skylight	Light Pink	Same with reduced reflections from surfaces of filter
	Cloudy	Light Brown	More warming effect for subjects photographed on overcast day
	Morn & Eve	Light Blue	Reduces red color of early and late sunshine
	Flash	Blue	Use with clear flashbulbs
	Flood	Dark Blue	Use with tungsten light
	FLR	Salmon	Use with fluorescent light
Any Type	Polarizer	Gray	Polarize light entering lens
Tungsten Type A	Type A	Orange	Tungsten film with daylight

Pentax filters come in thread sizes to fit most lenses. Most are available with Super Multi-Coating (SMC) which reduces flare and improves contrast.

If you use tungsten film in tungsten light, the manufacturer has already solved the problem for you and you don't have to use a filter to change the color balance of the light that gets on the film.

If there is not enough room light to shoot with, you can add light by using special photo lamps, commonly called *photofloods*. There are two types. Photofloods that are unmarked for color temperature operate at 3,400K to get more light output but with shorter life. Those marked 3,200K operate at that temperature, which is closer to normal room lighting.

Type B tungsten film is intended for use with 3,200K lights. If you use 3,400K lamps with Type B film, you should use a filter over the camera lens.

You can often "get away" with mixing 3,400K photofloods with room light from table and floor lamps, but technically this is mixed lighting with a visible color difference between the two types of light.

Type A color film is designed for use with 3,400K lighting. If you use it with 3,200K lamps or ordinary room lighting, you should use a filter over the camera lens to compensate for color temperature.

The accompanying tables give filter recommendations for various types of films and lighting.

Daylight color film is balanced for daylight, but you may need to use a filter anyway.

Ultra-violet light is reduced by the atmosphere but present in some amount everywhere. The higher you are in altitude, the more UV there is to expose your film. You can't see it and your exposure meter probably ignores it, but the film will be exposed by UV. There are *UV filters* which reduce transmission of UV. They are clear because they don't stop any visible wavelengths.

Even at sea level they are of benefit—partly because they protect the lens itself. In the mountains a UV filter should always be used. This applies equally to b&w and color film because both are sensitive to UV.

If atmospheric haze is a problem, you want to exclude short wavelengths. With color film, you can't use a strongly colored filter unless you want the picture to have that color. *Haze filters* for color film cut UV and also cut some of the barely visible blue wavelengths—the shortest. A haze filter for use with color film is practically clear. If you use one, you don't need a UV filter because it will do both jobs.

A subject in shade outdoors is illuminated by skylight which has more blue in it than average daylight or direct sunlight. With color film, the effect is usually noticeable as an overall blue cast to the picture and bluish skin tones on people. *Skylight filters* for use with color film block some of the blue light to give a more warm-looking picture. Some photographers like the effect even in daylight or direct sunlight, so they put a skylight filter on the lens and keep it there all the time with color film outdoors. It also blocks UV.

There are filters which allow you to use indoor film in daylight, and daylight film indoors.

Using daylight slide film with tungsten lighting makes the scene appear orange. This is often acceptable unless there are people in the picture.

A light-conversion filter such as an 80A converts tungsten light so it appears as daylight to the film. Skin tones improve. The conversion filter is blue-colored.

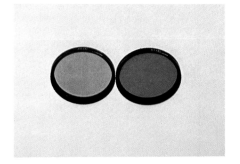

Orange-colored filters make daylight look OK to tungsten film. Blue-colored filters make tungsten light look OK to daylight film.

Warm-looking tungsten light on one side and daylight on the other don't work with tungsten film. Daylit side looks too cold. Warm up daylight by using an 85 or 85B filter so daylit side of subject looks OK. Other side looks a little too warm, but this is the best choice.

OTHER BRANDS OF FILTERS

FILM TYPE	DESIRED RESULT	LIGHT ON SCENE	VISUAL COLOR OF FILTER	HOYA	TIFFEN	VIVITAR	BDB FILTRAN	FILTER FACTOR (Approx.)
Any	Reduce UV exposure of film	Day	Clear	UV	Haze 1	UV-Haze	UV/Haze	1X
	Reduce amount of light 2 stops without affecting colors	Any	Gray	NDX4	ND 0.6	ND-6	ND4X	4X
	Reduce amount of light 3 stops without affecting colors	Any	Gray	NDX8	ND 0.9			8X
	Soften facial lines in portraits, soften lines in any image	Any	Clear	Diffuser	Diffusion Filter #1	Soft Focus	Soft Focus	1X
	Increase softening effect	Any	Clear	Soft Spot	Diffusion Filter #3			1X
B & W	Darken blue sky and sea, lighten clouds for contrast	Day	Light Yellow	K2	6	K2	Yellow	1.5X
	Stronger sky/cloud contrast, lighten yellow and red	Day	Dark Yellow		9	G-15		2X
	Outdoor portraits, natural reproduction of foliage	Day	Green	X1	11	X1	Green	2X-4X
	Improve contrast of distant landscapes, penetrate haze	Day	Orange	G	16	O2	Orange	3X
	Exaggerate sky/cloud contrast, dramatic landscapes	Day	Red	25A	25A	25(A)	Red	8X
Day-Light COLOR	Reduce blue effect of open shade, overcast days, distant mountain scenes, snow	Day	Very Faint Pink	1B	SKY 1A	1A	Skylight 1A	1X
	Warmer color in cloudy or rainy weather or in shade. More effect than Skylight filter	Day	Pale Orange	81C	81C	81C	R1-1/2	1.5X
	Reduce red color when shooting daylight film in early morning or late afternoon.	Day	Light Blue	82C	82C		B 1-1/2	1.5X
	Use with daylight film for shooting with clear flashbulbs at night or indoors	Clear Flash-bulb	Blue	80C	80C	80C	B6	2X
	Normal color when exposing daylight film under 3400K tungsten tungsten lighting	Tung-sten	Blue	80B	80B	80B	80B	3X
	Normal color when exposing day-light film under 3200K tungsten lighting	Tung-sten	Dark Blue	80A	80A	80A	80A	4X
	Reduce blue-green effect of exposing daylight film under fluorescent lighting	Fluor-escent	Purple	FL-D	FL-D	CFD	DAY FL	1X
Tung-sten COLOR	More natural color with tungsten film exposed by daylight in morning or late afternoon	Day	Amber		85C		R3	2X
	Natural color with tungsten Type A film exposed by mid-day sunlight	Day	Amber	85	85	85	85	2X
	Natural color with tungsten Type B film exposed by mid-day sunlight	Day	Amber	85B	85B	85B	85B	2X
	Reduce red effect of shooting tungsten films under ordinary household incandescent lights	Incan-descent	Light Blue	82C	82C		B 1-1/2	1.5X
	Reduce blue-green color effect of shooting tungsten film with fluorescent lighting	Fluor-escent	Orange		FL-B	CFB	ART FL	1X

NOTE: Filters made by different manufacturers are not represented to be exact equivalents even though labeled the same or designated for the same purpose. These filters should be approximately equivalent and satisfactory for the indicated uses. Filter factor may vary with brand.

Available Pentax filters don't cover all applications you may encounter. From this list of accessory filters, you can find others you may need.

To use tungsten film in daylight, the filter has to alter daylight so it looks like tungsten to the film. The filter will reduce the amount of blue and green so what comes through has a color balance similar to tungsten light. Such filters have a yellow-orange appearance when viewed in white light.

To use daylight film indoors, it depends on what kind of illumination is being used inside the building. If it is tungsten light, the filter must change it so it appears to be daylight as far as the film is concerned.

The filter will block a lot of red and will look bluish or blue-green in white light.

If the indoor illumination is fluorescent lamps, it is difficult to filter. Some look bluish and some are designed to look like daylight to humans. Daylight fluorescent light sources do not look like daylight to film. Filter manufacturers offer one or more types of filters for use with fluorescent lighting and the best guide to their use is the maker's instructions.

Except for polarizing and neutral-density filters which will be discussed shortly, those are the filter types which can be used with color film without an unusual or noticeable effect on the overall color of the picture. If you shoot through a red filter, you get a red picture—including skin and snow which most people expect to be skin-colored and snow-colored.

I have done some experimenting with color filters for special effects with color film and enjoy doing it. I suggest you try it.

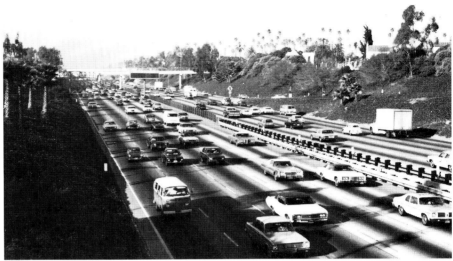

While in Los Angeles, Josh Young became vexed at the freeway traffic and decided to eliminate all other drivers. Notice tree shadows on cars.

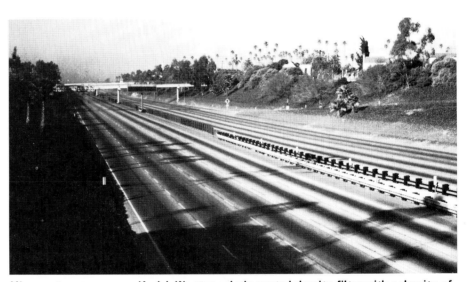

His secret weapon was a Kodak Wratten gelatin neutral-density filter with a density of 4.0. This filter allows multiplying exposure time by 10,000 plus additional exposure for reciprocity failure. No moving vehicle remained in the frame long enough to have visible effect on the film. Tree shadows are still there. Don't vex Josh!

FILTER FACTORS

Most filters reduce light at visible wavelengths. They reduce it more at some wavelengths than others, but the net result is still less light on the film. This does not apply to visually clear filters such as UV and some haze filters for color film.

Filter manufacturers normally state the amount of light loss as it affects the film exposure by a number known as the *filter factor*.

This number is used to *multiply* the camera exposure that would be used *without* the filter—to get the correct exposure *with* the filter. The symbol X is included in a filter factor to remind us that it is used as a multiplier.

Some examples will clarify this. A 2X filter must be compensated by two times as much exposure which is one more exposure step. Use the next smaller f-number or the next longer shutter speed. A 4X filter requires two exposure steps. An 8X filter needs three exposure steps.

Pentax cameras meter behind the lens and the camera exposure meter *automatically compensates* for the effect of a filter on the lens. You can ignore filter factors as long as you are using the camera's built-in meter.

This is a great convenience. You

can put on different filters and shoot quickly just by balancing the viewfinder display for exposure.

You are not getting filtering free. Even though it is simple and uncomplicated to set exposure with a filter on the lens, the correction you make *must* have the effect of increasing aperture or exposure time.

If you are shooting action in poor light and decide to pop on a red filter with a filter factor of 8X so the sky will be dramatic, you may also have a dramatic shooting problem called *you can't do it!* With action, you probably can't slow down the shutter by three steps. If you were already shooting in poor light, you probably can't open up by three *f*-stops and even if you can, depth of field may disappear.

Even though behind-the-lens metering spares you the inconvenience of using filter factors to compensate every exposure, you still need to know about them because they can affect the technical solution you are using to make the picture. Filter factors are also a guide in purchasing a filter because they tell you how strong the color will be. Higher filter factors mean deeper colors and more light loss.

NEUTRAL-DENSITY FILTERS

There are circumstances when you want to get less light into the camera so you can use larger aperture for less depth of field. There are also some cases where you want less light so you can use longer shutter-open times.

Gray-colored filters, called *neutral density* (ND) reduce the amount of transmitted light uniformly across the visible spectrum, which is why they are called *neutral.*

These filters can be used with either color or b&w film because they have uniform color response. Some people say because an ND filter only has the effect of taking out white light, it does not change the colors or color balance of the image. It depends on your point of view. If you look through an ND filter, all colors are different because they are less bright.

Some ND filters are rated the same way as color filters—by a filter factor. Commonly available ratings are 2X, 4X and 8 X.

You may have to stack filters, meaning put one in front of another, to get the required density. When stacking filters using filter factor ratings, the combined rating is obtained by *multiplying* the individual ratings. A 2X filter and an 8X filter used together have a rating of 16X.

Some ND filters are labeled with their optical density instead of a filter factor. The two ratings can be tied together by the fact that each increase in optical density of 0.3 is equal to a filter factor of 2X.

When filters rated by optical density are stacked, the densities *add* directly. An ND 0.3 filter plus an ND 0.3 filter make an ND 0.6 filter—with a filter factor of 4X.

Some technical filters are rated by optical transmittance, or the percentage of light transmitted through the filter. A transmittance of 100% implies no light loss at all.

One can strain the brain in this welter of different kinds of ratings, so I made this table to tie them all together.

Optical Density	Percent Transmission	Filter Factor	Equivalent *f*-Stops
0.1	80	1.25	1/3
0.2	63	1.5	2/3
0.3	50	2	1
0.6	25	4	2
0.9	12.5	8	3
1.0	10	10	3-1/3
1.2	6	16	4
1.6	3	32	5
1.9	1.5	64	6
2.0	1	100	6-2/3
3.0	0.1	1,000	10
4.0	0.01	10,000	13-1/3

You can use ND filters in ordinary photography when the film in the camera is too fast for the job at hand. If you have high-speed film already in the camera and you need to make a shot or two in bright sunlight, clip on an ND filter and effectively slow down the film.

The camera will *behave* as though the film speed is divided by the filter factor. If you have ASA 400 film in the camera and put on an ND filter with a factor of 4X, you will end up setting aperture and shutter speed as if the film had a rating of ASA 100.

Does this mean you should change the film-speed dial of the camera from 400 to 100? No, even though some instructions seem to say that.

POLARIZING FILTERS

Still another property of light waves is responsible for *polarization,* the direction of movement or vibration of the light waves. Water waves serve as a good analogy. Water particles in a water wave move up and down, so the wave is *vertically polarized.* Light can be vertically polarized, horizontally polarized, or polarized in all directions at once—called *random polarization.* Direct sunlight is randomly polarized.

Some materials have the ability to transmit waves with only a single direction of polarization. These materials are made into *polarizing filters,* sometimes called *polarizing screens.* A polarizing filter that transmits vertically polarized light will not transmit horizontally polarized light, and the reverse.

If randomly polarized light arrives at a polarizing filter oriented to pass vertical polarization, the horizontally polarized component will be blocked by the filter. If the filter were perfect, this would block exactly half of the total light in a randomly polarized beam and the filter would have a filter factor of 2X or a density of 0.3. Practical filters vary from around 2.5X to 4X. They don't block all light of the wrong polarization, but the filter material is gray-colored so it also absorbs some light of all polarizations just because of the gray color.

Unpolarized light becomes polarized by reflection from smooth surfaces—except unpainted metal. Where such reflections occur, we

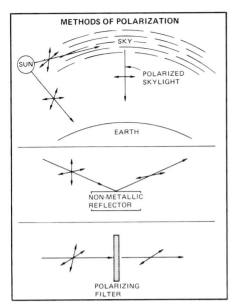

Light from the sky is polarized when viewed at a right angle to the sun. In this drawing, crossed arrows indicate unpolarized light; single arrow perpendicular to ray path indicates polarized light. Light reflected from a non-metallic surface is polarized in the plane of the reflecting surface. Light passing through a polarizing filter emerges polarized, according to rotation angle of filter.

Polarizing filters can remove reflections from windows, darken blue skies without effecting other colors, and do other magic tricks. Notice that the polarizer angle that darkens blue sky is not the same as the angle that removes reflection from glass windows.

see the reflection as glare, such as in a store window or glass display case, and on the surface of varnished wood furniture. When a polarizing filter is used to block such reflections the improvement is sometimes dramatic.

When unpolarized light is reflected from a surface, vibrations in the light which are parallel to the surface are reflected and those which are perpendicular are suppressed. For example, unpolarized light reflecting from a horizontal surface will become polarized horizontally.

Polarizers are normally supplied in mounts which allow the filter to be rotated so you can change the angle of polarization while viewing the result. With Pentax cameras,

meter and set the exposure controls *after* you have rotated the polarizer for the desired effect.

A polarizer is the only way to darken blue skies to make the clouds stand out, when using color film. Scattered blue light from

the sky is polarized and the effect is maximum when viewed at a right-angle to the sun. When you rotate the polarizer so it suppresses the polarized blue light, the sky becomes darker and white clouds become highly visible.

CIRCULAR POLARIZERS

Ordinary mirrors, such as those used in most Pentax SLRs have a thin metal coating on the front, and are called *front-surfaced*. These mirrors do not polarize light when they reflect it because the reflecting surface is unpainted metal.

With a camera using an ordinary front-surfaced mirror, you can use an ordinary polarizing filter and normally there will be no effect on metering or operation of the camera.

The LX and MEF use special semi-transparent mirrors that reflect part of the light and allow part of the light to pass through. These mirrors polarize both the reflected light and the transmitted light.

If an ordinary polarizing filter is used with these cameras, the light transmitted by the filter may not be transmitted through the the mirror because the light has the wrong polarization. It depends on the rotation of the polarizing filter.

The LX uses light transmitted through the mirror for exposure metering. If an ordinary polarizing filter is rotated so this light is reduced, overexposure may result.

The MEF uses transmitted light to operate the auto-focus system. If this light is reduced by use of an ordinary polarizing filter, the auto-focus system may not work satisfactorily.

With the LX and MEF, a special *circular polarizer,* available from Pentax dealers, can be used without noticeable effect on camera operation. This filter has two internal parts. The front part works like an ordinary polarizer and blocks light of a certain polarization, depending on how you rotate the filter. Light passing through the front part is then restored to *circular* polarization by the second part. Circular polarization is equivalent to unpolarized light.

With these cameras, a circular polarizer provides the photographic benefits of polarizing light from the scene without causing operational difficulties.

FILTER MOUNTING

There are about as many ways to mount filters on cameras as human ingenuity can achieve. Pentax uses the screw-type filter, which screws into the threaded accessory-mounting ring on the front of most lenses. Each filter repeats the lens thread on the outer edge of the filter, so a second filter can be screwed into the first. As many filters as desired can be stacked by screwing them into one another.

A problem results from lenses with different screw-thread diameters at the front.

With screw-in filters, the lens-size problem can be solved by purchasing filters to fit your largest-diameter lens. Adapter rings are available at most camera shops. These mount a large filter on a smaller lens. These are usually called *step-up rings* and *step-down rings.* The step-down type puts a smaller filter on a larger lens—which may cause vignetting of the image by blocking some of the light around the edges of the frame. Using a filter larger than the lens rarely causes any problem unless several are stacked.

Pentax offers a 52-49mm Step-Down Ring and a 49-52mm Step-Up Ring.

IMAGE DEGRADATION DUE TO FILTERS

Besides vignetting due to stacking filters, image quality may deteriorate when several filters are used together. The image will normally show no visible effect from a single filter—except the desired effect. You can normally use two without worrying. When using three or more, test first to be sure you don't have problems with an important shot.

The light reflects back and forth between glass surfaces of a stack of filters, just the same as in a lens. Most good quality modern filters are coated to reduce reflections.

Some Pentax K filters are available either Super Multi Coated (SMC) or with the standard single coat. SMC filters benefit the photographic image in the same way SMC lenses do—improved image sharpness, better contrast and less flare. The SMC filters cost more than the old type. The K designation of filters means only that they are in thread sizes to screw into the filter threads of K-type lenses. They are threaded just the same as filters for any other lens with 49mm, 52mm and larger sizes. The 52mm size can be used on M lenses with 49mm filter threads by using a 49-52mm adapter.

Filters have least effect on the image when they are mounted close to the front of the lens. Stacking and use of step-up rings puts some of the glass far enough from the lens to make aberrations and defects more apparent.

Dirt, scratches or fingerprints on a filter surface will scatter the light and reduce image contrast, the same as dirt does on the lens itself. Filters should receive the same care as lenses.

Filters may fade with age, particularly if exposed to bright light a lot of the time. This change is hard to detect because it is gradual, but it may not be important until you can detect it.

FILTER CATEGORIES

There is very little standardization in the names given to types of filters to indicate their purpose. The most common designations are those of Kodak, which have been adopted by several other major suppliers. This discussion uses Kodak terminology.

Filters are often grouped into categories that are logical but possibly misleading. A filter is a filter and it has some effect on light. Even though one may be labeled for use in making color prints in the darkroom, it can be just as useful in front of your camera if you can find a way to hold it there.

Conversion Filters—This type of filter alters the light spectrum to make it suitable for the film you are using. It *converts* the light to

your purpose. Examples are converting daylight to look like tungsten illumination and vice versa.

Light-Balancing Filters—These make smaller changes in the quality of light, such as changing from 3,200K light to 3,400K light and the reverse for Type A and Type B color film. Another example is a skylight filter to take out some of the blue when the subject is in open shade.

Exposure-Control Filters—These are neutral-density filters. They alter only the amount of light, not the relative amounts at each wavelength. A double polarizing filter, which can be rotated to change the amount of light, also fits into this class.

Contrast-Control Filters—These are color filters used with b&w film to control or alter visual contrast on the print between objects of different color in the scene. The red apple among green leaves, for example.

Haze Filters—Useful with either color film or b&w, depending on the filter. They cut haze by cutting the shorter wavelengths of light. Obviously, a dark red filter used to cut haze with b&w film can also serve as a special-effect filter with color film.

Color-Compensating Filters—These are for making prints from color film but can also be used over the camera lens. They have

relatively low densities in the six colors that are important in color films: Red, green, blue, cyan, magenta, and yellow.

These filters have an orderly system of nomenclature using the letters CC as prefix in all cases. Following the prefix is a number such as 05, which means 0.05 and is the optical density of the filter. Following the density indicator is a letter that is the initial of the visual color of the filter. If the filter looks red when viewed against white light, it is called a red, or R, filter.

A filter identified as CC30G looks green to you. Therefore it suppresses red and blue. The density of 0.30 is to magenta light. A CC50M filter is magenta-colored.

CC filters have good optical quality and can be used in front of a camera lens and below the negative in an enlarger without noticeable image degradation.

Color-Printing Filters—These have the same colors and density ranges as CC filters but are not of good optical quality. They are intended to change the color of the printing light by insertion of the filter *above* the negative in an enlarger. At that point in the optical path, the image is not yet formed, so optical quality of the filter is not important as long as the color is correct.

Special Filter Types—These include such things as star-effect filters, and soft-focus or diffusion filters.

Other Types—There are lots of other types of filters in various categories. If you have a technical interest in filters, a good book to read is Kodak Publication B-3, entitled *Kodak Filters for Scientific and Technical Uses*. It is available through your camera shop.

FILMS

I waited until after the discussion of light and filters to give you the accompanying table of available films because you should consider all aspects when choosing film. The table does not list all available films the world over, but it gives enough brands and types to be helpful in most parts of the western world.

RECIPROCITY-FAILURE CORRECTIONS

This is also the appropriate place to include data on correction of reciprocity failure because, with color films, color filters are sometimes required. As you will see in the table, the color density needed to correct changes due to reciprocity failure is usually very small—such as 0.05 or 0.10.

		TYPICAL EXPOSURE INCREASE FOR RECIPROCITY FAILURE OF KODAK BLACK & WHITE FILMS			
	If Indicated Exposure Time Is:	USE ONE OF THESE CORRECTIONS (NOT BOTH)		And Change Developing Time:	
Film		Increase Aperture	Exposure Time		
Panatomic-X	1/100,000	1 step	Use Aperture Change	20% more	
Plus-X	1/10,000	1/2 step	Use Aperture Change	15% more	
Tri-X	1/1,000	None	None	10% more	
	1/100	None	None	None	
	1/10	None	None	None	
	1	1 step	2 seconds	10% less	
	10	2 steps	50 seconds	20% less	
	100	3 steps	1200 seconds	30% less	

SOME 35mm FILMS

Film Type	ASA SPEED/CONVERSION FILTER			Film Type	ASA SPEED/CONVERSION FILTER		
	Daylight	Tungsten 3400K	Tungsten 3200K		Daylight	Tungsten 3400K	Tungsten 3200K
COLOR SLIDE FILM				COLOR NEGATIVE FILM			
Kodachrome 25	25/none	8/80B	6/80A				
Kodachrome 64	64/none	20/80B	16/80A	Kodacolor II	100/none	32/80B	25/80A
Kodachrome 40	25/85A	40/none	32/80A	Kodacolor 400	400/none	125/80B	100/80A
5070 Type A				Kodak Vericolor II Professional, Type S	100/none	32/80B	25/80A
Ektachrome 64 Daylight	64/none	20/80B	16/80A	3M Color Print Film	80/none	25/80B	20/80A
Ektachrome 200 Daylight	200/none	64/80B	50/80A	Fujicolor F-11	100/none		32/80A
Ektachrome 160 Tungsten	100/85B	125/81A	160/none	Fujicolor F-11 400	400/none		125/80A
Agfachrome 64	64/none	20/80B	16/80A	BLACK & WHITE			
Fujichrome 100	100/none		32/80A				
				Kodak Panatomic-X	32	32	32
				Kodak Plus-X	125	125	125
				Kodak Tri-X	400	400	400
				Ilford PAN F	50	50	50
				Ilford FP4	125	125	125
				Ilford HP5	400	400	400

TYPICAL EXPOSURE INCREASE AND FILTERING TO CORRECT RECIPROCITY FAILURE IN COLOR FILMS

Film	INDICATED EXPOSURE TIME (Seconds)										
	1/50,000	1/25,000	1/10,000	1/1000	1/10	1/2	1	2	10	64	100
Kodachrome 40 5070, Type A	*		None No Filter	None No Filter	None No Filter		1/2 Step No Filter		1 Step No Filter		NR
Ektachrome 64 (Daylight)			1/2 Step No Filter	None No Filter	None No Filter		1 Step CC15B		1-1/2 Step CC20B		NR
Ektachrome 200 (Daylight)			1/2 Step No Filter	None No Filter	None No Filter		1/2 Step CC10R		NR		NR
Ektachrome 160 (Tungsten)			1/2 Step No Filter	None No Filter	None No Filter		1/2 Step CC10R		1 Step CC15R		NR
Kodachrome 25			None No Filter	None No Filter	None No Filter		1/2 Step No Filter		2 Steps CC10B		3 Steps CC20B
Kodachrome 64			None No Filter	None No Filter	None No Filter		1/2 Step No Filter		NR	NR	NR
Fujichrome 100				None No Filter		None No Filter	None No Filter	2/3 Step No Filter	2/3 Step No Filter	1-2/3 Step CC10C	1-2/3 Step CC10C
Kodacolor II	1 Step CC20B	1/2 Step CC10B	None No Filter	None No Filter	1/2 Step CC10C		1/2 Step CC15C		1-1/2 Step CC30C		1-1/2 Step CC30C
Kodacolor 400			None No Filter	None No Filter	None No Filter		1/2 Step No Filter		1-1/2 Step CC10M		2 Steps CC10M
Vericolor II Professional Type S			None No Filter	None No Filter	None No Filter		1/2 Step No Filter		2 Steps CC10B		3 Steps CC20B
Fujicolor F-11				None No Filter		None No Filter	2/3 Step No Filter	2/3 Step No Filter	1-2/3 Step No Filter	1-1/3 Step No Filter	2-2/3 Step No Filter
Fujicolor F-11 400				None No Filter	None No Filter		1 Step No Filter		2 Steps No Filter		3 Steps No Filter

NR—Not Recommended
* Blank spaces indicate data not published by manufacturer. Where blank is *between* published data, estimate correction.
All data subject to change by film manufacturer

PENTAX SPECIAL-EFFECT FILTERS

In addition to the standard Pentax filters listed earlier in this chapter, Pentax offers some filters that alter the image for special effect. These devices are commonly called *filters,* mainly because they look like filters and mount like filters. Some of them aren't filters in the standard meaning of the word and should properly be called *lens attachments* or something similar.

Fantastic Color Filters—Two of these units are special-effect filters that change color as you rotate the outer rim of the mount. These are Fantastic Color Filter R/B and R/G. The nomenclature indicates what they do.

With the R/B unit, turning the outer rim changes the color from a strong red to a strong blue. In between the settings that give red and blue, the color gradually changes. It is always a combination of red and blue but as the outer rim is rotated, one color "fades out" while the other "fades in." What you see are all shades of purple ranging from reddish-purple to bluish-purple.

The R/G unit works in a similar way but the colors pass through yellow as you change from red to green.

Multiple-Image Attachments—Magic Image Attachments 5C, 4C and 2C each make a central image of the subject surrounded by 5, 4 or 2 duplicate images, depending on which attachment you use. The attachment can be rotated on the camera lens to change the orientation of the multiple images.

They work best with 50mm or 55mm lenses, simple subjects and plain dark backgrounds. If you use a long-focal-length lens, the peripheral images fall outside of the film frame and the attachment doesn't work properly. With wide-angle lenses, the images cluster in the center of the frame and the corners may become dark. The most suitable aperture size is f-4 to f-5.6.

Clockwise from the top: Pentax Magic Image case, Pentax Filter Box, Magic Image Attachment 4C, Fantastic Color Filter R/B, top half of clear-plastic filter case, Magic Image Attachment CF. Shadow cast by Magic Image Attachment 4C shows four panels surrounding a center panel. CF has clear center spot surrounded by diffuser area.

Rotating the rim of the Pentax Fantastic Color Filter R/B causes the color to change from red to blue. These three photos were made with the same R/B filter, at different settings of the outer rim.

PENTAX SPECIAL-EFFECT FILTERS			
Filter	Thread Size (mm)	Effect	Film
Fantastic Color Filter R/B	49, 52	Changes from red to blue	Color
Fantastic Color Filter R/G	49, 52	Changes from red to green	Color
Magic Image Attachment 5C	49, 52	Center image with five surrounding duplicate images	Color or b&w
Magic Image Attachment 4C	49, 52	Center image with four surrounding duplicate images	Color or b&w
Magic Image Attachment 2C	49, 52	Center image with two adjacent duplicate images	Color or b&w
Magic Image Attachment 6M	49, 52	Main image with 5 additional duplicate images in a row	Color or b&w
Magic Image Attachment CF	49, 52	Image sharp in center, soft and hazy around center	Color or b&w

This scientific demonstration shows exactly what the Magic Image Attachment CF does. It gives a clear area in the center which blends into a diffused area. You will get a more artistic result if you photograph something interesting inside the clear area when you use the CF attachment.

Magic Image Attachment 4C produces five images from one subject: four of them surrounding one in the middle. The position of the four outside images changes as you rotate the outer rim of the attachment.

Magic Image Attachment 6M makes a main image at one side of the frame and then repeats it 5 more times along a straight line, all overlapping. The direction of the repeated images can be changed by rotating the frame of the accessory. This also works best with 50mm or 55mm lenses, except the 50mm macro lens.

Central Spot Accessory—Magic Image Attachment CF is not a multiple-image device. It's a glass disc with a clear circular spot in the center surrounded by frosted glass to give the perimeter a soft, hazy appearance. It can make one flower stand out clearly among a group of flowers, for example. Use this attachment with 50mm or 55mm lenses and apertures of around *f*-4 to *f*-5.6.

Exposure Compensation—None of the Magic Image Attachments affect the amount of exposure. They have a filter factor of IX.

HOW TO USE FLASH

It is convenient to divide artificial light into three categories: Bulb-type flash, electronic flash, and continuous light sources such as photolamps. Electronic flash has some further subdivisions according to how it works.

Although flashbulbs can be used with Pentax cameras, they are not discussed in this book. Data normally packaged with flashbulbs should give you the necessary information if you need it.

CONNECTING FLASH TO CAMERA

The simplest way to connect a flash to the camera is to install the flash in the accessory shoe on top of the camera. This is sometimes called a *hot shoe* because it has an electrical contact that fires the flash. Most Pentax hot shoes are only "hot" electrically when a flash is installed, therefore they are called *hot/cold shoes.* In addition to the hot shoe, some Pentax cameras also have an electrical socket or terminal on the camera body so you can use an electrical cord to interconnect flash and camera instead of mounting the flash in the hot shoe. This cord is called a *PC cord, sync cord,* or sometimes *flash cord.*

ELECTRONIC FLASH

Electronic flash requires a high voltage, usually obtained from batteries through a voltage-multiplying circuit.

Electronic flash produces a color temperature of around 6,000 degrees Kelvin. They are generally considered to have the same photographic effect as daylight. Filters on the camera or over the flash

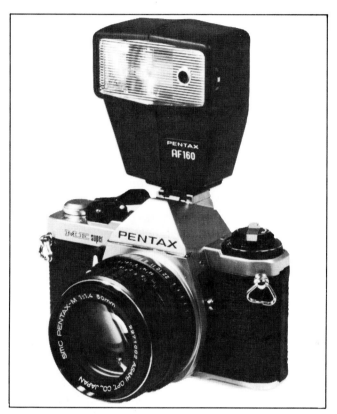

Pentax offers compact, dedicated electronic flash units for automatic cameras. *Dedicated* means the flash performs special functions with certain cameras. This is the AF 160 flash on an ME Super.

unit can be used to alter the color slightly if necessary.

Electronic-flash units fire virtually instantaneously and reach full brightness immediately. To fire electronic flash with a focal-plane shutter, the flash contacts in the camera are closed at the instant the

first curtain of the focal-plane shutter reaches fully open—called *X synchronization.*

SYNCHRONIZING WITH FLASH

Pentax cameras typically have a hot shoe and two terminals or sockets on the camera body labeled

MX FLASH-SYNC TABLE														
SHUTTER SPEED		$\frac{1}{1000}$	$\frac{1}{500}$	$\frac{1}{250}$	$\frac{1}{125}$	$\frac{1}{60}$	$\frac{1}{30}$	$\frac{1}{15}$	$\frac{1}{8}$	$\frac{1}{4}$	$\frac{1}{2}$	1	B	
ELECTRONIC FLASH	X													
FLASH BULB	FP		M, FP CLASS											
	X							M, MF, FP CLASS						

Shaded areas indicate usable shutter speeds.

X and FP, where you connect flash cords.

The hot shoe and the X terminal are both intended for "X" sync, meaning electronic flash with no delay between firing the flash and opening the shutter. Some combinations of shutter speed and bulb-type flash will also work when triggered by the X contact. These combinations are shown in the accompanying table for the MX camera, as an example. Similar tables for other models are in Chapter 16.

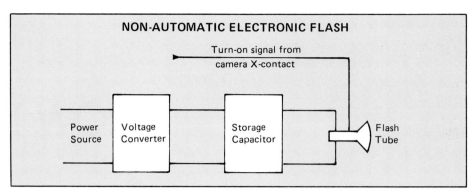

Figure 13-1/A non-automatic electronic flash is turned on by a signal from the camera. The flash tube makes light until the storage capacitor discharges to the point where the flash tube extinguishes.

HOW A NON-AUTOMATIC ELECTRONIC FLASH WORKS

You don't have to be an electronic whiz to understand the basic operation of an electronic flash. Figure 13-1 shows a power source feeding a voltage converter. The power source is usually batteries, but for some equipment it is AC power from a wall socket.

Either way, the electrical voltage to operate the flash tube is higher than the supply or source voltage so a special circuit converts it to a higher voltage. This high voltage is accumulated in a storage *capacitor.*

An electrical capacitor behaves very much like a rechargeable battery. The storage capacitor charges up to the high voltage from the voltage converter, then suddenly dumps its charge into the flash tube to make the bright light.

A signal is required to tell the capacitor to dump its charge and cause the flash. This signal comes from the X-sync contacts in the camera. The flash turns itself off when the storage capacitor has discharged.

Once the flash has been fired, it cannot be operated again for a short period of time needed to charge up the capacitor again, called the *recycle* time. When batteries are the source of electricity for the capacitor, recycle time depends on battery condition. If they are fully charged, recycle time is short. As they approach full discharge, recycle time takes longer.

Alkaline cells give a lot more flashes than the common variety, before recycle time becomes excessively long or the unit won't recycle at all.

The type of capacitor used in electronic-flash units may deteriorate if left a long time without an electrical charge. Just before you put the flash away after shooting, it's a good idea to let it recycle so it is ready to shoot, but don't fire the flash. That allows you to store it in a charged condition. In long storage it is beneficial to turn on the flash unit and recharge the capacitor about once a month, returning it to storage in a charged condition.

Most electronic-flash units have a signal light, or ready light, which glows when the capacitor has enough charge to operate the flash. The signal light is usually set to turn on when the charge is 70% or 80% of the full amount.

If you operate the flash as soon as the signal light turns on, light from the flash will be less than if you wait a while longer and allow the capacitor to accumulate more charge. You may get approximately double the amount of light from the flash if you wait an additional length of time equal to the recycle interval. In other words, if it takes 10 seconds for the ready light to come on, wait another 10 seconds and get about one step more light—if the batteries are in good condition. If they are nearly discharged, the additional light after waiting may be only a small amount more.

GUIDE NUMBERS

Guide numbers help you set camera exposure controls properly when using flash bulbs or non-automatic electronic-flash units. Higher guide numbers indicate more light from the flash.

Suppose a non-automatic flash or flash bulb makes enough light to expose a subject at a certain distance from the camera. This implies a certain film speed, aperture and shutter speed.

Starting with that situation, the light source could be moved farther from the subject and proper exposure could still be made by opening the aperture to compensate for the reduced amount of light.

Variation of light on the subject due to a changed distance between flash and subject is assumed to follow the inverse-square law. Therefore, doubling the distance between light source and subject should reduce the amount of light by a factor of 4. There would be one-fourth the amount of light on the subject.

The aperture change to get the same exposure as before should be opening up two stops.

Now let's use some numbers to illustrate that. Suppose the light is 5 feet from the subject and a suitable aperture is *f*-16. Please notice that the distance in feet multiplied by the *f*-number is: 5 x 16 = 80.

Double the distance to 10 feet and open up the aperture two stops to *f*-8. The product of distance times *f*-number is still 80.

All combinations of distance and

f-number which produce the same exposure with that flash will have the same product—80 or whatever the number turns out to be. That number is called a *guide number.*

Obviously, guide numbers will be different for different film speeds because with faster film, you need less light on the subject. Shutter speed may be important. With bulb flash, which happens over a fairly long interval of time, shorter shutter speeds admit less of the total light produced by the flash bulb. Therefore guide numbers for flash bulbs are specified for a certain film speed *and* a certain shutter speed.

With electronic flash, film speed is important but shutter speed is not because the entire flash happens in a time interval much shorter than the shutter speed you are allowed to use with a focal-plane shutter. More on this point in a minute.

A non-automatic electronic flash may have a guide number of 60 feet for ASA 25. Here's how to use guide number (GN) to find

the *f*-stop you should use:

$$f\text{-number} = GN/Distance$$

If the guide number is 60 feet, and you are shooting at a distance of 15 feet from the subject, the *f*-number you should use is $60/15 = f\text{-}4$.

If you move closer, say 7.5 feet to keep the arithmetic simple, the new aperture is $60/7.5 = f\text{-}8$.

Notice that a guide number includes distance between light source and subject. If the distance is measured in feet, a certain guide number results. If measured in meters, a different guide number results. Unless you know if the number is based on feet or meters, you can miss exposure by working at the wrong *f*-stop.

Sometimes guide numbers are specified only for one film speed. If you decide to shoot with film of a different speed, you should know how to convert the guide number. Let's use the terms *New GN* and *New ASA* to mean the GN and film speed you intend to use. *Old GN* and *Old ASA* will mean the published guide number.

$$New\ GN = Old\ GN \times \sqrt{\frac{New\ ASA}{Old\ ASA}}$$

Sometimes the film speeds make the calculation easy. Suppose the guide number as stated in the specs is 60 feet with ASA 100 film. You intend to shoot with ASA 400 film.

$$
\begin{aligned}
New\ GN &= 60\ \text{feet} \times \sqrt{\frac{400}{100}} \\
&= 60\ \text{feet} \times \sqrt{4} \\
&= 60\ \text{feet} \times 2 \\
&= 120\ \text{feet}
\end{aligned}
$$

If you switch to ASA 400 film instead of ASA 100 film, the guide number doubles. You can place the flash at double the distance *or* close down the aperture by two stops.

Guide numbers for electronic-flash units are quoted at ASA 25 or ASA 100 or some other film speed. The flash unit "looks better" when a higher film speed is used as the base—because the guide number is higher. If you are shopping for an electronic flash, compare guide numbers based on the same film speed.

Guide numbers are just that—a guide. They are based on photographing people indoors because more flash is used for that purpose than any other. Some of the light from the flash bounces off ceiling and walls and then illuminates the subject while the shutter is still open. If you use flash outdoors, you will lose the light that would otherwise bounce off ceiling and walls and the picture may be underexposed. Try figuring *f*-stop with the guide number and then opening up one or more stops for outdoor locations.

A guide-number calculation for a non-automatic flash usually gives a good exposure indoors because guide numbers are based on indoor shots where some light from the flash bounces off the walls and ceiling. The bounced light adds to the direct light from the flash. Outdoor shots based on guide numbers are usually underexposed because only direct light from the flash illuminates the subject. Compensate when shooting outdoors by opening the lens a half stop or full stop more than the calculation suggests.

ESTABLISHING YOUR OWN GUIDE NUMBERS

Because guide numbers are based on average conditions, the published guide number for your flash may not work well under your shooting conditions—such as a room with a high dark ceiling.

You can figure and assign your

own guide number to your equipment and shooting environment by testing—remember that a guide number is just the product of distance and *f*-stop which gives a good exposure at a specified shutter speed.

A handy shooting distance for the test is ten feet from the subject. Use several different *f*-stops above and below the one suggested by the published guide number. Make notes or have the subject hold a card showing the *f*-stop for each exposure. After processing, pick the one you like best. The guide number for that situation is the *f*-stop used multiplied by the distance used. If you like *f*-8 best, and you are testing at 10 feet, the guide number is 80 feet. Use color-slide film for the test.

FLASH WITH A FOCAL-PLANE SHUTTER

When shooting with flash, a focal-plane shutter is at a disadvantage.

The first curtain is released to make an exposure, and the second curtain follows behind at a time interval equal to the desired length of exposure. When the first curtain reaches the end of its travel, the film frame is uncovered *as far as the first curtain is concerned,* so it closes the electrical contacts for X sync and fires the flash.

If the second curtain is following too closely behind the first, at 1/500 second for example, part of the frame will already have been covered up by the second curtain at the instant of the flash. The only part of the frame which could be exposed is the narrow slit between the two curtains.

To use electronic flash with a focal-plane shutter, a shutter speed must be selected so the first curtain reaches the end of its travel and then a brief instant passes before the second curtain *begins* its journey across the frame. During that brief instant, all of the frame is open to light and the flash occurs.

This means the exposure time on the shutter-speed dial must be

FLASH SYNCHRONIZATION SPEEDS OF PENTAX 35mm CAMERAS			
1/60	1/75	1/100	1/125
MX K 1000	LX	MG	ME Super MEF

Models with X-sync speeds of 1/100 and 1/125 second have vertical shutters. Those with X-sync speeds of 1/75 and 1/60 have horizontal shutters.

slightly longer than the time required for the first curtain to travel across the frame.

Vertically moving focal-plane shutters synchronize with electronic flash at faster shutter speeds than horizontal shutters. The accompanying table shows flash-sync speeds for Pentax 35mm cameras. At slower shutter speeds, the second curtain waits even longer before starting across the frame, so electronic flash works OK.

FP-type Bulb Flash—A special FP flash bulb produces light for about 1/40 second. The bulb is ignited before the focal-plane shutter starts to open. Shutter speed is chosen so the shutter opens and closes while the bulb is burning—1/60 or faster. No flash sync is required except to fire the bulb. Some Pentax cameras have a sync terminal marked **FP**, for this purpose.

GHOST IMAGES

Focal-plane shutters require exposures for electronic flash of 1/125 or 1/60, minimum, but the actual time of exposure due to the bright light of the flash is very much shorter—1/500 second down to as little as 1/50,000 second or less in some cases. If there is enough illumination on the scene from sources other than the flash to cause some exposure during the full time the shutter is open, then there are two exposures. One short-time exposure due to the flash and another longer-time exposure due to the ambient light on the scene. If the subject moves during the time

the shutter is open, or the camera moves, the image due to ambient light will not be in register with the image due to flash. This can cause a blur or a faint "echo" of the subject on the film.

With a motionless subject, the cure is to hold the camera still during the entire period of exposure. With a moving subject, there isn't much you can do about it except try to shoot so the flash is the dominant light and the other light on the subject is too dim to make a visible image on the print, or else pan with the subject. *Pan* means follow motion by moving the camera.

LIGHTING RATIO

A thing to worry about with artificial lighting, and sometimes outdoors, is the difference in the amount of light on the best-lit areas of the subject and the amount in the worst-lit areas.

Direct sunlight from above or the side can spoil a portrait by casting deep and well-defined shadows of facial features. This can be helped by using reflectors to cast some light into the shadows, or using flash to *fill* some of the shadowed areas with more light—called *fill lighting.*

A single light source of small dimensions tends to make dark and well-defined shadows with "sharp" edges. A second light source—even a small distance from the first— softens the shadow edges to give portraits a more pleasing appearance.

A single light source of relatively large dimensions, such as a wall reflecting light onto your subject, acts like many smaller light sources at different locations and therefore makes shadows which are not as dark or sharp as a single small source.

This leads to some general rules or observations: Small light sources cast sharp shadows, big ones don't. Multiple light sources act like a big one. Light from all directions casts no shadows at all.

If you are using more than one

source of light, you can usually control some or all of them to adjust both the amount of light and the directions of illumination on the subject. In portraiture and other kinds of photography, arrangement of lighting is important for artistic effect.

For a portrait, suppose there are two light sources such as flood lamps or flash. With the subject looking straight ahead, one light source is to the left at an angle of 45 degrees. Let's say this source puts 4 units of light on the subject.

Another source, at a 45 degree angle on the opposite side only puts one unit of light on the subject. This gives a *lighting ratio* of 4 to 1—which is simply the ratio of the two amounts of light.

On the subject, there are *three* values of light. Where illumination is only from the brighter source, the amount of light is 4 units. Where it is only from the less-bright source, which will be in the shadows cast by the brighter source, the illumination is one unit. Where both lights overlap and both illuminate the subject, the total light is 5 units. The *brightness ratio* is 5 to 1 because the brightest part is five times as bright as the darkest part.

In photographic exposure steps, a brightness ratio of 5 to 1 is only a fraction more than two steps, usually no problem for b&w film. It is often recommended as the upper limit for brightness variation in color photography because of the nature of color film.

Color film has two jobs to do. It must record differences in scene brightness, just as b&w film records the different brightnesses along the gray scale. In addition, it has to record color information.

A simple way to think about that is to remember that the brightness information gets on the film first. After that color is introduced by chemical processing. When there is conflict between brightness information and color, color loses.

By restricting the lighting ratio to about 4 to 1, giving a brightness ratio of 5 to 1 as measured by the

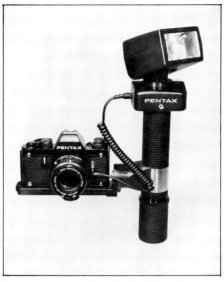

Flash units mount either in the hot shoe on top of the camera or on a bracket that supports both flash and camera. Some flash units have a pivoting flash head so you can direct the light upward or to one side, even with the flash attached to the camera. This is the Pentax AF400T, which is part of the LX system. It can also be used with other cameras.

exposure meter in your camera, you allow "room" on the film for both brightness and color variations. If the colors in the scene are very bold and vivid, you may need to hold the lighting ratio to 2:1.

With color, the colors themselves produce visual differences between objects in the scene, so we don't have to rely as much on brightness differences.

HOW TO CONTROL LIGHTING RATIO

If the lights are floods or flash, you can control the brightness of each source by selecting sources of different light output and you can control the amount of light from any source by adjusting the distance from source to scene. Sometimes this is more difficult in the real world than on paper.

With floodlights, you can confirm lighting ratio by measuring at the scene with a hand-held meter, or by moving your camera up close so it only "sees" parts of the scene.

Measure the brightest part and the darkest part of interest.

With lights of the same intensity, control lighting ratio by moving one farther back. If they are located so they put the same amount of light on the scene, and then one is moved back to double the distance, the light from that one drops to one-fourth its former value due to the inverse-square law.

Using Flash for Fill Lighting—When using flash, you have to predict the amount of light on the scene when the flash happens. The simplest way is to use the guide number to figure *f*-stop and then consider the *f*-stop as an indicator of the amount of light. If you are using two flash units to make a portrait, one is located so it requires *f*-4 and the other requires *f*-8 to produce full exposure, you will get a 4-to-1 lighting ratio by setting the camera at *f*-8.

Remembering that *f*-8 is 2 stops away from *f*-4, and each stop doubles the amount of light, settings of *f*-4 and *f*-8 represent a lighting ratio of 4 to 1. The usual rule is, set camera exposure controls for the brightest light. The flash unit which needs *f*-8 for proper exposure is obviously brighter than one which can use *f*-4. Therefore you set to *f*-8 to avoid overexposure by the brighter source.

This is generally true of fill lighting whether continuous light or flash.

Multiple flash units can be triggered by each other using connecting wires if the manufacturer designed them that way. They can also be triggered by light. One flash is operated by the camera. One or more additional flash units are equipped with an accessory light sensor which "sees" the light from the main flash and triggers the other flash units. When so arranged, the additional flash units are called *slaves.*

USING FLASH IN SUNLIGHT

A special case of fill lighting with flash is when the main light is the sun.

A sunny day gives a poor lighting ratio and portraits with deep shadows. Using flash for fill lighting solves the problem.

To Decrease Illumination By:	Multiply Distance By:
Zero	1
1 stop	1.4
2 stops	2
3 stops	2.8
4 stops	4
5 stops	5.6
6 stops	8

If you have the type of flash which connects to the camera by a PC cord, you can locate the flash away from the camera by using PC cord extensions.

If you cannot remove the flash from the camera because it is a direct-connected hot-shoe type, then you can't use a different distance for flash and camera. It is always possible to find some distance that will give the lighting ratio you want, but that may not give good composition of the picture.

When your calculation indicates that the flash should be moved back to reduce its light, but you can't move it back independent of the camera, you can reduce the amount of light coming from the flash.

CAUTION: Flash *bulbs* get very hot. Don't touch one with your fingers.

With electronic flash which doesn't get hot, you can cover about half of the window that lets light out and about half of the light will come out—a reduction of one stop. Some photographers develop high skill at covering part or all of the electronic flash opening.

A practical rule is, one thickness of pocket handkerchief over an electronic flash cuts the light by one stop. Two thicknesses—two stops. Don't do this with flash bulbs.

Some electronic-flash units come with neutral-density filters which fit over the flash lens. 2X is one stop, 4X is 2 stops.

PROBLEMS WITH FLASH

Flash has several kinds of problems.

Flash on camera, very close to

With the shutter at the speed required for flash, and sunlight on the subject *at an angle which makes shadows,* the camera exposure setting should be for the main light source—the sun. Then locate the flash at the right distance from the subject so it gives the desired lighting ratio.

Here's a procedure for using flash fill lighting in sunlight.

1. Set the camera shutter speed as required for use with flash—1/60, 1/100, or 1/125, depending on camera model.
2. Focus, meter the subject and set aperture for normal exposure using sunlight. Notice the distance from the camera location to the subject, either by reading the distance scale on the lens or actual measurement.
3. Using the guide number of the flash for the film speed you are using, calculate the flash f-stop for the distance between camera and subject. For a 4-to-1 lighting ratio, that f-stop as calculated should be two stops larger than the camera setting.
4. If it is not 2 stops larger, use the guide number to figure distance between flash and subject which will give the desired aperture.
5. Put the flash at that distance. Remember about flash outdoors being less effective than flash indoors where ceiling and wall reflections help. Fudge the flash forward a little ways to compensate. That's not scientific but it's practical.
6. Shoot at the camera setting you made for sunlight, *not* the larger aperture you calculated for normal exposure with the flash.

The mathematical series used for f-numbers also applies to distances between light and subject.

the axis of the lens can cause "red eye" when using color film. Light rays from the flash enter the subject's eyes and reflect back to the lens from the retina of the eye. The light will be colored red from the blood vessels in the eye. To avoid this, pocket cameras come with an extension which raises the flash bulb a few inches above the lens. Most SLR cameras mount a flash high enough to avoid this problem, but it can happen.

Flash on camera produces "flat" lighting because it is usually aimed straight at the face, eliminating all shadows. The exception of course is when the flash is used for fill lighting.

When people stand close to a wall while being photographed with flash on camera, there are often sharp shadows of the people visible on the wall behind them.

Mounting a flash on the camera is convenient because it is all one unit, but has those disadvantages. If the flash connects to the camera with a PC cord, and the cord is long enough, it is preferable to hold the flash high and to one side. This casts shadows similar to those caused by normal overhead lighting and the effect is more realistic.

Also, a flash held high tends to move shadows on the wall downward and they may not be visible in close "head shots" of people.

The light from a single flash unit falls off drastically with increasing distance. If you photograph a group of people with different distances from the flash, and make a guide-number calculation for the middle of the group, people nearest the camera will be overexposed, those in the center will be OK and those in the background will be underexposed.

Using guide numbers to find f-stop is a bother, particularly when you are shooting in a hurry.

BOUNCE FLASH

A technique used to avoid flat lighting and harsh shadows from a single flash is to aim it at the ceiling. With a flash detached from the

Direct flash produces flat lighting and sometimes harsh shadows behind the subject. Flash bounced off the ceiling gives a more natural appearance because we expect lighting from above. Shadows are softer and moved downward on the wall.

camera, just point it at an angle toward the ceiling so the bounced light will illuminate your subject. Some flash units intended for hot-shoe mounting have a swivel head so the light can be bounced.

This has all the advantages of holding the flash unit high plus the added diffusion of the light from a broad area of the ceiling. If the ceiling is colored, it will also color the reflected light and change skin-tones in a color photograph.

To bounce with non-automatic flash, the distance to use in the guide-number calculation is the distance from flash to ceiling and then from ceiling to subject. With a little practice and a tape measure if necessary, you can learn to estimate this distance fairly well. You must also allow for light absorption by the ceiling which can require open-

ing up one or two stops larger than the guide-number calculation suggests. A flash must be more powerful—meaning make more light—to be used this way but it is a much-improved method.

AUTOMATIC ELECTRONIC FLASH

Automatic electronic-flash units measure the amount of light reflected from the subject and automatically turn off the flash when the desired amount of light has been measured.

Automatic flash units have constant brightness when turned on, but vary the time duration of the flash to produce a desired amount of *exposure* on the film.

Automatic flash units eliminate guide-number calculations and are handy for bounce flash. But to use one effectively, you have to understand what it does.

How Light-Sensing Automatic Flash Works—The light-measuring sensor of most automatic flash units is mounted in the housing, so it faces the scene being illuminated by the flash.

A turn-on signal comes to the flash tube from the camera. The flash tube is turned on and starts making light. The light sensor measures light reflected from the scene. When the correct amount of light has been measured, the flash turns itself off.

It is possible to use the flash at a shorter distance by closing down aperture so the camera accepts less light, and it is also possible to work at different film speeds by changing aperture on the camera. Shutter speed cannot be changed because it must be at the flash setting.

Specifications for different distance ranges, camera f-stops and film speeds seem complicated because there are many different combinations of those three variables. The data is usually presented to the user by a calculator on the flash.

You set film speed into your camera and also into the calculator on the automatic flash. Then the

calculator on the flash unit displays an *f*-stop for the camera along with a maximum shooting distance and sometimes a minimum distance. There is always a minimum distance even if not shown on the dials. Check the flash instruction booklet. Some say the minimum distance is 10% of the maximum distance.

If you set the camera lens for the *f*-stop recommended by the flash-unit calculator dial, you can shoot automatically anywhere within the specified distance range without changing *f*-stop on the lens.

Suppose the distance range shown by the calculator is from 2 to 18 feet, and the *f*-stop is *f*-4. If the subject is at the maximum distance in that range, the automatic flash will operate as long as it can. If you shoot at a shorter distance, the sensor on the flash receives more light from the subject and decides that exposure is correct with a shorter time duration of the flash. It turns off sooner. At the shortest range—2 feet—the unit turns on then turns back off again as fast as possible. The exposure time will be extremely short, such as 1/30,000 second.

Some automatic flash units allow you to choose from 2 or more *f*-stops at the camera and make an adjustment to the sensor of the flash so it will still give correct exposure. Choice of *f*-stop gives you some control over depth of field.

The adjustment of the flash may be a set of apertures of different size on a movable metal plate so you can position one of them in front of the light sensor. Alternate methods are neutral-density filters of different densities in front of the sensor or electrical controls.

By reducing light into the camera and light into the flash sensor by equal amounts, the sensor can still judge exposure on behalf of the camera.

The switch or slide positions of the sensor control must be identified some way. One way is to

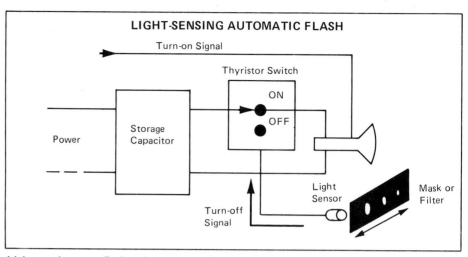

LIGHT-SENSING AUTOMATIC FLASH

Light-sensing auto-flash units are turned on by the X contact in the camera. Light returning from the subject is measured by the sensor in the flash unit. The sensor controls the *time duration* of the flash, turning the flash off at a standard amount of exposure.

assign letters to them because this is a control not used before in photography and there is no handy name. A reasonable name is sensor-sensitivity control, because that's what it does. We could call the two slide positions **A** and **B**. Position **A**, which admits more light to the sensor, would go with lens aperture *f*-4. Position **B** would go with *f*-5.6. A third position, **C**, could be used with *f*-8, and the flash would then allow choice of 3 *f*-stops for each film speed.

These additional *f*-stops don't come free, even though it seems so at first. Each smaller *f*-stop allowed by the flash calculator dial is accompanied by a shorter maximum working distance of the automatic flash.

A choice of *f*-stops expands the versatility of the electronic flash but complicates the display of information on the calculator. Sometimes the sensor control and the display are color-coded instead of labeled with letters.

Some automatic flash units are built with swivel heads to allow bouncing the light off the ceiling. The sensor does not swivel but continues to look where the

camera does—assuming the flash is mounted on the camera. Thus the flash also compensates automatically for light loss due to bouncing and will not shut off until the proper amount of exposure is received by the sensor looking at the scene. Naturally the flash must have enough power to bounce light off the ceiling.

Some automatic flashes are detachable from the camera but have a small detachable sensor unit which mounts on the camera. This allows you to point the flash in any direction and hold it anywhere. Meanwhile the sensor mounted on th camera still does its job of keeping the flash on until it thinks the film got enough exposure.

Automatic flash units with a sensor-sensitivity control normally have one position of the control to block all light from the sensor. This simply allows the flash to run for maximum time duration at every firing. It puts the automatic flash on non-automatic or manual operation. Then you can use it with its guide number just like any other non-auto flash.

How TTL Auto Flash Works— The type of auto flash described in

the preceding section is called *light-sensing* to indicate that it measures light reflected from the scene. This is done by a light sensor *in the flash unit itself* and therefore the flash measures light on behalf of the camera.

With cameras that have a light sensor in the mirror box, such as the LX and Super Program, another type of automatic electronic flash became possible: The camera measures light from the scene, during the actual exposure, and turns off the flash when there has been enough light. Pentax refers to this as *TTL Auto,* where TTL means "through-the-lens" and indicates the light from the scene is measured inside the camera by the silicon photo diode in the camera mirror box.

This method of controlling electronic flash works only with the camera set for automatic exposure control, and only with special dedicated flash units described later in this chapter.

Here's the sequence of events: After you press the shutter button, the first shutter curtain starts to open. At the instant the first curtain is fully open, an X-sync electrical signal is sent to the flash and the flash tube fires. At this moment, the entire film frame must be uncovered so it can be exposed by the brief burst of light from the flash unit. This means that the second shutter curtain must not have been released to start closing. The fastest shutter speed at which this happens is called the X-sync shutter speed. For the LX, this is 1/75 second.

When the first curtain is fully open and the flash fires, the sensor measures light from the flash and ambient light. When enough total exposure from both light sources has been measured, the camera shuts off the flash and releases the second shutter curtain.

This system has several important advantages: You can select any aperture available on the lens, provided the subject is not beyond the effective range of the flash at

Dedicated flash units can control shutter speed and viewfinder indicators in the camera. The camera hot shoe has a center contact to fire the flash, and auxiliary contacts for the dedicated functions. This is the the hot shoe of an LX camera.

that aperture. Measuring light after it has come through the lens automatically compensates for any light reduction due to filters on the lens or the use of high-magnification equipment such as bellows or extension tubes. The light sensor always has the same angle of view as the lens in use, rather than a fixed angle of about 20°.

One of the benefits of electronic flash is that it freezes subject motion and minimizes the effect of camera shake because of the short time duration of the flash—typically in the range of 1/1,000 to 1/30,000 second. Normally, we use flash only when the camera indicates underexposure with ambient light alone. Therefore, exposure is due mainly to light from the flash, and the duration of that exposure is the same as the duration of the flash no matter how long the shutter is open.

The exposure interval due to electronic flash and the exposure interval due to ambient light are not the same. This is true of all 35mm SLR cameras with focal-plane shutters.

As you know, exposure time to ambient light is measured from the instant the first curtain is released to the instant the second curtain is released. X-sync speed for the LX is 1/75 second; therefore, that is the duration of exposure to ambient light. Exposure due to the flash is perhaps 1/5,000 second and exposure due to ambient light is 1/75 second—66 times as long.

USING AUTOMATIC ELECTRONIC FLASH

Plug an automatic flash into the X-sync flash connector on the camera body or if it is a hot-shoe mounting type, put it in the hot shoe.

When you buy an electronic flash, assume it is going to work just right, but make notes during your first roll of exposures and test extreme situations. Then you will know if some adjustment must be made for your shooting circumstances.

With automatic electronic flash, be wary of reciprocity failure when shooting a highly reflective subject at very short distances. The flash unit may be making light for something like 1/30,000 second—shorter than ordinary film is intended to use. It works in a surprising number of cases, but if you see underexposure or color changes in color film, suspect reciprocity failure and try more exposure. How do you do that? Change the film-speed setting to a smaller number.

Bounce flash is theoretically more reliable with automatic flash, but it is beset by all the variables of any other type of bounce flash. Test before making critical shots that you can't shoot a second time—such as your brother's wedding.

BASIC SPECIFICATIONS FOR PENTAX FLASH UNITS

	GUIDE NUMBERS (meters)		Type	Power on Manual	Sync Connection	Covers Lenses down to	Sensor Angle
	ASA 100	ASA 400					
AF400T	40 at full power	80 at full power	Handle Mount with Bracket	Full, 1/4, 1/16, 1/25	Sync Cord A Sync Cord B Standard Cord	35mm	20°
AF280T	28 at full power	56 at full power	Hot Shoe	Full, 1/16	Hot Shoe	28mm	20°
AF200T	20 at full power	40 at full power	Hot Shoe	Full, 1/2, 1/4, 1/8	Hot Shoe	28mm	20°
AF200S	20	40	Hot Shoe	Full	Hot Shoe	28mm	18°
AF160	16	32	Hot Shoe	Full	Hot Shoe	28mm	18°
AF080C RING LIGHT	8 at full power	16 at full power	Control Pack in Hot Shoe Ring flash on lens	Full, 1/4	Hot Shoe	See Text	No sensor in flash
Takumar AF14	14	28	Hot Shoe	Full	Hot Shoe	35mm	18°

ENERGY-SAVING AUTO FLASH

Recent developments in automatic flash use a *thyristor* switching circuit that does two things:

It shuts off the flash at the desired instant and also "turns off" current flow from the capacitor so any electrical energy not used to make light is saved for the next flash.

The word *thyristor* and the phrase *energy saving* usually identify this type of flash. An energy-saving flash unit is preferred because the battery charge lasts longer and makes more flashes.

Also, taken out of the capacitor by one flash, recycle time is shorter because only the energy used must be replaced.

DEDICATED FLASH

Some Pentax flash units control functions in specified camera models, such as setting shutter speed to X-sync automatically. Flash units of this type are called *dedicated*. Normally, dedicated flash units can be used on other cameras but without some or all of the special functions.

DEDICATED FUNCTIONS

Here's a list of dedicated functions that may be obtained depending on which flash you use, which camera, and how the controls are set. The accompanying table shows which features are available with Pentax flash units and cameras.

Automatic Shutter Speed Selection—The dedicated flash sets the camera to X-sync shutter speed when the flash ready light glows. When the light is off, the camera operates as if the flash were disconnected.

Ready Light in Viewfinder—In addition to a ready light—sometimes called *pilot light*—on the flash, some dedicated flash units also control a ready indicator in the camera viewfinder.

Auto Check Indicator in Viewfinder—Most automatic flash units have a test button on the flash—often combined with the ready light. When pressed, it fires the flash independent of the camera.

Flash at incorrect shutter speeds is prevented in *all camera modes where the flash controls shutter speed* and sets it at X-sync.

BASIC SPECIFICATIONS FOR PENTAX FLASH UNITS

	Aperture Choices (Max. Range in meters) on Auto with ASA 100	Dedicated features	Bounce Capability	Power Sources	Accessories	Dimensions W x D x H	Weight
AF400T	Auto: f-11 (3.6m) f-8 (5m) f-4 (10m) TTL Auto: Any aperture (28m with 1.4)	Yes See Table	Yes	6AA Batteries 6C Batteries (Ni-Cd OK) 510V Battery AC Adapter	AA-size Battery Holder Bracket, Sync Cord A Optional: Sync Cord B, AFW2, AFT2	86 x 92 x 260mm 3.4 x 3.6. x 10.2 in	770g 27 oz
AF280T	Auto: f-8 (3.5m) f-4 (7m) TTL Auto: Any aperture (20m with f-1.4)	Yes See Table	Yes	4 AA Batteries (Ni-Cd OK)	Optional: AFW1, AFT1	80 x 68 x 116mm 3.1 x 2.7 x 46 in	300g 10.5 oz
AF200T	Auto: f-2.8 (7m) f-5.6 (3.5m) TTL Auto: Any aperture (14m with f-1.4)	Yes See Table	No	4 AA Batteries (Ni-Cd OK)	Optional: AFW1, AFT1	62 x 97 x 58mm 2.4 x 3.8 x 2.3 in.	175g 6.1 oz.
AF200S	f-2.8 (7m) f-5.6 (3.5m)	Yes See Table	No	4 AA Batteries (Ni-Cd OK)	Optional: AFW1, AFT1	105 x 67 x 60mm 4.1 x 2.6 x 2.4 in	285g 10 oz
AF160	f-2.8 (6m) f-4 (4m)	Yes See Table	No	2 AA Batteries (Not Ni-Cd)		81 x 66 x 41mm 3.2 x 2.6 x 1.6 in	102g 3.6 oz
AF080C RING LIGHT	TTL Auto: Any aperture within range	Yes See Table	No	4 AA Batteries (Ni-Cd OK) TR Power Pack Power Pack 510V AC Adapter II		Control Pack: 70 x 70 x 82mm 2.8 x 2.8 x 3.2 in Ring Flash: 93 x 122 x 22mm 3.7 x 4.8 x 0.9 in	235g 8.3 oz 135g 4.7 oz
Takumar AF 14	f-4 (3.7)	No	No	2 AA Batteries (Ni-Cd OK)		66 x 61 x 41mm 2.6 x 2.4 x 1.6 in	91g 3.2 oz

Automatic Aperture Selection— With program cameras in the programmed auto or shutter-priority auto mode, the flash not only sets shutter speed to X-sync but also sets a suitable aperture size.

TYPES OF ELECTRONIC FLASH

There are many capabilities that can be built into electronic flash in various combinations.

The unit may be energy saving or not. An energy-saving flash costs more but is preferred if you use it a lot because it recycles faster and reduces the cost of batteries.

The flash may be manual only. If you don't mind thinking and doing arithmetic, a simple manual flash is satisfactory.

The flash may offer both manual and automatic, depending on how you set the flash controls. These are more versatile. If automatic, there and two types—light-sensing, using a sensor on the flash, and TTL Auto flash.

POWER SOURCES

A variety of power sources is available for electronic flash. Most common is AA-size batteries in the flash unit. There are three kinds of batteries.

After a test firing, some automatic flash units provide a flashing or glowing light if there was enough light for correct exposure. This is usually called *Auto Check*. In addition to testing, it functions after each exposure. Some dedicated flash units operate an Auto Check indicator in the viewfinder.

Flash Override System—Some camera models will not fire the flash at bright scenes. This is determined by the shutter speed that would be required for correct exposure of the scene by ambient light—without flash. This works only with the camera in an automatic-exposure mode.

If the ambient-light shutter speed will be equal to or *higher* than X-sync speed, the flash will not fire and the camera will use ambient light to make a correct exposure.

If the ambient-light shutter speed will be *slower* than X-sync, the flash will fire and the camera will use both flash and ambient light to make a correct exposure.

DEDICATED FLASH CAPABILITIES WITH PENTAX 35mm SLR CAMERAS

	LX	Program Plus	Super Program	ME Super
AF400T	Automatic Shutter-Speed Selection Ready Light in Viewfinder Auto Check in Viewfinder Flash Override TTL Auto flash capability	Automatic Shutter-Speed Selection Ready Light in Viewfinder Auto Check in Viewfinder Sets aperture*	Automatic Shutter-Speed Selection Ready Light in Viewfinder Auto Check in Viewfinder Flash Override TTL Auto flash capability Sets aperture*	Automatic Shutter-Speed Selection Ready Light in Viewfinder
AF280T	Automatic Shutter-Speed Selection Ready Light in Viewfinder Auto Check in Viewfinder Flash Override TTL Auto flash capability	Automatic Shutter-Speed Selection Ready Light in Viewfinder Auto Check in Viewfinder Sets aperture*	Automatic Shutter-Speed Selection Ready Light in Viewfinder Auto Check in Viewfinder Flash Override TTL Auto flash capability Sets aperture*	Automatic Shutter-Speed Selection Ready Light in Viewfinder
AF200T	Automatic Shutter-Speed Selection Ready Light in Viewfinder Auto Check in Viewfinder Flash Override TTL Auto flash capability	Automatic Shutter-Speed Selection Ready Light in Viewfinder Auto Check in Viewfinder Sets aperture*	Automatic Shutter-Speed Selection Ready Light in Viewfinder Auto Check in Viewfinder Flash Override TTL Auto flash capability Sets aperture*	Automatic Shutter-Speed Selection Ready Light in Viewfinder
AF-200S	Automatic Shutter-Speed Selection Ready Light in Viewfinder Flash Override	Automatic Shutter-Speed Selection Ready Light in Viewfinder	Automatic Shutter-Speed Selection Ready Light in Viewfinder	Automatic Shutter-Speed Selection Ready Light in Viewfinder
AF-160	Automatic Shutter-Speed Selection Ready Light in Viewfinder	Automatic Shutter-Speed Selection Ready Light in Viewfinder	Automatic Shutter-Speed Selection Ready Light in Viewfinder	Automatic Shutter-Speed Selection Ready Light in Viewfinder
AF080C RING LIGHT	Automatic Shutter-Speed Selection Ready Light in Viewfinder Auto Check in Viewfinder Flash Override TTL Auto flash capability	Automatic Shutter-Speed Selection Ready Light in Viewfinder Auto Check in Viewfinder Sets aperture*	Automatic Shutter-Speed Selection Ready Light in Viewfinder Auto Check in Viewfinder Flash Override TTL Auto flash capability Sets aperture*	Automatic Shutter-Speed Selection Ready Light in Viewfinder

*Flash sets aperture only on programmed auto or shutter-priority auto

Ordinary carbon-zinc dry cells don't provide as many flashes as more expensive batteries. If you use flash only occasionally and the batteries discharge before you use them again, ordinary disposable dry cells are best.

Alkaline cells, sometimes called alkaline-manganese cells, are similar in appearance and also disposable after use. They cost more but give more flashes than ordinary dry cells.

Nickel cadmium cells, also called NiCad, Nicad and Ni-Cd, are the same size and shape but are rechargeable. Although it costs more to buy Nicad cells and a special recharger, it will pay off provided the batteries are used often.

Separate battery packs with a connecting cord are available for some equipment to provide more power than self-contained batteries. These battery packs may contain larger batteries of the same type normally installed in the flash. Another approach is to use a non-rechargeable high-voltage 510-Volt battery pack. These provide a lot of flashes and usually the shortest recycle time.

If household electrical power is available, you can substitute an AC power supply for batteries. This is the most economical way to power a flash, if you use it a lot.

CAUTION: Nicad cells can provide a stronger surge of electrical current than other types. Flash units not designed to handle such current can be damaged. Film winders and motor drives have more force when Nicads are installed and may damage film if they're not designed for Nicads. Check the specs before installing Nicad batteries.

AF400T AUTOMATIC FLASH

Offering manual operation, light-sensing automatic and TTL Auto, the AF400T is a powerful, energy-saving, handle-mount flash supplied with a camera bracket. The flash head tilts from −15° for close-ups to +90° and also swivels 180° to make bounce flash convenient with the flash on the bracket. The bracket releases the flash easily so you can hold it away from the camera.

Power is normally supplied by six AA batteries in the AM-3 battery holder that fits on the bottom of the handle. Nicad cells can be used. A power-cord receptacle is available for external power sources. The power switch has three positions: OFF, INT. ON for power from AM-3 and EXT to use an external power source.

The Mode Selector has six positions. M selects ordinary manual operation using the flash guide number. In this mode, the flash

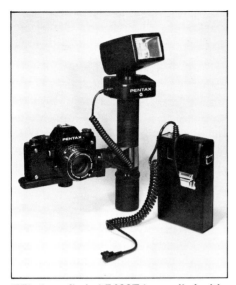

TTL Auto flash AF400T is supplied with bracket and sync cord. Standard power source is battery pack shown on bottom of flash handle. Optional power sources include separate TR Power Pack, shown, a 510V pack and an AC Adapter to use household power.

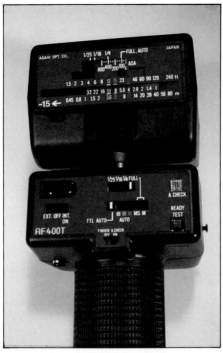

Control panel on back of AF400T is used for all six operating modes.

can be used with any camera that has X-sync at a hot shoe or terminal on the body. The calculator scales on the flash can be used, or you can make guide-number calculations.

MS selects manual operation plus one dedicated feature. When the ready light is on, the flash automatically sets certain camera models to X-sync.

In either of the manual settings, an adjacent Light Intensity Selector allows setting power at FULL, 1/4, 1/16 or 1/25. ASA film speed is set by a sliding control. Before using, set film speed. For any automatic setting or full power on manual, the ASA film-speed number is placed opposite the index mark labeled FULL,AUTO. When lower power settings are used on manual, the film-speed number is placed opposite the index marked for the reduced power level.

There are three light-sensing automatic settings: red (with a range of 1.25–10m), green (0.76–5m) and yellow (0.45–3.6m). Ranges

are the same at each film-speed setting, but a different choice of f-stops is available. Notice the aperture for the selected range and set that aperture on the lens.

In the TTL AUTO mode, you can use any aperture, provided it gives a suitable operating range. The film-speed setting on the camera controls the system. Set the flash to the same film-speed so you can use the calculator scales to show maximum operating range. Minimum range is 1/8 of maximum.

Ready Light—This light glows when the capacitor has charged to within 1/2 step of maximum. With fresh batteries, the capacitor will charge fully in about 10 seconds after the ready indication. When the ready light is not lit, the camera operates as though the flash were disconnected. With some camera models, the flash operates a ready indicator in the viewfinder.

Test—Pressing the ready light when it is glowing fires the flash independent of the camera.

Auto Check—After firing the flash with the test button while in any *light-sensing automatic* mode, and after each exposure with flash in any auto mode, the A.CHECK (Auto Check) lamp on the flash will glow for about 2 seconds if there was sufficient light for correct exposure. With some camera models, the flash also operates an Auto Check indicator in the viewfinder.

While the ready light on the flash is lit, you can expose frames continuously in rapid sequence—manually or with motor drive. However, if the flash is also operating an Auto Check indicator in the camera, the camera cannot be used during the indication. The flash has a FINDER A.CHECK OFF ON switch to turn the finder indication off for maximum shooting speed.

Sync Connector—Sync Cord A is supplied for connection to a camera-body sync terminal with adjacent auxiliary contacts for dedicated functions, as on the LX. For cameras with auxiliary contacts only in the hot shoe, use optional Sync Cord B, which plugs into the hot shoe. For flash without dedicated functions, use any standard PC cord between flash and camera.

To Use with LX—Use either Sync Cord A or B. Select any mode.

To Use with ME Super, MEF or MG—Use Sync Cord B. Select any mode except TTL.

To Use with Other Cameras—Connect to camera sync terminal with standard PC cord. Select any mode except TTL Auto and MS.

Wide-Angle Adapter AFW2—Slides onto the flash head for use with 24mm to 30mm lenses. Maximum range is reduced by 1/2.

Telephoto Adapter AFT2—Slides onto flash head for use with 85-200mm lenses. Maximum range is doubled.

AF280T AUTOMATIC FLASH

This is a medium power, energy-saving, hot-shoe-only flash with manual, light-sensing automatic and TTL Auto. The flash head tilts from −15° for close-ups to +90°

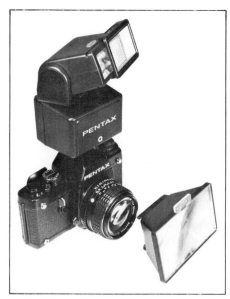

AF280T is a TTL Auto flash for hot-shoe mounting. The flash head swivels and tilts for bounce flash. This and other Pentax flash units use beam widening panels, shown partially covering the flash head, and attachments to narrow the beam for use with telephoto lenses—shown separately.

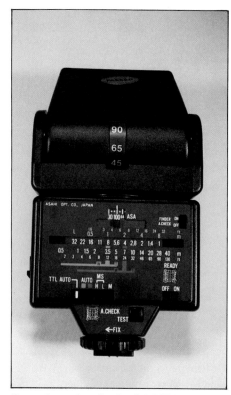

Control panel on back of AF280T serves all operating modes.

Ready Light—This light glows when the capacitor has charge to within 1/2 step of maximum. With fresh batteries, the capacitor will charge full in about 10 seconds after the ready indication. When the ready light is not lit, the camera operates as though the flash were disconnected. With some camera models, shown in the table on page 136, the flash operates a ready indicator in the viewfinder.

Auto Check—After firing the flash with the TEST button in any *light-sensing automatic* mode, and after each exposure using flash in any automatic mode, the A. CHECK (Auto Check) lamp on the flash will glow for about 2 seconds if there was sufficient light for correct exposure. With some camera models, shown in the table on page 136, the flash operates an Auto Check Indicator in the viewfinder.

While the ready light on the flash remains lit, you can expose frames continuously in rapid sequence—manually or with motor drive. However, if the flash is also operating an Auto Check indicator in the camera, the camera cannot be used during the indicating. The flash has a FINDER A CHECK OFF ON switch to turn the finder indication off for maximum shooting speed.

To Use with LX—Install in hot shoe. Select any of the 6 modes.

To Use with ME Super, MEF or MG—Install in hot shoe. Select any mode except TTL Auto.

To Use with Other Cameras—Install in hot shoe. Select any mode except TTL Auto.

Wide-Angle Adapter AFW1—Slides onto the flash head for use with 24mm to 30mm lenses. Maximum range is reduced by 1/2. Use the aperture indicated by the symbol **W** in the red or green band.

Telephoto Adapter AFT1—Slides onto flash head for use with 85mm to 200mm lenses. Maximum range is doubled. Use the aperture indicated by the symbol **T** in the red or green band.

and also swivels 180° to make bounce flash convenient. Power is supplied by four AA batteries in the flash. Nicads are OK. Before using the flash, set ASA film speed opposite the index.

The Mode Selector has six settings. M selects ordinary manual operation using the flash guide number. In this mode, the flash can be used with any camera that has X-sync at a hot shoe. The calculator scales on the flash can be used, or you can make guide-number calculations.

MS designates a zone that includes two selector positions, labeled H and L. At either of these, the flash is set for manual operation plus one dedicated feature. When the ready light is on, the flash automatically sets certain camera models to X-sync as shown in the table on page 136.

If set to H, the flash produces full power. At L, it produces about 3.5 steps less power. If either set-

ting in the MS zone is used with a camera that cannot be set to X-sync speed automatically by the flash, the two power levels are available anyway.

There are two light-sensing automatic settings, colored red (range: 1-7m) and green (range: 0.5-3.5m). Maximum ranges are the same at all film speeds. For each film-speed setting, a different choice of f-stops is available. Notice the aperture for the selected color and set that aperture on the lens.

In the TTL AUTO mode, the film-speed setting on the camera controls the system, no matter what film-speed is set on the flash. It's good practice to set the flash to the same film-speed because you can then use the calculator scales to show maximum operating range for each lens aperture. Minimum range is 1/8 of maximum range. You can use any aperture setting, provided it gives a suitable operating range.

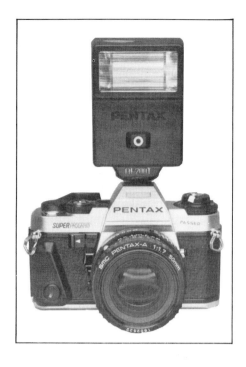

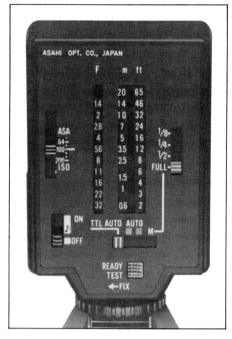

AF200T AUTOMATIC FLASH

This is a medium-power, energy-saving, hot-shoe-only flash. It features TTL auto, light-sensing auto with two power levels, manual with four power levels, and the capability of setting aperture size automatically with program cameras. The flash head does not rotate.

Power is supplied by four AA batteries. Nicads are OK. The Power Switch has two "on" settings. When set to the musical-note symbol, the flash is turned on and a built-in beeper indicates sufficient exposure after the flash fires. When set to ON, the beeper does not operate.

Beam-Angle Adapters—The flash beam covers the angle of view of a 28mm lens. Two optional clip-on adapters are available to fit over the flash window. Wide-angle Adapter AFW1 increases coverage to 24mm lenses. Telephoto Adapter AFT1 narrows the beam for use with focal lengths up to 200mm.

Film Speed—Set ASA/ISO film speed on the back panel of the flash. Range is ASA 25 to 800.

Ready Light—The READY TEST light on the back panel glows when the flash has charged within about 1/2 step of full charge and

can be fired. Waiting a short time longer brings the flash to full charge. The light also serves as a test switch. Press it to fire the flash independently of the camera.

Automatic Shutter-Speed Selection—With the camera on any auto mode, when the flash is charged, shutter speed is set to X-sync. With the camera on manual, operation depends on camera model.

Auto Check—With the flash in any auto mode, sufficient exposure is indicated by a built-in beeper in the flash. A viewfinder indication also appears in some camera models.

TTL Auto Mode—This mode can be used only with cameras that have a light sensor in the mirror box, such as the LX and Super Program. Set the flash Light Intensity Selector to FULL. Slide the flash Mode Selector to TTL AUTO.

The *f*-number scale on the flash shows the range of apertures that can be used. Opposite each aperture is the maximum distance range in meters and feet. Minimum range is approximately 1/3 of maximum but never less than 0.6 meters or about 2 feet.

With the camera on aperture-priority auto or manual, set the lens manually to any aperture suitable

for the subject distance.

With a program camera on programmed or shutter-priority auto, aperture will be set automatically when the flash is charged. The setting is displayed in the viewfinder. Aperture depends on film speed. Range is always 1.7 to 5 meters (approx. 5 to 16 feet).

Light-Sensing Auto Mode—This mode uses the light sensor on the flash to control exposure. It can be used with any camera with X-sync at the hot shoe.

Set the flash Light Intensity Selector to FULL. Set the flash Mode Selector to either of the AUTO settings—red or green. A single aperture is shown on the flash panel. Set the lens to that aperture. Shooting range is indicated by a red or green band on the distance scale. The change in range caused by a beam adapter is indicated by T for AFT1 and W for AFW1.

Manual—Set the camera for manual exposure. Set the flash Mode Selector to M. A range of usable apertures appears on the *f*-number scale on the flash. Subject distances for each aperture appear opposite.

Use the Light Intensity Selector to choose FULL or reduced power. The subject-distance scales change automatically. Choose aperture according to subject distance and set that aperture on the lens.

Depending on the camera model, the flash may set shutter speed to X-sync automatically. If not, set shutter speed manually to X-sync or slower.

Recycle time is shorter when less power is used. At 1/8 power, with fresh alkaline batteries and the flash fully charged, several exposures may be made in sequence using a motor drive or film winder.

If AFW1 wide adapter is used, change film speed on the flash to 1/2 the actual value. With AFT1, set to twice the actual value. Indicated subject distances will then be correct for the adapter in use.

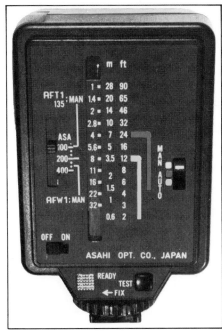

AF200S AUTOMATIC FLASH

This light-sensing auto flash works in the hot shoe with special "dedicated" operating features shown in the table on page 136. With the listed cameras, the flash automatically selects the X-sync shutter speed when the flash is charged and ready to fire. The flash also controls a flash-ready indicator in the viewfinder—see Chapter 16.

When the flash ready-light is not lit or when the flash is turned off, the camera reverts to normal operation using whatever shutter speed is required for correct exposure.

The AF200S has two automatic settings plus manual, with a guide number of 65 feet (20mm) at ASA 100.

To Use with LX, ME Super, MEF or MG—Install flash in hot shoe. Turn the flash Power Switch on. Set the ASA lever on the flash to the same film-speed number as the camera, using the center white index mark for the ASA scale. Choose one of the three operating

modes of the flash, using the MAN-AUTO Selector.

With the LX, set shutter speed to AUTOMATIC or X. With the ME Super, set the mode selector to AUTO or M. With MV-1 or MV, select AUTO. Focus on the subject of interest. Read subject distance off the lens, or estimate it. Consult scales on the flash to find correct lens aperture as described in following paragraphs. Make the correct aperture setting on the lens. Wait for the ready light to turn on in the viewfinder and on the flash. Depress the shutter button.

Choosing Flash Mode and Lens Aperture—The red setting of the MAN-AUTO Selector is one of two automatic settings. It gives correct exposure over a range of distances. The maximum distance is 7 meters or 24 feet as shown on the flash opposite the red index mark. Minimum distance is 1.4 meters, or 4.5 feet.

The green setting gives automatic exposure to a maximum distance of 3.5 meters or 12 feet,

as shown on the flash opposite the green index. Minimum distance is 0.6 meters or 2 feet.

To find lens aperture for the automatic modes, use the *f*-number on the scale opposite the red or green index mark. In the accompanying photo, with ASA 200, the red setting of the MAN-AUTO Selector calls for a lens aperture of *f*-4 and green calls for *f*-8.

For manual operation, set the MAN-AUTO Selector to white. Any lens aperture can be used, depending on subject distance. Use the aperture setting that is opposite the distance to your subject.

To Use With Other Cameras —AF200S can be used with any camera that has X-sync at a standard hot shoe. The flash does not have a connector for a sync cord. The procedure for other cameras is exactly as already described, except that you must set shutter speed on the camera to X-sync speed for that camera, or slower.

Ready-Light—The ready-light on the AF200S and in the viewfinder glows when the flash reaches 80% of full charge. In the green auto mode, you can shoot when you first see the ready-light or any time later. In the red auto mode with subjects farther than 5 meters or 16 feet, it is advisable to wait 2 to 5 seconds to assure adequate charge. In the white manual mode, wait 2 to 5 seconds with any subject distance.

Wide-Angle Adapter AFW1— Slides over the flash window and spreads the beam of light. Recommended for 30mm and 28mm lenses, necessary for 24mm and shorter. When using this adapter, reset film speed so it is opposite the index labeled AFW1:MAN—then reset lens aperture as indicated.

Telephoto Adapter AFT1—Produces a narrower beam for use with lenses longer than 135mm. On auto, no compensation is required. On manual, reset film speed so it is opposite the index labeled AFT1 135:MAN—reset aperture.

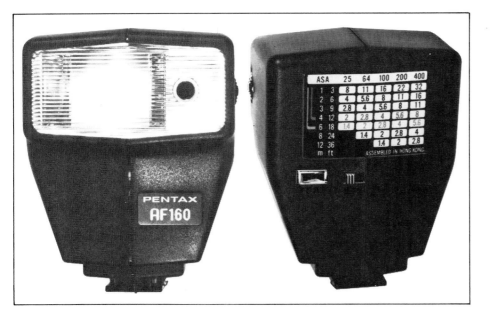

AF160 AUTOMATIC FLASH

This light-sensing automatic flash is similar to the AF200S except that the AF160 produces less light output and has fewer operating features. It's a "dedicated" flash with special capabilities shown in the table on page 136. It can be used only in the camera hot shoe.

When the flash ready-light is lit on the flash, X-sync shutter speed is automatically selected on cameras specified in the table, provided the camera is set to AUTO or M (Manual) on the ME Super. The flash also controls a flash-ready indication in the viewfinder of these camera models.

When the flash ready-light is not lit, or the flash is turned off, the camera reverts to normal operation in the auto or manual mode.

The AF160 has two automatic settings, plus manual with a guide number of 16 meters at ASA 100.

To Use with LX, ME Super, MEF or MG—Install flash in hot shoe. Turn the flash Power Switch on. Choose one of the three operating modes of the flash, using the Auto/Manual Selector on the side of the unit.

With the LX, set shutter speed to AUTOMATIC or X. With the ME Super, set the mode selector to AUTO or M. With MEF or MG, select AUTO. Focus on the subject of interest. Read subject distance off the lens, or estimate it. Consult the table on the back of the flash.

Make the correct aperture setting on the lens. Wait for the ready indication on the flash or in the viewfinder as described in Chapter 16 for each of these camera models. Depress the shutter button.

Choosing Flash Mode and Lens Aperture—The Auto/Manual Selector has two automatic settings, identified by two colors: orange and green. The orange setting gives correct exposure over a range of distances from 1 to 6 meters (3.3 to 18 feet); green from 0.5 to 4 meters (1.5 to 12 feet).

To find lens aperture for automatic modes, consult the table on the back of the flash. There are five columns of f-numbers on this table, each headed by a film-speed number, ASA film-speeds are: 25, 64, 100, 200 and 400. Starting at the film speed you have in the camera, read down that column to find the f-number printed in the same color you have set on the Auto/Manual Selector.

For example, if you are using ASA 25 film, the green f-number in that column is f-2 and the orange f-number is f-1.4.

At the left of this table, maximum operating distances are shown for each row of f-numbers. For the green row, the maximum distance is 4 meters or 12 feet. For the orange row, the distance is 6 meters or 18 feet.

For manual operation set the Auto/Manual Selector to M. At this setting, flash operation is based on its guide number. The table does the guide number arithmetic for you. You can use any of the f-numbers shown below each of the film speeds on the table. The operating distance for each f-number is shown at the left in meters and feet.

If you are using film with a guide number not shown on the table, convert the ASA 100 guide number to the number for the film you are using, as discussed earlier in this chapter. Then maximum automatic operating range, or the operating distance on manual, can be calculated with that guide number.

To Use with Other Cameras—The AF 160 can be used with any camera that has X-sync at a standard hot shoe. The flash does not have a connector for a sync cord. The procedure for other cameras is exactly as already described except that you must set shutter speed on the camera to X-sync speed for that camera—or slower.

Ready-Light—The ready-light on the flash and in the camera turns on when the flash reaches 80% of full charge. For full and repeatable brightness of the flash, wait a few seconds before firing the flash.

TAKUMAR AF14

This flash is designed for the K1000 camera. It is hot shoe only, with no dedicated features. A ready-light on the back can also be used as a test button. The ASA 100 guide number is 14 meters or 46 feet. Convert this to other film speeds as discussed earlier in this chapter. It has manual and one automatic mode using a sensor in the flash. On automatic with ASA 100 and f-4, the distance range is 2 to 12 feet. For other distances and film speeds, consult the table on the back of the flash.

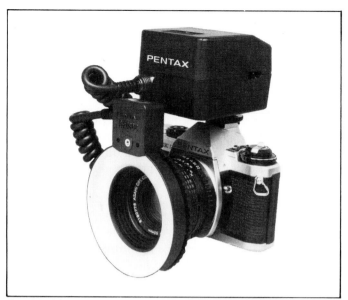

The AF080C Ring Light provides uniform, shadowless illumination of close-up subjects.

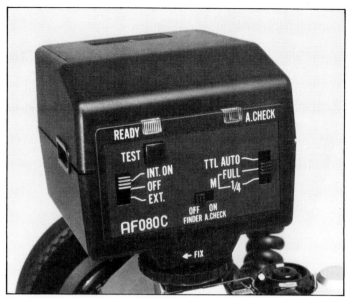

The AF Ring Light Control Pack mounts in the hot shoe. All controls are on the back panel.

AF080C RING LIGHT

In macro photography with flash, if the flash is in the hot shoe, the lens may cast its shadow on the subject. If the flash is placed near the subject, to one side, illumination is uneven and there are strong shadows.

The AF080C is a special ring-shaped flash that mounts in the filter threads on the front of the lens. It gives uniform, shadowless illumination of subjects being photographed in the close-up and macro range—from about 1 meter to a few centimeters in front of the lens.

The AF Ring Light Control Pack mounts in the camera hot shoe and connects to the ring light. Controls and a ready-light with a test button are on the control pack.

The AF080C can operate in the TTL Automatic mode on an LX camera. An Auto Check lamp on the flash operates simultaneously with the Auto Check indicator in the LX. The LX viewfinder indication can be turned off by a switch on the flash if desired.

On other cameras, and the LX if you wish, it operates as a manual flash. Dedicated features are in the table on page 136.

Guide number with ASA 100 is 8 meters at full power and 4 meters at 1/4 power. However, guide numbers are valid only at flash-to-subject distances greater than about 10 times the flash diameter. For the AF080C, the guide number is valid for distances greater than about 1 meter.

Set-up distances and aperture sizes for shorter distances are in tables in the instruction booklet. Recommended lenses include the 50mm and 100mm macro on extension tubes or bellows; 100mm bellows lens on a bellows; the 100mm *f*-2.8 and 135mm *f*-3.5 on a bellows; lenses with focal length of 50mm or less reversed on a bellows; and the 40—80mm zoom in the macro mode. Other lenses can be used but you may have to estimate settings or make tests.

Power is provided by 4 AA batteries installed in the flash or by one of three accessory sources listed on page 135. The Power Switch has OFF and two other settings. INT. ON draws power from the internal batteries. EXT. connects the flash to an external source.

To Use with the LX—Install the control pack in the hot shoe and the ring flash on the lens. Turn the power on. Set the Mode Switch to TTL AUTO. This mode automatically adjusts exposure for filter factors and the exposure factor as discussed in Chapter 11.

Set the FINDER A. CHECK to ON if you wish to see the Auto Check indication in the LX viewfinder.

Set the LX shutter dial to AUTOMATIC. Select an aperture size from the table in the instruction booklet that is suitable for the magnification or lens-to-subject distance you are using. You have a choice of 5 settings for depth-of-field control.

Wait for the ready-light and make the exposure.

To Use with Other Cameras— Use the manual mode. Install the control pack in the hot shoe and the ring flash on the lens. Set the camera to X-sync shutter speed. Turn the power on.

Select an aperture on the Manual Exposure chart in the instruction booklet that is suitable for the magnification or lens-to-subject distance you are using. You have a choice of two aperture settings, depending on whether you set the Mode Switch to FULL or 1/4. This setting does not correct for filter factors or the exposure factor due to high magnification. Make those adjustments as discussed in Chapter 11.

Wait for the ready-light and make the exposure.

HOW TO CARE FOR YOUR CAMERA

With proper care, Pentax cameras and lenses will give you many years of good service and great photographs. The best care you can give any piece of equipment is to use it properly so you don't cause problems to develop.

READ THE INSTRUCTION BOOKLET

If your camera is new, or if you haven't used it lately, read the instructions to be sure you are familiar with the controls and what they do.

CHECK OUT YOUR NEW CAMERA

You will not harm a Pentax 35mm camera by operating it without film. You can get acquainted with its operation and practice using the controls by firing "blank shots" as much as you wish. Operate the controls to get the feel of them. Trip the shutter a few times at different shutter-speed settings and notice the different sounds. Rotate the focus control while looking through the viewfinder so you know how it is supposed to work and feel.

Open the back and trip the shutter a few times at different shutter speeds while looking into the camera. You'll see the shutter open and close. While the shutter is open, you'll see a round disc of light which is the aperture in the lens. At different aperture settings, the disc of light should be different sizes.

Don't touch the shutter or interfere in any way with its motion. It's fast, precise and vulnerable.

If the camera is new, or you haven't used it in a long time, test

If you normally carry and use the camera with only one lens, this type of case is handy. The front part of the case unsnaps and drops forward for a quick shot. If you will be using the camera continuously for a period of time, it's more convenient to remove the camera from its case. To carry one or more camera bodies together with a set of lenses and accessories, use a larger "gadget bag" available at camera shops.

by exposing a roll of film.

If the battery is more than 6-months old it's good insurance to replace it before leaving on a trip. If the battery is more than a year old, it's living on borrowed time. When installing a battery, be careful not to touch the top and bottom with your fingers. They must be kept clean to allow good electrical connections between the battery and the battery receptacle. It's a good idea to rub top and bottom briskly on a clean cloth before installing, to remove any oxidation or corrosion which may have formed in storage.

For any kind of testing with film which you will send out for processing, color-slide film is best. If you shoot slide film and see bad

exposure, poor focus, or some other problem in the finished slides, chances are it happened in the camera.

When you load film, be sure the leader is caught in the slot in the take-up spool. After closing the camera back, watch the rewind knob to be sure it rotates as film is being advanced.

Make your get-acquainted shots under a variety of lighting situations. This gives you the opportunity to check the camera's built-in exposure meter, shutter-speed timer and aperture settings over a wide range of operating conditions. Start indoors and make a few shots at slow shutter speed and large aperture—on a tripod so camera shake doesn't fuzz up the image.

Then move outdoors and shoot at higher shutter speeds and smaller apertures. Naturally you will try to make worthwhile images but the main thing on this test roll is to get shots in a variety of conditions that can fully check out your exposure meter and other camera parts.

Send the roll in through your local dealer. Carefully inspect the finished slides. If you see something that doesn't look right, it could be your shooting technique, improper use of the camera controls, a fault in the camera, or a problem resulting from improper processing. If you can't figure out which, your dealer will be glad to look over the slides and help you.

THINGS THAT CAN HARM YOUR CAMERA

Camera mechanisms can be damaged due to improper storage and improper use. Here are some of the camera's "natural enemies" and what you should do about them.

Dirt—Cameras and lenses are not dustproof. Under normal conditions of use and storage, dirt, dust and grit are not a problem. When you use a camera at the beach, in the desert when sand is blowing, at dirt race tracks, cement plants, and all such places where dirt is in the air, protect your camera by keeping it enclosed except while using it. Use a camera case, or a plastic bag, or even an article of clothing wrapped around the camera. You can shoot with the camera inside a plastic bag if you cut an opening for the lens.

Water—Cameras are not waterproof. There are several places where water can get inside and do a lot of damage. Protect both body and lenses from rain or splashing water. If the camera gets wet, dry it immediately with a clean soft cloth.

If a camera is thoroughly wet due to being submerged or left for a long time in rainfall, it may be damaged beyond repair. Get it to an authorized Pentax service facility as soon as possible.

When you must shoot where the

Keep a lens cap on the front of your camera lens except when you are actually using the camera. The more you keep the lens covered, the less dirt the front surface accumulates.

Install a rear lens cap, sometimes called *lens mount cap,* on the back of every lens except when installed on the camera. This protects the rear lens element from dirt and scratches and also protects the levers and pins on the back of the lens.

camera may get wet, protect it as much as you can. Use any kind of shelter or overhead protection. Don't overlook the old camera-in-a-plastic-bag trick.

Lengthy Storage—Like people, cameras need a bit of exercise. If you are not using a camera, it will survive the inactivity better if you exercise it every 2 or 3 months. Fire some blank shots at various shutter speeds. Operate the film-advance lever and other camera controls to free them up. If you know you won't be using a camera for several months, it's a good idea to remove the battery and replace it with a new one when you start using the camera again.

Storage Conditions—Store camera and lenses in a cool dry place. A shelf or drawer in a room occupied

by people is much better than a basement or attic where the camera may be attacked by humidity or temperature extremes. Store the equipment in cases, wrappings or bags. It's a good idea to package it with small cloth bags of dessicant to hold down humidity. New camera equipment usually has these dessicant bags in the packaging—don't throw them away.

Shooting Conditions—Be careful not to bang your camera against walls or drop it. A short neckstrap, used around your neck instead of over your shoulder is very good insurance against inadvertent bangs and knocks that can damage your camera. A good rule is: Whenever you are using the camera, have the strap around your neck. A good exception to that rule is: Except when using a tripod.

When carrying a camera in a vehicle such as a car or airplane, keep it in the passenger compartment and pad it some way so it does not receive steady vibrations from contact with the frame of the vehicle. Vibration can loosen screws and possibly damage the precision mechanisms.

When you're using the camera, always have the proper lens hood affixed to the lens. Not only will it improve image quality but also it will help protect the front of the lens. A dented or cracked lens hood is a lot cheaper and easier to replace than a camera or lens.

You should also try to protect the camera from extremes of heat or cold. If you're going outdoors in very cold weather, keep the camera under your coat when you're not actually shooting. This will help keep the battery functioning and when you return to the warmer area, you won't have to worry about condensation forming on or inside the camera and causing rust.

If you've been out long enough so the camera has gotten cold, wrap it in your jacket, or better yet place it inside a plastic bag before going into a warm room. Allow it to return to room temperature slowly, and don't take it out

of the bag until it is the same temperature as the surrounding air. Otherwise, condensation will form both inside and outside the camera and cause problems later on. This is especially important if you are going to go back outside, into the cold again. Condensation inside a camera may quickly freeze when you go outside, jamming the camera.

In hot weather, protect the camera from the direct heat of the sun.

Don't leave your camera in the open sun. Don't leave it in the trunk of a car, the glove compartment, on the car's dash or back window ledge, especially in cars with lots of glass.

Caution: Catalytic converters are mounted under the floor of a car and get extremely hot. Keep your camera away from this heat source.

If you're going to be doing a lot of photography in extremely hot or extremely cold areas, your dealer can advise you, or check Kodak's list of publications on photography under extreme cold or extremely hot and humid conditions.

Normally you will not have any problems with your Pentax as its special lubricants allow it to function at temperatures from -40F (-40C) up to 150F (66C). Your major problem will be the effect on film of extreme temperature or humidity.

ASSEMBLE A CLEANING KIT

Put together a small cleaning kit and keep it with you whenever you're using your camera. Include a spare battery or batteries if your camera uses more than one. Also camera lens-cleaning tissue, lens-cleaning fluid, a 1"-wide camel's hair brush or equivalent for lens barrel and camera body, a soft lens-cleaning brush for glass surfaces, Q-Tips, and a can of pressurized air such as Omit or Dust-Off. The can of air can be left at home because it is a bit bulky to carry in your camera bag.

How To Clean a Lens—With lens cap in place, or both caps if the

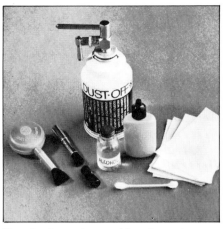

You don't need everything shown here but you do need some way to make a jet of air, lens-cleaning fluid, lens-cleaning tissues and *two* soft brushes.

A cotton swab moistened with lens-cleaning fluid is a good way to get the viewing window clean.

Blower brushes dislodge dirt particles two ways. Try a squirt of air first. Don't use the same brush to clean camera body and lens surfaces.

lens is removed from the camera, use a blast of air and your wide brush to clean dust from the lens barrel and the crevices around the controls. Be careful to use this brush only on metal surfaces and use the smaller lens-cleaning brush only on glass surfaces.

Then remove the front lens cap and blow the loose dust off the front glass element. With the lens brush, gently stroke any remaining dirt particles of the front surface.

Apply a drop or two of lens-cleaning fluid to a piece of lens-cleaning tissue and lightly wipe the lens starting at the center and spiraling outwards.

Don't rub hard and don't use more than a drop or two of lens-cleaning fluid. Never apply fluid directly to the lens as it may seep into the lens, dissolving the lubricant and possibly getting between lens elements. The rear lens element can be cleaned in the same way. It should not require frequent cleaning because it is protected by a rear lens cap or the camera body. A rear cap will protect the lens element but, more important, it protects lens mount and levers. Regular use of a rear cap prevents trouble.

Clean a lens only when it actually needs it—when it's covered with dust or has finger smudges. If you

clean it too often, you're taking a chance on scratching it and reducing image quality. Scratches cause flaws and reduced contrast.

How To Clean The Camera Body—Start with your wide brush to clean loose dust off the body and out of crevices. Work around all controls to remove loose dirt. Otherwise, dirt may work its way past the film-advance lever or shutter-speed dial to the inside of the camera and cause problems later on.

Then open the back of your camera. Use the large brush to clean out any dust or film particles.

Body caps cover the opening in the camera body when the lens is removed. If a camera body is to be stored or carried without a lens installed, use a body cap to keep dirt and miscellany out of the camera body and protect the mirror.

Use lens tissue or a clean soft cloth to remove dirt from pressure plate, rollers and film-guiding rails.

You can also use a puff of air to do the job. Be very careful not to to spray the air directly on the shutter curtains and don't touch them with anything.

Using a small piece of lens-cleaning tissue dampened with cleaning fluid, clean the pressure plate and guide rails in the camera body.

Never attempt to clean the camera mirror. It is surfaced on the front rather than on the back of the glass and is easy to scratch. Never apply a piece of lens cleaning tissue or even try to brush it. This is the place to use your can of air or squeeze bulb to clear away loose dirt.

IF YOU HAVE A PROBLEM

What if the film stops advancing? There's a good chance you've simply reached the end of a roll of film. It may be a 20 exposure when you thought it was a 36, or maybe you advanced the film a little farther than normal before closing the camera back. Never use an unusual force to advance the film—or on any other camera control. Rewind the film, operate the camera without film and it may check out OK. If so, try another roll of film.

If the meter quits, put in a new battery. This will frequently solve exposure or meter problems instantly. You should replace the camera battery once a year, even if it tests OK.

How to Test Exposure Accuracy— If you are getting some bad exposures, check the simple things first. Try a new battery. Is your metering technique causing the problem—such as shooting a subject against a bright background without making any compensation?

Exposure errors due to a fault in the camera metering system will usually occur at all shutter-speed settings and all apertures. One check is to compare the settings read from the camera meter to those of a separate accessory meter. A hand-held meter will normally measure a much wider area than that in your camera, and the readings may vary depending on your subject. Another SLR camera can be used for domparison. They should agree within about one-half step. Check at different scene brightnesses. If you get fairly good agreement, the meter in your camera is probably OK—if the comparison camera is making good exposures.

How to Test Focus—It may be your vision or technique instead of the camera. When your vision is getting fuzzy images from everything, it's hard to distinguish good focus from bad.

With the camera on a tripod and at large aperture so depth of field is minimum, ask somebody with good vision to focus your camera sharply. Then you do it. If you had to refocus, somebody did it wrong because there is only one camera setting that gives best focus.

Maybe it's technique. Are you checking focus *carefully* on each shot? It's easy to grow lax about it until one day you realize your pictures are not as sharp as they should be.

HOW TO GET IT FIXED

If you can tell by feel of the controls or the pictures you get that the camera needs repair, have it fixed by an authorized Pentax service agency. Save your receipts when you purchase camera gear, so you will have a record of the purchase date. Read the warranty card that comes with new equipment—it is different in different parts of the world. Save the warranty card with your receipt so you will later be able to double check warrant provisions and also check to see if your equipment is still in warranty. If so, repair cost will be considerably reduced.

In The United States—The best place for Pentax service is a Pentax service center.

In Other Parts of the World—The procedure is generally the same. The dealer where you bought your camera, or any Pentax dealer will be glad to assist you.

Current Addresses—Up-to-date lists of authorized service centers are included with Pentax equipment and available at all Pentax dealers.

AVAILABLE LENSES FOR 35mm CAMERAS

Technical data is shown in the accompanying tables. Lenses no longer in production and a few special-purpose lenses are not included.

Basic information in these tables is supplemented by the following discussion of lens types, uses, special features and operating details.

REVIEW OF LENS TYPES

All but one of the lens mechanisms described here are still in use with current-model cameras. The discontinued type is included for historical interest or in case you ever use one.

Manual—The earliest and simplest lenses with adjustable apertures used a diaphragm ring on the lens with a direct connection to the aperture. Turn the ring and aperture size changes immediately. Even with a camera designed to control aperture automatically, manual lenses are controlled manually, using stop-down metering.

Preset—A preset lens has two diaphragm rings, side by side, one serving as a mechanical limit or stop for the other. When the aperture setting is decided, that *f*-number is set on the mechanical limit ring which has strong detents or click-stops. The other ring actually controls aperture size. For viewing and focusing, the second ring is turned for open aperture. Then, to shoot, it is turned until stopped by the first ring, at the *f*-stop which was *preset* on the first ring. This makes it handy to view at open aperture and quickly change to the shooting *f*-stop without removing

Some long-focal-length and special lenses have manual aperture—opened and closed manually by the diaphragm ring on the lens.

your eye from the viewfinder. These are basically manual lenses, used with stop-down metering.

Semi-automatic Diaphragm—This lens was the first step toward the modern concept of camera automation. These lenses had a single diaphragm ring which was set to shooting aperture according to a reading taken by an external exposure meter. Then a "charging lever" on the lens was moved. This opened aperture fully and also tensioned a spring inside the lens

so the spring could later close down to the selected aperture. Viewing and focusing was done with the lens held open by the charging lever. At the instant of shutter release, a linkage between camera and lens released the spring in the lens which stopped down to shooting aperture just before the camera shutter opened. This lens type is no longer manufactured.

Automatic Diaphragm — In some Pentax literature, this type of lens is called *fully automatic* because

SMC PENTAX AND PENTAX-M LENSES

Type	Lens	Minimum Aperture	Diaphragm	Minimum Focusing (m)	(ft)	Angle of View (degrees)	Maximum Diameter & Minimum Length (mm x mm)	Weight (g)	(oz.)	Filter Size
Fisheye	SMC Pentax Fish-Eye 17mm ƒ-4	22	FA	0.2	0.66	180	64.5 x 34	234	8.19	BI
Ultra-wide angle	SMC Pentax 15mm ƒ-3.5	22	FA	0.3	1.0	111	80 x 81.5	600	21.2	BI
	SMC Pentax 18mm ƒ-3.5	22	FA	0.25	0.79	100	63 x 61.5	295	10.4	BI
	●SMC Pentax-M 20mm ƒ-4	22	FA	0.25	0.9	94	63 x 29.5	150	5.29	49
	SMC Pentax 24mm ƒ-2.8	22	FA	0.25	0.79	84	63 x 41.5	194	6.79	52
Wide angle	●SMC Pentax-M 28mm ƒ-2	22	FA	0.30	1.0	75	63 x 41.5	215	7.6	49
	●SMC Pentax-M 28mm ƒ-2.8	22	FA	0.30	1.0	75	63 x 31	156	5.50	49
	SMC Pentax 30mm ƒ-2.8	22	FA	0.30	1.0	72	63 x 39.5	215	7.52	52
	●SMC Pentax-M 35mm ƒ-2	22	FA	0.30	1.0	62	63 x 42	205	7.18	49
	●SMC Pentax-M 35mm ƒ-2.8	22	FA	0.30	1.0	62	63 x 35.5	174	6.14	49
Standard	●SMC Pentax-M 40mm ƒ-2.8	22	FA	0.60	2.0	56	63 x 18	110	3.88	49
	SMC Pentax 50mm ƒ-1.2	22	FA	0.45	1.5	46	65 x 48.5	335	13.48	52
	●SMC Pentax-M 50mm ƒ-1.4	22	FA	0.45	1.5	46	63.x 37	238	8.40	49
	●SMC Pentax-M 50mm ƒ-1.7	22	FA	0.45	1.5	46	63 x 31	185	6.53	49
	●SMC Pentax-M 50mm ƒ-2	22	FA	0.45	1.5	46	63 x 31	170	6.00	49
Telephoto	●SMC Pentax-M 85mm ƒ-2	22	FA	0.85	2.8	29	62.5 x 46	250	8.82	49
	●SMC Pentax-M 100mm ƒ-2.8	22	FA	1.0	3.3	24.5	62.5 x 55.7	225	7.88	49
	SMC Pentax-M 120mm ƒ-2.8	32	FA	1.2	3.9	20	62.5 x 63	270	9.50	49
	SMC Pentax 135mm ƒ-2.5	32	FA	1.5	5	18	67.5 x 85.9	470	16.45	58
	●SMC Pentax-M 135mm ƒ-3.5	32	FA	1.5	5	18	62.5 x 65.7	276	9.74	49
	●SMC Pentax-M 150mm ƒ-3.5	32	FA	1.8	6	17	62.5 x 75	290	10.23	49
	SMC Pentax 200mm ƒ-2.5	32	FA	2	6.5	12	89 x 145	1019	35.90	77
	●SMC Pentax-M 200mm ƒ-4	32	FA	2	6.5	12	63.5 x 111	405	14.18	52
Ultra-telephoto	●SMC Pentax-M* 300mm ƒ-4	32	FA	4	13	8.3	84 x 132	825	29.1	77
	SMC Pentax-M 300mm ƒ-4	32	FA	4	13	8.3	84 x 131.5	815	28.7	77
	●SMC Pentax-M 400mm ƒ-5.6	45	FA	5	17	6	85 x 276.5	1220	43.00	77
	SMC Pentax 500mm ƒ-4.5	45	M	10	35	5	126.5 x 440	3330	116.60	52 (R)
	SMC Pentax 1000mm ƒ-8	45	M	30	100	2.5	143 x 738	5250	183.80	52 (R)
	SMC Pentax Reflex 1000mm ƒ-11	—	ND	8	26.24	2.5	119 x 248	2300	80.50	BI/52 (R)
	SMC Pentax Reflex 2000mm ƒ-13.5	—	ND	20	66	1.25	180 x 530	8000	280.00	BI/52 (R)
Zoom	●SMC Pentax-M Zoom 24—35mm ƒ-3.5	22	FA	0.5	2.0	83—65	64 x 48	290	10.20	58
	●SMC Pentax-M Zoom 24—50mm ƒ-4	22	FA	0.4	1.4	84—46	64 x 71	380	13.4	58
	●SMC Pentax-M Zoom 28mm ƒ-3.5—50mm ƒ-4.5	22	FA	0.55	2	75—46	65 x 52	315	11.11	52
	●SMC Pentax-M Zoom 35mm ƒ-2.8—70mm ƒ-3.5	22	FA	1	3.3	63—34.5	67 x 76	470	16.58	67
	●SMC Pentax-M Zoom 40mm ƒ-2.8—80mm ƒ-4	22	FA	1.2	4.0	57—31	65.5 x 76	395	14.00	49
	SMC Pentax Zoom 45—125mm ƒ-4	22	FA	1.5	5	50.5—20	69 x 127	612	21.42	67
	●SMC Pentax-M Zoom 75—150mm ƒ-4	32	FA	1.2	4.0	32—16.5	63.5 x 111	465	6.40	49
	●SMC Pentax-M Zoom 80—200mm ƒ-4.5	32	FA	1.6	5.5	30—12	65 x 141.5	555	19.57	52
	SMC Pentax Zoom 135—600mm ƒ-6.7—	45	M	6	20	18—4	105 x 582	4070	142.50	52 (R)
	SMC Pentax Reflex Zoom 400mm ƒ-8—600mm ƒ-12	—	ND	3	9.8	6.2—4.1	82 x 108	730	25.75	67/40.5 (R)
Macro	●SMC Pentax-M Macro 50mm ƒ-4	32	FA	0.234	0.77	46	63 x 42.5	160	5.60	49
	●SMC Pentax-M Macro 100mm ƒ-4	32	FA	0.45	1.48	24.5	64.6 x 77.5	355	12.43	49
	SMC Pentax Bellows 100mm ƒ-4	32	FA/M	—	—	24.5	60 x 40	186	6.51	52
Shift	SMC Pentax Shift 28mm ƒ-3.5	32	M	0.3	1.0	75	80 x 92.5	611	21.39	BI

●Compact Lens BI—Filters Built-In FA—Fully Automatic M—Manual ND—ND filters built-in (R)—Rear Mount
NOTE: Lens length does not include mounting portion. M*—lens uses special low-dispersion glass.

This is the standard K mount without the electrical contacts that would make it a KA mount. The Aperture-Ring Feedback Lever travels in the curved opening at left. It "tells" the camera where the Aperture Ring on the lens is set. The Automatic-Aperture Lever (arrow) is operated by the camera to stop down the lens to the selected shooting aperture just before the shutter operates.

you don't have a charging lever to operate. Under control of the camera, lenses with auto diaphragm are wide open until the shutter button is depressed; then they close to the aperture selected by the diaphragm ring on the lens. When exposure is completed, the lens automatically opens up again.

SUPER MULTI-COATING

The SMC designation means that a technically advanced multiple-layer coating is applied to glass surfaces of the lens, resulting in better picture contrast and resolution and lens glare. SMC lenses are available in a wide range of focal lengths and types.

SMC PENTAX LENSES

The first bayonet-mount lenses were called SMC Pentax lenses and the mount was called the K mount. This mount is still in use on all Pentax 35mm SLR cameras. SMC Pentax is sometimes abbreviated to SMCP.

SMC PENTAX-M LENSES

The M designation indicates that these lenses are physically smaller, for compact cameras. SMC Pentax and SMC Pentax-M lenses are comparable optically and both types produce excellent images.

SMC PENTAX-A LENSES

The -A designation indicates lenses that can be used with programmed automatic or shutter-priority automatic exposure if the camera has those capabilities. They are on KA mounts, which is the standard K mount modified to include electrical contacts allowing automatic aperture control by the camera. A-type lenses also have an A setting added to the aperture ring. This setting prepares the lens so aperture size can be controlled by the camera. These lenses are compact and have excellent optical quality.

M* AND A* LENSES

The * symbol is called *star*. It indicates that the lens uses special low-dispersion optical glass which reduces chromatic aberration and improves image quality.

ED AND IF LENSES

The letters ED stand for *Extra-low Dispersion*. It has the same significance as the * symbol.

The letters IF mean *Internal Focusing*. Lenses with this feature are focused in the usual way by turning the focusing ring. However, the focusing action is done internally by moving elements inside the lens body. The overall length of the lens does not change as it is focused.

TAKUMAR BAYONET LENSES

These lenses are available in a limited range of focal lengths. They have conventional lens coating, rather than SMC coating. Image quality is slightly less than SMC lenses provide. At this time, Takumar Bayonet lenses are packaged with a camera body, to be sold as a kit. They are not intended to be sold individually.

LENS CATEGORIES

Most photographers and lens manufacturers classify lenses in groups or categories with similar optical properties. The paragraph titles below are commonly used nomenclature for lens categories.

FISH-EYE LENS

There are two types of fish-eye lens. Each "sees" a full circle with an angle of view of 180 degrees. If the camera were pointed straight up, the lens coverage would be horizon to horizon.

One type makes a circular image on film which includes the entire field of view of the lens. Because the image is circular and must fit within the rectangular film frame, all of the frame is not occupied by the image.

The other type, represented by the Pentax Fish-eye 17mm *f*-4 lens, is a full-frame fish-eye—meaning that the image does fill the entire film frame. Therefore the sides, top and bottom of the image circle are cut off by the

SMC PENTAX-A LENSES

Type	Lens	Minimum Aperture	Diaphragm	Minimum Focusing (m)	(ft)	Angle of View (degrees)	Maximum Diameter & Minimum Length (mm x mm)	Weight (g)	(oz.)	Filter Size
Wide angle	SMC Pentax-A 24mm *f*-2.8	22	FA	0.25	0.79	84	63 x 41.5	205	7.2	52
	SMC Pentax-A 28mm *f*-2	22	FA	0.3	1.0	75	63 x 41.5	215	7.6	49
	SMC Pentax-A 28mm *f*-2.8	22	FA	0.3	1.0	75	63 x 36.5	170	6.0	49
	SMC Pentax-A 35mm *f*-2	22	FA	0.3	1.0	63	63 x 41.5	205	7.2	49
	SMC Pentax-A 35mm *f*-2.8	22	FA	0.3	1.0	63	63 x 36.5	170	6.0	49
Standard	SMC Pentax-A 50mm *f*-1.2	22	FA	0.45	1.5	47	64.5 x 47.5	345	12.2	52
	SMC Pentax-A 50mm *f*-1.4	22	FA	0.45	1.5	47	63 x 37	235	8.3	49
	SMC Pentax-A 50mm *f*-1.7	22	FA	0.45	1.5	47	63 x 31	165	5.8	49
Telephoto	SMC Pentax-A 135mm *f*-2.8	32	FA	1.2	4	18	63 x 76.5	340	12	52
	SMC Pentax-A 200mm *f*-4	32	FA	1.9	6.2	12.5	63.5 x 111	410	14.5	52
Super Telephoto	SMC Pentax-A* 300mm *f*-2.8 ED (IF)	32	FA	3	10	8.3	133 x 236	2970	105	49
	SMC Pentax-A* 300mm *f*-4	32	FA	4	13	8.3	84.5 x 132	850	30	77
	SMC Pentax-A* 600mm *f*-5.6 ED (IF)	45	FA	5.5	18	4.1	133 x 386	3280	116	49
Zoom	SMC Pentax-A Zoom 24—50mm *f*-4	22	FA	0.4	1.4	84-47	64 x 67.5	375	13.2	58
	SMC Pentax-A Zoom 28—135mm *f*-4	22	FA	1.7	5.6	75-18	80 x 112	820	28.9	77
	SMC Pentax-A Zoom 350070mm *f*-4	22	FA	0.25	0.85	63-34.5	65 x 62	330	11.6	58
	SMC Pentax-A Zoom 35-105mm *f*-3.5	22	FA	1.5	5	63-23.5	70 x 97.5	615	21.7	67
	SMC Pentax-A Zoom 70—210mm *f*-4	32	FA	1.2	4	34-12	72 x 149	680	24	58
Macro	SMC Pentax-A Macro 50mm *f*-2.8	22	FA	0.24	0.79	47	63 x 50	229	7.8	49

Fish-eye lens, SMCP 17mm ƒ-4 has built-in filters selected by rotating a ring on the front of the lens. Filter selected is identified in window on top of lens Attached lens hood is cut away at sides leaving only a small projection at top and bottom.

A characteristic of fish-eye lenses is distortion of straight lines which do not pass through center. Lines are bowed away from center as you can see. In shots of architecture and objects with straight lines, this is very obvious and calls attention to the lens you are using. Fish-eye lenses can be used to photograph nature with great subtlety and effectiveness, without calling attention to the lens itself.

frame and the 180-degree field of view exists only on the diagonal of the frame.

When a lens has *and uses* a viewing angle of 180 degrees, a lens hood cannot be used because it will project forward into the lens field of view and cut off part of the image. The full-frame fish-eye doesn't use its full field of view at the sides, bottom and top, so a small lens hood is built into the lens but cut away at the sides of the frame so as not to restrict the viewing angle where the full 180 degrees is actually recorded on film.

A conventional filter screwed into the front of a lens with 180-degree viewing angle would also vignette the image because of the metal frame of the filter itself. To avoid this, the 17mm fish-eye has four built-in filters, behind the front glass surface.

By rotating a knurled ring at the front of the lens, you can select any of four commonly-used filters: UV, SKYLIGHT, Y2, O2. For information on these filter designations and their uses, see Chapter 12. If other filter colors are required, a ring on the back of the lens can serve as a retainer for cut-out circles of gelatin. Gelatin filters are available in a wide range of colors and densitites.

Because we are not used to seeing circular photographic images, a full-circle fish-eye view seems to call attention to the fact that this special type lens was used. The retangular image produced by a full-frame fish-eye is accepted more readily as a photograph rather than a technical trick.

You can use a fish-eye lens for attention-getting impact by taking advantage of fish-eye distortion and letting it be a dominant part of the picture. Or, you can use it so the distortion is hardly noticeable and the result is accepted as an unusual viewpoint or dramatic composition.

SUPER-WIDE-ANGLE LENSES

Pentax offers a series of lenses covering angles of view from 111° to 84°, referrring to them in some literature as *ultra-wide-angle.*

The widest angle in this group— the 15mm ƒ-3.5 with a viewing angle of 111°—uses a lens hood which is notched in four places so as not to vignette the corners of the film frame. It comes with four built-in filters, same as the fish-eye. Some lens aberrations are caused by the fact that conventional lens elements are spherical— segments of a sphere. An effective correction is to use a non-spherical lens element—called *aspherical.* Until recently, manufacturing difficulty prevented volume production of aspherical lenses and they were rare. The 15mm ƒ-3.5 lens uses an aspherical element for improved lens correction and picture quality.

Even though very wide angle, none of the lenses in this group causes straight lines to curve. They are useful for shooting in limited space, photographing groups of people, interiors, buildings and for the special impact of wide-angle scenic views and nature.

WIDE-ANGLE LENSES

Two focal lengths, 28mm and 35mm, have viewing angles of 75° and 62°. Because of their inherently large depth of field, lenses in these focal lengths are good for candid and snapshot photography in addition to interiors and general use. Because photos made with 35mm focal length are not extremely wide-angle, many photographers use a 35mm lens as the normal camera lens.

SHIFT LENS
FOR ARCHITECTURE

A very common problem in photographing architecture is, the corners of a room or building look closer together near the top of the photo, which makes it appear that the structure is leaning backwards. This sometimes surprises the unwary but it shouldn't because you can see it in your viewfinder

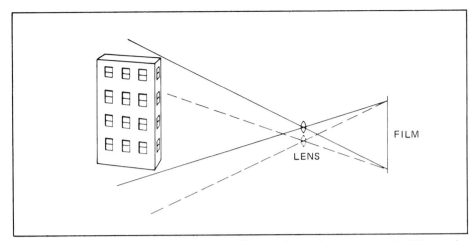

If a lens is shifted upward in respect to the film, the image includes more building and less parking lot.

The SMCP 28mm *f*-3.5 Shift Lens shown shifted on its axis. The lens can be rotated on its mount so you can shift it in any direction—up, down, sideways, or any angle in between. It's a preset lens as you can tell by the two *f*-number rings. It has built-in filters, selected by rotating a knurled ring (arrow).

before you take the picture. It can be avoided by holding the camera so vertical lines of a structure, such as corners, are parallel to the sides of the viewfinder.

This means holding the camera so it points horizontally and often you can't get the picture you want while holding it that way. When shooting a tall building, you get a lot of parking lot and not enough building to show the top. Tip the camera upward to include all of the building and it seems to fall over backwards in the resulting photo.

A shift lens solves the problem— the SMC Pentax Shift *f*-3.5 28mm lens. By rotating a control ring on the lens barrel, the optics can be shifted laterally up to 11 millimeters off center. The lens barrel rotates on its mount, so the shift can be in any direction—up, down or in between.

Shifting solves architectural photo problems as shown in the accompanying drawing and photos.

Because the lens shifts and rotates on its mount, mechanical linkages for auto diaphragm and full-aperture metering are not practical. The lens is a preset type used with stop-down metering. Normally this lens will be used on a tripod and some time taken to get the composition and shift just right.

Therefore the lack of automatic features in the lens is not a disadvantage.

The lens has three built-in filters—Y2, SKYLIGHT, O—selectable by a rotating ring near the front. Gelatin filters in colors can be used in an accessory holder over the front of the lens.

With an ordinary lens, you sometimes have to tilt the camera upward to get all of a building on film. Because the camera is tilted, the building seems to lean backwards. With a shift lens, you can hold the camera so the film is vertical and shift the lens to get the view you want. The building looks more "natural" in the resulting photo.

151

To show a size comparison, three of the original non-compact SMC Pentax lenses are shown at left: 50mm *f*-1.4, 50mm *f*-1.8 and 50mm *f*-1.2. The compact SMC Pentax-M lens at right is the 50mm *f*-1.7. SMC Pentax-A lenses are also compact, similar in size to the -M lenses.

STANDARD LENSES

40mm to 55mm focal lengths are standard for Pentax 35mm cameras, meaning they give a view we accept as normal or usual. One of these lenses is supplied with a camera unless the buyer makes other arrangements.

You can buy a camera body with any of the standard lenses, by specifying the lens you want. Or you can buy a camera body only—without lens—then choose whatever lenses you want.

The main difference among standard lenses is aperture size, ranging from *f*-1.2 to *f*-2.8. The 55mm *f*-1.8 or 50mm *f*-1.7 will give complete satisfaction to many camera users. The 50mm *f*-1.4 is nearly as popular because of its better light-fathering capability. If you often shoot in dim light, one of the larger-maximum-aperture lenses may be worth the extra cost and weight.

As a standard lens, you should consider the 50mm Macro. If you are an outdoor photographer, shooting scenics and nature, the maximum aperture of *f*-4 won't often be a handicap and the higher magnification available without accessories is very convenient.

MACRO LENSES

With the 50mm *f*-4 Macro lens, you have about two stops less light-gathering ability than the *f*-1.8 and three stops less than the *f*-1.2 lens.

Obviously this can be a handicap when shooting action in dim light, but otherwise it is not a problem. Much photography is done at apertures smaller than *f*-4.

When using this lens for high-magnification work you will probably use artifical lighting anyway to get more light on the subject and to control shadows and modeling of surface features. Try to get enough light to use *f*-8 or *f*-11 for best image quality.

The big advantage of this lens is a magnification of 0.5 with no accessories and no time spent fiddling. Crank the long-travel focus control out to full extension and you get an image on the film which is 50% as large as real life.

Using a 3 extension tube changes the magnification range so it is from 0.5 to 1.0 approximately.

This lens is corrected for close-up and macrophotography, including flatness of field so you can copy documents and photograph such things as stamps without the edges going out of focus.

With a 3 extension tube, the 50mm macro lens makes life-size images on film.

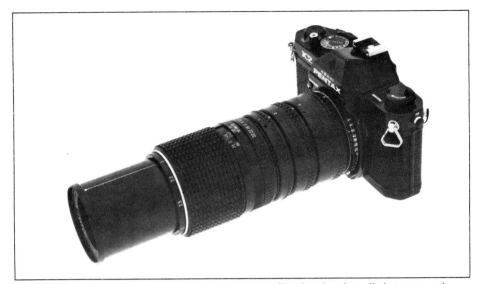

The 100mm macro also makes life-size images on film but it takes all three extension tubes or the 50mm extension tube. Working distance between the end of the lens and the subject will be longer than with a 50mm macro, which is sometimes an advantage.

If you already own a 50mm or 55mm lens, or if you prefer one of the standard lenses because of its larger maximum aperture, then consider the 100mm *f*-4 Macro as an additional lens for your set. Everything said above about the 50mm Macro applies, except the working distance between lens and subject will be almost twice as long with the 100mm Macro which can be an advantage, and you will have to use all three extension tubes to get magnifications between about 0.5 and 1.0. You should be able to use it as a general-purpose 100mm lens for outdoor photography except in poor light, and for any kind of photography under lights.

For product photography done under lights, such as many of the camera photos in this book, a 100mm macro lens is ideal. If you are an available-light fan, the maximum aperture of *f*-4 on this lens will be a disadvantage when shooting interiors and outside in poor light.

I happen to think that every photographer should own a Macro lens.

BELLOWS LENS
For use on a bellows, a lens doesn't need an internal focusing mechanism because it is moved back and forth by the bellows. The 100mm *f*-4 Bellows lens has no built-in focusing mechanism.

For use on a bellows with lots of extension available, a 100mm lens is a good compromise between magnification and working distance between lens and subject. This lens is also corrected for close-up and flatness of field.

The Bayonet lens has both automatic aperture and full-aperture metering. No Pentax bellows has the mechanical linkages to use both features. When used with Bellows K it is a manual lens with stop-down metering. With an auto bellows, it has automatic diaphragm because of the linkage in the bellows, but is still used with stop-down metering.

TELEPHOTO
These are the 85mm and longer focal lengths. The 85mm and 100mm lenses in this group are fine portrait lenses for two

reasons. One is that you don't get as close to your subject as with the 50mm lens which sometimes eases the tension of a portrait session and allows your subject to relax more. If you've forgotten the feeling of posing with a camera shoved into your face, try it once as the victim and you'll wish the photographer was using a longer lens.

The other reason relates to distortion of facial features by short subject distances. A very short lens, such as 20mm or 24mm, is often used to create a sort of caricature photo with an exaggerated nose or chin. We usually think these pictures ae funny even if the subject doesn't.

Using a lens much longer than 100mm for portraits has a flattening effect on facial features which also looks unnatural although the viewer may not be able to say why. Therefore the 85mm or 100mm lenses are the best choice for portraiture.

Incidentally, some Pentax literature assigns a magnification number such as 4X to lenses. These numbers are not magnification as defied in this book—image size divided by subject size. Instead, they are *relative* magnification, comparing magnification at various focal lengths to the magnification of a 50mm lens. From the same camera position, a 200mm lens will make everything 4 times larger on the film, compared to a 50mm lens, a a 200mm lens has a relative magnification of 4X. Relative magnification is simply the ratio of focal lengths.

A 200mm is very handy for sports and action photography. In good light, you can shoot fast enough to hand-hold the lens. I like the long "reach" of a 200mm in capturing distant subjects such as old farmhouses, mountain cabins and the like, taking advantage of a tripod or other firm support. Also terrain features and animals, including some smaller ones can be photographed well with a 200mm.

SUPER-TELEPHOTO

Pentax classifies lenses of 300mm and longer as super-telephoto. A 300mm lens is very useful for sports and nature photography. It requires a little more care and a firm support to avoid image blur, but I consider it a general-purpose lens that anybody can use.

The big change in Pentax telephoto lenses comes at 400mm focal length and longer. These lenses virtually require tripod support and have a tripod mount on the lens itself. Most have manual aperture and require stop-down metering. They are for stalking the long view; suitable for birds and small animals, missiles taking off, photographing giant suns on the horizon and such.

SMC PENTAX REFLEX LENSES

Reflex lenses are commonly called *mirror* lenses. Typically, they are made in long focal lengths such as 1000mm and 2000mm. To reduce the size of the lens, this design uses internal mirrors that bounce the light back and forth, "folding" the light path and making the lens physically shorter and lighter.

Reflex lenses do not have adjustable aperture. They have built-in neutral-density filters to control the amount of light reaching the film and can use 52mm filters screwed onto the back of the lens.

These lenses have excellent optical quality, with less inherent chromatic aberration than standard lenses of the same focal length. Small points of light that are out of focus usually appear in the image as "doughnut" shapes. This is because the front element in the lens is ring shaped with an opaque center.

ZOOM LENSES

The two focal lengths in the lens description, such as 80-200, are the shortest and longest focal lengths of th zoom range. *Zoom Ratio* is the longest focal length divided by the shortest, so it is one indicator of the versatility and potential usefulness of the lens. It also indicates the range of magnifications produced by zooming.

The lens mentioned above has a zoom ratio of 2.5. Most people think of zooming as a way to fill the frame with an image. With a zoom ratio of 2.5 you can make the image 2-1/2 times as large by using the full zoom.

In choosing a zoom lens, the first question is, "Do you really need it?" The main advantage of zooming is th ability to change focal lengths in a hurry. If you intend to shoot sports or other quick action where things happen quickly and at varying distances from the camera, a zoom lens is the only satisfactory way to improve your shooting score.

Because you can get different magnifications and angles of view from the same camera position, zoom lenses help you get good picture composition without a lot of walking around, climbing over fences and leaping chasms. This is particularly useful when shooting slides because with slides there is no further opportunity to crop or change composition. Most photographers like to fill the frame with the image they want and consider it a minor challenge to accomplish that. A zoom lens helps.

There is a penalty in lens light-gathering ability with most zoom lenses. In the data table at the beginning of this chapter, you can see the zoom lenses have smaller maximum apertures than most fixed-focal-length lenses in the same range. Zoom lenses are also heavier and usually longer.

Focusing ia zoom is usually more precise if you do it at the longest focal length. The image of the subject is larger. Depth of field is reduced, which makes it less likely that poor focus will be masked by depth of field. After focusing, set the focal length as you wish.

The challenge in designing zoom lenses is to make an image *as good as* one from a fixed-focal-length lens. For ordinary use, modern high-quality zoom lenses do that. This means that you can't see any difference. You can find a difference using laboratory instruments but, if you can't see it, the difference is probably not significant.

Reflex Zoom Lenses—The SMC Pentax Reflex Zoom 400-600mm is compact and lightweight for a long-focal-length lens with that zoom range. As it is zoomed, the fixed aperture changes from f-8 at 400mm to f-12 at 600mm. Used with a camera on aperture-priority automatic, the camera will automatically adjust shutter speed as needed to compensate for aperture changes.

THE MOST IMPORTANT LENS ACCESSORY

Faithful use of a lens hood will do more than any other single thing to improve your pictures. Light from sources outside the lens angle of view should never strike the front glass of the lens. If it does, some light will enter the lens, bounce around among the glass surfaces and cause decreased sharpness and contrast.

Because lenses have different angles of view, lens hoods must have different diameters and lengths so they block light outside the angle of view but do not intrude into the picture.

If you don't have a lens hood, use your hand or anything convenient, holding it so the front of the lens is in the shade.

Pentax lens hoods have several forms. Some screw into the lens filter threads, some are permanently attached, some clip onto the front of the lens. The mounting method is obvious by looking. Because lenses have different angles of view, lens hoods must have different diameters and lengths so they block light outside the angle of view but do not intrude into the picture.

This requirement is met by a series of Pentax Lens Hoods which are labeled to show the lenses they fit. Most fit several dif-

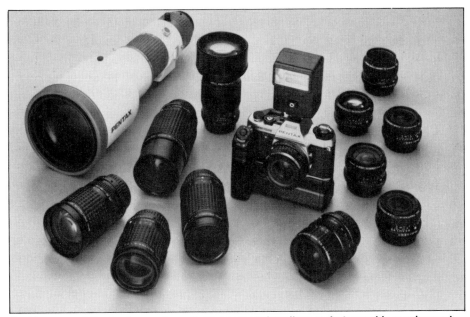

A wide range of Pentax lenses is available to meet virtually any photographic requirement.

ferent lenses, so only a few lens hoods will work with a large assortment of lenses. When buying a new lens, be sure you have a lens hood to fit. If not, buy it with the lens. Your dealer can advise you on available hoods.

Because lenses have different angles of view, lens hoods must have different diameters and lengths so they block light outside the angle of view but do not intrude into the picture.

If you don't have a lens hood, use your hand or anything convenient, holding it so the front of the lens is in the shade.

CHOOSING A SET OF LENSES

There are no fixed guidelines and basically it's every photographer for himself, but here's a rule I think makes sense. When you add a new lens, either double or halve (approximately) the focal length of a lens you already own. If you own a 100mm and want a longer focal length, try a 200mm. A 35mm lens is not different enough from a 50mm lens to justify owning both unless you have a good reason.

You want a wide-angle that is noticeably wider than your standard lens, and a telephoto that plainly has a narrower angle of view. Skill in using lenses is partly in knowing how to take advantage of focal length, and it comes mainly through taking pictures, looking at them, thinking about how you took them, and relating the equipment set-up to the end result.

It's a good idea to start in the medium-short and medium-long ranges when you first buy additional lenses for your set. For maximum versatility and general photography, you will want lenses both longer and shorter than standard. However, some people like to specialize. Obviously if your main interest is in wide-angle shots, buy wide-angle lenses.

Using the rule of thumb about choosing lenses with double or half the focal length of a lens you already own, here are two possible sets of lenses. There is no magic in these two sets except they don't have any lenses that are practically the same focal length and they cover a wide range.

One possible set is: 15 or 20, 35 or 40, 85, 150, 300, 500 and 1,000mm. Notice that this set doesn't include a standard 50mm or 55mm lens. Some travelers who go light prefer to leave out the standard lens and take along a 35mm or 40mm and an 85mm instead. If you choose these focal lengths, consider the 50mm Macro as part of the set.

Another possibility is: 24 or 28, 50, 100 or 120, 200, 400 and 1,000mm. If you purchased a camera with the standard lens of 50mm, this set gives you shorter and longer lenses that are usefully different from the standard lens. With this set, I would consider the 100mm Macro instead of the 100mm that does not have macro capability.

Once you try a zoom lens, you'll probably agree that they are so useful and such as aid to creative photography that you want some in your gadget bag. If so, they you must decide how to intermingle zoom lenses and fixed-focal-length lenses. The main problem with zooms is relatively small maximum aperture and you will find some photographic situations where a zoom won't open up enough to do the job. One solution to this potential problem is to have a zoom lens for general use and one larger aperture fixed lens with a focal length somewhere near the middle of the zoom range. That gives you a large aperture lens you can use when you need to.

For example, if you have the 45-125mm f-4 zoom lens you can supplement it with the 85mm f-2 fixed lens for use in dim light.

If you are an active photographer with a variety of photographic interests, you need more than one lens. Angle of view is important photographically and when you have experienced the use of different focal lengths you automatically consider focal length along with composition and lighting as part of your approach to a picture. If you are serious enough about photography to spend the money for a good camera, you should get and use more than one lens.

16

PENTAX 35mm CAMERAS AND ACCESSORIES

Pentax cameras from four series are currently available and described in this chapter: LX, M-series, program cameras such as the Super Program, and K-series. All use the same bayonet-mount lens types. You can choose from the lens list in Chapter 15. All of these 35mm SLR cameras accept the same lens accessories with bayonet mounts such as extension tubes, bellows and close-up lenses as described in Chapter 11. All use the same type of filters on the front of the lens. All have the same basic hotshoe dimensions so any flash with a standard mounting foot can be used. Some hot shoes have only the center contact to fire the flash; some have auxiliary contacts for dedicated functions as discussed in Chapter 13.

Film winders and data backs are available for most camera models but with limited interchangeability. The MX has its own set. The other M-series cameras share another set. The LX accessories in this category do not fit other models, and the same is true for the K-series. Descriptions in this chapter should make it clear which of these accessories fits which models.

You can ''go shopping'' in this chapter to add items to your camera equipment or to select a new system.

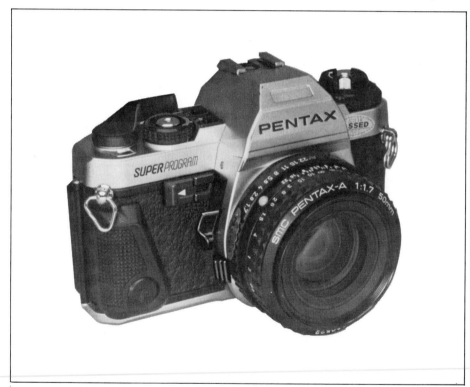

The Super Program camera, when used with SMC Pentax-A lenses, offers great versatility through six different modes of operation. This, and other current Pentax cameras are described in this chapter.

SUPER PROGRAM

The Super Program camera offers five automatic-exposure modes and one manual. The auto modes are: programmed automatic, aperture-priority auto, shutter-priority auto, TTL auto flash, and programmed auto flash. In the metered manual mode, the camera exposure meter operates to guide you in setting both aperture and shutter speed.

Programmed auto, aperture-priority auto and programmed auto flash require an SMC Pentax-A lens. With any lens, the camera can also use conventional automatic flash or manual flash.

Lens Mount—The Super Program uses the standard Pentax K-type bayonet mount with added electrical contacts to work with SMC Pentax-A lenses. This mount is called *KA*. It accepts all Pentax bayonet-mount lenses.

Recommended Lenses—SMC Pentax-A lenses are required to use all of the exposure modes. Earlier bayonet lenses, such as SMC Pentax-M and SMC Pentax, can be used—but only in the aperture-priority, TTL auto flash and metered manual modes.

Batteries—Remove the Battery-Compartment Cover on the bottom of the camera. Install one 3V lithium battery or two 1.5V silver-oxide or alkaline batteries with the negative terminals toward the cover.

Loading Film—Load film as described in Chapter 5. To advance film, set the Shutter Dial to AUTO or M. The shutter operates at 1/1000 second until film has been advanced to frame 1.

Film Advance/Rewind Indicator—On the back of the camera, near the Film-Advance Lever, three vertical red bars are visible in a window. When film is being advanced or rewound, the vertical red bars move from side to side.

Film Speed—Set ASA/ISO film speed by pressing the rectangular lock button to the left of the Rewind Knob while turning the outer rim of the Film

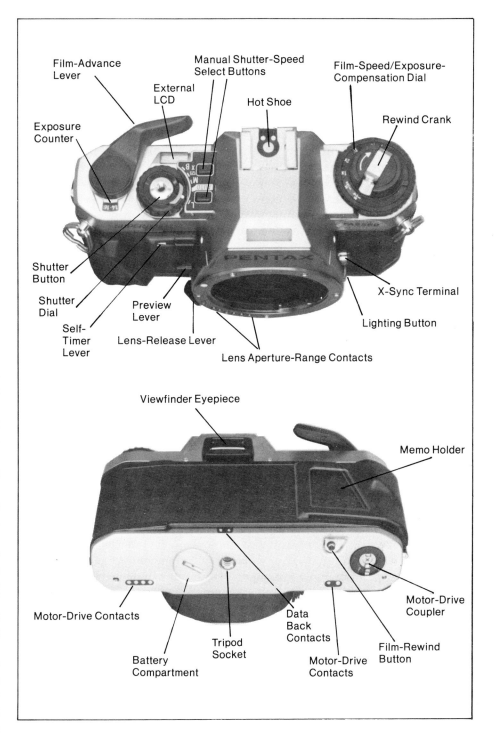

Speed/Exposure Compensation Dial to place the desired speed number in the window. Film-speed range is ASA/ISO 6 to 3200.

Shutter-Cocked Indicator—When the Film-Advance Lever has been moved through a complete stroke and released, a — symbol appears in the top-right corner of the External LCD display. If film is in the camera and advanced past frame 0, this in-

dicates that the shutter is cocked and an unexposed frame of film is ready to be exposed.

The shutter-cocked symbol remains in view even when the camera is turned off.

Focal-Plane Shutter—The shutter is metal and travels vertically. Shutter-speed range is 1/2000 to 15 seconds, electronically controlled.

Metering—Full aperture, center-

weighted metering is done using a GPD light sensor in the viewfinder housing. Metering range is EV 1 to EV 18 with *f*-1.4 and ASA 100. In addition, there is an SPD light sensor in the side of the mirror box, used for TTL flash metering.

Displays—Two LCD displays are visible in the viewfinder, below the image frame. The Shutter-Information LCD at left shows shutter speed and other data to be discussed. The Aperture-Information LCD at right shows aperture and other data.

An External LCD on top of the camera displays status—which mode has been selected and a shutter-cocked symbol. In addition, it displays the shutter speed on manual and auto.

In dim light, the viewfinder LCDs may be illuminated by pressing the Lighting Button on the side of the lens mount.

The nearest standard shutter-speed is displayed even though the camera may actually use an intermediate value. Aperture values are displayed to the nearest half-step.

LCD displays may become dark at unusually high temperatures and sluggish at low temperatures. At normal temperatures, operation will return to normal.

Shutter Dial—The operating mode is determined both by the setting of the Shutter Dial on the camera and the setting of the lens aperture ring with SMC Pentax-A lenses. The Shutter Dial has 5 settings—L, AUTO, M, 125X and B.

The L setting locks the shutter button and turns off the camera electronics.

Use the AUTO setting when the camera will set shutter speed automatically. These modes are programmed auto, aperture-priority auto, TTL auto flash and programmed auto flash. A lock button on the Shutter Dial must be depressed to turn it *away* from the AUTO setting.

Use the M setting when you will set shutter speed manually. These

SUPER PROGRAM SPECIFICATIONS

Type: 35mm multimode SLR with full-aperture through-the-lens metering and TTL auto-flash capability.

Modes: Programmed auto, Aperture-Priority auto, Shutter-Priority auto, Metered Manual, TTL auto flash and Programmed auto flash.

Lens Mount: Pentax KA type with electrical contacts. Accepts all Pentax bayonet lenses.

Shutter: Vertical-run metal focal plane. Electronically controlled stepless speeds from 1/2000 to 15 seconds plus 1/125 and B.

Film-Speed Range: ASA/ISO 6 to 3200.

Exposure Compensation Dial: +2 to –2 steps.

Exposure Meter: Full-aperture, center-weighted, through-the-lens using GPD sensor. EV range is EV 1 to EV 19 with *f*-1.4 and ASA/ISO 100 film. Also SPD sensor in mirror box for TTL flash metering at film plane.

Viewfinder: Pentaprism with fixed focusing screen. Biprism and Microprism focusing aids. Shows 92% of image area. 0.82X magnification with 50mm lens at infinity. Eyepiece is –1.1 diopter. LCD exposure indicators below frame.

Displays: LCD Shutter-Information and Aperture-Information windows below image frame in viewfinder with illuminator button. External LCD on top of camera. Exposure data, Exposure Confirmation warning symbol, Flash Ready symbol, Control-Setting Error symbol, Battery Discharge warning, Mode indication.

Depth-of-Field Preview: By lever on camera body.

Flash sync: 1/125 second at hot shoe and camera-body terminal.

Self-Timer: Built-in. 12 second delay. Can be cancelled. LED and beeper indicators.

Film Advance: Single stroke film-advance lever with 30° standoff and 135° stroke. Has shutter-cocked indicator in External LCD window. Has Film Advance/Rewind Indicator.

Frame Counter: Automatic reset when back opened. Sets shutter speed to 1/1000 during film advance to frame 1.

Batteries: One 3V lithium or two 1.5V silver-oxide or alkaline batteries. Low battery warning in viewfinder.

Dimensions: Without lens, 131mm x 86.5mm x 47.5mm (5.2 x 3.4 x 1.9 inches).

Weight: Without lens and batteries, 490g (17.4 oz.).

modes are metered manual and shutter-priority auto.

The 125X setting selects X-sync shutter speed of 1/125 second. This is used with non-dedicated flash, when shutter speed is not set automatically by the flash.

At B, the shutter remains open as long as you hold the shutter button depressed. The camera metering system does not operate.

On/Off—With the Shutter Dial not at L or B, the camera metering system and displays are turned on when you depress the shutter button partway. If an exposure is not made, the camera turns itself off in about 30 seconds to conserve battery power—except for the External LCD status display, which is turned off only when the Shutter Dial is set at L.

Programmed Automatic—This mode can be used only with SMC Pentax-A lenses. The camera sets both aperture and shutter speed according to a built-in program.

To select, set the Shutter Dial to AUTO and the lens aperture ring to A. The shutter-information LCD at left in the viewfinder and the External LCD on top of the camera both display a P symbol immediately.

When you turn on the meter by pressing the shutter button partway, the shutter-information LCD and the External LCD also show the shutter speed to be used, such as P 125. The Aperture-Information LCD at right in the viewfinder shows the symbol F and the selected *f*-number, such as F 1.4.

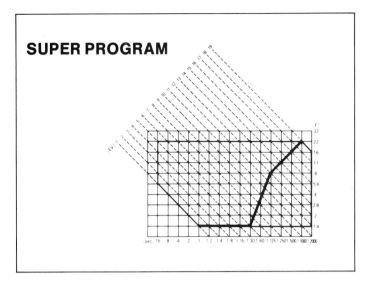

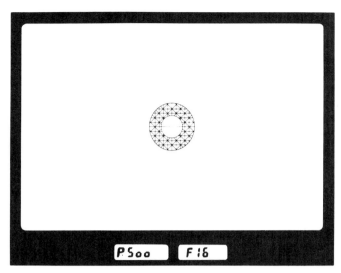

If scene illumination is brighter than the meter-coupling range of the camera, both shutter speed and aperture blink at low values. Change scene illumination, use slower film or an ND filter. If the scene brightness is below the meter-coupling range, shutter speed and aperture blink at high values. Change scene illumination or use faster film.

Aperture-Priority Auto—With any lens, set the Shutter Dial to **AUTO**. Set the lens aperture ring manually to the desired *f*-number. The camera selects shutter speed for correct exposure of an average scene.

Shutter speed is displayed in the viewfinder and the External LCD. The aperture setting is not displayed.

Overexposure is indicated by blinking the fastest shutter speed, **2000**, in the shutter-speed displays. Underexposure is indicated by blinking the slowest shutter speed, **15**. Use larger or smaller aperture, as appropriate.

Shutter-Priority Auto—This mode can be used only with SMC Pentax-A lenses. Set the lens to **A** and the Shutter Dial to **M**.

You set shutter speed by pressing either of the Manual Shutter-Speed Select Buttons on top of the camera. The camera sets aperture for correct exposure of an average scene. Both aperture and shutter-speed values are displayed.

Overexposure is indicated if the minimum aperture of the lens in use blinks in the viewfinder display. Underexposure is indicated by blinking the maximum aperture of the lens. Use faster or slower shutter speed, as appropriate.

If scene illumination is brighter than the meter-coupling range of the camera, both shutter speed and aperture blink at low values. Change scene illumination, use slower film or an ND filter. If the scene brightness is below the meter-coupling range, shutter speed and aperture blink at high values. Change scene illumination or use faster film.

Metered Manual—With any lens, set lens aperture manually to the desired *f*-number. Set the Shutter Dial to **M**. Set shutter speed by pressing either of the Manual Shutter-Speed Select Buttons on top of the camera.

The camera metering system measures scene brightness and determines correct exposure settings for an average scene, but *does not* control the camera.

Shutter speed is displayed by the Shutter-Information LCD in the viewfinder and the External LCD. The LCD on the right in the viewfinder serves as an exposure indicator. It displays numbers with plus or minus symbols to indicate over- or underexposure—compared to what the camera

"thinks" the settings should be. The range of this indicator is +3 to −3 exposure steps.

If the scene is average, adjust shutter speed and aperture so the viewfinder LCD on the right indicates 0 with both plus and minus symbols, meaning that exposure will be correct for an average scene. Because you are controlling exposure manually, you may use more or less exposure as you choose.

Overexposure of more than 3 steps is indicated by a blinking +3. Underexposure of more than 3 steps is indicated by a blinking −3.

If scene illumination is brighter than the meter-coupling range of the camera, the set shutter speed value and the +3 symbol will blink. Change scene illumination, use slower film or an ND filter. If the scene brightness is below the meter-coupling range, the set shutter speed and the −3 symbol will blink. Change scene illumination or use faster film.

Exposure Compensation—All automatic-exposure modes set exposure on the assumption that the scene is average. If it is not average, such as a subject against an unusually bright background, exposure may not be correct and exposure compensation may be needed.

The Exposure-Compensation Dial surrounds the Rewind Knob.

SUPER PROGRAM

It has five settings: 1/4X, 1/2X, 1X, 2X and 4X. The X symbols indicate that these numbers are exposure factors. The amount of exposure is multiplied by the factor. For example, 1/2X provides half as much exposure, which is one exposure step less. A setting of 1X does not change the exposure.

To use exposure compensation, turn the outer rim of the control to place the desired exposure factor opposite the index mark on the side of the viewfinder housing. When you don't want exposure compensation, be sure the control is set to 1X.

When the Exposure-Compensation Dial is set to any factor other than 1X, a blinking EF symbol appears in the right LCD window of the viewfinder display.

At the extremes of the film-speed dial settings, the full range of exposure compensation is not available. If film speed is set to the lowest number, you cannot use exposure compensation to provide still more exposure. If set to the next higher number, one step of compensation is available, but not two. Similar limits are at the high end of the film-speed scale.

The exposure-compensation system works also in the metered manual mode but is normally not necessary because you have manual control of exposure.

Substitute Metering—Use the metered manual mode. Meter and set exposure on the substitute surface, then make the exposure without changing exposure controls.

Depth-of-Field Preview—If the lens aperture ring is set to an *f*-number, you can see in advance the depth of field that will result. Before making the exposure, depress the Depth-of-Field Preview Lever on the camera body. The lens will close to the set aperture. Release the lever before pressing the shutter button, otherwise exposure will be incorrect.

You cannot view depth of field by this method with an SMC

Pentax-A lens set to **A**. You can observe the aperture value in the viewfinder display, set that aperture on the lens and then press the lever to view depth of field. Before making the shot, return the lens to the **A** setting.

Flash Sync—The X-sync shutter speed is 1/125 second. X-sync is available at the hot shoe and the X-sync terminal on the camera body.

Dedicated Flash—Most current Pentax dedicated flash units have labels ending with T, such as AF200T. These and the AF080C Ring Flash have the following dedicated functions with the Super Program camera:

Flash charge is indicated by a "lightning" symbol in the left LCD window in the viewfinder.

In the automatic modes, the camera is set to X-sync shutter speed automatically when the flash is charged and ready to fire. In the manual mode, if shutter speed is set faster than X-sync, it is changes automatically to X-sync speed. If set slower than X-sync, the slower set speed is used.

Sufficient exposure is indicated by blinking of the "lightning" symbol in the viewfinder after each flash exposure. If the symbol does not blink, the flash unit used the full flash duration during the shot. If more light than that was needed, the photo may be underexposed.

TTL auto flash is available using the flash sensor in the side of the camera mirror box.

With SMC Pentax-A lenses, aperture is set automatically with the camera on programmed auto or shutter-priority auto.

With both flash and camera in an auto mode, the flash will not fire if the scene is sufficiently bright for exposure without flash.

Precaution: When the flash power switch is on, the camera metering system is also on. Both flash and camera battery power are being used. If you are not using the flash, be sure to turn it off.

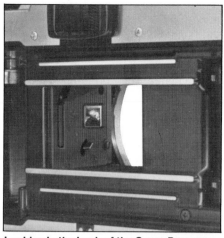

Looking in the back of the Super Program camera, with the shutter open, you can see the light sensor used for TTL auto flash. It's on the side of the mirror box.

TTL Auto Flash—Any Pentax bayonet lens can be used. Set the flash to TTL auto. Set the camera to aperture-priority auto or metered manual. Select any aperture that is suitable for the subject distance using the scales on the back of the flash as a guide. When the flash is charged, the flash ready light glows and the flash-ready indicator in the viewfinder becomes visible. Shutter speed is set automatically to X-sync. The exception is if a shutter speed slower than X-sync has been set on metered manual. If so, the set shutter speed is used.

The left LCD in the viewfinder displays shutter speed and the flash-ready indicator. Aperture is not displayed.

Programmed TTL Auto Flash—Instead of manually selecting from a range of aperture settings, you allow the camera to set aperture. An SMC Pentax-A lens is required. Set the flash to TTL auto. Set the camera to programmed auto or shutter-priority auto.

Shutter speed is set automatically to X-sync. Aperture is set automatically to a programmed *f*-number, depending on film speed. The left LCD in the viewfinder displays shutter speed and the flash-ready indicator. The right

LCD shows aperture. The distance range for that aperture is shown on the scales on the back of the flash.

Auto Flash—This mode uses the light sensor on the flash unit to control exposure. Any Pentax bayonet lens can be used. Set the flash to one of the AUTO modes—red, green or yellow, depending on the flash model. Set the camera to aperture-priority auto or metered manual. Refer to the flash panel to find the required aperture setting. Set the lens to that aperture. The distance range is shown on the flash scales.

When the flash is charged, the flash ready light glows and the flash-ready indicator in the viewfinder becomes visible. Shutter speed is set automatically to X-sync. The exception is if a shutter speed slower than X-sync has been set on metered manual. If so, the set shutter speed is used.

The left LCD in the viewfinder displays shutter speed and the flash-ready indicator. Aperture is not displayed.

Programmed Auto Flash—An SMC Pentax-A lens is required. Set the camera to programmed auto or shutter-priority auto. Shutter speed is set automatically to X-sync. Aperture is set automatically to the same value that would be manually set in the conventional auto flash mode. The left LCD in the viewfinder displays shutter speed and the flash-ready indicator. The right LCD shows aperture. The distance range for that aperture is shown on the scales on the back of the flash.

Non-Dedicated Flash—To use non-dedicated flash, set the Shutter Dial to 125X. Mount the flash in the hot shoe or connect it to the flash-sync terminal on the camera body. Set lens aperture manually by reference to tables on the flash or by a guide-number calculation.

Self-Timer—To prepare the camera for delayed shutter release, slide the Self-Timer Lever away from the lens mount. A red LED lamp becomes visible on the front of the camera.

To make the exposure, press the shutter button. The delay is 12 seconds. During the first 10 seconds, the LED flashes and an audible beeper intermittently beeps. During the last 2 seconds the LED and beeper operate more rapidly.

During the self-timer delay interval, shutter operation can be cancelled by sliding the Self-Timer Lever back to its normal position.

Long Exposures—To make exposures longer than 15 seconds, set the Shutter Dial to B. The left LCD in the viewfinder and the External LCD display a B symbol. The shutter will remain open as long as you hold down the shutter button. The camera metering system does not operate.

The B mode cannot be used with an SMC Pentax-A lens set to A or with the self-timer set.

A locking cable release is convenient for long exposures. Use Pentax Cable Release type 30 or 50 and Double Cable Release A. Other cable releases may not work correctly.

Warning of Incorrect Control Settings—A blinking E symbol appears in the left LCD window in the viewfinder and in the External LCD if you set the Shutter Dial to B with the lens on A or with the self-timer set. When the E symbol appears, the shutter will not operate even if the shutter button is pressed.

Battery Check—With the Shutter Dial not set to L, press the shutter button partway. If the LCD displays work, the battery is OK.

Low-Battery Warning—When the battery is nearly discharged, the LCD displays switch back and forth between the normal exposure information and a row of zeros.

Rewinding Film—At the end of the roll, depress the Rewind Button on the bottom of the camera. Turn the Rewind Crank clockwise to wind the exposed film back into the cartridge.

Finder Cap—When making an exposure on automatic without your eye at the viewfinder, slide the viewfinder cap over the eyepiece. This prevents light from entering the camera and causing incorrect exposure.

Stop-Down Metering—With lenses and lens accessories that prevent full-aperture metering, the camera is automatically switched to meter stopped down. The camera is operated normally.

Multiple Exposures—Use the "three-finger" method described in Chapter 10.

Memo Holder—A memo holder on the camera back holds the end flap of a film carton, or other memo. This is shaped to also serve as a grip for your right thumb.

Grip Super A—A removable finger grip for your right hand attaches to the front of the camera body. Remove the grip when using a film winder or motor drive.

Mirror Lockup—No provision is made to lock up the mirror before making an exposure.

Major Accessories—The Super Program can use all Pentax bayonet lenses and lens accessories. The program capability is available only with SMC Pentax-A lenses. Earlier screw-mount lenses can be mounted with Adapter K and used with manual exposure control and stop-down metering. It uses M-type viewfinder accessories except that Refconverter-A shows the viewfinder displays but Refconverter-B does not. It uses Bellows A, A-type rear converters, Rear Converter K T6-2X, K-type auto extension tubes, Winder ME II (on AUTO) and Motor Drive A. The camera back cover can be replaced with Digital Data M to imprint data on the film.

PROGRAM PLUS

PROGRAM PLUS

The Program Plus offers three automatic-exposure modes and one manual. The auto modes are: programmed automatic, aperture-priority auto, and programmed auto flash. In the metered manual mode, the camera exposure meter operates to guide you in setting both aperture and shutter speed.

Programmed auto and programmed auto flash require an SMC Pentax-A lens. With any lens, the camera can also use conventional automatic flash or manual flash.

Lens Mount—The Program Plus uses the standard Pentax K-type bayonet mount with added electrical contacts to work with SMC Pentax-A lenses. This mount is called *KA*. It accepts all Pentax bayonet-mount lenses.

Recommended Lenses—SMC Pentax-A lenses are required to use all of the exposure modes. Earlier bayonet lenses, such as SMC Pentax-M and SMC Pentax, can be used but only in the aperture-priority and metered manual modes.

Batteries—Remove the Battery-Compartment Cover on the bottom of the camera. Install one 3V lithium battery or two 1.5V silver-oxide or alkaline batteries with the negative terminals toward the cover.

Loading Film—Load film as described in Chapter 5. To advance film, set the Shutter Dial to AUTO or M. The shutter operates at 1/1000 second until film has been advanced to frame 1.

Film Speed—Set ASA/ISO film speed by pressing the rectangular lock button to the left of the Rewind Knob while turning the outer rim of the Film Speed/Exposure Compensation Dial to place the desired speed number in the window. Film-speed range is ASA/ISO 6 to 3200.

Focal-Plane Shutter—The shutter is metal and travels vertically. Shutter-speed range is 1/1000 to 15 seconds, electronically controlled.

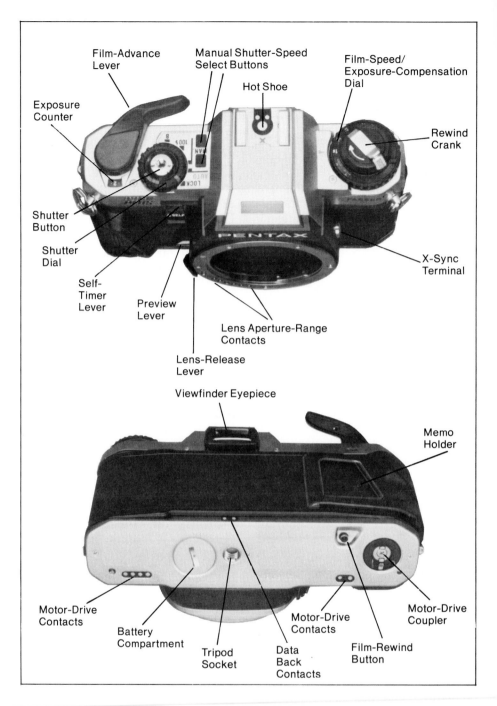

Metering—Full-aperture, center-weighted metering is done using a GPD light sensor in the viewfinder housing. Metering range is EV 1 to EV 18 with *f*-1.4 and ASA/ISO 100 film.

Displays—Two LCD displays are visible in the viewfinder, below the image frame. The Shutter-Information LCD at left shows shutter speed and other data to be discussed. The Aperture-Information LCD at right shows aperture and other data.

The nearest standard shutter-speed is displayed even though the camera may actually use an intermediate value. Aperture values are displayed to the nearest half-step.

LCD displays may become dark at unusually high temperatures and sluggish at low temperatures. At normal temperatures, operation will return to normal.

Shutter Dial—The operating mode is determined both by the setting of the Shutter Dial on the

PROGRAM PLUS

camera and the setting of the lens aperture ring with SMC Pentax-A lenses. The Shutter Dial has 5 settings—L, AUTO, MAN, 100X and B.

The L setting locks the shutter button and turns off the camera electronics.

Use the AUTO setting for programmed auto, aperture-priority auto and programmed auto flash. A lock button on the Shutter Dial must be depressed to turn it *away* from the AUTO setting.

The MAN setting selects metered manual.

The 100X setting selects X-sync shutter speed of 1/100 second. This is used with non-dedicated flash, when shutter speed is not set automatically by the flash.

At B, the shutter remains open as long as you hold the shutter button depressed. The camera metering system does not operate.

On/Off—With the Shutter Dial not at L or B, the camera metering system and displays are turned on when you depress the shutter button partway. If an exposure is not made, the camera turns itself off in about 30 seconds to conserve battery power.

Programmed Automatic—This mode can be used only with SMC Pentax-A lenses. The camera sets both aperture and shutter speed according to a built-in program.

To select, set the Shutter Dial to AUTO and the lens aperture ring to A. The shutter-information LCD at left in the viewfinder displays a P symbol immediately.

When you turn on the meter by pressing the shutter button partway, the shutter-information LCD also shows the shutter speed to be used, such as P 125. The Aperture-Information LCD at right in the viewfinder shows the symbol F and the selected *f*-number, such as F 1.4.

If scene illumination is brighter than the meter-coupling range of the camera, both shutter speed and aperture blink at low values. Change scene illumination, use slower film or an ND filter. If the scene brightness is below the meter-coupling range, shutter speed and aperture blink at high values. Change scene illumination or use faster film.

Aperture-Priority Auto—With any lens, set the Shutter Dial to AUTO. Set the lens aperture ring manually to the desired *f*-number. The camera selects shutter speed for correct exposure of an average scene. Shutter speed is displayed in the left viewfinder LCD. The aperture setting is not displayed.

Overexposure is indicated by blinking the fastest shutter speed, 1000, in the shutter-speed displays. Underexposure is indicat-

ed by blinking the slowest shutter speed, 15. Use larger or smaller aperture, as appropriate.

Metered Manual—Set the Shutter Dial to MAN. With any lens, set lens aperture manually to the desired *f*-number. Set shutter speed by pressing either of the Manual Shutter-Speed Select Buttons on top of the camera.

The camera metering system measures scene brightness and determines correct exposure settings for an average scene, but *does not* control the camera.

Shutter speed is displayed by the Shutter-Information LCD in the viewfinder. The LCD on the right in the viewfinder serves as an exposure indicator. It displays numbers with plus or minus symbols to indicate over- or underexposure—compared to what the camera "thinks" the settings should be. The range of this indicator is +3 to −3 exposure steps.

If the scene is average, adjust shutter speed and aperture so the viewfinder LCD on the right indicates 0 with both plus and minus symbols, meaning that exposure will be correct for an average scene. Because you are controlling exposure manually, you may use more or less exposure as you choose.

Overexposure of more than 3

steps is indicated by a blinking +3. Underexposure of more than 3 steps is indicated by a blinking −3.

If scene illumination is brighter than the meter-coupling range of the camera, the set shutter speed value and the +3 symbol will blink. Change scene illumination, use slower film or an ND filter. If the scene brightness is below the meter-coupling range, the set shutter speed and the −3 symbol will blink. Change scene illumination or use faster film.

Exposure Compensation—All automatic-exposure modes set exposure on the assumption that the scene is average. If it is not average, such as a subject against an unusually bright background, exposure may not be correct and exposure compensation may be needed.

The Exposure-Compensation Dial surrounds the Rewind Knob. It has five settings: 1/4X, 1/2X, 1X, 2X and 4X. The X symbol indicates that these numbers are exposure factors. The amount of exposure is multiplied by the factor. For example, 1/2X provides half as much exposure, which is one exposure step less. A setting of 1X does not change the exposure.

To use exposure compensation, turn the outer rim of the control to place the desired exposure factor opposite the index mark on the side of the viewfinder housing. When you don't want exposure compensation, be sure the control is set to 1X.

At the extremes of the film-speed dial settings, the full range of exposure compensation is not available. If film speed is set to the lowest number, you cannot use exposure compensation to provide still more exposure. If set to the next higher number, one step of compensation is available, but not two. Similar limits are at the high end of the film-speed scale.

The exposure-compensation system works also in the metered manual mode but is normally not necessary because you have manual control of exposure.

Substitute Metering—Use the metered manual mode. Meter and set exposure on the substitute surface, then make the exposure without changing exposure controls.

Depth-of-Field Preview—You can see in advance the depth of field that will result at any f-number setting. Before making the exposure, depress the Depth-of-Field Preview Lever on the camera body. The lens will close to the set aperture. Release the lever before pressing the shutter button, otherwise exposure will be incorrect.

You cannot view depth of field by this method with an SMC Pentax-A lens set to A. You can observe the aperture value in the viewfinder display, set that aperture on the lens and then press the lever to view depth of field. Before making the shot, return the lens to the A setting.

Flash Sync—The X-sync shutter speed is 1/100 second. X-sync is available at the hot shoe and the X-sync terminal on the camera body.

Dedicated Flash—Most current Pentax dedicated flash units have labels ending with T, such as AF200T. These and the AF080C Ring Flash have the following dedicated functions with the Program Plus camera:

Flash charge is indicated in the viewfinder by a "lightning" symbol in the left LCD window in the viewfinder.

In the automatic modes, the camera is set to X-sync shutter speed automatically when the flash is charged and ready to fire. In the manual mode, if shutter speed is set faster than X-sync, it is changes automatically to X-sync speed. If set slower than X-sync, the slower set speed is used.

Sufficient exposure is indicated by blinking of the "lightning" symbol in the viewfinder after each flash exposure. If the symbol does not blink, the flash unit used the full flash duration during the shot. If more light than that was needed, the photo may be underexposed.

With SMC Pentax-A lenses, aperture is set automatically with the camera on programmed auto.

Precaution: When the flash power switch is on, the camera metering system is also on. Both flash and camera battery power are being used. If you are not using the flash, be sure to turn it off.

Auto Flash—This mode uses the light sensor on the flash unit to control exposure. Any Pentax bayonet lens can be used. Set the camera to aperture-priority auto or metered manual. Set the flash to one of the AUTO modes—red, green or yellow, depending on the flash model. Refer to the flash panel to find the required aperture setting. Set the lens to that aperture. The distance range is shown on the flash scales.

When the flash is charged, the flash ready light glows and the flash-ready indicator in the viewfinder becomes visible. Shutter speed is set automatically to X-sync. The exception is if a shutter speed slower than X-sync has been set on metered manual. If so, the set shutter speed is used.

The left LCD in the viewfinder displays shutter speed and the flash-ready indicator. Aperture is not displayed.

Programmed Auto Flash—An SMC Pentax-A lens is required. Set the camera to programmed auto. Shutter speed is set automatically to X-sync. Aperture is set automatically to the same value that would be manually set in the conventional auto flash mode. The left LCD in the viewfinder displays shutter speed and the flash-ready indicator. The right LCD shows aperture. The distance range for that aperture is shown on the scales on the back of the flash.

Non-Dedicated Flash—To use non-dedicated flash, set the Shutter Dial to 100X. Mount the flash

in the hot shoe or connect it to the flash-sync terminal on the camera body. Set lens aperture manually by reference to tables on the flash or by a guide-number calculation.

Self-Timer—Slide the Self-Timer Lever upward. To make the exposure, press the shutter button. The delay is 12 seconds. During the first 10 seconds, the LED flashes and an audible beeper intermittently beeps. During the last 2 seconds, the LED and beeper operate more rapidly.

During the self-timer delay interval, shutter operation can be cancelled by sliding the Self-Timer Lever back to its normal position.

Long Exposures—To make exposures longer than 15 seconds, set the Shutter Dial to B. The left LCD in the viewfinder displays a B symbol. The shutter will remain open as long as you hold down the shutter button. The camera metering system does not operate.

The B mode cannot be used with an SMC Pentax-A lens set to A or with the self-timer set.

A locking cable release is convenient for long exposures. Use Pentax Cable Release type 30 or 50 or Double Cable Release A. Other cable releases may not work correctly.

Warning of Incorrect Control Settings—A blinking E symbol appears in the left LCD window in the viewfinder if you set the Shutter Dial to B with the lens on A or with the self-timer set. It appears if you set the lens to A with the camera on metered manual. When the E symbol appears, the shutter will not operate when the shutter button is pressed.

Battery Check—With the Shutter Dial not set to L, press the shutter button partway. If the LCD displays work, the battery is OK.

Low-Battery Warning—When the battery is nearly discharged, the LCD displays switch back and forth between exposure information and a row of zeros.

Rewinding Film—Depress the Rewind Button on the bottom of the camera. Turn the Rewind Crank clockwise.

Finder Cap—When making an exposure on automatic without your eye at the viewfinder, slide the viewfinder cap over the eyepiece. This prevents light from entering the camera and causing incorrect exposure.

Stop-Down Metering—With lenses and lens accessories that prevent full-aperture metering, the camera is automatically switched to meter stopped down. The camera is operated normally.

Multiple Exposures—Use the "three-finger" method described in Chapter 10.

Memo Holder—A memo holder on the camera back holds the end flap of a film carton, or some other small memo. The holder is shaped to also serve as a grip.

Grip Super A—A removable finger grip for your right hand attaches to the front of the camera body. Remove the grip when using a film winder or motor drive.

Mirror Lockup—No provision is made to lock up the mirror before making an exposure.

Major Accessories—The Program Plus can use all Pentax bayonet lenses and lens accessories. The program capability is available only with SMC Pentax-A lenses. Earlier screw-mount lenses can be mounted with Adapter K and used with manual exposure control and stop-down metering. It uses M-type viewfinder accessories except that Refconverter-A shows the viewfinder displays but Refconverter-B does not. It uses Bellows A, A-type rear converters, Rear Converter K T6-2X, K-type auto extension tubes, Winder ME II (on AUTO) and Motor Drive A. The camera back cover can be replaced with Digital Data M to imprint data on the film.

PROGRAM PLUS SPECIFICATIONS

Type: 35mm multimode SLR with full-aperture through-the-lens metering and TTL autoflash capability.

Modes: Programmed auto, Aperture-Priority auto, Metered Manual and Programmed auto flash.

Lens Mount: Pentax KA type with electrical contacts. Accepts all Pentax bayonet lenses.

Shutter: Vertical-run metal focal plane. Electronically controlled stepless speeds from 1/1000 to 15 seconds plus 1/125 and B.

Film-Speed Range: ASA/ISO 6 to 3200.

Exposure Compensation Dial: +2 to -2 steps.

Exposure Meter: Full-aperture, center-weighted, through-the-lens using GPD sensor. EV range is EV 1 to EV 18 with f-1.4 and ASA/ISO 100 film.

Viewfinder: Pentaprism with fixed focusing screen. Biprism and Microprism focusing aids. Shows 92% of image area. 0.82X magnification with 50mm lens at infinity. Eyepiece is -1.1 diopter. LCD exposure indicators below frame.

Displays: LCD Shutter-Information and Aperture-Information windows below image frame in viewfinder. Exposure data, Flash Ready symbol, Control-Setting Error symbol, Battery Discharge warning, Mode indication.

Depth-of-Field Preview: By lever on camera body.

Flash sync: 1/100 second at hot shoe and camera-body terminal.

Self-Timer: Built-in. 12 second delay. Can be cancelled. LED and beeper indicators.

Film Advance: Single stroke film-advance lever with 30° standoff and 135° stroke.

Frame Counter: Automatic reset when back opened. Sets shutter speed to 1/1000 during film advance to frame 1.

Batteries: One 3V lithium or two 1.5V silver-oxide or alkaline batteries. Low battery warning in viewfinder.

Dimensions: Without lens, 131mm x 87mm x 47.5mm (5.2 x 3.4 x 1.9 inches).

Weight: Without lens and batteries, 490g (17.4 oz.).

165

MX

MX

The MX is non-automatic.

Camera On-Off Switch—The Shutter-Button Lock Lever serves as a master switch for the camera. When you unlock it by rotating the lock lever clockwise, it is then possible to turn on the camera. There are two ways:

With the Rapid-Wind Lever closed all the way against the camera body, depressing the shutter button half-way turns on the metering circuit and activates the viewfinder display. Removing your finger turns it off.

With the Rapid-Wind Lever in the stand-off position, as you normally leave it after advancing film, depressing the shutter button halfway turns on the metering circuit and it remains on continuously until you push the Rapid-Wind Lever all the way against the camera body.

Metering and Viewfinder Display—Through-the-lens metering is by two GPD sensors located near the viewfinder eyepiece. Metering is open-aperture with a center-weighted pattern.

The focusing aid supplied with the camera is a biprism surrounded by a microprism. MX viewing screens are easily interchanged with 8 available screens—see Chapter 9.

To remove the screen, first remove the lens. Inside the lens opening, at the top, you will see both the retaining plate and a spring clip which holds it in place. Depress the spring clip and the retaining plate pivots downward. Remove and replace the viewing screen carefully, using the special tool supplied with individual viewing screens or clean fingers touching only the edges of the screen.

The *f*-stop selected at the lens is visible in the viewfinder display at the top of the screen.

On the right side of the viewfinder, the selected shutter speed is displayed on a clear plastic disc that also shows the next faster and slower shutter speeds.

Just to the right of the shutter-speed display is a vertical column of 5 LED exposure indicators. If you have selected aperture and shutter speed to agree with the camera's exposure calculator, a green LED in the center of the display beams at you.

If the controls are set for a half-step over or under, a yellow LED indicator lights up—above the green LED indicator for overexposure, below for underexposure. If the controls are set for a full step over or under, or more, a red LED lamp glows at the top or bottom of the display.

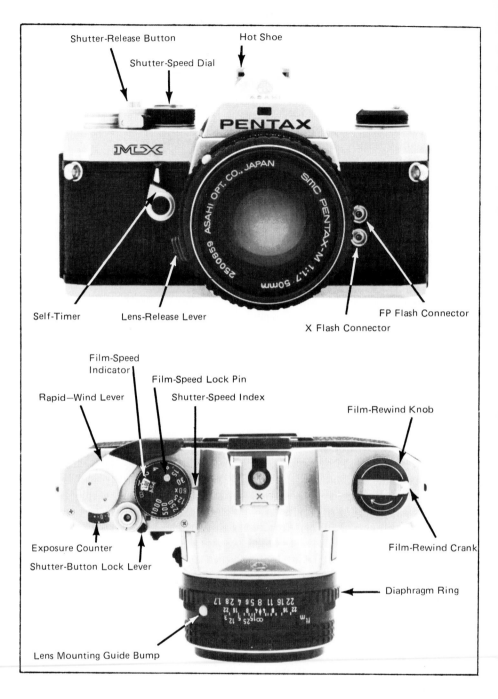

Shutter-Release Button — Hot Shoe — Shutter-Speed Dial — PENTAX — MX — smc PENTAX-M 1:1.7 50mm — ASAHI OPT. CO., JAPAN — 2500859 — Self-Timer — Lens-Release Lever — X Flash Connector — FP Flash Connector

Film-Speed Indicator — Film-Speed Lock Pin — Rapid—Wind Lever — Shutter-Speed Index — Film-Rewind Knob — Exposure Counter — Shutter-Button Lock Lever — Film-Rewind Crank — Diaphragm Ring — Lens Mounting Guide Bump

MX METER SENSITIVITY PATTERN

MX SPECIFICATIONS

Type: 35mm SLR with built-in through-the-lens light meter and horizontal focal-plane shutter.

Standard Lenses: SMC Pentax 50mm f-1.2, SMC Pentax-M 50mm f-1.4, SMC Pentax-M 50mm f-1.7, SMC Pentax-M 40mm f-2.8.

Shutter: Horizontal-run focal-plane shutter of rubberized silk with shutter-button lock. Shutter speeds: B, 1, 1/2, 1/4, 1/8, 1/15, 1/30, 1/60, 1/125, 1/250, 1/500 and 1/1000.

Flash Synchronization: X-sync hot/cold shoe. FP and X connectors on camera body. X-sync speed is 1/60.

Self-Timer: Built-in. 8 to 15 seconds delay.

Viewfinder: Silver-coated pentaprism finder with user-interchangeable screens. Standard screen supplied with camera uses biprism surrounded by microprism ring. See page 59 for alternate screens. Magnification 0.95 with 50mm lens. Shows 95% of frame. Shutter speed and aperture visible in viewfinder. Viewfinder eyepiece is −0.5 diopter.

Film Advance: Ratchet-type Rapid-Wind Lever. 20° standoff position, 162° stroke.

Exposure Counter: Automatic reset when camera back opened.

Film Rewind: Folding crank on Rewind Knob.

Lens Mount: Pentax bayonet. Rotation 65°.

Exposure Meter: Gallium Photo Diode through-the-lens meter with center weighting. Measures at full aperture. LED exposure indicators.

Exposure Meter Measuring Range: EV 1 to EV 19. For conversion to camera settings, see pages 70—72.

Power Source: Two 1.5 V silver-oxide batteries (Eveready S76E or Mallory MS76H or equivalent).

Meter Switch: Shutter-Lock Lever is camera master switch. With shutter unlocked, meter is turned on when shutter button is depressed halfway. If Rapid-Wind Lever is in standoff position, meter remains on.

Depth-of-Field Preview: Push Self-Timer Lever toward lens.

ASA Film-Speed Range: ASA 25 to ASA 1600.

Operation with Dead Batteries: All shutter speeds available.

Dimensions: With no lens: Width 135.8mm (5.3″), height 82.5mm (3.2″), depth 49.3mm (1.9″).

Weight: With no lens: 495g (17.5 oz.).

MX FLASH-SYNC TABLE

SHUTTER SPEED		1/1000	1/500	1/250	1/125	1/60	1/30	1/15	1/8	1/4	1/2	1	B
ELECTRONIC FLASH	X												
FLASH BULB	FP	M, FP CLASS											
	X							M, MF, FP CLASS					

Shaded areas indicate usable shutter speeds.

MX VIEWFINDER

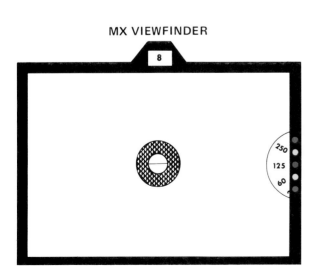

Self-Timer—The Self-Timer control must be rotated more than 90° or it will not trip the shutter: A delay of 8 to 15 seconds is available, depending on how far you rotate the lever past 90°. When the lever is rotated from its rest position, it uncovers a small chrome button. After advancing film and setting the timer, depress the button to start the timer.

You can leave the self-timer set and operate the camera in the normal way, using the shutter button, with no delay. There is no way to cancel the timer once you have it set. You must release it sometime and let the lever rotate

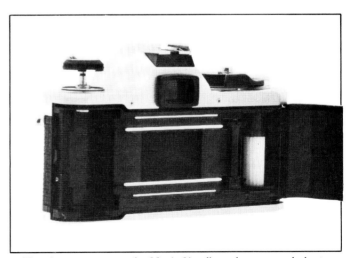

M-series cameras use the Magic-Needles take-up spool. Just push film-end between any two of these plastic needles and start winding.

back to its rest position. However if you do it between exposures when the shutter is not cocked, it will not trip the shutter and no exposure will result.

Shutter-Button Lock Lever—A rotating collar surrounding the shutter button serves to lock the button so it can't be depressed accidently. With the shutter set on **B**, you can make time exposures by depressing the shutter button and then holding it depressed using the Shutter-Button Lock Lever.

Viewing Depth of Field—When pushed toward the lens, the Self-Timer Lever has a second function. It stops down the lens to show depth of field at shooting aperture.

Accessories—The MX uses all K-type lens accessories such as bellows and extension tubes. It accepts screw-mount Takumar lenses by use of Mount Adapter K, using stop-down metering.

The camera back is easy to remove to install Magazine Back MX which is a 250-frame magazine loaded from bulk film, or either of two data backs-Dial Data MX or Data MX.

The bottom of the camera has provision to attach Motor Drive MX to shoot frames at up to 5 per second, or Automatic Film Winder MX to advance film at 2 frames per second.

Multiple Exposures—There is no special button or procedure for multiple exposures. This procedure will work: Tension the film by turning the Rewind Knob until *slight* resistance is felt. Hold Rewind Knob in that position while depressing the Rewind Button on the bottom of the camera. Move the Rapid-Wind Lever through one full stroke. This should cock the shutter for the next exposure without advancing the film.

Battery Check—When the LED indicators in the viewfinder display are weak and intermittent, the batteries need replacement. With dead batteries, the camera will still

Winder MX attachment is very simple. Coupler at right mates with coupler in camera bottom. Threaded cover for camera coupler is removed and threaded into Winder MX for safe keeping.

operate but the exposure meter and display will not function.

Flash Sync—The hot/cold accessory shoe on top of the camera is switched on by insertion of a flash unit. The camera body has two flash connectors: One for X sync and certain flashbulbs at slow shutter speeds, and one for FP flashbulbs at high shutter speeds.

Film Loading—Uses a Magic-Needles take-up spool.

Shutter-Cocked Indicator—On top of the camera, a small window near the Rapid-Wind Lever shows black if film is not advanced for the next frame.

AUTOMATIC FILM WINDER MX

This unit is very easy to install. ON the bottom of the camera is a threaded motor-drive coupler cover similar to a battery-compartment cover. Use a coin to unscrew it. A threaded cavity on the top side of the winder holds the cover, so you don't lose it.

Place the winder against the bottom of the camera and turn the Attachment Screw until it is tight. This screw threads into the tripod socket on the bottom of the camera. The winder unit has its own tripod socket.

The winder switch has 3 positions: C, OFF and S. These select continuous operation, off, or single frames each time the winder pushbutton is depressed.

The winder is controlled by a pushbutton on top of the handgrip. When the winder button is depressed, the camera exposes a frame, then advances the next frame into position for exposure. When set ot **S**, it stops after each frame. When set to **C**, it repeats continuously up to 2 frames per second.

By using the shutter button on the camera and advancing film manually using the Rapid-Wind Lever, you can use the camera in the normal way, as though the winder were not attached.

At the end of the roll, or if the film jams for any reason, a red LED indicator on the winder unit turns on. This indicator also flashes when the shutter operates and when film advances, so you know the unit is operating.

A Rewind Button on the winder operates the Rewind Button on the camera baseplate so you can rewind film and reload without remove the auto Film Winder.

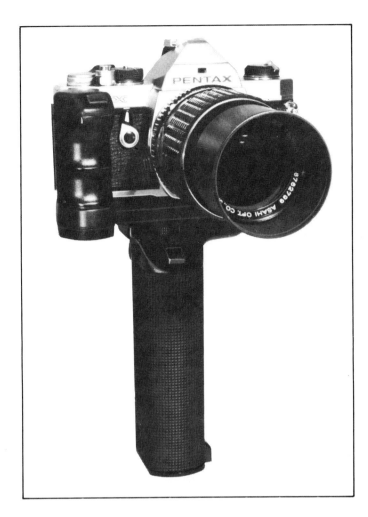

MOTOR DRIVE MX SPECIFICATIONS

Frame Rate:	Choice of single-frame or consecutive exposures in a steplessly variable range of 1 to 5 frames per second.
Usable Shutter Speeds:	All shutter speeds except **B**.
Power Source:	NiCad Battery Pack M, DC Battery Grip M, AC Power Pack M.
Bulk Film Capability:	Can be used with Magazine Back MX which quickly interchanges with back cover of MX providing up to 250 exposures using bulk film.
Remote Control:	3-meter and 10-meter Power Cables allow remote control in single-frame or continuous modes using Remote Trigger Connector.
Exposure Counter:	Subtractive type with automatic stop when counter reaches zero.
Shutter Release:	Controlled by Trigger Release Button built into grip, or by remote control.
Dimensions:	Width 143mm (5.6″), height 71mm (2.8″), depth 64mm (2.5″).
Weight:	225.5g (8 oz.).

Motor Drive MX is a thin wafer that fits on the bottom of the MX camera and a handle with Trigger-Release Button. The motor drive unit accepts a variety of power supplies. This is Battery Grip M. It has its own Trigger-Release Button and gives you an alternate way to grip the camera.

MOTOR DRIVE MX

For faster frame rates and additional features not available on Automatic Film Winder MX, use Motor Drive MX. The motor-drive unit attaches to the camera base in the same way as the auto winder. A selector dial labeled C and S allows choice of continuous firing or single exposures. When set to C for continuous operation, a range of speeds can be chosen between 1 and 5 frames per second, with all intermediate speeds available.

An Exposure Counter on the motor-drive body is preset for the number of frames you want to expose. When that many have been shot, the motor drive turns off. The counter subtracts from whatever number you dial in. If you want to shoot 36 frames continuously, set the control to 36 and it will count down to zero before shutting off the drive.

All shutter speeds except B can be used. If the shutter speed is too long for the selected motor-drive speed, the motor drive will wait for the shutter.

Power Source—Three power sources are available. Battery Grip M uses 12 AA-size penlight batteries. Ni-Cad Battery Pack M supplies 15 volts to the drive motor and is rechargeable using accessory Charger Pack M. For use where AC power is available, Power Pack M converts AC into DC for the motor drive and requires no batteries.

Remote Control—Any of the three power sources can be separated from the motor-drive unit using either a 3-meter Power Cable M or a 10-meter Power Cable M. Remote control at the power source is done by the Trigger-Release Button on the power source.

DIAL DATA MX

To record alphanumeric data in the upper left corner of the film frame, remove the standard MX camera back and replace it with Dial Data MX. Three dials on the data back are used to select letters or numbers to be imprinted on the film. By selecting symbols, you can record the date, or photographic data, or use the symbols any other way you choose.

A dial on the data back controls exposure of data on film and is set according to film speed in use. An LED indicator flashes at each exposure. Battery check is done by pressing a Battery Check Button. If the associated LED flashes, the batteries are OK.

DIAL DATA MX SPECIFICATIONS	
Attachment:	Instantly interchangeable with back cover of Pentax MX.
Available Data:	Data selected from three dials of which the left dial is used to imprint the year (76-86) or aperture, the central dial for the month (0-12), shutter speed, or letters of the alphabet (A-M), and the right dial for the day of the month or frame number (0-36).
ASA Range:	Two settings available for black and white or color film, ASA 25-50 and ASA 64-400.
Confirmation:	Confirmation of imprinting data by observing an LED which flashes at the moment data is imprinted.
Battery Check:	Battery-Check LED flashes when depressing Battery-Check Button if battery voltage is sufficient.
Power Source:	Three 1.5 V silver-oxide batteries.
Speed Range:	Imprints data when using Camera normally or with Winder MX or Motor Drive MX.

DATA MX SPECIFICATIONS	
Attachment:	Instantly interchangeable with Back Cover of Pentax MX Data camera, a factory-modified MX.
Available Data:	Built-in clock indicates day of the month, hour, minute, second, and the central portion of the watch has a ground-glass surface for penciling in additional data. Clock is interchangeable with Memo Plate which can be used to record any type of data desired.
ASA Range:	Three settings provided for black and white film (ASA 100, 200, 400) and one setting for color film (ASA 64-160).
Confirmation:	Confirmation of imprinting data by observing an LED which flashes at the moment data is imprinted.
Battery Check:	Battery-Check LED flashes upon depressing Battery-Check Button if battery voltage is sufficient.
Power Source:	One 6 V silver-oxide battery.
Speed Range:	Imprints data when using camera normally or with Winder MX or Motor Drive MX.

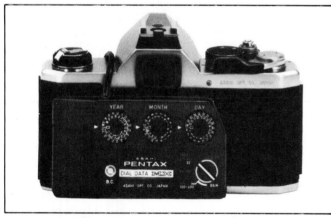

Dial Data MX replaces the removable back of an MX camera or a Data MX camera. It imprints data on the corner of the frame.

DATA MX

Despite the similarity in names, Data MX and Dial Data MX are different units. Data MX also replaces the camera back but is used only with a slightly modified MX camera, called Pentax MX Data. This camera can be ordered from a Pentax dealer.

The main difference is the data recorded on film. The Data MX has no external dials for alphanumeric data. Instead there is a clock which is imaged on the film to show day-of-the-month, hour, minute and second. The center of the watch face is ground glass so you can write on it with a pencil to record month, year, AM or PM, or whatever is appropriate and can fit in a small space.

When time is not important to the photo but other data is, a Memo Plate interchanges with the clock. Write desired information on the memo plate and it will record in the corner of the frame.

MAGAZINE BACK MX

For use with Motor Drive MX or Film Winder MX, Magazine Back MX replaces the back cover of the MX camera and holds 250 frames of film.

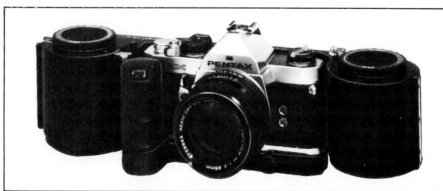

Magazine Back MX interchanges with the removable back cover of an MX camera. It holds 250 frames of 35mm film which adds both capacity and convenience.

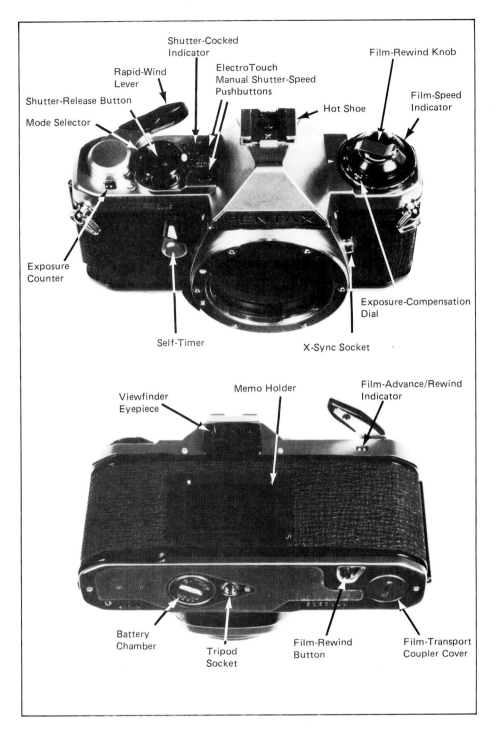

Shutter-Cocked Indicator
Rapid-Wind Lever
Shutter-Release Button
Mode Selector
ElectroTouch Manual Shutter-Speed Pushbuttons
Film-Rewind Knob
Film-Speed Indicator
Hot Shoe
Exposure Counter
Exposure-Compensation Dial
Self-Timer
X-Sync Socket

Viewfinder Eyepiece
Memo Holder
Film-Advance/Rewind Indicator
Battery Chamber
Tripod Socket
Film-Rewind Button
Film-Transport Coupler Cover

ME SUPER

The ME Super was introduced after the ME and has more features and capabilities. Even though introduced last, it is discussed first in this book.

The ME Super offers both automatic and manual exposure control. On automatic, it operates over a very wide range of shutter speeds—from 4 seconds to an unusually fast 1/2000 second. On manual, the

same range of shutter speeds is available, selected by a new and surprisingly convenient method.

On top of the camera, near the Rapid-Wind Lever is a five-position Mode Switch with these settings:

L means lock. It turns the camera electronics off when set to L and also locks the shutter button.

AUTO selects aperture-priority automatic exposure. The camera chooses a shutter speed to work with the aperture setting you select at

the lens. You must depress the white button on the Mode Selector to rotate it *away from* AUTO.

M selects manual exposure control. You select both aperture size and shutter speed. The camera measures light from the scene and provides an exposure display in the viewfinder to assist you.

125X sets shutter speed to 1/125 second which is X-sync speed for electronic flash. This shutter speed is provided mechanically rather than electronically and will work with dead batteries.

B sets the shutter so it stays open as long as you hold the shutter button depressed, either with your finger or a locking cable release. B is also a mechanical shutter speed which doesn't require a battery.

Metering—Fast-acting GPD sensors are used with a center-weighted pattern, measuring the light at open aperture with any M or K lens directly mounted on the camera. With accessories which prevent open-aperture metering, the camera is automatically switched to meter stopped-down.

The camera electronics and viewfinder display are switched on by depressing the shutter button partway. To conserve battery power, the camera turns itself off in about 30 seconds if you have not operated the shutter. To restore operation, depress the shutter button partway again.

When set to 125X or B, the camera meter does not work and the camera does not control exposure automatically.

Viewfinder Display—The viewfinder displays numbered shutter speeds from 1/2000 to 4 seconds in a vertical column along the left. At the top, above 1/2000, the word OVER signifies overexposure. Above that, the letter M indicates manual operation. At the very top is the symbol EF—for Exposure Factor—which serves as a reminder when the Exposure Compensation control is set to give more or less exposure to a non-average scene.

Among the numbered shutter speeds, 125X indicates X-sync

ME Super

speed. At the bottom of the display, the word UNDER indicates underexposure.

Each of these viewfinder symbols is designated by an adjacent LED. When the camera is set for one of the numbered shutter speeds, an LED glows adjacent to that speed—whether selected by the camera on automatic or by you, on manual.

On automatic, shutter speeds do not have to be a standard speed on the scale. If two adjacent LEDs flash alternately, the camera will use a shutter speed between the two values.

On manual, the camera will use the indicated standard shutter speed.

Shutter speeds of 1/60 and faster have a green LED to indicate that you can hand-hold the camera with a standard lens. Shutter speeds slower than 1/60 use a yellow LED which cautions you to use firm camera support.

The focusing aid is a biprism surrounded by a microprism. The viewing screen is not interchangeable.

Setting Shutter Speed—On manual, shutter speed is set using two *ElectroTouch* pushbuttons on top of the camera to the left of the shutter button.

When the button near the front of the camera is pressed, shutter speed increases a step at a time and the viewfinder LED appears to move upward along the scale of shutter speeds. If it runs off the top, it returns at the bottom and continues to move upward as long as you depress the pushbutton.

The pushbutton at the rear causes shutter speed to decrease a step at a time, in a similar way.

Setting Correct Exposure—On automatic, the camera sets exposure correctly for an average scene and displays the shutter speed.

On manual, the OVER and UNDER indicators serve as a guide while you operate the ElectroTouch pushbuttons. When exposure is correct for an average scene, neither of these indicators blinks. To compensate for non-average scenes or for

any other reason, you can give more or less exposure just by selecting the shutter speed you want to use—disregarding the over- or underexposure indication.

Viewing Depth of Field—No provision is made to view depth of field at shooting aperture using K or M lenses mounted directly on the camera. When it is necessary to meter stopped down, you see depth of field at shooting aperture.

Substitute Metering—Use the manual mode. Meter and set exposure on the substitute surface, then make the exposure without changing exposure controls.

ASA Film-Speed Control—To set film speed, lift the outer rim of the control and turn until the desired setting appears in the Film-Speed Window.

Exposure Compensation—The Exposure Compensation Dial is combined with the ASA Film-Speed Control. To select an exposure factor, turn the control without lifting the outer rim. Read the amount of compensation against an index mark

ME SUPER SPECIFICATIONS

Type: 35mm SLR with aperture-preferred automatic exposure and ElectroTouch manual control using pushbuttons to select shutter speed.

Standard Lenses: SMC Pentax 50mm ƒ-1.2, SMC Pentax-M 50mm ƒ-1.4, SMC Pentax-M 50mm ƒ-2, SMC Pentax-M 40mm ƒ-2.8, SMC Pentax-M 50mm ƒ-1.7.

Shutter: Seiko MFC-E2 vertical-run metal focal-plane. Automatic shutter speeds: electronic, stepless between 4 and 1/2000 second. Manual control with 14 standard speeds from 4 to 1/2000, controlled electronically; plus mechanical 125X and B.

Flash Sync: Set automatically to 1/125 with Pentax dedicated flash unit in hot shoe and camera set to AUTO or M. With non-dedicated flash, use 125X setting of Mode Selector. X-sync only at hot shoe or sync socket.

Self-Timer: Built in. 4 to 10 seconds delay.

Viewfinder: Silver-coated pentaprism with split-image and microprism focusing aid. Magnification 0.95 with 50mm lens. Shows 92% of frame. Viewfinder eyepiece is -1.0 diopter. LED exposure and flash-ready indicators. Exposure compensation signal.

Film Advance: Single-stroke Rapid-Wind Lever. 30° standoff position, 135° stroke.

Exposure Counter: Automatic reset when camera back opened.

Film Rewind: Folding crank on Rewind Knob.

Lens Mount: Pentax bayonet. Rotation 65°.

Exposure Meter: Gallium Photo Diode through-the-lens meter with center weighting. Measures at full aperture. LED indicators show over- and underexposure. Range is EV 1 to EV 19 at ASA 100 with ƒ-1.4.

Exposure Compensation: Plus or minus two steps. Warning in viewfinder.

Power Source: Two 1.5 V silver-oxide batteries (Eveready S76E, or equivalent).

Meter Switch: Depress shutter button halfway. Automatic turn-off in 20 to 35 sec.

ASA Film-Speed Range: ASA 12 to ASA 1600.

Operation with Dead Battery: Available shutter speeds are 1/125 and B.

Dimensions: With no lens: Width 131.5mm (5.2"), height 83mm (3.2"), depth 49.5mm (1.93").

Weight: With no lens: 445g (15.7 oz.).

METER SENSITIVITY PATTERN

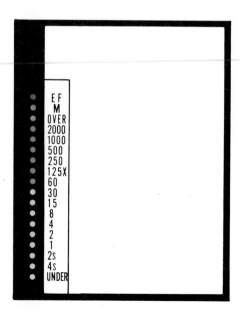

on the camera body. Range is from 1/4X to 2X. This control affects exposure on auto or manual, but I suggest using it only on automatic.

Exposure Compensation Warning—When you have the Exposure Compensation Control set to any exposure factor other than 1X, a red LED blinks rapidly at the symbol **EF** in the viewfinder.

Mirror Lock-up—No provision is made to lock up the mirror.

Self-Timer—Rotate the Self-Timer Lever 90° and it will remain at that setting. With shutter cocked, nudge the lever and it will rotate back to the rest position and release the shutter.

The camera can be operated normally with the self-timer set, using the shutter-release button. Eventually you have to allow it to "unwind". If you don't need to use it for an exposure, let it run down between frames, when the shutter is not cocked.

Finder Cap—A Finder Cap is packaged with the camera. When making an exposure on automatic without your eye at the viewfinder, use the Finder Cap to cover the eyepiece. This prevents excessive light from entering the camera and causing incorrect exposure.

Multiple Exposures—Follow the procedure given earlier for the MX camera.

Battery Check—If any LED indicating a *numbered* shutter speed is weak or intermittent, the batteries are discharged and should be replaced. Blinking of any other LED can be normal.

Flash Synchronization—Only X sync is available at the hot/cold accessory shoe or the flash terminal on the camera body.

When the camera is set to AUTO or M, Pentax dedicated flash units such as the AF 200S or the AF 160 can set shutter speed automatically. The flash must be installed, turned on and ready to fire. When the ready-light on the flash glows, shutter speed is simultaneously switched to **125X** and M blinks. When the flash is charging or turned off, the camera returns to automatic or man-

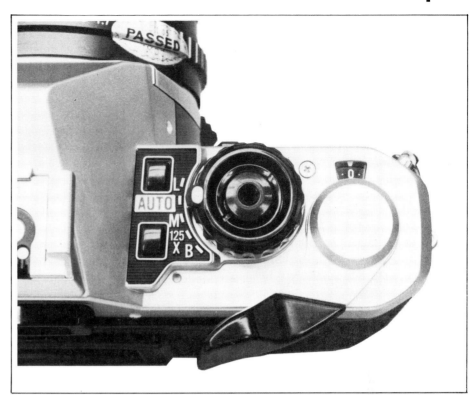

Mode Selector on ME Super has a white lock button which must be depressed to turn the selector *away from* AUTO.

ME SUPER FLASH SYNCHRONIZATION			
Electronic Flash Type	Mode Selector	Shutter Speed	Flash Connection
Pentax Dedicated	AUTO or M	1/125	Hot Shoe
Non-Dedicated	125X	1/125	Hot Shoe or X-Sync Socket

ual and can be used normally.

To use other than dedicated flash units, set the camera Mode Selector to **125X**. At this setting, there is no exposure display in the viewfinder.

Film Loading—The ME Super uses a Magic Needles take-up spool. When advancing to frame 1, set the Mode Selector to **125X**. Then choose the operating mode you want to use.

Shutter-Coked Indicator—On top of the camera, a small window near the Rapid-Wind Lever shows black if film is not advanced for the next frame. Advance the film and it turns red.

Film Transport Indicator—Just below the Rapid-Wind Lever on the camera back is a small window displaying black stripes on an orange background. When film is moving in either direction, the stripes move back and forth. This confirms that film is actually advancing as you expose a roll of film. On rewind, movement of the indicator stops at the instant the film-end separates from the take-up spool.

Memo Holder—A holder on the camera back displays the end of a film carton or any other memo you insert.

Accessories—The ME Super uses all K and M lenses and lens accessories such as bellows and extension tubes. It accepts screw-mount lenses by use of Mount adapter K. Viewfinder accessories include Correction Lens Adapter M to install eyesight correction lenses in the viewfinder eyepiece, Magnifier M for precise focusing and Right-Angle Finder M.

Automatic Film Winder ME II or the earlier ME version can be used. The camera back can be removed to install Dial Data ME.

M-SERIES ACCESSORIES

DIAL DATA ME

To record alphanumeric data in the upper left corner of the film frame, remove the standard back of the ME Super, ME or MV-1 and replace it with Dial Data ME. Connect the sync cord from the data back into the flash terminal of an ME Super or ME. To use with an MV-1, a special Hot Shoe Adapter 2P is necessary. Install the adapter in the MV-1 hot shoe; plug the sync cord into the adapter.

Three dials on this "data back" are used to select letters or numbers to be imprinted on the film. By selecting symbols, you can record the date, or other data.

A dial on the back controls exposure according to the film speed in use. An LED indicator flashes at each exposure. The battery is checked by depressing a Battery Check Button. If the associated LED flashes, the batteries are OK.

Dial Data ME replaces the standard back cover of the ME Super, ME or MV-1 and imprints alphanumeric data on one corner of the frame. These units are commonly called *databacks*.

WINDER ME II

This convenient accessory automatically advances film one frame at a time or continuously at up to two frames per second—and also provides a comfortable and useful handgrip.

To install, remove the Film-Transport Coupler Cover on the bottom of the camera and store the cover in the threaded receptacle on top of the winder. The Attachment Screw on the winder threads into the tripod socket on the camera. The winder has its own tripod socket.

The winder switch has three positions: C, OFF and S. These select continuous operation, off, or single frames. When the winder Trigger-Release Button is pressed, an exposure is made and then film is advanced.

On the side of the winder grip, the Auto/125X lever has two positions which cause the symbol AUTO or 125X to appear in a window on top of the grip. Set it to AUTO if the camera is on automatic, or 125X if the camera is set to 125X, or 100X, depending on model.

With the winder installed, you can ignore it and operate the camera manually, using the Rapid-Wind Lever and shutter button on the camera.

A red LED flashes each time the winder operates, and it glows steadily at the end of the roll. A Rewind Button is on the winder.

An optional Remote Control Cord is available. Four AA-size alkaline cells mount in a cartridge which clips onto the base of the winder.

Winder ME—An earlier version with similar capabilities. It also fits the ME Super, ME and MV-1.

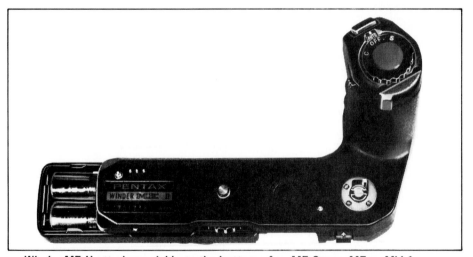

Winder ME II attaches quickly to the bottom of an ME Super, ME or MV-1.

WINDER ME II SPECIFICATIONS

Frame: Single frame or continuous at up to 2 frames per second.
Shutter Release: By Trigger-Release Button on top of winder grip.
Allowable Shutter Speeds: All except B.
Confirmation: Red LED flashes when film advances.
Power Source: Four carbon-zinc or alkaline 1.5V AA-size batteries installed in removable battery cartridge.
Capacity: Minimum of 20 36-exposure rolls with fresh carbon-zinc batteries.
Dimensions: Width 144mm (5.6"), height 89mm (3.5"), depth 69mm (2.7").
Weight: 325g (11.4 oz.) with batteries.

DIGITAL DATA M

This data back imprints year/month/date or time of day in the lower-right corner of a print or slide. It can be used with M-type and program cameras. An LCD display on the rear of the data back shows the data that will be imprinted on the film.

Power Source—The data back uses two LR-44 or SR-44 batteries.

Installation—Remove the standard camera back by depressing the Back-Cover Release Pin near the top of the hinge. Replace with the data back.

Film Speed—The ASA Film-Speed Switch has three film-speed settings and a RESET setting. Set the switch to the film speed you are using or the nearest value.

X-Synchronization—The data back requires X-sync from the camera. For use with some M-type cameras, a sync cord is packaged with the data back. It connects to a socket on top of the data back and to the X-sync terminal on the camera.

For M-type cameras with no sync terminal, install the accessory Hotshoe Adapter 2P in the hotshoe and plug the sync cord into the adapter.

The Program Plus, Super Program and some M-type cameras have two electrical contacts at the back of the bottom plate. They make the sync connection without use of a sync cord.

Mode Selection—The MODE button on the rear of the data back determines what will be displayed and imprinted. By pressing the button, three modes appear in rotation: "Year/Month/Day," "Hour/Minute" and "- - - -." The dashes indicate that nothing will be imprinted.

Setting Data—To set or correct the data in any mode, move the ASA Film-Speed Switch to the RESET position. Depress the MODE button repeatedly until the desired mode is displayed. The three buttons to the right of the MODE button are used to change the data.

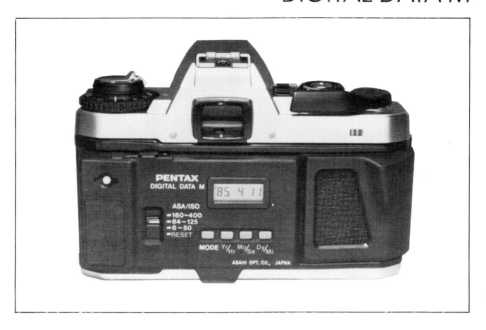

An example of the Y/M/D mode is '88 6 16. The button labeled Yr/Hr changes the year, the Mo/Se button changes the month and Dy/Mi changes the day. Press the buttons in any order until the data is correct.

An example of the Hour/Minute mode is *12—45.* The hour and the minutes on the display are separated by a dash symbol which blinks at one-second intervals. The same buttons are used to make changes. The Yr/Hr sets the hour, Mo/Se controls seconds and Dy/Mi sets minutes.

To set the time, begin with the Mo/Se button. At any exact second, press Mo/Se. The dash symbol appears instantly and blinks at one-second intervals from that starting point. Then set minutes and hours in either order.

When the data is correct, move the ASA Film-Speed Switch to the desired film-speed setting.

Battery Check—Depress the red Battery Check Button. If the red LED on the data back glows, the batteries are OK.

Imprint Indicator—The same LED flashes briefly each time the data back imprints data on the film. When set to imprint nothing,

the LED will not flash.

To Use—Set the camera to any mode of operation. A flash can be used, if desired. Set the ASA Film-Speed Switch on the data back. Use the MODE button to select the data to be recorded or the group of dashes that indicates no data. Compose the scene so the lower-right corner of the frame is relatively dark, if possible. That makes the imprinted characters easier to read.

Press the shutter button. With your eye at the viewfinder eyepiece, you can see the LED imprint indicator flash.

With motor drive, Digital Data M will imprint film at speeds up to two frames per second.

If the camera temperature drops below freezing, the data back batteries may lose power and the unit may not function. Operation will return to normal at normal temperatures.

Replacing Batteries—If the LCD display on the data back is still operating, you can save the data. Set the MODE to Year/Month/Day. If you replace the batteries in less than a minute, the data back will retain its settings.

MOTOR DRIVE A

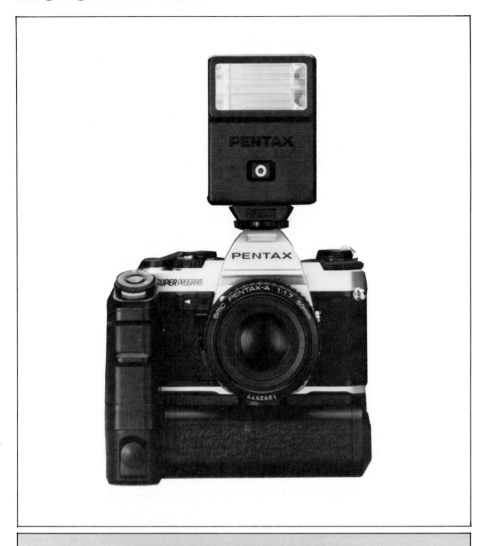

MOTOR DRIVE A SPECIFICATIONS

Frame Rate: Single frame or consecutive at either 2 or 3.5 maximum frames per second.
Usable Shutter Speeds: 1/2000 to 15 seconds, 1/125 and B.
Power Source: Eight AA-size batteries in detachable Battery Pack A.
Film Rolls per Battery set: Manganese—50 rolls; Alkaline—100 rolls; Nicad—100 rolls.
Confirmation: LED glows at each film advance.
Dimensions: With Battery Pack A, 142mm x 108mm x 70mm (5.6 x 4.3 x 2.8 inches).
Weight: Without batteries, 435g (15.4 oz.).

MOTOR DRIVE A

This motor drive is for use with program cameras, such as the Program Plus and Super Program. It can be used to expose single frames or a continuous sequence of frames.

It has a removable battery pack. Without the battery pack, it is convenient to leave the unit attached to the camera—it consists of a grip and a thin gear case that extends across the bottom of the camera.

Power Source—The detachable battery pack clips onto the bottom of the motor drive. It holds eight AA-size batteries. Manganese, alkaline or rechargeable nicad batteries can be used.

Installation—Remove Grip Super A from the front of the camera. The motor drive has its own grip. With or without the battery pack attached, place the motor drive in position on the bottom of the camera and turn the attaching screw. It threads into the tripod socket on the camera. The motor drive has its own tripod socket.

Operation—The camera can be set to any mode except B. With the motor drive attached, you can still operate the camera manually.

There are two shutter-release buttons on the motor drive. One is on top of the motor drive grip. The other is on the end of the battery pack, which is convenient to use when you rotate the camera to shoot vertical frames.

The motor-drive switch is on top of the grip. It has four settings: S, OFF, L and H. At the S setting, a single frame is exposed each time you press a shutter-release button on the motor drive and the next frame is advanced by the motor drive.

At the L setting, frames are exposed and advanced continuously as long as you hold down either of the shutter-release buttons. The maximum frame rate is 2 frames per second.

At the H setting, frames may be exposed continuously at rates up to 3.5 per second if shutter speed is 1/125 second or faster.

The motor drive always waits for the shutter to close before advancing the next frame. Therefore the frame rate may be slower than 2 or 3.5 frames per second if the exposure time for each frame is long.

A red LED on the motor drive flashes each time a frame is advanced. When the last frame has been exposed, the motor drive stops and the LED glows continuously. Turn off the motor drive to conserve power. Depress the Rewind Button on the back of the motor drive. Use the Rewind Crank on the camera to rewind the film.

Remote Control—The battery pack can be used remotely by connecting it to the motor drive using a 3-meter or 10-meter Power Cord A. The shutter-release button on the battery pack can then be used for remote control.

A Remote Control Socket on the battery pack can be used to trigger the motor drive remotely using 10-meter Remote Cord A or other accessories including user-supplied equipment.

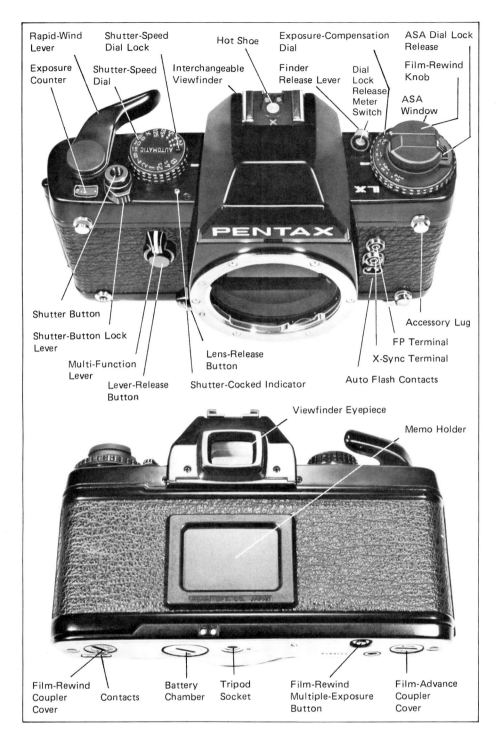

Rapid-Wind Lever
Shutter-Speed Dial Lock
Hot Shoe
Exposure-Compensation Dial
ASA Dial Lock Release
Exposure Counter
Shutter-Speed Dial
Interchangeable Viewfinder
Finder Release Lever
Dial Lock Release Meter Switch
Film-Rewind Knob
ASA Window
Shutter Button
Shutter-Button Lock Lever
Multi-Function Lever
Lens-Release Button
Lever-Release Button
Shutter-Cocked Indicator
Accessory Lug
FP Terminal
X-Sync Terminal
Auto Flash Contacts

Viewfinder Eyepiece
Memo Holder

Film-Rewind Coupler Cover
Contacts
Battery Chamber
Tripod Socket
Film-Rewind Multiple-Exposure Button
Film-Advance Coupler Cover

The LX is a system camera with a wide range of accessories. It offers manual control and aperture-preferred automatic using the Integrated Direct Measuring system (IDM) described in Chapter 10.

It has special connectors for the camera strap. Two grips are available: Accessory Grip B is molded plastic, Grip A is wood that you can carve to fit your right hand. When a grip is installed, the camera strap is attached to the opposite end of the body.

Loading Film—The LX has a Magic Needles take-up spool. Use the procedures in Chapter 5. To prevent delays while advancing to frame 1, load film with the lens cap off if the LX is on automatic or use a fast manual speed.

On-Off Switch—Depress the shutter button partway to turn the camera on. An LED shutter-speed indicator will glow in the viewfinder. The camera turns itself off in about 25 seconds unless you make an exposure or partially depress the shutter button again.

Automatic or Manual—For automatic, turn the Shutter-Speed Dial to **AUTOMATIC**. For manual, depress the lock button on the dial and turn to any other setting.

Metering—The LX uses a silicon photo diode in the bottom of the camera, facing the film. This sensor meters all modes of operation. On manual, 15% of the light passes through a semi-transparent area of the mirror and is reflected to the light sensor by a secondary mirror. The viewfinder displays shutter speed for correct exposure of an average scene.

You can choose that speed or any other. When you press the shutter button, the shutter operates at the speed you selected.

On automatic, before exposure, the viewfinder display shows the approximate shutter speed to be used. When you press the shutter button, the IDM system controls exposure time by measuring light reflected from the first shutter curtain while it is opening and from the film as it is uncovered.

With flash, the IDM system measures the combined effect of flash and ambient light.

Metering Pattern—Center-weighted on both manual and automatic.

ASA Film-Speed—Depress the ASA Dial Lock Release while turning the control ring to place the ASA speed in the ASA Window. Range is ASA 6 to 3200.

Exposure Compensation—Depress the Dial Lock Release button to turn the control ring away from 1X. Range is +2 to −2 steps in increments of 1/3 step. See the accompanying table.

Shutter-Speeds—On manual, the camera operates at the exact shutter speed selected on the Shutter-Speed Dial—from 4 seconds to 1/2000 in standard steps.

On automatic, any speed may be used, such as 1/232, in the range of 1/2000 to 125 seconds with ASA 100. Doubling film speed cuts the maximum time on automatic in

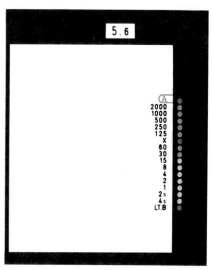

The LX exposure display with the standard FA-1 viewfinder.

LX SPECIFICATIONS

Type: 35mm SLR with IDM metering system. Aperture-preferred automatic or manual. TTL Auto flash control with Pentax T-type flash.

Standard Lenses: SMC Pentax-M 50mm ƒ1.2, SMC Pentax-M 50mm ƒ1.4, ƒ1.7, ƒ2, SMC Pentax-M 40mm ƒ2.8.

Shutter: Horizontal-run titanium focal-plane with shutter-button lock. On auto, shutter speeds are stepless from 1/2000 to 125 sec. with ASA 100. On manual, standard mechanical shutter speeds from 1/2000 to X (1/75) plus 1/60 to 4 sec. by electronic control.

Flash Sync: FP and X-sync (1/75) with TTL contacts on body. Standard FA-1 finder has hot/cold shoe with X-sync and TTL contacts.

Self-Timer/Depth-of-Field Preview/Mirror Lock: Multi-Function Lever provides mechanical self-timer with 4 to 10 seconds delay, depth-of-field preview and mirror lock.

Viewfinders: Interchangeable. All show 98% vertically and 95% horizontally of film frame. Standard FA-1 shows aperture, shutter speed and LED exposure display and exposure compensation flag; has built-in diopter correction.

Focusing Screens: Interchangeable. Standard SC-21 has biprism surrounded by microprism in matte field.

Film Advance: Single-stroke Rapid-Wind Lever. 25° standoff, 120° stroke. Accepts Winder LX and Motor Drive LX.

Exposure Counter: Automatic reset when back cover opened. Counts backward on rewind.

Multiple Exposures: Use Film-Rewind/Multiple-Exposure Button. Random access feature allows rewinding to previously exposed frame.

Exposure Meter: Silicon Photo Diode in camera body used in Integrated Direct Metering system and TTL Auto flash control. Range: On manual, EV 1 to EV 19 with ASA 100 and ƒ1.4. On Automatic, EV −6.5 to EV 20 with ASA 100 and ƒ1.2. Film-speed range: ASA 6 to 3200.

Exposure Compensation: Plus or minus two exposure steps in 1/3 step increments.

Meter Switch: Depress shutter button partway. Automatic turnoff after 25 seconds.

Power Source: Two 1.5V alkaline or silver-oxide batteries, S-76 or equivalent.

Operation With Dead Batteries: Manual only with mechanical shutter speeds of 1/2000 to X, and B. Meter inoperative.

Back Cover: Removable to mount special backs.

Body Size: 145 x 90.5 x 50mm (5.7 x 3.6 x 1.9 in.) with FA-1 Finder.

Weight: 570g (20 oz.) with FA-1 Finder.

ASA FILM SPEED	EXPOSURE COMPENSATION RANGE				
	4X	2X	1X	1/2X	1/4X
6					
12					
25-800					
1600					
3200					

half. Halving film speed doubles it.

Viewfinder Displays—In the standard viewfinder, aperture setting is displayed above the screen. Not all interchangeable viewfinders show aperture. If an extension tube or bellows is between camera and lens, aperture is not displayed.

With all viewfinders, the Shutter-Speed Dial setting is shown by a blue pointer moving along a scale at the side of the image area.

If the pointer indicates A at the top of the scale, the Shutter-Speed Dial is set to AUTOMATIC. If it indicates LT.B at the bottom, the dial is set to B.

Beside the scale is a row of LEDs to give exposure information.

If the top, red, LED glows, the scene will be overexposed with the camera settings you are using.

Another red LED is at the bottom adjacent to LT.B. *On automatic*, if it glows, the camera will expose for a Long Time—longer than 4 seconds. On manual *but not* B, the LED at the bottom signals underexposure. On B, disregard the LED indication. The red LED at X is used with dedicated flash.

The remaining LEDs indicate shutter speeds. On manual, an LED shows shutter speed recommended by the camera. The blue pointer shows the shutter speed set by you. On automatic, an LED shows the shutter speed to be used.

Above the scale, a red flag appears if exposure compensation is being used.

Interchangeable Focusing Screens—The standard screen, SC-21, and interchangeable screens are shown on page 58. To change, remove the lens. The screen is held in a hinged frame at the top of the mirror box. A special tool is supplied. Use the tapered end to pull forward on the catch at front center of the frame. The frame will swing down. Use the pincers to grasp the tab on the focusing screen and remove it carefully. Install the replacement screen in the frame and swing it up until it locks in place.

A field lens is in the body, above the focusing screen.

Interchangeable Viewfinders—Move the Finder Release Lever toward the finder and slide the finder to the back. Handle carefully. Use the protective covers. To install, slide the finder forward along the metal rails until it locks in place. No meter correction is needed for any finder or screen.

Eyepiece Accessories—M-type accessories fit FA-1, FA-1W and FA-2 finders. Diopter ratings are net values, as they affect your vision.

FA-1 Eye-Level Pentaprism Finder—This standard finder shows a correctly oriented image with exposure display at the right and aperture above the frame. Built-in correction

of 0 to −1.5 diopters is made using a special tool.

FA-1W Eye-Level Pentaprism Finder—Same as FA-1 except diopter range is −3 to +1.

FA-2 Eye-Level Pentaprism Finder—Same as FA-1 except without a hot shoe and without display of aperture.

FE-1 Waist-Level Finder—You look straight down from above to see a laterally reversed image and exposure display. Aperture is not displayed. The image is larger than eye-level pentaprism finders for critical focusing. Rotating the eyepiece makes a diopter adjustment from −5 to +4.

FB-1 System Finder—A pentaprism base for three interchangeable eyepieces. Image and exposure display are correctly oriented. Eyepieces for the FB-1 are:

FD-2 Standard Eyepiece—The eyepiece is angled at 45°. Similar to FA-2 finder but with a larger image. There is no diopter correction.

FD-1 Magni-Eyepiece—Also angled at 45° with a correctly oriented view and still larger image magnification for critical focusing. Aperture is displayed at the bottom. Turn the eyepiece for diopter correction from −5 to +3.

FC-1 Action Eyepiece—This shows a correctly oriented image, smaller than eye-level pentaprism finders, with the exposure display at the right and aperture at the bottom. You don't have to place your eye close to the eyepiece to see the entire frame. This is convenient with eyeglasses. The eyepiece housing rotates clockwise from the top, so you can look down or from the back or any angle in between.

FF-1 Waist-Level Finder—Not yet available at press time, this is a simple, four-sided light shield that pops up for viewing. You see the shutter-speed scale and LED indicators reversed, at the left. Aperture is not displayed. A magnifier lens aids in critical focusing.

Substitute Metering—On manual, meter on the substitute surface, set exposure, point the camera at the scene and shoot.

Interchangeable viewfinders mount on precision metal rails in the camera body. Shutter-speed scale is printed in reverse on the field lens. Most finders reverse the scale so it reads normally though the eyepiece.

FB-1 System Finder contains a pentaprism and uses interchangeable eyepieces. Shown here: FC-1 Action Eyepiece mounted on the FB-1.

On automatic, notice the shutter-speed indication while metering the substitute surface. Then point the camera at the scene. Turn the Exposure Compensation Dial to produce the same shutter speed.

Depth-of-Field Preview—Move the Multi-Function Lever toward the lens. The aperture will stop down to the setting on the lens.

Mirror Lock—Depress the button on the Multi-Function Lever and rotate the lever toward the lens until it locks. The mirrors will lock up and aperture will close to the setting on the lens to minimize vibration in high-magnification photography and when using a long-focal-length lens. To release, depress the button.

Self-Timer—Depress the button on the Multi-Function Lever and rotate the lever away from the lens. Press the shutter button. Delay before

the shutter operates will be 4 to 10 seconds, depending on how far you rotated the lever.

With the shutter not cocked, the timer will run but the shutter will not operate. After setting the timer, you can cancel it by rotating the lever back to its normal position. Once started, it cannot be canceled.

The timer operates with dead batteries. The shutter depends on other factors. See paragraph entitled "Dead Batteries." Winder LX or Motor Drive LX must be turned off to use the self-timer.

Exposure Counter—Resets when the back cover is opened. Runs backward when rewinding.

Rewinding Film—Use the standard procedures in Chapter 5. Power rewind is provided by Winder LX and Motor Drive LX.

Multiple Exposures—After the first exposure, press the Film-Rewind/Multiple-Exposure Button. Move the Rapid-Wind Lever through one full stroke. This cocks the camera without advancing film. Set exposure and shoot. For additional exposures on the same frame, repeat the procedure.

When the multiple exposure is complete, operate the Rapid-Wind Lever without depressing the Film-Rewind/Multiple-Exposure Button. This will advance the next frame and cock the camera. The exposure counter will not advance during a multiple exposure.

Random Access Multiple Exposures—Before the film is rewound, you can multiple expose a previously exposed frame. Press the Film-Rewind/Multiple-Exposure Button. Turn the rewind crank clockwise. When the counter shows the next number *smaller* than the desired frame, stop.

Set the camera to a fast manual shutter speed. Cover the lens with a lens cap. Move the Rapid-Wind Lever through one full stroke. Press the shutter button. This would expose that frame if the lens cap were not used.

Then advance to the desired frame. This provides registration

within 0.2mm. Set controls and make the exposure.

Shutter-Button Lock Lever—A lever at the base of the shutter button. Turn counterclockwise to lock the button so it can't be depressed accidentally—clockwise to unlock. On B, you can hold down the shutter button by turning the lock lever counterclockwise. Shutter remains open until you turn the lever clockwise again.

Shutter-Cocked Indicator—A small circular window near the Shutter-Speed Dial shows red when the shutter is cocked.

Battery Check—If any LED glows steadily, batteries are OK. If an LED flickers, the camera will operate normally but batteries should be replaced.

Dead Batteries—The meter and automatic exposure system will not operate. If the shutter is set at X, any speed faster than X, or B, the shutter can be operated. If set to AUTOMATIC or any speed slower than X, the mirror will lock up and the shutter will not operate.

After replacing batteries, reset the mirror by selecting 1/2000 or X. The shutter will operate immediately at 1/2000 or 1/75. Install a lens cap while resetting. Then use the multiple-exposure procedure to expose the frame.

Time Exposures—At B, the shutter will remain open as long as you depress the button with your finger or use a locking cable release or the Shutter-Button Lock Lever.

Flash Sync—Viewfinders FA-1 and FA-1W have a hot shoe that is "hot" only when a flash is in the shoe. The shoe has two auxiliary contacts for Pentax dedicated flash units. The LX body has two flash terminals: One for FP flashbulbs and one for X-sync and flashbulbs—see the accompanying table. Adjacent to the X-sync terminal are two auxiliary contacts for dedicated flash.

Electronic Flash—The LX can be used with virtually any electronic flash, as discussed in Chapter 13. With ordinary manual flash, mount it in the hot shoe or connect to

LX FLASH SYNCHRONIZATION															
		$\frac{1}{2000}$	$\frac{1}{1000}$	$\frac{1}{500}$	$\frac{1}{125}$	X̄	$\frac{1}{60}$	$\frac{1}{30}$	$\frac{1}{15}$	$\frac{1}{8}$	$\frac{1}{4}$	$\frac{1}{2}$	1	2S 4S B	Terminal
Electronic flash	On Auto						▓	▓	▓	▓	▓	▓	▓	▓	X
	On Manual							▓	▓	▓	▓	▓	▓	▓	X
FP-type bulbs		▓	▓	▓	▓	▓	▓								FP
F-type, MF-type bulbs											▓	▓	▓	▓	X

▓ USABLE SPEEDS

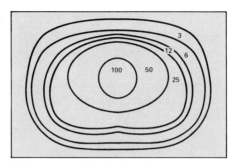

LX center-weighted metering pattern on IDM automatic as measured by *Modern Photography* magazine. Numbers indicate relative sensitivity. Drawing courtesy of *Modern Photography*.

The LX has two flash terminals on the camera body. The FP terminal is for special-purpose long-duration flashbulbs. The X terminal delivers X-sync for electronic flash. Two contacts adjacent to the X terminal are used by Pentax dedicated flash units and require special Sync Cord A.

the X terminal. Set shutter speed to X or slower.

With non-dedicated light-sensing automatic flash, mount in hot shoe or connect to the X terminal. Set the shutter to X or slower.

With Pentax dedicated *light-sensing* automatic flash, such as the AF160, set shutter speed to AUTOMATIC or X. When the flash ready light glows, the camera is automatically set to X-sync.

With Pentax dedicated *TTL Auto* flash, set the LX to AUTOMATIC or X. When the flash ready light glows, the camera is automatically set to X-sync and the camera controls flash duration.

Pentax bracket-mount TTL Auto flash requires 4-pin sync cord A or B. Cord A connects to the X terminal and adjacent auxiliary contacts. Cord B fits the hot shoe and connects to the center contact and both auxiliary contacts.

Viewfinder Flash Indicators—When a Pentax dedicated flash sets the LX to X-sync, it turns on the LED at the X symbol in the viewfinder.

When the auto check confirms correct exposure, the LED flickers for about two seconds.

Accessories—The LX uses all Pentax and Pentax-M lenses and bayonet-mount lens accessories such as bellows and extension tubes. It accepts screw-mount Takumar lenses by use of Mount Adapter K, using stopped down metering. It uses interchangeable focusing screens and viewfinders. Eye-level penta-prism viewfinders accept all M-type viewfinder accessories: Correction Lens Adapter M, Magnifier M, Right-Angle Finder M and Eye-cup M.

It uses camera straps with special connectors and the choice of two

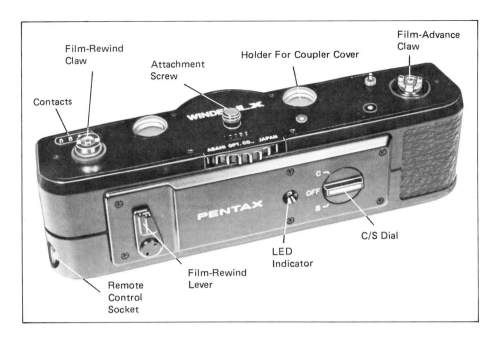

Contacts

Film-Rewind Claw

Attachment Screw

Holder For Coupler Cover

Film-Advance Claw

WINDER LX

ASAHI OPT. CO., JAPAN

PENTAX

C/S Dial

LED Indicator

Film-Rewind Lever

Remote Control Socket

WINDER LX SPECIFICATIONS

Frame Rate: Single frame or continuous up to 2 frames per second, depending on shutter speed.
Shutter Release: Use camera shutter button or optional Remote Release Cord.
Power Source: Four 1.5V AA-size cells, alkaline, manganese or Ni-Cd.
Film Rewind: Manual or motor-driven.
Dimensions: 146 x 46 x 39mm (5.8 x 1.8 x 1.5 in.).
Weight: 287g (10.1 oz.) without batteries.

handgrips. Motor Drive LX or Winder LX fit on the bottom of the camera. The camera back is easy to remove to install Bulk Film Magazine LX, or either of two data backs—Dial Data LX or Data LX.

WINDER LX

This winder advances single frames after each exposure or continuously at speeds up to two frames per second, synchronized with the shutter and controlled by the camera shutter button. It rewinds film if desired.

To install, be sure it is turned off. Unscrew two coupler covers on the bottom of the LX and store in sockets on the winder. Place Winder LX against the bottom of the camera and turn the Attachment Screw into the tripod socket.

When attaching or detaching the winder with film in the camera, *shield the base of the camera from direct light.*

When the winder is turned off, you can load film, operate the camera and advance film manually. A rewind button on the bottom of the winder depresses the camera rewind button for manual rewind.

Power is supplied by four AA-size batteries in the winder. The C/S Dial has three positions: C, OFF and S. On C, the winder advances film continuously up to 2 frames per second, depending on shutter speed. On S, it advances one frame for the next exposure. At the end of the roll, or if the film jams for any reason, a red LED on the winder turns on. If you are not going to power rewind, turn the winder off to conserve batteries.

Motor Drive LX installed on the LX, using Battery Grip M, which also serves as a convenient handle.

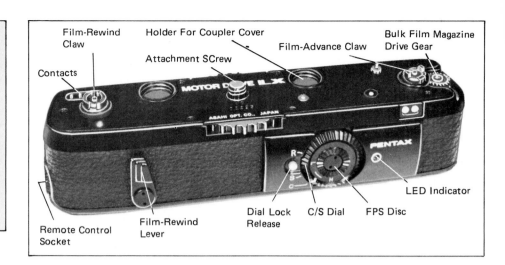

MOTOR DRIVE LX SPECIFICATIONS

Frame Rate: Single frame or continuous from 0.5 to 5 frames per second, depending on shutter speed.
Shutter Release: Use camera shutter button or release at power source.
Power Sources: Battery Grip M with 12 AA-size cells, rechargeable Ni-Cd Battery Pack M or AC-operated Power Pack M.
Film Rewind: Manual or motor-driven.
Dimensions: 146 x 31 x 36mm (5.8 x 1.2 x 1.4 in.).
Weight: 240g (8.4 oz.).

For power rewind, leave the winder set to C or S. Depress the Rewind Button on the winder—*not the Battery-Cartridge Lock Release*—Then rotate the Film-Rewind Lever clockwise. Do not use power rewind for the Random Access Multiple Exposure capability.

When loading film, you can use the winder set on S to advance to frame 1. When sprocket holes are engaged on both sides, close the cover.

To operate the camera from a distance, connect accessory 3-meter Remote Control Cord to the Remote Control Socket on the winder and use the pushbutton on the end of the cord.

With the winder attached, the shutter button travel is shorter and the button is more sensitive. The winder must be turned off to use the camera self-timer or to make multiple exposures. When film advance becomes sluggish, replace the batteries.

MOTOR DRIVE LX

For faster frame rates and additional features, use Motor Drive LX. C/S Dial settings are R, S, C, and a green button that must be pressed to rotate the dial and serves as the off setting.

At C, speed is set by rotating the FPS disc (Frames Per Second) in the center of the C/S Dial. Range is 0.5 to 5 frames per second between the symbols L and H with no indication of exact rate. If the shutter speed is too slow for the selected motor drive speed, the motor drive will wait for the shutter.

At S, single frames are advanced after each exposure.

At the end of the roll, or if the film jams for any reason, a red LED light turns on. If you are not going to power rewind, turn the motor drive off to conserve batteries.

For power rewind, turn the C/S Dial to R and rotate the Film-Rewind lever clockwise. Do not use power rewind for the Random Access Multiple Exposure capability.

When loading film, you can use the motor set on S to advance to frame 1. When sprocket holes are engaged on both sides, close the cover.

To use the LX self-timer, you must turn the motor drive off. When attaching or detaching the motor drive with film in the camera, *shield the base of the camera from direct light.*

Power Sources—Three sources are available. Battery Grip M attaches to the bottom of the motor drive and serves as a handle. It holds 12 AA-size penlight batteries.

For use where AC power is available, Power Pack M requires no batteries.

Ni-Cd Battery Pack M attaches to the bottom of the motor drive. It is rechargeable by accessory Charger Pack M or Power Pack M.

Any of the three power sources can be separated from the motor-drive unit using 3-meter or 10-meter Power Cable M.

The power sources also have C/S Dials with C, OFF, and S settings that can be selected independent of the motor drive. Use OFF to operate the camera manually.

Operation using the camera shutter button is set by choosing C or S on the motor drive. Operation with a power source control is set by selecting C or S on the power source. You may then control using different modes at the two locations.

Remote Control—Use 3-meter or 10-meter Power Cable M between the motor drive and any of the three power sources. Remote control at the power source is done by the Trigger-Release Button on the source. Trigger Cord M connects the Remote Control Socket of any power source to a user-supplied two-conductor cable and remote pushbutton for control at distances of several hundred feet.

Multiple Exposures—Turn the motor drive C/S Dial to OFF to make the first exposure. Then turn the dial to R, which is equivalent to depressing the Film-Rewind/Multiple-Exposure button on the camera. Move the Rapid-Wind Lever through a full stroke. Set the dial to OFF again. Make the next exposure. For additional exposures on the same frame, repeat the procedure. Do not use the motor drive for random-access multiple exposures.

DIAL DATA LX

To record aphanumeric data in the lower left corner of the film frame, remove the camera back and replace it with Dial Data LX. Three dials on the data back are used to select letters or numbers to be imprinted on the film. By selecting symbols, you can record the date or photographic data, or use the symbols any other way you choose.

A dial on the data back is set according to film speed in use. An LED indicator flashes at each exposure. Battery check is done by pressing a Battery Check Button. If the associated LED flashes, the batteries are OK.

DATA LX

Data LX has a clock that is imaged in the upper left corner of the frame to show day of the month, hour, minute and second. The center of the clock face is ground glass so you can write on it with a pencil to record additional information. When time is not important to the photo but other data is, a Memo Plate interchanges with the clock. Write desired information on the memo plate.

To use, remove the camera back. Rotate the thumbwheel on the right side of the focal-plane shutter counterclockwise to move a rectangular blind over one corner of the frame. Attach the Data LX unit. Set the ASA Ring for the film speed to be used.

MAGAZINE BACK LX

For use with Motor Drive LX or manual film advance, Magazine Back LX replaces the back cover of the LX camera and holds 250 frames of film.

Magazine Back LX replaces the standard camera back and holds 250 frames of film in 3-piece cartridges as shown at right. Removable back of magazine back allows loading film cartridges. Camera and magazine back are shown here operated by Motor Drive LX with Ni-Cd Battery Pack M.

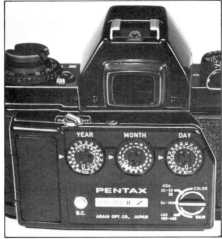
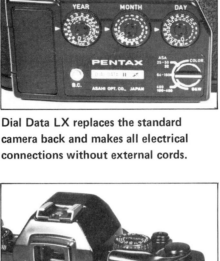

Dial Data LX replaces the standard camera back and makes all electrical connections without external cords.

DIAL DATA LX SPECIFICATIONS

Mounting: Replaces LX back cover. Built-in contacts make sync cord unnecessary.
Data for Imprinting: Years: 80 to 91; f-numbers: 1.2 to 45; Months: 1 to 12; Shutter Speeds: 1 to 2000, AUTO, b; Letters: A to O; Days: 1 to 31; Numbers 0 to 36.
ASA Film-Speed Settings: Color: 25-50, 64-160, 400; B&W: 32, 100-400.
Power Source: Three 1.5V silver-oxide or alkaline batteries, S-76 or equivalent.
Dimensions: 147 x 53 x 29mm (5.8 x 2.1 x 1.1 in.).
Weight: 122g (4.3 oz.).

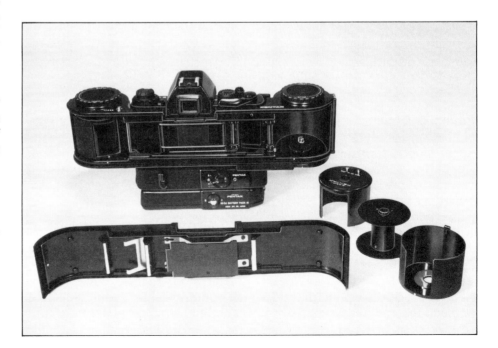

Data LX also replaces the standard camera back.

DATA LX SPECIFICATIONS

Mounting: Replaces LX back cover. Built-in contacts make sync cord unnecessary.
Data for Imprinting: Clock face showing date of month, hour, minute and second plus handwritten data in center. Or handwritten data only in larger area.
ASA Film-Speed Settings: Color: 64-100, 400; B&W: 100, 200, 400.
Power Source: One 6V alkaline or silver-oxide battery. (Eveready 537 or 544, or equivalent).
Dimensions: 147 x 54 x 113.5mm (5.7 x 2.1 x 4.4 in.).
Weight: 122g (4.4 oz.) without battery.

K-1000

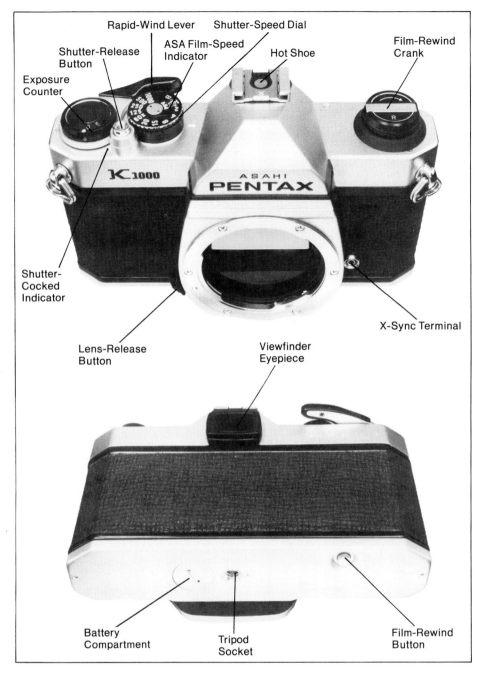

Shutter-Release Button
Rapid-Wind Lever
ASA Film-Speed Indicator
Shutter-Speed Dial
Hot Shoe
Film-Rewind Crank
Exposure Counter
Shutter-Cocked Indicator
Lens-Release Button
Viewfinder Eyepiece
X-Sync Terminal
Battery Compartment
Tripod Socket
Film-Rewind Button

K1000

The K1000 is a simple, non-automatic camera. The internal mechanism is fully mechanical except for exposure metering. Everything except the exposure meter works with a dead battery or without a battery installed. It is an inexpensive camera, but it will produce the same image quality as any other Pentax 35mm SLR because it uses the same lenses. The exposure display in the viewfinder is a moving needle, which is very simple to use and understand.

On-Off Control—You can't find an on-off switch on the K1000. When you remove the lens cap, the meter is turned on by a special cadmium sulfide (CdS) photocell inside the viewfinder housing, called a *photoswitch*. The only function of this photocell is to turn the metering system on when the lens cap is removed.

When not using the camera, put the lens cap on to turn off the meter and reduce battery consumption. If you should lose the lens cap, you can effectively turn off the meter by putting the camera inside a case.

Metering—Two additional CdS photocells are inside the viewfinder housing, one on each side of the eyepiece. They meter by measuring brightness of the focusing screen, using a full-frame averaging pattern.

This means that a bright spot in a corner of the frame affects the meter just as much as a bright spot at the center. When using the camera, you should be aware of the metering pattern to guard against exposure errors due to unusually bright or dark backgrounds.

The metering range is EV 3 to EV 18. For conversion to camera settings, see Chapter 10.

Viewfinder Display—The exposure indicator is a single moving needle that travels vertically on the right side of the screen. A + symbol is at the top and a − is at the bottom. When the needle is centered, exposure is correct for an average scene. When the needle moves upward in the display, increased exposure is indicated. Downward movement of the needle indicates less exposure.

The focusing aid is a circular microprism. Focusing screens can be changed at Pentax service centers.

Exposure Controls—Both aperture and shutter speed are set manually, while observing the meter needle in the viewfinder. Set aperture using the Aperture Ring on the lens. Set shutter speed by turning the Shutter-Speed Dial on top of the camera. The shutter-speed range is 1 second to 1/1000 second.

You can set the Aperture Ring between numbers on the scale. Always set the Shutter-Speed Dial exactly on a numbered shutter speed, or on **B**.

Operating on B—An additional setting of the Shutter-Speed Dial is labeled **B**. At this setting, the shutter will remain open as long as you hold the shutter button depressed with your finger or a cable release. The exposure meter will operate but you should disregard

K1000 SPECIFICATIONS

Type: 35mm SLR with manual exposure control. Built-in exposure meter.

Standard Lens: SMC Pentax-M 50mm f2.

Shutter: Horizontal-run focal-plane. Standard speeds from 1/1000 to 1 second, plus B.

Exposure Meter: Cadmium Sulphide, open-aperture, through-the-lens, full-frame averaging. Range is EV 3 to EV 18 with f1.4 and ASA 100. ASA range is 20 to 3200.

Flash Synchronization: X sync, 1/60 second at hot shoe or terminal.

Viewfinder: Pentaprism. Focusing screen has split-image (biprism) or microprism focusing aid. Shows 95% of picture area. Magnification is 0.88 with 50mm lens set at infinity. Eyepiece is −1 diopter. Needle-centering exposure indicator.

Film Advance: Ratcheting Rapid-Wind Lever with 10-degree standoff and 160-degree stroke. Built-in Shutter-Cocked Indicator.

Exposure Counter: Automatic reset when camera back opened.

Batteries: One 1.5V silver-oxide G-13 or alkaline LR44, or equivalent.

Dimensions: With 50mm f2 lens, 143mm x 91.4mm x 83mm (5.6" x 3.6" x 3.3").

Weight: With lens, 790g (28 oz.)

K1000 VIEWFINDER

K1000 FLASH-SYNC TABLE

SHUTTER SPEED		1/1000	1/500	1/250	1/125	1/60	1/30	1/15	1/8	1/4	1/2	1	B
ELECTRONIC FLASH	X												
FLASH BULB								M · MF · FP CLASS					

Shaded areas indicate usable shutter speeds.

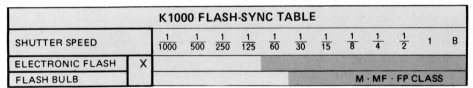

the reading because the meter does not "know" how long you will hold the shutter open.

Substitute Metering—Meter the substitute surface and set the exposure controls for correct exposure. Then compose the scene you intend to shoot and make the shot without changing exposure. The meter needle will not be centered. Disregard the meter indication.

Exposure Compensation—No exposure compensation control is provided, but none is needed. If you are photographing a non-average scene, first set the camera so the meter needle indicates correct exposure. Then decide the amount of exposure compensation you wish to use. Change aperture, shutter speed, or both to produce that amount of compensation.

Make the shot.

Viewing Depth Of Field—No provision is made to view depth of field at shooting aperture using bayonet lenses mounted directly on the camera. When it is necessary to meter stopped down, you see depth of field at shooting aperture.

Mirror Lockup—No provision is made to lock up the mirror.

Multiple Exposures—Use the "three-finger method" described in Chapter 10.

Setting ASA Film Speed—Lift up the outer rim of the Shutter-Speed Dial and turn to place the desired ASA film-speed number in the window on the face of the dial. When this control is rotated *without* lifting the outer rim, it changes shutter speed.

Film Loading—The take-up spool

has slots to accept the film end. The film-loading procedure is described in Chapter 5.

Shutter-Cocked Indicator—This shows black if film is not advanced for the next frame. Advance the film and it turns red.

Flash—The hot shoe is turned on only when a flash is installed. To use flash, set shutter speed to 1/60 second or slower. The camera provides X-sync only, for electronic flash. Flashbulbs can be used at shutter speeds of 1/30 second or slower, as shown in the accompanying Flash-Sync Table.

Pentax dedicated flash units can be used, but without dedicated functions.

Battery—The K1000 uses one 1.5 volt silver-oxide battery, S-76E or equivalent, in a battery compartment on the bottom of the camera. To install, unscrew the battery-compartment cover.

If the meter needle does not move when the camera is pointed at scenes of varying brightnesses, the battery is dead and should be replaced.

If the battery is dead or missing, the camera can still be used normally at all shutter speeds, but the meter will not operate.

Accessories—The K1000 uses all Pentax bayonet mount lenses and accessories such as extension tubes and bellows. It can use the earlier Takumar screw-mount lenses with Mount Adapter K. It uses all K-type lens accessories and eyepiece accessories.

MISCELLANEOUS

Stereo Adapter makes two images of each scene. Use a Stereo Viewer to view slides made with Stereo Adapter. This gives a realistic third dimension—depth—to your photos.

Mirror Adapter lets you point the camera one way while taking a picture at 90-degrees.

Compartment cases are available to hold one or more cameras plus lenses and accessories.

Some camera cases have interchangeable fronts for use with the standard lens or longer telephoto lenses.

For M cameras, you can get a Quiet/Action Case with a cutout for the lens and a special pushbutton on the top flap that operates the shutter. The case makes the camera more quiet and immediate access to the shutter button allows you to shoot faster than with a standard camera case.

AUTO 110 SUPER

The Auto 110 Super is a tiny SLR camera that uses 110 film in drop-in cartridges. It is a complete SLR system with its own interchangeable lenses, lens accessories, motor drive and dedicated flash. It has the technical advantages of an SLR but is much smaller than a 35mm camera.

The 110 negative makes medium-size enlargements of good quality. For 8x10 or larger prints, a 35mm frame size or larger may be preferable.

The camera is simple to use because exposure is programmed automatic. Both shutter and aperture are in the camera body, behind the lens. Therefore, the lens has only a focusing ring.

Shutter-Speed and Aperture Ranges—The range of shutter speeds is 1 to 1/400 second. Because the aperture is built into the camera body, aperture range with any of the interchangeable lenses is *f*-2.8 to *f*-18.

Loading Batteries—Inside the back cover, to the right of the film chamber, is a removable battery holder. Insert two 1.5V alkaline or silver-oxide batteries and replace the holder. The camera will not operate without battery power.

Loading Film—Depress the Back-Cover Release and the back cover pops open. Drop in the 110 film cartridge with the label right-side up so you can read it later through the window in the back cover.

Frame Counter—Frame numbers are visible in a window in the back of the film cartridge, which can be seen through the window in the camera back cover. When loading film, use the Film-Advance Lever to advance to frame 1.

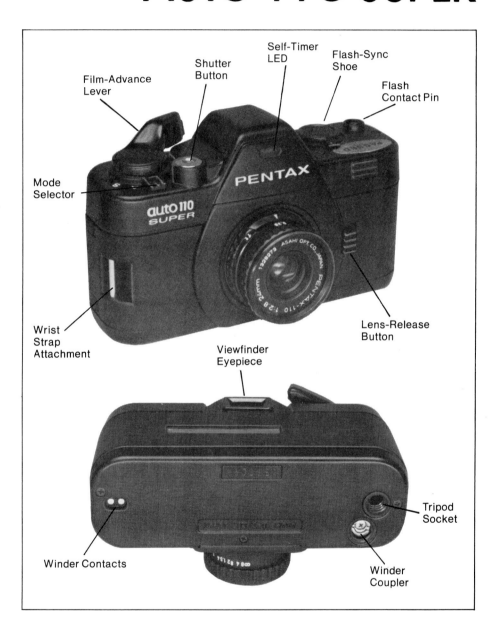

Film Speed—The film-speed setting is made automatically. On the right end of the 110 film cartridge is a flange that "tells" the camera what film speed you are using. The camera has two film-speed settings. ASA 400 is used with ASA/ISO 400 film. A setting of ASA 80 is used for films in the range of ASA/ISO 64-125. The

film has enough exposure latitude to allow for small deviations in the film-speed setting.

Mode Selector—The Mode Selector has three settings. At **L**, the camera is locked and cannot be operated. At **A**, the camera is set for programmed automatic exposure. At **S**, the self-timer system is turned on.

AUTO 110 SUPER PROGRAM

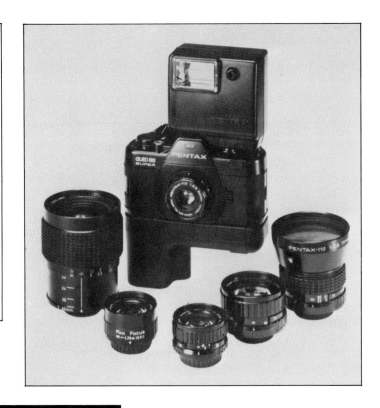

On/Off—With the Mode Selector at **A** or **S**, the camera is turned on by depressing the shutter button partway. An exposure indicator lamp will glow in the lower-right corner of the viewfinder.

Exposure Metering—A center-weighted metering pattern is used. Light is measured at full aperture by an SPD sensor in the camera body. Metering range is EV 3 to EV 17.

Focusing Aids—A circular bi-prism, surrounded by a micropr-ism ring, is in the center of the frame. The surrounding matte area can also be used for focusing.

Exposure Program—The accompanying graph shows the exposure program with ASA/ISO 100 film. If the scene is very bright, the camera chooses minimum aperture and the fastest shutter speed, *f*-18 and 1/400. As scene brightness diminishes, the aperture gradually opens and shutter speed becomes gradually slower. At 1/60, aperture is fully open. For darker scenes, shutter speed becomes slower until the slowest speed is reached.

Exposure Indicator—When the shutter button is depressed partway, an LED glows in the lower right corner of the viewfinder. If shutter speed will be 1/45 second or faster, a green LED glows. If slower, a yellow LED blinks to indicate that a flash or firm camera support should be used.

Exposure Compensation—For subjects against a bright background, an exposure increase of 1.5 steps is provided by depressing the Exposure Compensation Button during exposure.

End of Roll—When an X appears in the frame-counter window, the last numbered frame has been exposed. Continue advancing film gently until the window shows a solid pattern and no more film can be advanced. Open the back and remove the exposed cartridge.

Battery Check—If the batteries are discharged or improperly installed, the LED exposure indicator in the viewfinder will not glow.

Self-Timer—With the Mode Selector at **S**, you can use the self-timer. When you press the shutter button, there will be a 10-second delay before the shutter operates. A red lamp on the front of the viewfinder housing blinks slowly during the first 8 seconds, rapidly for the last 2 seconds.

If your eye is not at the viewfinder when you press the shutter button, cover the eyepiece with the accessory Eyepiece Cap to prevent incorrect exposure due to stray light entering the eyepiece.

During the countdown, self-timer operation can be cancelled by returning the Mode Selector to the **A** setting.

Eyepiece Correction Lenses—To add your eyeglass correction to

PENTAX-110 INTERCHANGEABLE LENSES

Type	Lens	Minimum Aperture	MINIMUM FOCUS Meter	MINIMUM FOCUS Inch	Angle Of View (Degrees)	DIAMETER X LENGTH mm	DIAMETER X LENGTH inch	WEIGHT (g)	WEIGHT (oz)	Filter Size (mm)
Wide-Angle	18mm f-2.8	f-18	0.25	9.8	61.5	34 x 21	1.34 x 0.83	28	1.0	30.5
	PF 18mm f-2.8	f-18	1.75	72	61.5	34 x 21	1.3 x 0.8	29	1.1	30.5
Standard	24mm f-2.8	f-18	0.35	13.8	47	29.6 x 12.8	1.17 x 0.50	13	0.5	25.5
Telephoto	50mm f-2.8	f-18	0.9	35.4	24	43 x 27.2	1.69 x 1.07	53	1.9	37.5
	70mm f-2.8	f-18	1.5	60	17.2	51 x 51	2 x 2	169	6	49
Zoom	20mm—40mm f-2.8	f-18	0.7	18	57.5—31	54 x 45	2.1 x 1.8	174	6.1	49

PENTAX-110 LENS ACCESSORIES

Type	Description	Thread Diameter (mm)	Lens Used With
Filters	UV	25.5	24mm
	UV	30.5	18mm
	UV	37.5	50mm
	Skylight	25.5	24mm
	Skylight	30.5	18mm
	Skylight	37.5	50mm
Lens Hoods	Screw-in	25.5	24mm
	Screw-in	30.5	18mm
	Screw-in	37.5	50mm
Lens Caps	Snap-in	25.5	24mm
	Snap-in	30.5	18mm
	Snap-in	37.5	50mm
Close-up Lenses	S-31	25.5	24mm
	S-16	25.5	24mm
	W-21	30.5	18mm
	T-86	37.5	50mm
	T-43	37.5	50mm

The Auto 110 Super camera with AF 130P flash and the 110 winder installed is very small and compact.

the viewfinder optics, clip a correction lens over the eyepiece. Diopter ratings are from −5 to +3, but not zero. Select by testing.

Interchangeable Lenses—To remove a lens, slide the Lens-Release Button upward and hold in that position while turning the lens body counterclockwise until it can be detached from the camera. To install a lens, align the red focusing index mark with the red dot on the camera body. Turn the lens clockwise until it latches into place.

The accompanying table shows available Pentax-110 lenses. All have the same aperture range of f-2.8 to f-18. Most have only a focusing control.

The Pan-Focus, PF, lens is an 18mm lens without a focus control. It makes a sharp image of a subject that is 1.75 meters or far-

ther from the camera. There is also a 20—40mm zoom lens.

The angle of view of a Pentax-110 lens is about the same as that of a 35mm format lens of twice the focal length. In other words, the angle of view of a Pentax-110 24mm lens is about the same as that of a 50mm lens on a camera using 35mm film.

FLASH UNITS

Two dedicated flash units fit the Auto 110: the AF 130P and the AF 100P. Both set shutter speed and aperture automatically. The 100P has a guide number of 10 (meters) with ASA/ISO 100 film. The 130P guide number is 13 (meters). Operation of the two units is basically the same.

To install, remove the Flash Sync-Shoe Cap. Put the flash in position and turn the knurled

knob on the flash mounting foot until the flash is securely attached. An adjacent chromed projection on the base of the flash fits over the Flash Contact Pin on the camera.

The flash **ON/OFF** switch sets shutter speed and aperture. When the flash is turned on, it mechanically depresses the Flash Contact Pin on the camera. That causes the camera to select 1/125 second and f-5.6 with ASA/ISO 400 film or 1/60 second and f-2.8 with films in the range of ASA/ISO 64 to ASA/ISO 125.

If the flash is turned off, the camera operates as though the flash were not attached. Do not use flash when the green exposure indicator glows. Overexposure will result. Don't depress the Flash Contact Pin on the camera by accident when shooting without

AUTO 110 SUPER

AF 130P AUTO FLASH SPECIFICATIONS

Type: Automatic, light-sensing, sets camera aperture and shutter speed.
Guide Number: At ASA/ISO 100: 13 meters (43 feet).
Operating Distance Range: 0.8 to 4.6 meters (2.6 to 15 feet).
Beam Angle: Sufficient for Pentax 110 18mm *f*-2.8 wide-angle lens.
Sensor Reception Angle: 18°.
Number of Flashes: 250 with alkaline batteries.
Recycling Time: 7 seconds with fully charged batteries.
Color Temperature: Equivalent to daylight.
Power Source: Two 1.5 V AA-size alkaline batteries.
Mounting: Special mount for Auto 110 SUPER camera only.
Synchronization: Automatically sets camera at 1/125 second and *f*-5.6 with ASA/ISO 400 film; 1/60 second and *f*-2.8 with ASA/ISO 64, 100 or 125 film.
Dimensions: Height 71mm (2.8"), width 63mm (2.5"), depth 41mm (1.6").
Weight: Without batteries: 102 grams (3.6 oz.).

AF 100P AUTO FLASH SPECIFICATIONS

Type: Automatic, light-sensing, sets camera aperture and shutter speed.
Guide Number: At ASA/ISO 100: 10 meters (33 feet).
Operating Distance Range: 0.8 to 3.6 meters (2.6 to 12 feet).
Beam Angle: Sufficient for Pentax 110 18mm *f*-2.8 wide-angle lens.
Sensor Reception Angle: 18°.
Number of Flashes: 150 with alkaline batteries.
Recycling Time: 7 seconds with fully charged batteries.
Color Temperature: Equivalent to daylight.
Power Source: Two AAA-size alkaline batteries.
Mounting: Special mount for Auto 110 SUPER camera only.
Synchronization: Automatically sets camera at 1/125 second and *f*-5.6 with ASA/ISO 400 film; 1/60 second and *f*-2.8 with ASA/ISO 64, 100 or 125 film.
Dimensions: Height 49mm (2"), width 63mm (2.5"), depth 48.5mm (1.95").
Weight: 100 grams (3.5 oz.) with batteries.

110 WINDER SPECIFICATIONS

Type: Battery-powered film winder.
Operation: Advances single frames after each exposure is complete. Triggered by release of shutter button on camera.
Shutter-Speeds: Operates at all shutter speeds.
Power Source: Two 1.5V AA-size penlight batteries.
Mounting: Attaches to camera bottom plate using camera tripod socket. Winder has tripod socket on bottom surface.
Dimensions: Height 52mm (2.0"), width 100mm (3.9"), depth 35mm (1.4").
Weight: Without batteries: 112 grams (4.0 oz.).

flash. Incorrect exposure will result.

When the flash is charged and ready to fire, a ready light glows on the back of the flash. The ready light also serves as a test button to fire the flash independently of the camera.

The automatic operating range is the same at all film-speed settings. The AF 130P range is 0.8 to 4.6 meters (2.6 to 15 feet). For the AF 100P, it is 0.8 to 3.6 meters (2.6 to 12 feet).

The AF 130P uses two AA-size batteries. The AF 100P uses two AAA-size batteries. Do not use rechargeable Nicad cells. Damage to the flash may result. Alkaline cells are recommended. Discharge is indicated when the recycle time becomes excessive or the flash doesn't recharge at all.

PENTAX 110 WINDER II
This handy accessory automatically advances film to frame 1 when a new cartridge of film is inserted. It also advances single frames while you expose the roll and then automatically finishes winding to the end of the roll after the last frame has been exposed. The only control on the winder is an **ON/OFF** switch.

To prepare for use, install two AA-size alkaline batteries in the battery chamber of the winder.

When attaching the winder to the camera, be sure the winder is turned off. Align the winder with the recesses on the bottom of the camera. Press camera and winder together while turning the Lock Knob on the winder.

The winder attachment screw fits into the tripod socket on the camera. Another tripod socket is in the bottom of the winder.

If you drop in a fresh cartridge of film and then turn on the winder, it will automatically advance film to frame 1 and then stop.

With the winder turned on, it will automatically advance the next frame after each frame is exposed. You cannot expose sequential frames by holding the shutter button down. You must release the shutter button and wait for the film to advance before exposing the next frame.

With the winder switched off, the camera operates as though it were not attached. If you are partway through a cartridge of film and then install the winder, be sure it is turned off. When you turn the winder on, it will advance film to the next frame if you have not manually advanced to a fresh frame.

When you shoot the last frame on the roll, the winder will automatically advance film to the end and then stop. Turn off the winder, open the camera and remove the exposed cartridge.

Battery discharge is indicated by sluggish winding action.

The 110 Winder adds convenience of operation and also makes a very handy grip.

CLOSE-UP LENSES

Pentax 110 Close-Up Lenses have two-part labels, such as **W21**. Letters are used to indicate which type of camera lens each close-up lens is to be used with. *W* means wide-angle; *S* means standard; and *T* means telephoto.

The numerical part of the label is the focal length of the close-up lens in *centimeters*. For example, the focal length of the **W21** is 21 centimeters, or 210mm. The accompanying table shows typical magnifications with these lenses.

FILTERS

UV and Skylight filters are available with filter-thread diameters of 25.5mm, 30.5mm and 37.5mm. The other lenses in this series have filter-thread diameters of 49mm and can use the same filters as the 35mm cameras.

OTHER ACCESSORIES

Lens hoods are available for each Pentax-110 lens. A handstrap, packaged with the camera, clips over a fitting on the side of the camera body. A soft case is also available.

MAGNIFICATION WITH PENTAX-110 CLOSE-UP LENSES

CLOSE-UP LENS	USED WITH	FOCUSING RANGE MEASURED FROM FILM PLANE (cm)	MAGNIFICATION RANGE
S31	24mm	20 to 36	0.16 to 0.08
S16	24mm	15 to 20	0.24 to 0.16
W21	18mm	16 to 26	0.18 to 0.09
T86	50mm	49 to 92	0.13 to 0.06
T43	50mm	34 to 49	0.19 to 0.12

Medium-size prints have excellent sharpness. Actual size of negative is shown at right.

INDEX